INGRES

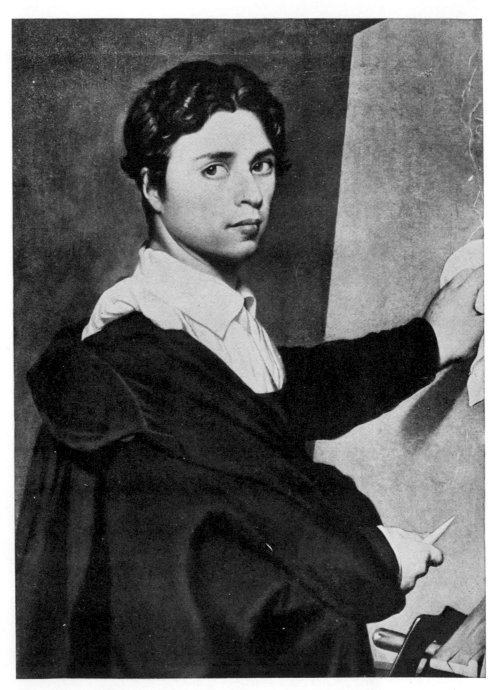

Self-portrait, 1804, Private Collection, New York

INGRES

By

WALTER PACH

HACKER ART BOOKS
NEW YORK
1973

First published 1939, New York

Reissued 1973 by
Hacker Art Books, New York, New York

Library of Congress Catalogue Card Number 77-143359
ISBN 0-87817-078-2

Printed in the United States of America

To
EDWARD ROBINSON,
ROGER E. FRY
and
BRYSON BURROUGHS,
among those who are no longer with us;
to
GISELA M. A. RICHTER,
HENRY W. KENT,
and
HARRY B. WEHLE,
LACEY DAVIS CASKEY,
ALFRED VANCE CHURCHILL,
and
WILLIAM R. VALENTINER,
*as typical of those inspired and devoted men
and women who, through their activity in
American museums, are carrying on a work
which lay near to the strong heart of Ingres
—that of giving to the ever new world a
creative re-embodiment of the finest of its
earlier thought, and of making it accessible
to all men.*

CONTENTS

ILLUSTRATIONS

Illustrations

Illustrations

Illustrations

GRATEFUL ACKNOWLEDGMENT IS HEREBY MADE TO MESSRS. M. Knoedler & Co., Wildenstein & Co., Durand-Ruel, Jacques Seligmann & Co., and the C. W. Kraushaar Galleries for photographs of the magnificent works by Ingres which they have brought to America. Thanks are also tendered to the collectors who have permitted the reproduction of drawings and paintings in their possession.

PART I

The Life and Work of Ingres

CHAPTER I

The Early Years: 1780-1806

IN A WORLD AS CHANGING AS OURS IS TODAY WE PARTICU-
larly need to know what Goethe called "the things that are permanent."
Never have they had more consistent homage than that of Ingres, and
never have the classical qualities more clearly proved by results their
continuing power to renew the genius of mankind. Therefore this first
book written in English on a painter who gave fervent study to the past
is above all a document on modern art, its origin and purpose. The
Greeks were the moderns of their day; Ingres, in similar fashion, was
necessary to his period; both reach out to times quite infinitely beyond
their own. They demonstrate to us by their works the way in which
the arts are essential in character — which is to say modern.

Incomparably the best testimony on such questions is that of the
artists themselves, and so I offer at the outset an incident which proves
the position of Ingres in the world of today. In 1875, when the master
was looked on with suspicion by the great young men who saw the
vital influence of the time in his rival, Delacroix, a copy of that paint-
er's *Jewish Wedding*, in the Louvre was commissioned from Renoir,
himself one of the "revolutionaries" whose art was formed above all
under the influence of Delacroix.

Yet each time that he left his easel for a rest and a stroll in the gal-
lery, he found himself drawn, and always more strongly, to the pic-
tures by Ingres, who became the special guide of his work in its next
period. To the end of his career Renoir remained unswervingly faithful
to Delacroix, whom he considered, indeed, the greatest painter of the
French school. And so, his being fascinated by the man regarded as

3

the antithesis of his favorite tells us again that the qualities of art must be sought beneath the surface of appearances.

For the world, as for Renoir, Ingres reserves the surprise we always feel on discovering that there is still inexhaustible wealth in a production we thought to know through and through. What misleads people into forming such an idea is not the painting of the master himself, but that of his followers — frequently men devoid of value. They are far from summing up his influence. His real inheritors, Courbet and Puvis de Chavannes, Manet and Degas, Seurat, Picasso and Derain tell a different story about Ingres's effect on the world. The great realists of the later time stem from him, and it is he whose classical measure offers its corrective when their schools have reached the point of excess. The discipline he imposed is asked for again by a generation re-awakened to the need for order and logic; but even these qualities take a secondary place in the minds of his admirers. To define the dominant of his work they do not hesitate to use a term that many people have come to regard as "unscientific." Perhaps it is so, but it has always been honored in the realm of art. So that we introduce Jean Auguste Dominique Ingres as one of those, and one of the chief of those who still give meaning to the word beauty. It is the distinguishing element in his work.

Jean Auguste Dominique Ingres[1] was born in 1780 at Montauban, in what is now the Department of Tarn-et-Garonne (it was only under Napoleon that this political division was created). The country in which the ancient town is situated is typical of the South of France both in the matter of physical character — the dry, hard, well-drawn landscape, and in the matter of its people. Boyer d'Agen, who has done

[1] *One thing which people ask of books about artists is the pronunciation of their names. That is frequently difficult to render in another language; but if one takes the English word "angry" and leaves off the y, the resulting sound is practically that of* Ingres *as pronounced by Frenchmen, quite a different thing from "anger," as the name is badly rendered by those who, when speaking, insert an* e *before the* r, *as they do with the numerous French words like* Louvre, perdre, timbre, *etc. That is about the equivalent of saying* athaletics *or* umberella.

so much for our knowledge of Ingres, sees in Montauban a meeting place of the Latin and the specifically French elements of the race, and his ear for accents permits him to hear in the speech of the city echoes of the language brought into France by the conquerors of Caesar's time. From that to seeing in the temperament and even in the physiognomy of the painter something of imperial Caesar is only a brief step in the analysis which prefaces his volume, with its valuable series of letters from Ingres.

There was nothing imperial in the circumstances surrounding the youth of the great man. His father, an artist, led a difficult life in the small city, where even his ability to turn his hand to any form of painting, sculpture, or architectural decoration hardly sufficed to support his large family. Unbusinesslike, and unsteady in character, he was competent in his various professional activities, and his son grew up in that "family life of art" which explains the good and early start of so many a painter in the time before the French Revolution.

Yet more than that is needed to account for the quasi-perfection of the work on which the artist wrote "my first drawing, Ingres, 1789." It tells that the man was born with a positive genius for drawing, one that continued along the lines laid down at the age of nine and that we may indeed see, in the light of the seventy-eight years to follow, as a prophecy of the great lifetime of art before him. The first known drawing by Delacroix contains a sketch of himself; the work which Ingres tells us is his first drawing is from a cast of an antique head. One needs to give way but little to one's imagination to see foreshadowed, on the one hand the introspection of the Romantic school, on the other the reliance on the past of the Classicist. The terms always applied to the two masters are right, then, even if Delacroix's tremendous study of the museums carries him to almost unparalleled breadth and depth of knowledge of the classics, and if the instinct of Ingres, rooted in the genius of his country, moves along with it as the great adventure of modern thought unrolls throughout his career. In that long space of time, the tenacity of ideas inherited from the past

5

was as important as the new forms they received through the minds of imaginative men.

Joseph Ingres, the father (whose family name we find spelled in various ways, in the old documents) gave his son a start with music as well as with painting. Having taught the boy to play the violin, he took him, at the age of twelve, to the larger city of Toulouse, near by, where his talent helped to pay for his education — a better one than he could have had in his native place. Montauban was, however, the city he always looked on as his home, even though he returned to it but once. Friends of his childhood were among his first portrait sitters; the great *Vow of Louis XIII*, the earliest of his important compositions, was commissioned by the government for Montauban, where it still hangs in the cathedral; a long correspondence with his compatriots (men of the same *petite patrie*) served to keep fresh his memories, so that, at the end of his life, it was to the city of his birth that he bequeathed the big mass of his drawings, some five thousand in number. Together with other studies and finished works, they form the Musée Ingres, one of the great monuments to the lives of artists.

Toulouse, in the eyes of Ingres, was almost another Rome. Several artists contributed there to the developing of his talent; the most important among them, Roques, had been a friend of Louis David's during the latter's stay in Italy. Years later, Ingres wrote to Roques in gratitude for the instruction he had received in his studio, where a collection of engravings, particularly one from Raphael's *Madonna della Sedia,* had kindled his admiration and contributed largely to forming the ideal to which he was to hold. In later life, much of his own teaching consisted in having the students work from engravings after the masters, especially at the beginning; and at the end of his own career, the very last drawing he ever touched, a few days before his death, was from a print of a Giotto at Padua.

Five years of work at Toulouse prepared him to go on to Paris, whither he journeyed in 1797, together with a son of Joseph Roques. The teacher gave him a letter of recommendation to his old friend

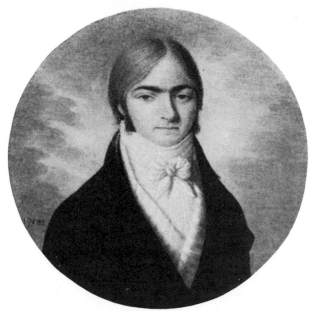

Portrait of a Man, Miniature by the Father of Ingres, Louvre

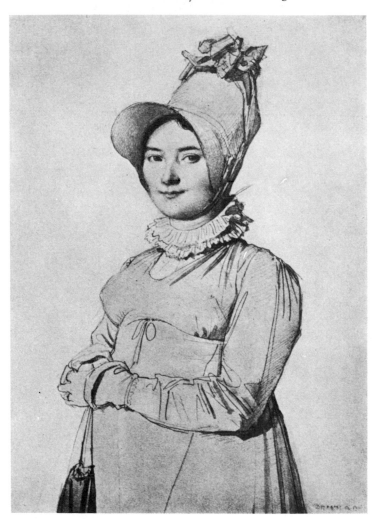

Mme Ingres (Madeleine Chapelle), 1814, Musée Ingres, Montauban

The First Drawing by Ingres, 1789, Formerly collection of Henry Lapauze

David, who immediately took the young man into his studio. Although the number of pupils there made it a school, the old traditions of constant relationship between master and student continued in full force; and close contact with a man of such personal power, such unquestioned authority as was that of Jacques Louis David was bound to be a pivotal experience.

Born in 1748, a force for artistic and intellectual renewal since almost two decades, an important actor in the drama of the Revolution, David was at the fullness of his powers, and nearing the height of his position as the dictator of the arts when the seventeen-year-old Ingres came to work under him. Delécluze, in his basic and vivid book on David, tells us of Ingres as he saw him at the studio, where the critic was himself a pupil at the time. Taking but little part in the escapades traditional with art students, Ingres devoted himself to his work with an intensity that soon won the admiration of his teacher. One would give much to know what the two men thought of each other at the time, but there is not a great deal of evidence on which to base an idea of their relationship. Yet it is significant, from the standpoint of David, that he had his young pupil make drawings (still existing) for the portrait of Mme Récamier, that superb work of the year 1800 in which some of the accessories in the canvas itself are from the brush of the young disciple. And the grace of the famous figure in the Louvre seems to owe much to those drawings made by the student from a nude model in the pose of the sitter. Through them Ingres already reaches one of his glorious statements as to feminine beauty in its quintessence.

Such an ideal was not the one usually sought for in the severe atelier of the painter of the Revolution. To be sure this is the period when David was working on the *Sabines,* where some of his loveliest renderings of women's movement are to be found. But the mere mention of that great canvas makes us feel the difference between him and Ingres. David, in reaction against the eighteenth century, sees its delight in nuances, its naturalness and gaiety, as decadence and weakness. A master so lovable — so exalted indeed, as Watteau is to the eyes of

today, was proscribed as mercilessly as the lightest-minded artist of the end of the royal period. One remembers the terrible word of Victor Hugo describing the old court theater stripped of all its delicate carving, gilding and color to become the hall of the Convention — "Boucher guillotined by David."

And now the reaction begins to take the opposite course, to turn against the coldness and severity of the men of the republic. Grand as was their antique simplicity, it could not continue as the note of a time that looked to gentler and subtler arts in the past — and in the future. To see Ingres as a harbinger of such a change is not alone to understand his difficulties with the great master under whom he studied, but to see the Romantic in him; even while under the spell of the past, he was still in harmony with his time and its need for new beauty. David could not accept such an attitude to art. The fact is evidenced by an early impression recorded by Amaury-Duval in that precious book, *L'Atelier d'Ingres,* the most fascinating contemporary account of the artist.

The writer of this book, one of the most faithful and intelligent of the many students who worked in the atelier, relates at the outset how he came to choose Ingres as his master. He had been, as he says, brought up "amidst the painters of the Empire," and so, in 1825, when he decided to enter upon the career of artist, it was natural for him to think first of studying under Gros, the official successor of David. A trusted adviser spoke against the idea: Gros was old, he said, and no longer interested in teaching; Ingres was the man to go to. It is then that the young aspirant gives us the sentences which reveal the feeling about our artist that we may ascribe to David and his group.

The name of Ingres, which had only very recently begun to echo throughout a certain part of the public, presented to my mind a pretty vague impression; his pictures had struck me more through their originality, which seemed to me queerness, than through the reality of their beauty. They had given to M. Ingres a place in my mind like that of an old master, and his absence from Paris [during his long sojourn at Rome] had added to that impression. When I

said to M. Varcollier that I thought Ingres was in Italy, my idea was rather that I did not look upon him as of our time.

This clear statement of the ideas of a young man echoing the opinion of the great Davidian circle is preferable to what we get from the professional critics of the time, and may be relied on for an insight into David's own thought as to his pupil. Further light on the matter is offered by the passionate exclamation of Ingres upon seeing the great Italian primitives when he arrived in Florence. More than once he was to repeat the severe judgment on his early mentors: "How they deceived me in Paris!" The reference is to the warnings against the primitives he had received from "the painters of the Empire," with his all-powerful teacher at their head.

Refusing to heed the admonitions — or, more exactly, impelled by his own fixed character and taste — he had incurred the reproach of being "Gothic." The word comes to mind as we read Amaury-Duval's statement, "I did not look upon him as of our time." Ingres never saw that particular version of the accusation against him (his pupil was too reverent to let such a thought transpire), but he replies to it in one of the most striking bits of expression we have from him, the first that I shall cite of those extracts from the master's own words which, after his works, give us our best understanding of him.

Let me hear no more of that absurd maxim: "We need the new, we must follow our century, everything changes, everything is changed." All that is sophistry! Does nature change, do the light and the air change, have the passions of the human heart changed since the time of Homer? "One must follow one's century" ... but if my century is wrong? Because my neighbor's acts are evil, are my own obliged to be so too? Because virtue, as well as beauty, is misunderstood by you, am I obliged to misunderstand it also, am I obliged to imitate you?

There is at least a hint that David was aware of the determined character of his pupil, despite the admiration with which the young man

regarded him. The latter sentiment was inevitable: David is to be seen not only as one of the greatest men that France has produced, but as the initiator of the whole line of what today is called modern art, the pioneer of the new century. "But," asks Ingres in his devastating sentence, "if my century is wrong?"

Perhaps it is unjust to David to say that, realizing the different course Ingres was to take, he opposed his pupil, as the latter presently said he did. Yet one concrete fact remains, the preference that David showed for Granger in 1800 when the *Prix de Rome* was given to that student, a man of relatively slight talent, as against Ingres, who was competing. The reason sometimes offered is that Granger needed the exemption from military service which the prize carried with it. It is true also that in the following year Ingres received the award. Yet his mind — as it was to remain throughout his lifetime — was so sensitive in personal relationships that he felt David's opposition very keenly. The human side of the matter is not essential to us today: what we need to understand is the principle involved, the difference between the man of the Revolution, with Gros and Rude carrying forward his ideas, on the one hand and, on the other, Ingres, seeing beauty in the older schools that the "moderns" thought to have left behind.

The winning of the *Prix de Rome* did not carry with it the immediate departure for Italy that the young man had longed for; the national treasury was depleted, and only after five years and the intervention of a well-disposed official (the father of that Amaury-Duval who was later to be Ingres's pupil) could the various prize winners depart. The intervening period was occupied by work principally directed to earning a livelihood. There were drawings for publishers and there were portraits. Also, there were returns to the *Ecole des Beaux-Arts* for further study — a testimony to the seriousness with which young artists looked on their calling at the time; Géricault and Delacroix are other examples of men who went back to school after a great public success.

Among the advantages which Ingres received from his position as a

prize winner was the use of a studio in a government building which had formerly been a convent of Capucines, situated in what is now the rue de la Paix. It must have been a wonderful place, for under its roof Ingres had such neighbors as Gros and Girodet, former students of David and then famous themselves, Granet the painter from Aix-en-Provence, of whom Ingres was to produce a magnificent portrait when in Rome, and Bartolini the sculptor, of whom our artist entertained a very high opinion. Later on, when Bartolini had returned to his native Florence, Ingres was his guest there. Two portraits of the sculptor which the young Frenchman painted tell of the friendly relationship between the two men.

But beside the artists, who were quick to recognize Ingres's extraordinary gift as a portraitist, there was a whole series of other sitters. Early among these was a boyhood friend — Jean-François Gilibert, who had come to Paris at about the same time as Ingres and who, while studying law, was initiated by his comrade into matters of art. He showed a genuine appreciation for them and, returning to his home town, was apparently the cause of a number of commissions from Montalbanais visiting Paris. Portraits in paint or in pencil and other small works which his "compatriots" ordered from him helped to carry the young artist through difficult years. Another consequence of Ingres's intimacy with his fellow townsman was the long correspondence preserved by Gilibert from 1817 until his death in 1850 and, later, passed on by his daughter to Boyer d'Agen, who published it. While many of the letters derive their chief value from the accent of Ingres's passionate voice, which speaks through them of personal happenings, there are not a few passages where we get far more important material, his opinions on art.

By 1803 the success of Ingres was sufficient to induce Napoleon to give him some sittings, which resulted in the portrait of the emperor ordered for the city of Liège and executed in 1805. Other paintings of the great man, portraits or compositions, were to follow. When the Bourbons regained the throne, Ingres, unlike his master David, had no

difficulty in accepting service under them, as he did with the house of Orléans after the revolution of 1830, and as he did with Napoleon III again, when that ruler came to power. Bitter reproaches were addressed to the artist because he went on complacently with his work at times of national stress and misfortune, but he seems to have ignored the charges, letting his pictures be his sole reply to such criticism — and to that concerned with his professional activity. Yet on the latter score, his private correspondence and conversation show him to have been sensitive to an extreme degree, at times a morbidly exaggerated degree.

That was partly an effect of his exclusive concentration on art, and partly an effect of his temperament. It was one which the French themselves see as meridional, in contrast with the cooler, steadier character of the North. Nerves just under the surface of a thin skin made him bound at the touch of an unfriendly hand, above all when questions of painting (his own or that of the masters) came up. Whether or not one agrees with a given opinion of his, every artist must take pride in the intensity with which Ingres believed in the importance of his calling. Among many examples of the kind, we may remember the one which shows us Ingres having heard a word of disrespect as to a great artist, immediately turning to his doorkeeper and saying, "Notice that gentleman: I shall never be at home to him when he calls."

The incident dates from his later stay in Rome, when he returned as director of the French school there; but everything we know of his life, early or late, tells of the same sensibility. To know it in terms of his human relationships (and we shall find endless examples of it when we get to his letters) is to be prepared for the expression of it we find in the portraits he drew and painted. They are perhaps the works of Ingres most accessible to appreciation. There may be a time in our development when his workmanship seems to us dry and aloof, but even then we can usually feel the warmth of his nature by means of his response to the beauty or the character of his sitters.

The head of young Bernier, one of his earliest companions, has the look of surprised intimacy that tells of the attention with which

the artist peered into the mind of his model. Or take such a work as the self-portrait of 1804, the one at Chantilly, or the variant of it in an American collection that is reproduced in this book. Here, as is usually the case when artists paint themselves, there is a certain calm reserve. Yet in this image of a man at work, the dramatic, dynamic quality of the composition is only another expression of the intensity of life which seems to make the dark eyes in the dark face glow with a fire of their own. Before the photograph, one can scarcely think of the absence of color, because one is convinced that it bears out the splendor of the things visible; and it does so, for with all its sobriety, the painting responds to the tense mind of the man who reveals himself so powerfully.

As one portrait after another of this great early period thrills us by the depths of character it opens up, we are prepared for a preliminary glance at Ingres's color. It is not as simple a matter as it seems at first when, for the moment, we may imagine ourselves free of the complications surrounding the subtlest of the attributes of painting. No one has more consistently used the local color of the object (the brown coat is done with solid brown paint, the blue sky with solid blue paint, etc.); a generally neutral tone predominates, and it is easy to see that the artist's emotion expressed itself almost entirely through form.

Yet our own emotion, once we are attuned to him, may well find deep satisfaction in his narrow range of hues. Dürer and Holbein are not colorists in the sense that Rubens and the Venetians are, but the modest flush of pink, the cool browns and grays of the two German masters surprise us by the delight they add to what we had felt in the presence of engravings or even drawings by those great men. Like them, Ingres never attempts to get relationships of color that will work together reciprocally and release a new magic in his picture; the life and unity of his work is attained by line, plane and mass, in the proportions that his instinct and study dictated. Color was an afterthought, a minor detail that had no functional necessity in his scheme.

Testimony to this fact is found in his own words when we consider a passage in Amaury-Duval's book. At a time when Ingres's art was

fully mature, he came to see a copy that his pupil had made of his great portrait of M. Bertin, now in the Louvre. Amaury-Duval writes that he was nervous about the visit, especially as the master's wife had said, "Ingres claims that his work cannot be copied." Yet after a very careful inspection, the painter of the original said that he would be willing to sign his name to the copy. Then came the words that caused "stupefaction" to the younger artist.

"Why didn't you try a different background, a greenish background?"

Armand Bertin did not conceal a sign of astonishment and I could not pre-vent myself from smiling, for I had said to him, a few days before, that if, to our sorrow, M. Ingres were no longer alive, I should have permitted myself to modify the background and to have made it, preferably, of a greenish tone. This chance, which caused me to fall in with the master's own thought, was what impressed us both, but I was able to explain the effect that M. Ingres's words had produced on us, for I said:

"Could you suppose, sir, that I would permit myself to make a change, even the most insignificant one, in a work by you — and how much more so a change of such importance?"

"That's true ... that's true ... you're right: still, I regret that the attempt was not made. Now it's too late. The copy is very fine, and I thank you again for the evidence of affection you have given me."

Amaury-Duval had by chance, as he says, fallen in with his master's thought as to what color the background should have been; but there was no accident about the agreement of the two artists on the possibility of substituting one color for another in a picture; they did not consider that this meant changing every tone in it. With Ingres, as with his faithful follower, color was like a garment, a thing to be put on or re-moved at will, as good taste might dictate. For men who see a picture in terms of color, its parts can no more be changed or moved about than a man's eyes or mouth or heart can be. And though Ingres enjoined the most humble submission to nature and was the first to obey his own rule in this respect, he never appreciated the role which color plays in rendering such aspects of nature as light and shadow, atmosphere and

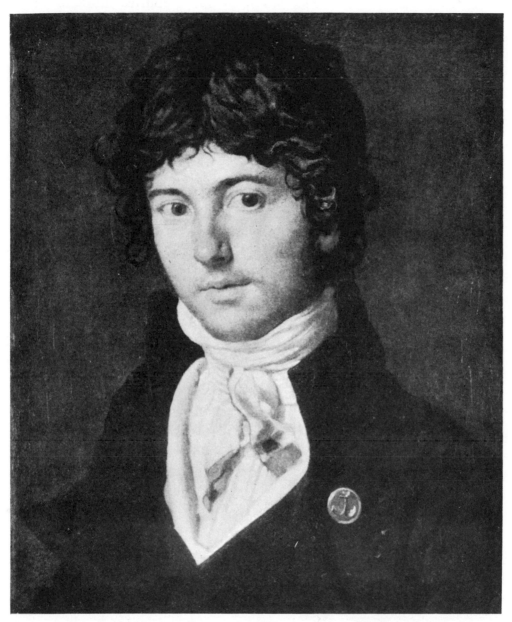

Pierre-François Bernier, about 1800, Collection of H. S. Southam, Ottawa, Canada

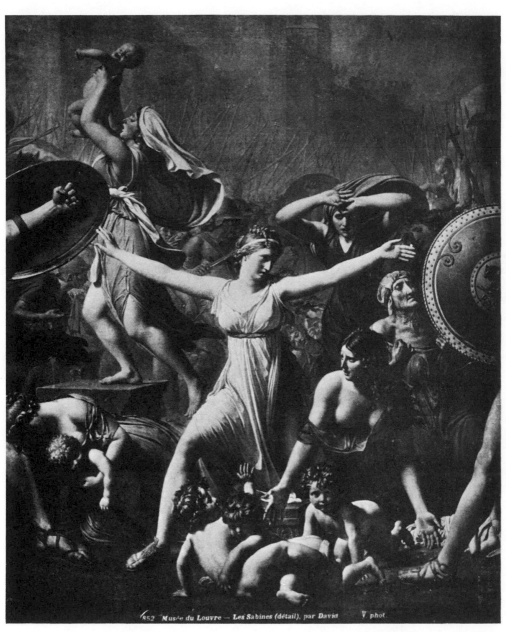

Detail from *The Sabines* by Jacques Louis David, Louvre

distance. They are not absent from his work, certainly, but they are obtained by means of black-and-white values and by linear perspective.

We must get to the point of seeing the color element in the work of Ingres as a necessary phase of his great art. A picture by him repainted with the color of Titian, for example, would be as anomalous as a work by the great Venetian redrawn in the proportions and given the peculiar personal finish of an Ingres. And it is not by chance that I associate the two names, for when the young master reached Florence he copied the great Venus of Titian in the Uffizi. However, like his forerunner among French artists visiting Italy, like Poussin who also gave study and admiration to Titian's color, he knew too well where his strength lay to be led off into paths that he was not fitted to pursue. Submissive as he was to external nature, the thing that made him great was his following out the law of the nature within him, that of his genius.

CHAPTER II

Ingres Goes to Italy

ALL THE DAYS IN WHICH ROME WAS BUILT WERE LOOKING
to the use that Ingres would make of them, or so we may permit our-
selves to imagine when we find him, at last, in the city of the Caesars.
He had seen Napoleon, the modern Caesar, had painted that Frenchman
of the South and, painting his own portrait in later years, has caused
more than one person to remark on the likeness to the two conquerors
that he unconsciously gave to his image. Later on, we shall hear from
Mme Ingres, who was very direct in her speech, a statement that the
portrait of himself which he sent her before their marriage was "nicely
flattered." Though he condemned idealizing a sitter, it may well be
that his admiration for the two Latin emperors had given his likeness
an air of grandeur that his very small stature (about five feet, three
inches), failed to confirm.

Even more suited to his genius than the Rome of antiquity was the
Rome of Raphael. As we have seen, his earliest impressions of art in-
cluded those derived from engravings after the Renaissance master
which he had copied in the studio of Roques. We have a picturesque
word of his own about such works—that he "went after them like a
cat after its prey"; and this was when he was twelve years old. Paris had
shown him originals by Raphael, but only in Rome could he see the
works which were to represent to him the apogee of his idol's art: the
frescoes.

Amaury-Duval gives a vivid account of the scene at his father's
house when Thiers spoke to Ingres about Raphael. The celebrated
statesman of a later time was not yet the power in France that he was
to become, but he had written considerably and had no doubt as to the

16

rightness of his opinions, even when speaking to a man (this was in 1825) who had achieved the distinction of Ingres.

The latter listened, not opening his mouth, his eyes fixed on M. Thiers, and letting the famous critic run on; but for some moments his fingers had been tapping on the table as if he were playing the piano at terrific speed; it was apparent that he had much trouble in concealing his impatience.

Finally M. Thiers, who does not easily come to a stop, began on Raphael, and developed the argument that all he had done was the madonnas, and that they were his real title to glory.

"Only the madonnas!" broke out M. Ingres at that point, "only the madonnas! . . . To be sure, my respect, the cult I have vowed to that divine man, is well known; the whole public knows whether I admire everything that he touched with his brush. But I would give all the madonnas, yes, monsieur, all . . . for a detail of the *Disputa,* or the *School of Athens,* or the *Parnassus.* . . . And the *Loggie,* and the *Farnesina!* One would have to go over the whole list."

The passionate defense of his great man led him to lengths for which he felt obliged to apologize next day to his host, especially in view of the eminence of his fellow guest. But the excitement of the discussion had been such that, as Amaury-Duval says, it was evident that he had passed a sleepless night over it. And when he saw his young pupil in the morning, he exploded in characteristic fashion:

"There! my dear friend, you heard him yesterday . . . And those are the people who judge us, who insult us. . . . Without having learned anything, seen anything, impudent and ignorant. . . . If it suits such gentry, one day, to pick up some mud in the street and throw it in our faces . . . what is left for us to do, for us who have worked thirty years, and studied and compared, who come before the public with a work (he showed me a portrait he was engaged on) which, if it is not perfect — good Lord, I know that — is at least honest, conscientious, produced with the respect one must have for art . . . well then, we who have no other trade, who do not know how to write, who can not answer them . . . what are we to do?" Taking his handkerchief from his pocket and rubbing both his cheeks with it, he said, "There, my dear friend, there is all we can do . . . wipe ourselves off."

17

Rome, in addition to its treasures of antiquity and the Renaissance had another attraction for Ingres: the tranquillity which he found there, as Poussin had found it in his long and voluntary exile, two centuries before. It is true that Ingres kept up a correspondence with Paris and that, each time a critic wrote ill of his work, words like "insult" and "mud-throwing" were prompt to burst forth from him, so that a writer of the time facetiously called him *The Painter and Martyr;* yet he was far from the scene of struggle, and produced with greater calm than at home, where his nervous susceptibility was under constant strain.

Soon after his departure from Paris in 1806, he had one of his bitterest experiences of the critics' ignorance and, what was worse, their willingness to attack an original man. The dead level of imitation which characterized so many of David's pupils made the independence of Ingres the more conspicuous, and neither master nor students pardoned it in the young prize winner. The journalists who (as usual) voiced the ideas of artists in vogue, fell upon Ingres's work at the Salon of the year; and so a really abominable group of articles followed the painter to Italy.

It was only in Rome that they reached him. In Florence where he stayed for a time before going on southward, he was still under the happy impressions of his arrival in the promised land.

I go every day to make a pilgrimage to the church of the Carmine, where there is a chapel that one could call the ante-chamber of Paradise: it is painted by Masaccio, a painter of the early Renaissance. I went to the Pergola, the leading theater here, where I saw a performance of *Artemisia,* a grand opera and, although the music was by the celebrated Cimarosa, I understood nothing of it; it is the most tiresome hodge-podge, in the matter of instrumental execution; no taste whatever and, what is more, no measure; half the orchestra is always behind the other half by a bar.

Although the criticism here is of the production, there is also a reference to the composer, and I have come on no other of Ingres's words

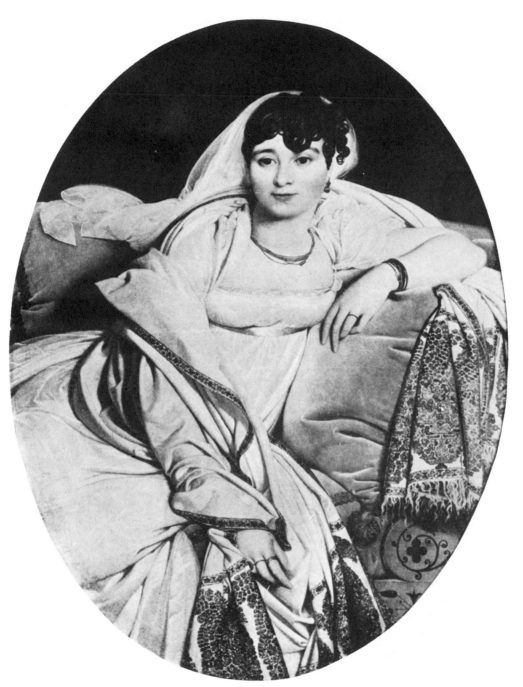

Mme Rivière, 1805, Louvre

Mlle Rivière, 1805, Louvre

to offset it. In one place he says that he cares only for German music, but the genius of Cimarosa is so closely allied to that of Haydn and Mozart that it is difficult to imagine how Ingres could have escaped the spell of the man. Still, when one thinks of Delacroix's adoration for Cimarosa, a difference between the two painters is to be remarked. For those who would mechanically range Delacroix with the "new school" and Ingres with the old, the difference is instructive, particularly when we note their attitude toward Beethoven. In Delacroix there is an element of doubt that lingers for years, however warmly he defends the "innovator," and however enthusiastic his response to the compositions he enjoyed. With Ingres there is no doubt: his attitude is far more nearly the one brought about by the passing of a century, a full acceptance of the composer as one of the great Olympians.

If we can see in this how much of open-mindedness Ingres possessed, we are prepared to grasp the significance of another line in the letter cited just previously, and to understand the young artist's allusion to himself as a "revolutionary," in a passage we are soon to read. It will seem a strange one to many people of today, remembering the position of Ingres as the man constantly invoked by academic painters and critics. But part of the mission of this book, as I see it, is to restore him to his position as an artist of the truest originality, one who knew how to use the past rightly, which is to say as the great guide to the present and the future.

It is with such a thought in mind that we must read the words of the twenty-six-year-old who stands before the frescoes of Masaccio at the Carmine and calls the chapel there the antechamber of Paradise. We read in Delécluze that David saw not merely intention but realization in Masaccio; yet for such fervor as we have just heard from Ingres, a new generation was needed and, more than that, a man who would see not merely historical importance in what his time called the "primitives" but a quality that swings open the very gates of heaven.

In the same letter he inquires anxiously about the response in Paris to the works he had sent to the Salon. They included the portrait of

Napoleon, the self-portrait of 1804, and those masterpieces of the Rivière family that are now among the proud possessions of the Louvre. "The Woman with the Shawl" (Mme Rivière) has become one of the most celebrated works in the history of French art. And if the picture of her daughter has not had an equal success with all critics, it may yet reach the highest place of all three of these family portraits. The character of the maiden is rendered with a deep and moving sense of mystery, and the grand opposition between the vertical of the figure and the horizontals of the landscape is perhaps even more impressive than the arabesque which dominates the composition of the mother's portrait. Just fifty years after painting the *Mlle Rivière,* the artist could say to Amaury-Duval, "I think that if I have done anything good, it is that portrait." He had not seen it for a very long time, and his statement may be somewhat colored by the pleasure an old man has in memories of his youth. Yet those who love the picture will always be grateful to him for so commending it.

With such works submitted to the public, it is fully comprehensible that a man as sensitive as Ingres should be thrown into a state of consternation on receiving the terrible and unjust criticisms of his work that were forwarded to him soon after his arrival in Rome. We have his reaction to them in a series of letters, the first of which flames up from its opening words, as follows:

And you also, my dear friends, would you abandon me to everything that is breaking me down? I know everything that is taking place in Paris, as far as it concerns myself. The Salon is, then, the theater of my shame: I am the victim of ignorance, of bad faith, of calumny — and I get no consolation from you, my dear friends. The scoundrels, they waited till I was gone before assassinating me in reputation. From one day to the next, have I changed from a distinguished painter to a man whose works may not be looked at, whose effect is to arouse fury, about whom all Paris talks in a frightful way? And I am not there, I can not defend myself; I would lay down my life or make that croaking mob of jealous and ignorant men stop their outcry. But have mercy, have pity on my despair; since my arrival in Rome, not a bit of news from you; all night

I drink the bitterest dregs [the French expression is "I swallow snakes"] and by day I die of vexation; never have I been so unhappy. Is it true that the few friends and men of taste who defend me hardly dare nowadays, to go to the Salon? What crime have I committed? What disaster have I caused?

The Jeremiad continues, but the above is a fair sample of its style. Added to the words about Thiers previously given, it shows the emotional side of Ingres's nature. In a subsequent letter in the same series, he is able to analyze the situation in a critical way:

Yes, there is big need of reform in art, and I should be very glad to be the revolutionary it calls for: just wait—I shall kick and bite until, one day, the change will come. I center my whole ambition on bringing it about. Those people in Paris are strengthening my ideas about the wide road before me, I see it more clearly than ever and it is no use for them to cry out that I am going astray. . . . Senseless men, it is you who cannot walk straight. I don't know where they got their idea of citing John of Bruges,[1] as if my works were meant to follow those of that painter. I esteem John of Bruges very much, I should be glad to resemble him in many ways; but still he is not my painter, and I imagine that he was cited at random.

. . . I think, I have no severer judge than myself. For, the further I go, the more I get to be my own tyrant, ambition devours me, as you know, and I will have all or nothing. Very brave of me, isn't it, for a man with such a sick mind! It is true that what I have just said is the result of my more sober judgment. But I have moments when I could let go completely. At such times I envy the lot of those who know nothing and who enjoy life peacefully, in a word, those who do not exhibit at the Salon. But that does not last, and the fever seizes me harder than ever. I have a pretty good notion of the part that my dear teacher, M. David, has been playing in this whole business. I should be obliged if you would write me a word on that subject. I have described the man to you more than once; it will be useless for him to write me, he is not dealing with a fool, it will be useless for him to cast his bait in my direction, he won't catch me with it.

[1] *It may be that the artist of Bruges referred to is John van Eyck or Hans (John) Memling. To be sure, there is a 14th century illuminator known as John of Bruges, but it seems less likely that he should be known to both the critic and to Ingres.*

The last sentence looks back to an earlier passage in the same letter, where Ingres says:

"What I love most is their solicitude in calling out to me that I am going astray, and their invitation to return to the true path."

The people here referred to are the dull followers of David, painters as well as critics. The real enemy of art in general, and not merely that of Ingres, they come to be entitled "the School." Elie Faure, by a masterly piece of analysis (in the notes to his edition of Amaury-Duval) shows that the young man's words about refusing the bait thrown out to him are not entirely justified by his later career. When the school is threatened by still bolder "revolutionaries," Géricault and Delacroix, it closes its eyes to Ingres's peccadillos (and its own denunciation of them) and, promptly electing him to the Institute, takes the man of genius into its midst, as a safeguard against a worse fate.

Meanwhile we may give one more glimpse into the early period of the master, and observe that turn — so difficult to grasp today — from the Empire to the more modern tendencies of Ingres. Some two months after the letter last quoted, he writes again:

If this business continues, my work will never be liked; for I am in no humor to change the one and true course that I have laid out for myself — quite the contrary; I am more set upon it than ever, with the sole idea of perfecting myself in it; I am inflexible, and incapable of any kind of complaisance with the bad taste that is so general — even, I venture to say, among those who are doing the best. I am tired of the advice I am getting. I don't want any more of it; let them keep it for themselves since they think it is good. The only advice I want is the kind I can give myself. With their talk about Gothic, senseless creatures that they are, they are referring to what possesses true character; it is not possible that in one day I have become Gothic; I say, rather, it is comparison with their feeble and cowardly painting on the walls round about that has caused error about my work in the minds even of men who have some title to judgment; it is this contrast which makes them regard as Gothic what is severe and noble.

Yes, that is the way I speak of my works. I think back to them and in vain — as far as finding anything Gothic about them; all they lack in order to be perfect is just that perfection that is called Gothic by the men who try to judge

me. Something Gothic in Mme Rivière's portrait, or that of her daughter! I lose the connection when I hear such talk, — I don't know what they mean. Here is a test: Bartolini is the man in whom I see not only the greatest talent, but a talent of the time of Pericles, that is to say a sense of beauty. I have the greatest confidence in him; do me the favor to sound him out adroitly on this question: I will agree to consider myself Gothic if he says I have such a defect.

To understand the attitude of David and his school, from which Ingres suffered so much, it is not enough to consider the absolutism of the teacher and the weakness of his followers. Turn rather from such a piece of Davidian painting as the detail from the *Sabines* reproduced in these pages to the early work of Ingres and you will see that the younger man was resisting a conception of antiquity due to a preceding, less informed contact with Rome. It is one that David himself, at the end of his life, was to denounce. I think there is no more impressive example of the love of great artists for their work and the honesty with which they regard it, than was furnished by David when, in his seventies, he goes to see the Elgin marbles and in his excitement writes to Gros, the inheritor of his school, that the whole conception of the classics on which they had based themselves was wrong. And here no "Gothic" ideas were correcting the Roman character of the old Revolutionist, but the newly rediscovered genius of Greece.

Following the great example thus given him, Ingres in his later years will modify the bitterness of his youth:

Do not think that I fail to do justice to my illustrious teacher. No one has more respect than I for M. David; but it is evident that his taste carried him on in a different direction. I took the road of the masters — that is what I did, gentlemen, I took the road of Raphael, who is not a man [cried the old artist in his excitement] he is a god who came down to earth.

The quotation is precious in two ways. It gives us the pleasure of knowing that the early resentment against David was outlived (just as we shall see, later on, a certain measure of reconciliation with Dela-

croix), and it gives to the full the passion with which Ingres was devoted to his ideals. This positive side of the matter is more important than the negative one.

Already in the letter from Rome last cited, the artist speaks of beginning work on a picture he had been planning. Paris was months behind him, the effect of the evil tongues there was wearing away. He was plunging into work. It absorbed him to such an extent that when the family of a girl to whom he had become betrothed pressed him to fulfill his engagement to her he replied with a letter which his devoted biographer, Henry Lapauze, qualifies as brutal in its breaking off of the relationship. He writes: "I should rather die than return to France" —in which statement we must see no more, however, than an expression of the way his work absorbed him, and also of the way he still felt over the outrageous treatment of his work at the Salon.

A second incident of the same type occurred a few years later. Ingres had again had the intention of marrying, and Lapauze reproduces the formal document in which, as a dutiful son, he asks the consent of his family to his union (it was with the daughter of a distinguished archeologist in Rome). But the young lady having shown an inordinate love of dancing, the serious-minded painter sees in his proposed match a danger to his art, and again takes back his liberty.

When he finally marries in 1813, it is because his friends have decided that the step is the right one for him. They arranged with a girl in France whom he had never seen to come to Rome and be his helpmate. The good judgment shown by all was fully confirmed by the long and happy relationship of Ingres and Madeleine Chapelle, whom he cherished until her death in 1849. She was a woman of rare common sense and she proved it effectively, for she allowed her difficult companion complete freedom with his work. Indeed, she guarded him against importunate people and even against disagreeable impressions.

Ingres was so sensitive in the matter of ugly sights that Madeleine, as is recorded, would throw her shawl over his head and lead him by the hand in their walks about Rome, whenever they came in view of

one of the beggars who expose deformations or sores in their appeal for alms.

She acted just a bit similarly when the question was one of money. The good French *ménagère* knew the value of the small resources that were all which even the most unremitting industry yielded in the long years of Ingres's poverty. She said he was not to be trusted with money, and permitted him to carry about with him only so much as his daily needs called for; otherwise his ready sympathy with unfortunates, or his constant temptation to acquire works of art might lead him into expenses unwarranted by the slender means of the household.

The governmental grant for the *Prix de Rome* ended after three years. Ingres remained in his land of art for eighteen years — until 1824 that is. During this period his main resource was portraiture, innumerable drawings of French and English visitors to Italy, occasional orders for painted portraits, and then small compositions like the *Sistine Chapel, Cardinal Bibbiena Betrothing his Niece to Raphael,* etc. Sometimes they were sent to Paris for sale, but the prices paid for works on which he had lavished infinite care and long weeks or even months were so small that financial worries were the steady order of life for the young couple.

It was hard indeed for even so able a housekeeper as Mme Ingres to meet her problems when Monsieur refused to declare a picture finished until he had worked on it for tenfold the amount of time that it should have cost him on any rational basis of calculation. Even then he would put it aside to see if it might not be further perfected, and then the prices woud be like the following: the large *Baigneuse de Valpinçon* — 400 francs, *Mme Devauçay* — 500 francs, the *Odalisque Couchée* (the one in the Louvre) — 1200. Today these three pictures are acknowledged as among the masterpieces of French painting, but for the sale of the *Odalisque* he had to wait five years, its exceptionally large size accounting for the price, since his usual charge at the time was 800 francs for a picture; and for so astounding a performance as the *Famille Stamaty,* a drawing of five persons in an interior, with accessories, 200

francs were paid, according to members of the family itself. Delaborde, the author of the Ingres biography which will always remain basic (he was himself a pupil of the master's) tells that the charge for a bust portrait drawing in the early days was eight *écus* — about forty-two gold francs or $8.40, normally; a full length was twelve *écus*. Late in life Ingres estimated that he had received about 8000 francs for more than three hundred portrait drawings; perhaps in the latter number, he included those he had done of friends, for nothing.

But the only period of real financial distress for Ingres was the one when the fall of Napoleon brought about the collapse of the French domination in Italy. It was an especially sad time for the young couple, their only child having died at birth, the same year. The country was in the throes of its new political regime, as France was, so that little help could come from home. Yet he went on steadily with his work, always saved by some bit of luck like the one we know of when he moved again to Florence. Here he made the acquaintance of a Swiss family, various of whose members he was to depict, in pencil or on canvas. The great portrait of Mlle Gonin now in Cincinnati is of this group of works.

Ever since the boyhood of Ingres, when he played in the orchestra at Toulouse, he had remained faithful to music, carrying his violin with him wherever he went, and keeping up the practice necessary for his very considerable mastery of the instrument. An echo from it has survived till the present day in memories of the master which appeared in the Bulletin of the Metropolitan Museum, when that institution was exhibiting three portraits of members of the Gonin-Guerber family. Their story as written by Louise Guerber (Mrs. Bryson Burroughs), constitutes one of those directly preserved impressions which are so valuable that I cannot do better than transcribe the lines verbatim. They tell of the master's visit to Florence in 1841, when he renewed the friendship with M. Gonin he had formed twenty years before.

26

Ingres was a favorite and frequent guest. When he came for long visits he would install himself in some of the numerous rooms of the Palazzo, set up housekeeping, and live independently of the Gonin family. When he had money he always insisted upon carrying it all with him "to hear it clink." Sometimes the jingle in his pocket tempted him to buy a rare curiosity to be had cheap and he would spend all his money to obtain it. On returning home, proudly exhibiting it to his wife and receiving from her an anxious inquiry about what they would eat, he would propose to play such lovely music on his violin that they would forget their hunger. As M. Gonin knew of this he instructed his young daughter Louise, whose schoolroom was directly beneath the rooms Ingres occupied, to report to him whenever she heard music there at meal-time. He would then send a lackey upstairs to invite M. and Madame Ingres to the next meal, an invitation which they always joyfully accepted! In the traditional manner of artists Ingres seems to have been properly absent-minded, for one day he appeared clad only in his nightshirt but carrying a hat and an umbrella and so quite ready to go out.

On one of his visits he gave to Louise Gonin a recently acquired curio, a cameo brooch, of which he thought very highly. After her marriage he gave her the portrait of her husband, Auguste Guerber, which is now on exhibition.

While the chief value of these portraits today lies in the revelation of the art of a great man, one got the feeling, on viewing them at the museum, of their association with the sitters as well as with the artist. The aesthetic qualities, for which distant times and places esteem these things were secondary matters to most of the people of the day when these drawings were produced.

At that time, before photography was dreamed of, the matter of likeness doubtless played a large part in the minds both of the artist and the sitter. But an eye as penetrating as that of Ingres, served by a hand of fabulous quickness and accuracy, gave renderings of character which carry the work far beyond questions of mere resemblance. One is breathless, again and again, over the life that resides in these drawings, thousands upon thousands of them, whether they are portraits, figure studies, compositions or mere details, as of hands, animals, drapery, etc.

This life is derived from sources more far-reaching than either their prodigious and detailed accuracy or even the research into character that we have just noted. There is beauty in the handling of the pencil which claims our attention quite as promptly as the immense fidelity of the representation. It is a chaste and reticent beauty, always with a sense of reserve, a feeling that the artist could go further, even when he carries his work to a finish that is equaled by few other men in all the centuries. But when he has given us the sphere of a child's head by a pale, silver line within which the eyes, nose and mouth develop with the ease and grace of a flower's opening up to the light, when he has added a few tones that model the whole so that we feel that our hand could follow the surfaces as they could those of a perfect thing in marble, he has brought us merely to the threshhold of the wonder of his drawing.

To cross it, let us look at some works in pencil by his great teacher. Before David's drawings at the Louvre and at Versailles, or before an astounding book of studies belonging to Mr. Grenville L. Winthrop of New York, one is almost physically struck by the masculine power of this art. In drawing after drawing of the personages in that vast and splendid work, *The Coronation of Napoleon*, one feels the impact of the mighty force that the world had been storing up during the quiet of the eighteenth century, and that was unleashed by the Revolution. Even here, however, it is no mere brute force with which we are dealing. When David referred to the decadence of the school of Boucher and Fragonard as academic, he did not propose to revivify art by so general a means as that of personality or nature. He had his specific remedy, in the work of antiquity.

The rediscovery of Pompeii and Herculaneum, about the middle of the eighteenth century, the studies of Winckelmann and other archeologists, and the increasing amount of classical art made available at this time (beside vases and other small works one thinks of the Venus of Milo and the Elgin marbles), all gave a new impetus to men in their search for antique greatness; and the republican forms of thought ensuing on the fall of the monarchy (or even causing that fall) lent to an-

28

cient art an authority it had not possessed even in the full tide of the Renaissance.

For centuries artists had learned to draw from antique statues, or casts of them. But it remained for David to raise this study to such a cult that an antecedent in some marble of Greece (or, more likely, Rome) was considered necessary for every figure having any pretention to the grand style, the one suited to the scenes of history or mythology which, for the Revolution and the Empire, represented the highest aim of art. Indeed, a favorite practice of David's was to make drawings of classical works and incorporate them, with little or no change, in new compositions.

For Ingres, this was incompatible with the new love of nature that was stirring in him; it was to stir in other men, more and more, as they got away from the rigors of the Revolution. Though he held to the Davidian principle in certain works (the figure of Jesus in the *Christ Giving the Keys to Peter* seems to be studied from some statue of a Roman orator, the draperies falling into the purely formal folds seen in such works), his explicit statements about the use of the antique tell us that he regarded the close study of it as an influence to form the mind rather than as an end in itself.

The classical idea of regular features and shapely bodies strongly affected his conception and his work, but he insisted that nature be the direct source of his painting. Thus there is an amusing scene in Amaury-Duval's book when his old schoolmate, Granger, meaning to pay him the compliments that were current under David's regime, found himself completely at odds with M. Ingres. (To this day, in France, the man is so present before people's minds and is so deeply respected, that he is far more often referred to as M. Ingres than without the title.)

Granger said to him [of his *Oedipus*] :
"I recognize your model."
"Yes, indeed; it's really he, isn't it?"

29

"It is, only you've embellished him tremendously."

"How do you mean that — embellished him? Why I copied him in the most servile way."

"Say what you like — he was not as beautiful as that."

Nothing could be more curious to see than the exasperation of M. Ingres who, in the presence of his pupils, was hearing himself accused of not following his own doctrines.

And so he broke forth with an exclamation:

"But look at it, since you remember the man — it's his portrait . . ."

"Idealized . . . "

That word gave the final blow, the more so as Granger was saying all the above in the most gallant fashion, and as a eulogy.

"To sum up," said M. Ingres, "you can think what you like about the thing; but I lay claim to having copied my model, to be the very humble servitor of my model, and I don't idealize."

Fortunately Granger found a phrase to bring the argument to an end. As Amaury-Duval says, there never could be real discussion with M. Ingres: he was able to state his own ideas, but he could not follow those of other people.

This fact, more than anything else, accounts for that singleness of purpose which runs through his work, from his first drawing to the last. But to say that one genius animates the whole immense production is by no means to say that no development in that genius takes place. If very early works have the accuracy and character we spoke of at the beginning of this analysis of his drawing, if beauty of workmanship was to develop rapidly, reaching very great heights, indeed, when the artist was still in his twenties or thirties, if the submission to nature so vehemently affirmed in the conversation with Granger was to mean astonishing powers of self-renewal until the end of the long life, it is only after he is seventy that the finest of his art appears.

It is marked by two characteristics, one a matter of modeling, one of line. He told a pupil who tended toward a thin, papery conception of form that in his early years he had himself been satisfied to model in that way but that in later life he had progressed from it. Before a work

of such amplitude as the *Mme Moitessier* (of 1856), we see how his grasp of depth and his use of the solids filling that depth produce harmonies of composition as perfect as the linear felicity of his early works. And then take the matter of drawing, pure and simple. In the time after he had passed the three score years and ten, the time which the Hebrew prophet saw only as one of weakness and bitterness, he produced the studies for the *Birth of the Muses* that add almost a new dimension to his drawing. Compare them with similar works of any preceding period in his life, and you will have the pleasure of realizing that the long effort of Ingres caused him to surpass what seems like ultimate perfection, the thing we marvel at in the earlier stages of his art. In the late drawings, a single line moves inward or outward according to the nature of the form, whereas in those masterpieces of his youth, modeling with more or less of shadow was needed.

In the days at Rome which saw his first great triumphs, an outline-drawing — as, for example, the one which leads to that perfection, the portrait of *Mme Devauçay* — dictates the course of the whole work. At the time when he painted the *Birth of the Muses,* we see in his drawings the outgrowth of his latter-day conception of depth-modeling; it is this final wedding of line and form that tells of his mastery. The early miracles of drawing are to be thought of in comparison with the designs on Greek vases; the late work stands the test imposed by a recollection of Greek sculpture, its masses rolling with the grandeur of the sea waves. George Moore associates for a moment two of the masters who seem most separated, when he says that the mystery of Ingres's drawing is like the mystery of Rembrandt's shadows.

Since a connection of quality is thus seen to exist between the two radically differing arts, our task is made easier when we look for a relationship between Ingres and Delacroix. The latter's painting, with all its flame and smoke, soon makes us aware that it is informed with classical measure and balance; and in the same way, that which seemed at first the antique limpidity of Ingres reveals, as we know him better, a new and truer character. It becomes a thing of unsuspected depths, and

31

so partakes of that adventure of the always receding horizon which we call Romantic.

This is not to play with the words that designate the schools of the two masters. I said on a previous page that Ingres is well called a Classicist, and Delacroix a Romantic. What we need to see is that each has his necessary share of the complementing quality — which is predominant in the work of his rival.

It was essential, in attempting the above analysis of the drawing which has always been looked on as the glory of Ingres, to follow him to the latter part of his career. We may now resume his history from 1806, the year of his first arrival in Rome, and see how his drawing relates to his work in painting. We may well reach a conclusion that will permit us to modify the drastic statement he made when he objected to the act of his pupils in hanging a group of his drawings, at an exhibition, beside his paintings. "No," he said, "these [the drawings] would kill those [the paintings]." It was simply one of the innumerable illustrations of the truth of Charles Blanc's remark about Ingres — whom he adored: "Exaggeration was the distinctive trait of his character and his mind." This opinion from a famous critic who had given long and deep study to the artist is hardly one to support the contention that Ingres is exclusively classical.

CHAPTER III

Rome, 1806 to 1824

IN THE LETTER DATING FROM THE FIRST WEEKS OF THE great journey to Italy, the reader has just seen Ingres referring to himself as a revolutionary and perhaps the person who regards him as a pure Classicist will say that the "reform" to which he proposes to devote himself is merely that of correcting the bad tendencies he had seen in Paris (and that he finds, in different or worse form, among the Italians he meets). For all the evils of art in his time the remedy he offers so positively throughout his life is, "Nature and the classics," above all Raphael and the Greeks. In his later years, when asked what models he had used for the horses of Napoleon's chariot in the *Apotheosis*, he replied "Phidias and the 'bus horses."

But is it not clear that to see the humble animals of the Paris streets in the same light as the coursers of the Parthenon is romance in its purest form? What is it that makes the horses of Phidias the incomparable classics they are if not the Greek master's combining his observation of the living things around him with such antecedents as the horses of the Assyrians?

It is the after-world that gives the word "classic" to the art of Greece. Delacroix was right when he said that Racine, for the men of his own time, was a Romantic; and some such word was doubtless applied to Phidias by his contemporaries when they noted the difference between his sculpture and that of the period before him. The new beauty he saw in his victorious young race after its defeat of the Persians called for new forms, and he created them, giving a fresh burst of life to the art he inherited from the earlier time. To see its flame rise to heights unknown before, could have been — for Greece — nothing else than

33

what the modern world calls romance, the thrill and adventure of pressing onward to enhanced powers.

To understand the excitement of Ingres as he sees new horizons opening up before him, and to understand the reproaches that the old school heaped upon his first masterpieces, it is necessary to see that he belonged to the great tradition in its twofold aspect: as the thing that renews itself quite as much as the thing that carries on earlier values. The latter process was the one that Ingres consciously sought to continue, and his relentless fidelity to this ideal has given to numbers of people their idea of him as a man completely under the spell of the past. But we should not find the artists of the generations since his time so fervid in their admiration of him if he had not been endowed by nature with the faculty of breathing his own life into the qualities he accepted in the museums.

It is perhaps easier to see this life in his drawings, for in them he stands unrivaled in his time. But confusion ensued when his followers went on with painting so closely imitated from his own that there may be genuine difficulty in saying that a given canvas is the work of Ingres in an uninspired moment and not the production of one of the many young men who, having no creative talent of their own, humbly set themselves to paint as he did. If doubt exists in such cases, no trace of the feeling assailed even one of the museum men, artists, and critics who wrote on the *Portrait of a Man* now owned by Mr. Grenville L. Winthrop when, without signature or history or other means of identification, it appeared in a Paris exhibition of "Ingres and his Pupils," a few years ago. So unmistakable was the note of the master's own art in it, that his was the only name pronounced by the authorities of the Louvre, and the other writers in Paris. They felt sure enough to date it —"about 1804."

The picture must indeed be of the last years before the artist left for Rome and, in the rendering of masculine character, it is of the Davidian firmness that we find especially often in the earlier work of Ingres. It occurs in the portrait of Desmarais of the year 1805 and is seen again

34

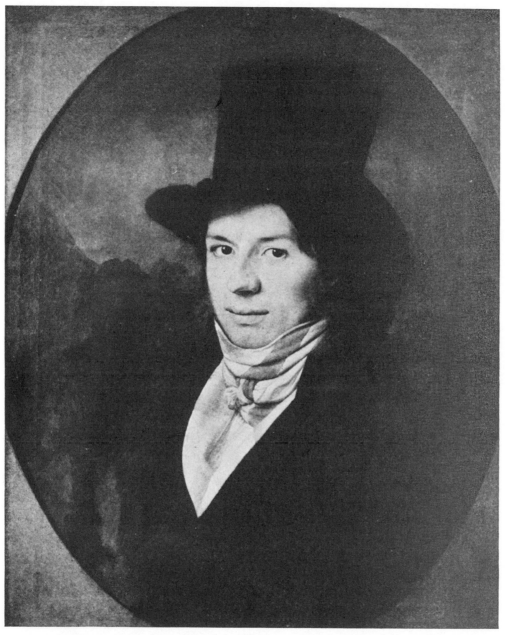

Portrait of a Man, about 1805, Collection of Mr. Grenville L. Winthrop,
New York

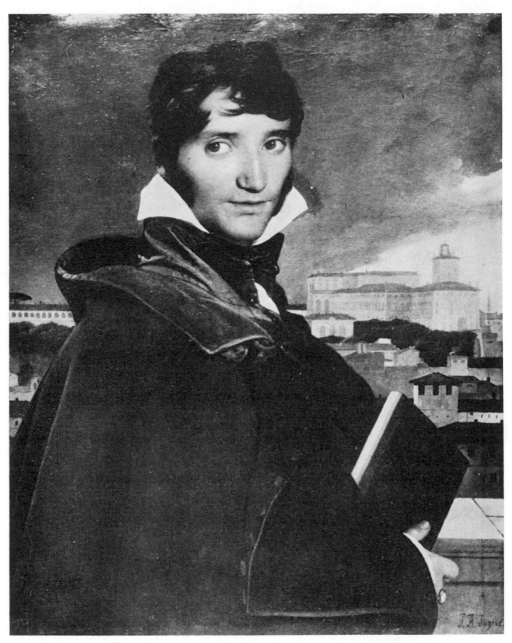

The Painter Granet, 1807, Museum of Aix-en-Provence

in the famous canvas of Granet, at Aix-en-Provence (1807). Very near this work in color and doubtless in date is the splendid portrait of a man (also with a Roman landscape) which is one of the Havemeyer Collection's great gifts to the Metropolitan Museum.

In short, the series of marvelous effigies of his friends and of other sitters that Ingres had begun in Paris continues uninterrupted when he is established in Rome. Some of the best-loved of his works, indeed, are of this period. For the French, the name of Mme Devauçay is one with which to conjure, and the truth is that the heavenly canvas at Chantilly ("a sister to Mona Lisa," writes Lapauze) goes beyond the great *Mme Rivière* in subtlety, even if the design of the earlier master-piece remains unsurpassed. But the new picture — it is of 1807 — already tell of the suavity brought into the young artist's work by his passionate frequenting of the Italian Renaissance. No wonder the word Gothic had stung, when he read it in his criticisms from Paris, the year before!

Raphael and the Greeks — to recall his watchword — meet in the subject that he chooses for the copy required by the terms of his grant from the government: it is the *Mercury* from the *History of Psyche* in the Farnesina that tells in Paris of the studies made by the *pensionnaire* at the Villa Medici. And the almost ultimately beautiful female figures that Raphael frescoed at the Farnesina stir the heart of the devotee with an emotion that will continue for over forty years — from the time when he makes his first drawings for the Venus Anadyomene to the time — as he nears seventy — when he will complete the celestial vision in far-away Paris!

For the present, in this severe but warmly sympathetic Rome, such a realization would have been beyond him, however exquisite the hint of it in the first studies. It is a masculine figure that tells us of his thought of antiquity in 1808, the *Oedipus and the Sphinx*. The pic-ture in the Louvre is the one sent home with other works of Ingres by Guillon-Lethière, the director of the French academy in Rome. The picture at the Walters Gallery in Baltimore is a later repetition, the

35

first we meet here (after the replica of the self-portrait of 1804) among the very numerous examples of this type of work in the artist's production. He replies to criticism of such painting by saying that his purpose was to perfect his earlier work through a new execution of it. Sometimes (as in the version of *Stratonice* dating from the last year of his life), he has done so indeed; in other instances one may well prefer the first version, where the inspiration is fresh, and the painting has not been dulled by overwork. Amaury-Duval tells of seeing that particularly famous picture of his master's, *La Source,* in the studio, before it got its present almost waxen finish; he liked it better when it still had about it something of the sketch.

But, delightful as the flower-like quality of a painting may be as it emerges from its dawn and still retains something of early morning freshness, such considerations rarely have any validity when one thinks of Ingres. The sensuous pleasure that a Rubens, among the giants, or a Manet, among lesser men, felt in the use of the pigment — now flowing from his brush like an ethereal vapor, now laid on with the solidity and resonance of enamel, has no share in the constitution of our artist's mind. Anything but an ascetic, he brings passion into his handling of line and form, even though the brushwork effaces itself to the point of anonymity, and his smooth surfaces reveal no more about the man than do those of a decoration seen from the distances of a great church. Mount on a ladder to the level of the painting, or see details of it by the aid of photographs, and the heads in Raphael's frescoes, for example, may tell a different story. Rodin said one should look at Greek marbles by the light of a candle held nearby in order to see the living quality of their surface, which one loses when surveying the ensemble of the work from the distance required to take in the whole of it together.

For Ingres in his painting it was the ensemble that counted. In his drawings we get the evanescence with which his sharp but infinitely sensitive pencil caresses the paper, going from pale, ghostly grays to brilliant and positive blacks. The gradation of tone continues in his painting, but there is no longer the sensation of seeing the work ac-

complished under our eyes. This is not a matter of renunciation: Ingres is unconscious of the quality he is foregoing, or if he notices it in the work of other artists, he does so only to reprove it. Thus he says:

What is called "the touch" (the brushwork) is simply an abuse in execution. It is the quality to be found only in false talents, those of the false artists who get away from the imitation of nature in order to exhibit their mere skill. The touch, however able, should not be apparent; otherwise it prevents the illusion and makes everything motionless. In place of the object represented, it shows the procedure; instead of leading to the thought, it leads to the hand.

Again and again in the work of Ingres himself we shall have to wonder at the hand—and the eye—that could produce such marvels. But a very brief consideration of that *Oedipus* of 1808 is enough to make us aware that the real marvel of the artist's genius is far less a matter of execution than of conception. He has meditated deeply over the classical stories and arrived at a firm idea as to how a scene in them looked when it occurred. At one time he writes that his library consists of twenty great books which he reads over and over. But he knew many more, and when his slender means did not permit him to own them, he copied out long passages from the books he borrowed. It is estimated that the pages he so accumulated would make up several big volumes.

But the respect with which he looks upon his subject would explain no more than the illustrative element in his work, and our first glance tells us that he went immeasurably beyond that. Amaury-Duval concedes the fact that Granger was not altogether wrong in using the word "idealized" about the head of Oedipus, notwithstanding Ingres's annoyance and his protestation that he had made a servile copy of the model. The idea of antiquity on which he had been drilled in David's studio was reinforced by constant drawing from the ancient works he saw in Rome—his personal sense of beauty modifying them, however, and leading to a creation so unexpected as the head of the sphinx. But, aside from the general lines of the imposing and original compo-

sition, what shall we say of the small figure of the terrified man in the background? It is pure Ingres in its discovery of a means of breaking up the space, in the utter felicity of its silhouette, and in the perfection of its scale.

Here are qualities that really interest the master (and, young as he is, he has richly deserved the title), so that they are of the most legitimate interest for the beholder. The whole secret of art appreciation lies in avoiding demands that a given school is not interested to meet, and in concentrating on the matters with which it actually deals. In the case of Ingres and his preoccupation with such qualities as composition, scale, form, line, and tone we are certainly in the presence of things of the deepest importance, so that our whole question is that of deciding how successfully he employs them. He had made pictures with complicated figure groups, and other masses before reaching his *Oedipus,* but here the achievement—according to the decision of a century of judges—is so remarkable that we may say that the work brings us to a point in his art where he is already mature.

The same year sees him outstrip even this success, for it is in 1808 that he paints the *Bather* of the Louvre that is called the *Baigneuse de Valpinçon* from the name of its original purchaser. Here, instead of a scene from antiquity—with however remarkable an adjustment of its parts—we have a spontaneous outpouring of Ingres's love for the beauty of women. The story of his two broken engagements and of his relations with the two ladies who were his wives (the biographers tell of no other attachments) might leave us with the impression that women played but little part in the artist's career. On the contrary, they are as deep a source of the emotion he puts into his work as his adored classics of Greece and the Renaissance.

Odilon Redon was voicing just his personal judgment and not—I am positive—an idea that he got from conversing with Degas, when he said that the latter's feeling for Ingres was an admiration of the head, not of the heart. Without weakening for a moment in my conviction as to the great mystic of the later time, I venture to disagree with

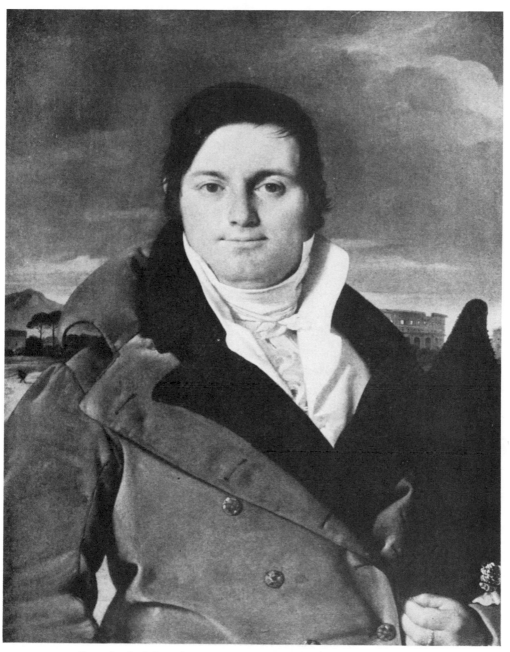

Portrait of a Man, about 1807, Metropolitan Museum, New York
(Havemeyer Collection)

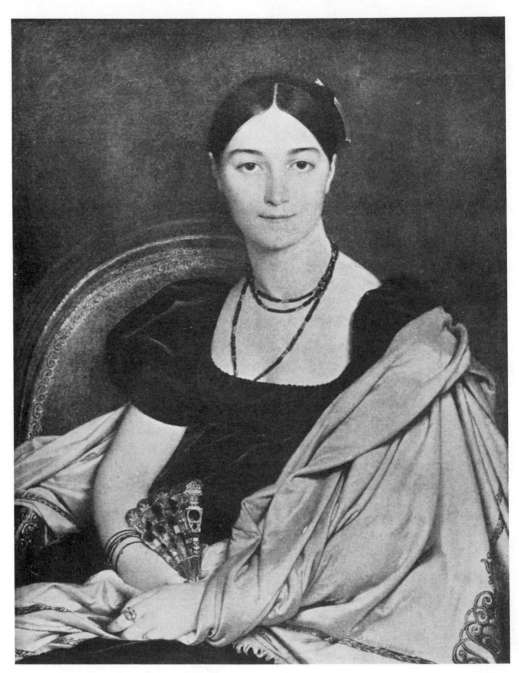

Mme Devauçay, 1807, Chantilly Museum

Redon, and to affirm that the response of Degas to Ingres was that of the younger master's passion for beauty, as evoked by the same thing in his predecessor in the Classical school.

Nowhere does this passion appear with greater intensity than in the *Grande Baigneuse* (the epithet traditionally applied derives from the quality of the work, we may be certain, and not from its large size). The color is of an unusually harmonious nature and has drawn forth enthusiasm from painters who, as a rule, prefer to pass over in silence this phase of Ingres's art. The tone is of a breathless perfection: no lightest play of light sifting through forest branches could exceed the delicacy with which whites and grays, pinks and yellows glide through the canvas, like flute notes through an orchestral passage dominated by the stringed instruments.

The great artist himself gives us reason for our devotion to this masterpiece, for he returns to it again and again throughout his life, sometimes with small pictures in oil, once at least with a water color of heavenly quality. Toward the very end of his life, when he dates the *Turkish Bath* and proudly writes on it "Ingres, eighty-two years old," he can look on his *Bather* once more: of the many figures in the extraordinary composition, it is one of the most beautiful, as it is the most prominent. A numerologist might take interest in noting that the eight and two of the age he had then reached were simply in the reverse position they had at the time when, at twenty-eight, he first conceived the adorable being who was to remain so long in his affections — and in those of mankind for an immeasurably longer time.

1810 was the last year in which Ingres received the stipend of a winner of the *Prix de Rome*. Until that year he could devote himself freely to works that had no immediate sale: the *Oedipus* waited over thirty years to find a buyer, the *Jupiter and Thetis*, the last composition he did in fulfillment of his position, was never acquired by a private collector, a mortification for the artist, who cared much for the work. The incomprehension of the Davidians in Paris continued against Ingres with full vigor, in face of the great pictures he was producing.

39

When the government finally bought the *Jupiter and Thetis,* it was to exchange it with the museum of Aix-en-Provence for a historical work by Gros that was wanted by Versailles.

From 1811 onward Ingres had to live by the sale of his work, and so he was glad to accept commissions for portraits, as he had been during the years in Paris, though he looked upon portraiture as a lesser type of art, compared to the religious or historical compositions that were his constant ideal. Sometimes, to be sure, lack of seriousness on the part of sitters, and the difficulty of getting them to pose regularly, gave him his cause for complaint. It was true that his perfectionism led him to work tremendous lengths of time (sometimes years) on a portrait.

But often the lamentations in which his emotional nature vented itself over the portraits are a result merely of his wish to devote himself to other forms of painting. Thus of the picture of the beautiful Comtesse d' Haussonville, who must have been angelic about posing and who inspired one of his most remarkable works (now in the Frick Collection, New York), he had the heart to write "I finished that disastrous portrait which, weary of tormenting me, has had four days of private-exhibition in my studio and has brought me the most complete success." There may be a bit of play-acting, to get sympathy, in the use of the words "disastrous" and "tormenting" as to his image of the gracious charmer of 1845, but there is no doubt of Ingres's inner difficulty in contenting himself with portrait work, however marvelously he was gifted for it. At a time when his finances were especially low, he rejected, with something near to indignation, an offer to go to England, where he was definitely assured of steady employment as a portraitist. He said it was unworthy of him.

Nevertheless, he applies himself to the work that comes to hand in Rome, and it is a superb series of canvases that results. The drawings of the time are especially numerous, and include some of his most fascinating production. The mere fact that he is facing a duty, that of giving to his sitter the likeness for which he is being paid, acts as a stimulus for Ingres, in whom the French respect for property and

legality was very strong. But if some of the effigies he traced tell of little more than making a living, by work of a quality that must be called unique when one considers the amount of it (and I do not forget men like Ottavio Leoni among the many portrait draftsmen of the Renaissance), others among these clear and sober drawings rise into a different category.

Conscientious observation of character is the minimum of his achievement in this field. Again and again it intensifies to the point of becoming profound psychological insight, and in very numerous portraits, especially those of women and children, the warm nature of the artist responds to the beauty of his sitter with an enthusiasm, an eloquence, that touches us only the more because of the precision and reserve of this art.

It seems as if nothing less than magic could have produced such a work as *The Family of Lucien Bonaparte*. Eleven people (if we include the busts of Napoleon's mother and brother) are seen together in a room of which the spaces and perspective are realized through the exact degree of insistence on the pure, thin line that defines each of the personages and the accessories. If there was ever a hesitation, a correction, an erasure, the eye fails to detect it. As the violinist plays over his piece a thousand times to render it with the perfection of a concert performance, so Ingres seems to have brought himself to the point of absolute virtuosity in preparing for this fantastically faultless thing. Yet it gives the impression of spontaneity, of being carried off with ease and delight. We are arrested for a moment by the beauty of this tiny head or that one which — despite all its quiet and dignity — makes us look at it; and immediately we resent a word so cold as "faultless," which I uttered a moment before. It might apply to the hairlike line of a Greek vase painting but all the wonder of such a thing does not save it from being, in most cases, a result of mere craftsmanship: some master designer gave the original for it, his inventiveness registering in the sensitive modulation that is the mark of those rarest works where the creating and the executing hand is the same one. What we see in all other

cases is the work of copyists. But if even the workshop production of Greece leaves us bewildered at its sureness and subtlety, how much more must we marvel at this drawing by Ingres (which has never before been reproduced). More than any other in the present book, it shows his admiration for Greek vase-painting — and also the reason why the reaction from Classicism looked on his submission to such an art as excessive. Yet even his critics could scarcely claim that he had fallen short of equaling his models in the ancient collections.

I do not forget his indignation at the people who offered him such praise during his lifetime. To a man with his pious reverence before the things of the past, it was objectionable to have his work compared with the classics. But we, of a hundred years later, have a new right to judgment on the matter. We can be impersonal when we say that, in point of technique, the best drawings of Ingres have a fineness not exceeded by the Greeks, by the Renaissance men, or by the Persians. Further than this, such work stands above considerations of mere handling, since we here face the great European problem of realism (upon which our artist will give us more light when we follow him in his career). But beyond even this, again, we grasp his significance as we note his rendering of life: all the love he has given to the Greeks and to Raphael, all the effect that their ideals have upon his own cannot lessen the wonder of the sensibility with which he responds to the mystery of living beings. At one moment it is felt in the virginal candor of a young girl's eyes, at another moment it gives warmth to the curve of a maternal bosom, or it appears through the majesty of an old man's features, or the tender treatment of the head of a child — in whose presentment there is still a full accounting for material qualities like the silky texture of the hair and the firm solidity of the skull under it.

A frequent return to the drawings, even when we want to proceed to the larger works, will be resented by no lover of Ingres, either among those who have followed him for years or those who are only on their way to a realization of his greatness. And surely a big distance along that way has been traveled by the artist when he reaches a portrait like

that of M. Marcotte. An artist friend of Ingres's recommended the latter as the man to do a likeness of this French official stationed in Rome; other members of the family followed him in the studio, and it is pleasant to learn that the relationship which began on purely professional lines ripened into a lifelong friendship, one that gave to the world, beside the series of pictures ordered by Marcotte, a number of letters which tell of the character of the painter.

That it must have had something in common with the character of the art patron who was to become one of his warmest admirers is observed by Henry Lapauze, who also notes a certain physical resemblance between the two men. It is apparent in the self-portrait of 1804. Here, also, is a grave, Roman type of form-rendering, which made of the picture a natural choice for the Salon, when the young master was deciding what to send there, six years before he did the superb (and similar) thing of Henri Marcotte d'Argenteuil. I have not seen the latter work for nearly thirty years, and though, as a rule, it is wrong to let such personal memories intrude (since they often become inexact with time), there is on the other hand a more than personal value to the recognition of the number of works by Ingres which seemed great to me in those days and which still loom up among my favorites. This test of time, the final test, is triumphantly withstood by the master. Few indeed are the persons who, once having cared for him, have weakened in their admiration. In the case of the *M. Marcotte,* the impression of deep and fine color that remains in my mind is confirmed by other works that are now accessible to me.

Such a one is the *Portrait of a Man,* from the Havemeyer Collection, in the Metropolitan Museum. Reticent as it is in its grays and browns, it has nothing less than nobility of color—as one must perforce agree if the imagination tried to introduce any livelier pigments than the earth ones that make up this grave work. They would at once appear discordant, and if the color scheme of a Venetian or a more modern master would indeed show a wider range of harmonies, a greater control in holding together his more varied hues, Ingres nonetheless proves

43

that he can, to the extent which his art requires, command even the quality that means the least to him. The same may be said of the *Sistine Chapel* which M. Marcotte ordered a few years later. These earlier years of Ingres's independence in Rome, under the brilliant government of Napoleon's representatives, were full of promise for the material success of the artist.

The Bonaparte family, as we have seen, the Murats, and others of the imperial nobility were his patrons. In 1812, he was asked to paint the mother of the Prefect of Rome, the Baron de Tournon. A magnificent portrait was the result. It recalls the grand severity of David's monumental compositions of the kind, but the powerful lines which tell the character of the old noblewoman enclose surfaces more subtle than those which the earlier master was interested to paint. And with all the marvel of his still-life rendering, there is perhaps in all of David's work no parallel for the delicate perfection with which Ingres has worked out the detail of Mme de Tournon's shawl: it adds a new lustre to the name of the man whose *Mme Rivière,* of seven years before, could come to be known as "The Woman with the Shawl." All these extraordinary merits, however, are merely accessory to what he did in depicting the live, masterful features of the countess. A smile softens the firm mouth (Ingres tells his pupils that they must please their patrons), and he loses no chance to notice the beauty remaining to the arms and hands. But it is the eyes that dominate: their fire burns deep into the memory of any one who has spent even a few minutes before this powerful character study.

The same year sees Ingres sign a work which, if not more intense, carries us to the greatest success in composition we have yet seen, indeed one of the supreme ones of his whole lifetime. This is the canvas, now in the museum of Toulouse, which portrays *Virgil Reading the Aeneid before Augustus,* or as it is also called, *Tu Marcellis Eris,* from the line of the poem which so powerfully affects Octavia, the sister of the emperor. Ingres tried several variants of the great work later on, as in 1830, when, in a wash-drawing, he introduced a statue of Marcel-

lus, the character around whom the drama turns. Superb as is the power with which he adds to his design, it is to be doubted whether the new rendering he looked to in Paris would have equaled the success of 1812. The fragment at Brussels (a new and complete picture, in reality) is an epic thing, and truly Roman in its imposing design; yet it does not create an effect as powerful as that of the first great canvas, painted under the inspiration of the antique history that Ingres studied with fervor.

As clear, as inevitable as David's overwhelming composition of the *Death of Marat,* the *Virgil* of Ingres has also a severity of effect recalling that of his master. Both pictures are dominated by the opposition of verticals and horizontals. The right angles thus formed, the most uncompromising that art has to deal with, are reinforced by David as his terrible expanses of empty darkness are cut across by the dead figure, the bath, and the geometrical mass of the foreground object. The artist's associates in the Revolution summon him to avenge their hero: it is their horror at the assassination which dictates the bleak grandeur of the forms. No less arresting in the presentation of the scene, Ingres's picture at Toulouse modifies the starkness of the right angles by diagonals that we are made to feel. They are drawn, in the mind's eye, by imaginary lines starting from the heads of the two chief actors, crossing with the opposed masses of the women's bodies, and continuing into the shadows at the two lower corners of the composition. The mosaic of the floor reinforces, by its pattern, the lines furnished by the characters of the drama. The scene might be taken from one of the classic plays that the artist read or saw at the theater, it might be taken from a vase or, more plausibly, from a sculpture in low or high relief.

Yet the idea of a possible derivation from an earlier art can not survive our first glance at the picture itself. In the same gallery where it hangs is a celebrated painting by Delacroix, *The Emperor of Morocco with his Guard.* It is one of the great results of the Romanticist's trip to the Orient, a theme that he was to return to many years later, for another superb achievement. Yet comparing this work with the Ingres,

as one is almost compelled to do, even a devout admirer of Delacroix will hardly feel that the latter master holds his own in this case. For all the prestige of his color (and the southern glow of his great expanse of blue sky sets a note that he sustains throughout), I think that numberless visitors have felt, as I did in Toulouse, that this time it is Ingres who creates the deeper impression.

I insist on the point, since I have mentioned the possibility of connecting the *Virgil* with some work of antiquity, and therefore seize the opportunity to show that Ingres's practice of basing himself on the classics takes away neither from his success in working out an original, functional design, or his capacity for making us feel that his work is new creation. Were it not that, we should see him outclassed by his great neighbor in the gallery.

The tendency to error on the score of Ingres's relationship to the past is no new one. The reproaches of his earliest time, which we have heard in words like those about John of Bruges and the Gothic, will reappear throughout the century—and down into our own, though they are rarer today. But in the period of Romanticism, one of its lesser exponents, Diaz, could say of Ingres, "Shut him up with me in a tower where there are no engravings, and the man will keep on standing there in front of a blank canvas, for he is incapable of getting anything from his own head: I will come forth with a picture!"

Théophile Silvestre, to whom the words were said does well to add that Diaz, though a man of generous nature, was "not exempt from injustice." It is quite true that Ingres needed documents, such as engravings; in his old age he would still seek them at the Bibliothèque Nationale. The fact that his work can be based, to a large extent, on that of other men and yet remain entirely his own is one of the real tests of his originality. Once at least, he replied to such criticism as that of Diaz. In a matter as particularly obvious as his debt to Raphael for the Madonna of the *Vow of Louis XIII,* he said "My picture is my own, for I have put my claw into it."

The remark applies to his whole work, though at times one does

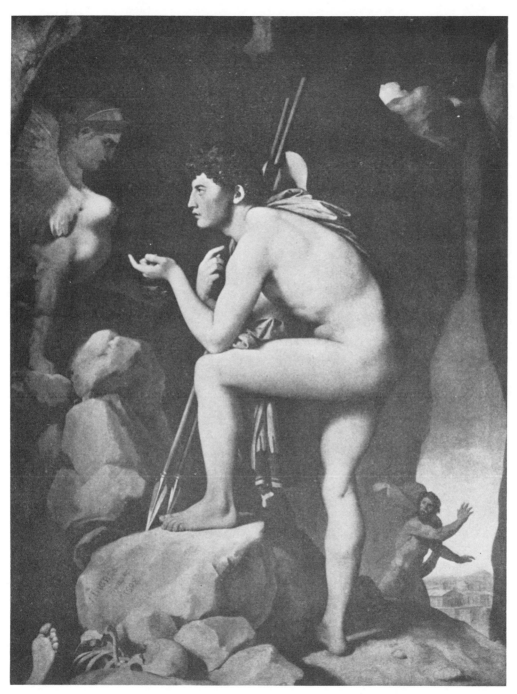

Oedipus and the Sphinx, 1808, Louvre

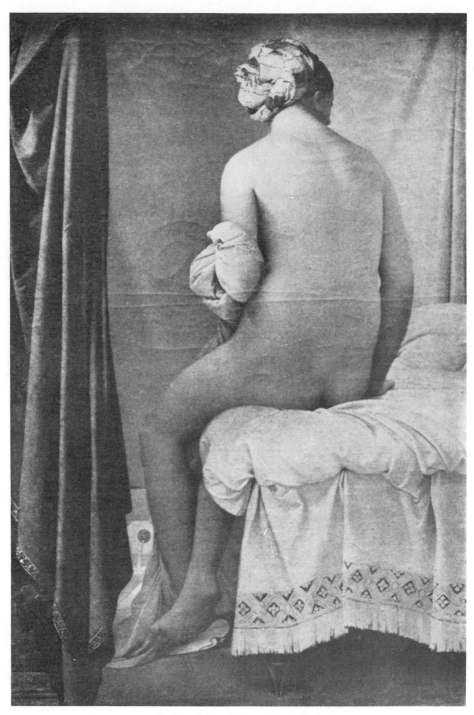

The Bather (of Valpinçon), 1808, Louvre

feel that his claw did not go deep enough, and that too much of the picture he had in mind as a model has remained unassimilated. One feels this before so purely Raphaelesque a head as that of the *Virgin of the Host,* as perhaps one felt it before, in observing the Roman style of the garments in the *Christ Delivering the Keys to St. Peter.* But people who, in this mood, make exacting demands on Ingres's originality should not fail to ask themselves whether they are as ready to see the lack of assimilation among other artists, those who take over from nature things which remain foreign to the design of the picture, and are accepted merely as a transcript of reality.

For critics who have neglected such ideas, the *Virgil before Augustus* should be especially rich in instruction. It is creative in its use of line and mass, in its invention of character, and in its employment of the light and dark. Separated by an abyss of race and place from the chiaroscuro of Rembrandt, it is no whit less vital in the effect it draws from the glare of the lamp and the depths of the shadow. Had Ingres no other work to prove his grasp of fundamentals, this picture would be enough to make us feel that his painting could go on, for the fifty-five years he had still to live, and never lack a substantial basis in the sense of life and the laws of art.

Two years after writing this definitive page in his story, he reaches another triumph, with his portrait of Mme de Senonnes. More, perhaps, than any other work of the long career, this picture tells of Ingres's genius for attaining perfection. The drama of the *Tu Marcellus Eris* that we have just been following brings before the mind elements of tragedy and terror that are banished from this serene vision. Its loveliness is obtained by the magic of line, above all, but the royal red of the lady's dress is treated with such felicity that, this time at least, even the harshest critic must concede to the painter a splendid achievement in the matter of color. If there is, as yet, but a small measure of that sculpturesque fullness of form which the artist will attain in later life, we do not feel any lack, for he has triumphed completely within the limits of the painting he envisages at the time. It

47

is not the number of qualities an art contains but the intensity with which they are followed out that spells perfection.

The portrait of Mme de Senonnes is so baffling in its beauty that we are made to wonder if art is not, after all, a simpler matter than we had been led to think by our study of the different schools. Here is nature, a human being fully represented, with the most explicit statement about her appearance, her jewels, her dress, the place she occupies in a room, and how her image is reflected in the mirror, where some visiting cards have been thrust between the glass and the frame. Of course, the subject is a beautiful woman, the accessories give a sense of richness that adds to the pleasure of the sight and, of course, again — the painter has learned his trade thoroughly and gives us a convincing image of this scene and of the adorable Italian dreamer.

One can almost imagine Ingres himself soliloquizing in some such fashion as he contemplates his lovely model or, later on, the picture he has done from her. Yet he could not have long maintained such a happy peace of mind, nor can we. Returning once more, as we must, to the very word perfection which he has defined by the carrying through of this immortal work, we realize that if what is in back of Mme de Senonnes is her reflection in a looking glass, what is in front of her is something of a totally different kind. It is her image in a mind formed by the accumulated inheritance of countless generations, by contact with life and with certain works of art.

Does anyone think that the portrait of Mme de Senonnes would be what it is if Ingres, since his childhood, had not been worshiping Raphael? So naïve an idea would be instantly dispelled by a glance at any of Ingres's Madonna pictures. Is it the Sistine or the Foligno Madonna of Raphael that we are seeing again as we gaze at the *Vow of Louis XIII?* And all the exactitude with which the painter has followed nature in the divine portrait at Nantes cannot lead us away from our memories of the Umbrian painter to whom he — like numberless other men — always applied the word divine. The great mystery of this work which seems so crystal-clear lies in its holding its

faultless balance between the outer world — the model in her sur-
roundings that anybody might have seen had he been in Rome dur-
ing those days of 1814 — and the inner world of the mind of Ingres,
something that occurs but once in all the centuries.

Of the same year as the *Mme de Senonnes,* the *Recumbent Odal-
isque* of the Louvre continues the homage to feminine beauty just
witnessed in the great portrait. Whether because the idol is revealed
here in full nudity and the artist was less at ease about the complete
naturalism he indulged in before the draped model, or whether the
warm glow of light he achieved in the portrait could come about only
under special inspiration, the fact remains that the *Grande Odalisque*
is harsh and metallic in tone as compared with the other picture. It is
aristocratic and imposing in its dryness, but the color is such that
when, in the Metropolitan Museum, one comes on the version of
the subject which Ingres retained till the end of his life and bequeathed
to his widow, one is far from regretting that the work is in *grisaille,*
only a few faint tones of color beginning to warm up the silver of the
otherwise pure black-and-white. As in all of Ingres's variants, some
other changes occur, beside the big one of the color. The proportions
of the canvas are different, and one may well permit oneself to enjoy
the greater space above the head that is found in the work in New York;
in 1825, when the artist repeated the *Odalisque* in one of his few litho-
graphs, he again gave more space above the head than he did in the
Louvre picture, eliminating also the dark note of the fan, which breaks
the line of the leg — in a way that he doubtless came to regret later on.

But if he had any fault to find with his great nude (and he had an
immense faculty for *pentimenti* as the Italians call later repaintings of
a picture), our own thought must be of the positive achievement of
the work. Obviously a thing of infinite grace, and modeled with a
subtlety that gives to the forms a mysterious, effortless undulation, the
finest phase of the art here seems to me, nevertheless, to lie in the crea-
tion of a space, enclosed by the frame, wherein solids appear — the
head, the torso, the limbs, the accessories — only to bring about new

harmonies with each new change they make in the composition of those solids.

This almost abstract beauty is fittingly symbolized by the character of the head: it is impersonal to the point of being a mere type, like many a head in ancient sculpture. But had Ingres particularized as to his model and given her likeness and character like that in which the *Mme de Senonnes* is so rich, the spell would have been lessened. When Manet's *Olympia* used to hang as a pendant to the *Odalisque,* at the Louvre, one had to recognize that all the brilliant painting and the impressive gesture of the later work could not balance the superiority of Ingres's pictorial conception. There will always be art lovers to whom Manet's response to life will be more sympathetic and who will prefer his grasp of the relationship between color and pigment, on the one hand, and substance and light, on the other.

Yet, splendid as is his mastery in his field, one is safe in saying that his chief influence will remain the one he had on the men who came just after him, for he deals with aesthetic problems more limited in extent and duration than those of Ingres. If one master after another —from Renoir to Picasso and beyond the latter, have taken Ingres as their guide, it is because he speaks with authority on the issues of form; and painting, no less than sculpture and architecture, designates these as supreme issues, throughout the history of art.

The fall of Napoleon and the breaking up of the brilliant French society that had patronized Ingres before 1815, made his next years in Italy very hard indeed, from the material standpoint. A number of English visitors to Rome continued his orders for portrait drawings. Some of them he executed in lithography, still a novel medium at the time and, in 1816, he produced the one etching of his life. The portrait of Monseigneur Gabriel Cortois de Pressigny, the French ambassador at Rome, is so marvelous a document, both of humanity and of etching, that one must lament the fact that Ingres did not produce many such plates, so that hundreds or even thousands of people could have the joy of possessing an original from his hand.

Small paintings, easy for collectors to hang in their homes, also appear in number during this period. But if severe physical privation was spared to Ingres and his wife, their existence was so difficult that in one of the most terrible articles ever written on the painter (terrible, above all, because of the immense importance of the writer) Théophile Silvestre feels constrained to bear witness to the fortitude and dignity with which Ingres sustained his long ordeal. It remained in his mind so strongly, however, as to be one of his reasons for certainty as to the rightness of his cause when, in later years, he waged such relentless war against the Romantic school.

Far more important than the material difficulties of the period we are considering, was the resentment of Ingres toward the men whom he looked on as his persecutors because of the continued abuse of his work in the Paris press. It broke forth again and again, reaching a point of especial ugliness and stupidity in its treatment of admirable work dating from 1823, the year before the end of his first sojourn in Italy. It was then that the artist painted his portrait of Mme Le Blanc, having done the one of her husband, the year preceding. The two pictures formed part of the collection of Degas, a judge of the work of Ingres, if ever there was one. He retained them until his death, after which they were acquired for the Metropolitan Museum by Bryson Burroughs, who thereby rendered one of his great services to the institution that had his devoted stewardship for twenty-five years. Now let us hear what was written about the *Mme Le Blanc* when it was shown at the Salon of 1834.

I cannot believe that this monster — without any top to her head, with her bulging eyes, and her fingers like sausages — can be anything but a deformation, due to an effect of perspective, of a doll seen from too near by, and reflected on to the canvas by several curved mirrors applied separately to each of the details.

No wonder if such words left Ingres "ulcerated," to quote his own expression. I take the extraordinary sample of "criticism" as it is quoted

51

in the detailed history of our artist published in 1911 by Henry La-
pauze, to whose researches we are indebted for immeasurably more
than the fore-going passage. Were it not actually preserved one would
hesitate to believe that such things — as malicious as they are false —
could ever have been written about a canvas that has given delight to
numberless people. Even if we take the charitable view that the author
of that article was merely an ass, the fact that his lines were given
space in the public prints is evidence that many people could accept
them, and therefore had opinions of a similar type. How many such
people are there today? Among the innumerable persons throughout
the world who take no interest in art and therefore would get no plea-
sure from this picture, I doubt if any — certainly no more than the
ones to be considered quite negligible exceptions — could be found to
say they look on the *Mme Le Blanc* as that writer of a hundred years
ago describes it. The fact seems to prove that people see differently at
different times in history.

The portraits of M. and Mme Le Blanc were painted in Florence,
where Ingres had been residing since 1820. His old Florentine com-
rade, Bartolini, reminding him of their student days under David, had
persuaded him to come there from Rome, and had again made him
royally welcome. Another admirable portrait of the sculptor had re-
sulted, but it was work of quite a different order that principally oc-
cupied Ingres during the four years he spent in Florence at this time.

Shortly before leaving Rome he had finished his *Christ Delivering
the Keys to St. Peter,* and had seen it installed in the church for which
it had been commissioned. Twenty years later it was obtained from
the authorities of the Trinité-des-Monts, and turned over to the Ad-
ministration of Fine Arts, whence it proceeded to the Louvre. It had
been a success from the first, marking as was said, a great advance in
Catholic art over anything that had appeared since the Revolution. Its
gravity made it contrast even more with the production of the eigh-
teenth century. David's revulsion against that period now found its
continuation in the religious painting of his pupil. The latter wrote

52

to his friend M. Marcotte, some years later, "Is art to be completely dead? No, not if a different road is taken, the road of nature, by way of the Greeks and Raphael. Our manners are vicious, they are mannerisms. But we must look to the past, go backward in time so as to rejoin the right path." The turning to classical sources in Ingres's study for the *Christ Delivering the Keys of Paradise* has been noticed; the thought of Raphael is equally evident.

A new or renewed force was certainly at work, and the men who hailed it in the big religious work by Ingres were eager to see him continue in the same vein. They accordingly obtained for him from the government in Paris a commission for a large picture, to be sent to the cathedral of Montauban. Ingres wanted to paint an Assumption, but the political powers, desiring a reference to the restored dynasty of the Bourbons, stipulated that the work contain an allusion to them. The subject thus became, by combination, the scene where Louis XIII vows his fealty to the Virgin and offers his crown and scepter before her apparition in heaven.

For the artist, the developing of a group of influential friends in Paris, and a new sense of acceptance by the authorities of the art world were signs that the period of self-imposed exile was to come to an end. The opportunity offered by the large dimensions and grandiose theme of *The Vow of Louis XIII* called for a magisterial response, a work of great importance as art. And then the time was ripe for an affirmation of his principles and his talent; the picture should compel recognition of the man, now forty years old, who had behind him the ample and imposing production of Ingres. (He often spoke of himself in the third person: "Ingres does this — Ingres will not admit that.")

The studies for the big canvas are unusually numerous, and of magnificent quality. The painter seems to have decided, at an early time in the work, just what its scheme would be — one based on the *Transfiguration* by Raphael. From the same great work, Ingres had accepted recognizable guidance for the type of individual heads and the character of drapery in the St. Peter picture. In the new work, his follow-

53

ing of the Vatican master is less a matter of detail, unless we can speak thus of the figure of the Virgin, the climax of the composition where he proclaims — quite literally — the inspiration of what he later called his *"ex voto."*

But the lesson of Raphael is utilized in a matter far more important than that of details. Goethe has written of the immense difficulty handled by the painter of the *Transfiguration* as he unites the two seemingly incompatible divisions of the picture: those of earth and of heaven. It is in the obtaining of a similar unity that we see the essential debt of Ingres to his great predecessor. The device of clouds, light bursting forth, and celestial personages floating in space to contrast with the central figure, is accepted by the modern artist (for he is one), and the design he draws from these elements is unmistakably like the one which marks the triumph of Raphael over one of the most formidable problems of pictorial unity which he ever had to meet.

Roger Fry, in discussing the *Vow of Louis XIII,* speaks of it as Ingres's nearest approach to a completely co-ordinated design — which, even here, he finds marred by certain details. And, however impressive the masterpiece at Montauban, I believe, even so, that we are left with a sense that the individual effort of the nineteenth century cannot attain such fulness of success as was possible in the Renaissance, with its collective effort. Raphael was not simply the chief of a *bottega* where magnificent assistants carried out his ideas: he lived at a time when a sensitive being like himself could accept from the great men around him or just before him — nay, from the distant world of antiquity — vague sensations or more concrete material to be freely assimilated and used with naturalness and ease.

That time is not the modern time, to which, a moment ago, I declared that Ingres belongs. It is marvelous that he can arrive at a perfection in the group of the Virgin and Child which permits Mr. Fry to say that here Raphael himself is not superior. But for the picture as a whole to come up to the plane of the *Transfiguration,* time would have had to turn back and repeat itself, as it never does. Instead we

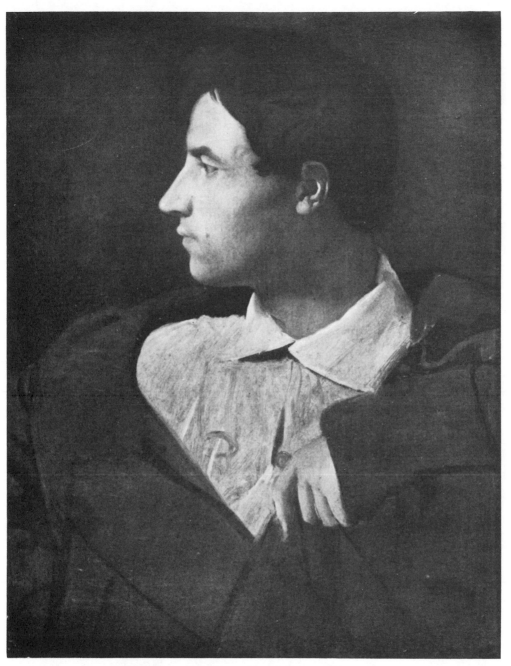

The Architect Dédeban, 1810, Museum of Besançon

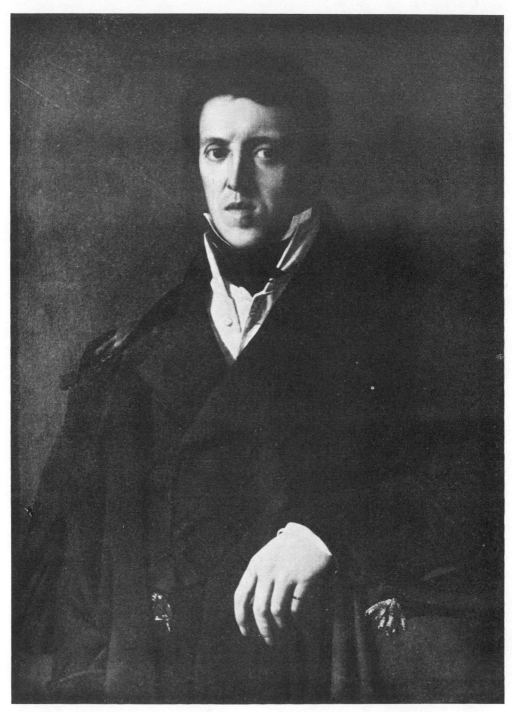

M. Marcotte, 1810, Collection of Mme Joseph Marcotte, Paris

get, from the earliest to the latest life of Ingres, works which offer us subtleties, purities, intensities which Raphael himself cannot equal.

Such a statement is not to be made without support from men more authoritative than myself. Among various corroborations of my idea which could be adduced, I offer three. First the words written by Mont-fort, the friend of Géricault, as to the time when that master was on his deathbed.

Once, when he was already very ill, I found him, as I entered, with a sheet of paper in his hands, that he was considering at length. "See here, Montfort, look at this," he exclaimed, throwing the paper toward me, at the foot of the bed. It was a pencil drawing of a woman, very beautiful in its character. "It is by Ingres," he resumed, and as I turned my eyes toward him to express the pleasure which that fine drawing aroused in me, he added: "It's like Raphael."

Then when Ingres's *Apotheosis of Homer* was taken down in 1855 for its showing in the World's Fair of that year, Delacroix, who had enough cause for complaint about his rival's attitude toward him, said to Amaury-Duval, "I have had the opportunity to examine the Homer ceiling on the level of the floor; I have never seen such execution; it is like the masters, a mere nothing does the work, and from a distance, everything is there." Unquestionably, the master whom he had in mind above all was Raphael, with whom he links the name of Ingres on other occasions.

But, as we come nearer the present time, we find an idea that is more specifically like my own in the one expressed by Renoir; and I was not thinking of it when I compared the great painter of the Renaissance and his modern emulator. Lionello Venturi, writing of Renoir's sojourn in Italy, would be the last person to repeat without due caution a statement like the following: that Renoir, after seeing the masterpieces of Raphael in their original setting, could say that though he preferred Raphael in his frescoes, he felt that Ingres, in his oil paintings, had gone beyond his master.

CHAPTER IV

Ingres in Paris, 1824 to 1834

FOR EIGHTEEN YEARS, WHICH IS TO SAY SINCE 1806, INGRES had not seen his native land, and when he arrived to witness the effect of the *Vow of Louis XIII* at the Salon of 1824, it was with so little certainty as to the future that he left his wife behind him in Florence, thinking that he would soon rejoin her there.

To one of his friends he wrote:

I had no idea of staying in France. I had thought that, once the exhibition was over, I should take the road back to my beautiful Italy. But the wind has turned. For the first time, I have been welcomed, fêted, recompensed—more than I deserve, perhaps, and I have written Mme Ingres to come here, and to bring everything with her, for when I came it was with just one valise and my pictures. And here I am in France, in my own country, which makes me feel I am wanted. And I shall stay—and I am happy to do so.

One understands his happiness. "Beautiful Italy," to which he returned ten years later, had been good to him in many ways: it had let him live in peace, it had shown him the painting and sculpture that remained his lifelong ideal, it had been the scene of his creating a series of master works, and a rich harvest of other pictures only less beautiful. But it was always the people at home whom he had in mind when he painted. Admirable as was the Rome of his youth, it was no longer the world capital it had been during the Renaissance and just after: Paris was already the arbiter of painting, and success there was the real success.

It had come now; the artists, the critics, and the public were practi-

56

cally unanimous in their enthusiasm for the works which Ingres
showed at the Salon. "For the first time," writes M. Lapauze, "Ingres
knew unmixed joy," and he adds that in his letters to Mme Ingres he
could "rave on to his heart's content, and he did not stint himself in
the least in doing so." Best of all, from our standpoint, as we look
back to the men who offered him their admiration, was the attitude
of Delacroix, whose "clarion note was awakening the artists, too much
inclined to slumber as they were, in that general weakness which
threatened the French school." The words, like those which follow,
are again from the text of M. Lapauze. I prefer to quote him here, for
his partisanship as regards Ingres, is so fervent that he cannot be sus-
pected of favoring the man whom his idol at once looked on as an en-
emy. At the same Salon hung an early masterpiece of the latter's, *The
Massacre at Scio,* before which Ingres indulged in jokes that went to
an extreme of vulgarity. Yet as the account cited tells us, "His young
rival Delacroix led the choir of praise. He found not a single thing to
criticize in the color of the picture, so rich in accent and in light."
Delaborde testifies that even before 1824, Delacroix had been giving
to Ingres "attention and eulogy."

Géricault had died early in the same year. His great *Raft of the
Medusa,* of five years before, was acquired by the Louvre at just about
the time when Ingres's picture was hung at the Salon, so that Delacroix
— with his own great success of the *Barque of Dante* two years behind
him, could feel himself what he was to remain till his death in 1863,
the head of the movement that meant new vitality, new genius in
France. The fact makes his tribute to Ingres only the more precious.

Had the old opposition to the "returning prodigal" kept up, Ingres
might have found himself on the same side of the barricade with
Delacroix, however different their arts. But, as we have heard him say,
the wind had turned — and his sails were well set to profit by it. After
the first outburst of eulogy, a few discordant voices were heard, but
soon an event occurred which offset their effect a hundred times. This
was the painter's election to the Institute, an honor that carried with

57

it important material advantages. The "School" itself recognized the success of the man it had opposed.

And the change was especially underlined by the fact that the opening in the ranks of the Academy which Ingres was called to fill was the one caused by the death of Baron Vivant Denon, the former Director General of the Imperial Museums, whom he had regarded as his bitterest opponent, his *anti-moi*—to use his own expression about their unbridgeable separation.

Boyer d'Agen introduces the passage in which he treats this subject with the words, "The immortals have eternal hatreds." He confirms his dictum with an extract from a letter written by Ingres's cousin, Mme Paul Lacroix, in 1854. She says:

He confessed to me again that the man who had persecuted him the most was Denon; and it was just the latter whom he replaced in the Academy. On the day of Denon's funeral, Ingres, according to what he told me, went along to the cemetery to see the body put into the grave, and he approached nearby, before the coffin was covered with earth, so as to be quite sure that everything was finished. Then, as his account ran, he had one last look at the grave, and said: "Right! right! That's all right! He's there, this time; he'll stay there!" When he sat down for the first time in the chair at the Academy where his dead enemy had sat, the terrible man had experienced an ineffable joy, as he admitted. And the whole thing was told with that air of gentleness which is so typical of him.

With this hostility of twenty years' standing behind him, Ingres could revisit Montauban, where new triumphs and festivities awaited him. His parents, and others of his immediate family had died during his absence, but the city remained dear to him; and the pride in their great fellow townsman which the Montalbanais evinced on this occasion, and which they continued throughout his lifetime (and beyond it) touched the artist very deeply. Though he never returned after this visit, when the *Vow of Louis XIII* was placed in the cathedral, he kept up a correspondence not only with Gilibert but with other friends, and took pride in the "Musée Ingres" at the Hôtel de Ville, to

which he bequeathed the great bulk of the work remaining in his studio when he died. Yet the quiet life of the provincial city was not for him: Paris was the place.

And if a Lapauze, writing only thirty years ago, could speak of a "slump" in the art activity of 1824, if a Delécluze—a witness to the return of Ingres after having visited him in Florence just previously—could shudder at the dangers the French school suffered from the new revolutionaries, we of today must look back to the period as one of the really exciting ones.

For people who had pinned their faith to the Revolution and to Napoleon, the return of the Bourbons spelled tragedy or exile—as with David, who died in Brussels the year after Ingres came back to France. But it seems as if anyone with half an eye must have seen that the vast movement in the field of human rights begun by men like David must continue despite reaction, just as his formidable gift of new energy to the arts was to go on—was going on, despite the let-down of the academic weaklings. Géricault had already furnished a tremendous example of the strength of the new period; Delacroix had set in motion a scheme of ideas that a century could not exhaust; Barye, Corot, and Daumier were at work and would soon be offering things of heroic vitality and beauty. And there were the poets—with Victor Hugo nearing the full cry of his genius, and the musicians at one of their supreme moments—as Beethoven approached his end, and Schubert and Schumann were stepping forward to continue his work.

The dynamic nature of the time is apparent, from whatever stand-point we look at it. Ingres is aware of its young strength—and op-poses it, as one is almost forced to say. The men who called him Gothic were wrong in their depreciation of his genius and that of the artists of early Italy (the men of the Campo Santo at Pisa, for example, whom the artist studied during the first weeks after he reached the pen-insula). But the reason why the accusation struck Ingres so forcibly was that it had a basis of truth in it. We have heard him say that art must turn backward in order to live. Here in Paris were painters who

lived — and with splendid fullness — yet who refused his formula.

That was really the difference between his tendency and that of Géricault and Delacroix. The Romantics, as they were already called, had not neglected the museums. Far from doing so, the two great painters who led the movement had gone as far as Ingres himself in giving to their art a basis of classical values. Only, these were furnished them by Rubens and Veronese, Rembrandt and Michelangelo, the masters of color, of mass, of movement and light—qualities which Ingres saw in no comparable degree in Raphael and the Greeks. The two schools overlapped in their equal admiration for Poussin, who unites so much of both the northern and the southern genius, but it was the differences, not the agreements, that were to be accentuated more and more as Ingres and Delacroix pursued their ways.

Eighteen years older than his rival (who was born in 1798), Ingres was rapidly gaining followers in the way that he had won the life-long fidelity of Amaury-Duval. On an earlier page we have seen what a revelation that artist had had of the greatness of his chosen master upon the latter's return to France. Previously, as will be recalled, the young man had thought of him as strange, even dangerous, and had intended to study with Gros. That leader of the pure Davidian tradition was still to be a power for some years, after which the hostility of the public and the critics weighed increasingly on his mind until the fatal moment when he could no longer bear his rejection by the world, and committed suicide.

The final tragedy, and the irony involved in the death of this glorious artist, came from his failure to see that—essentially—he had won his battle. His work continued in the great production of the men he taught or influenced — Géricault, Barye, and Delacroix; what was lost was the narrower part of the heritage from David, which he was sworn to carry on, and which had so hampered his own genius.

Doubtless the guiding minds of "the School" saw that Gros's major lesson was in the direction of modern life. His vivid painting of the era of Napoleon had given to the mass of men a token of the grandeur

of their time and, to the artists, specific inspiration for works like Géricault's masterpiece (an indictment of Bourbon inefficiency in the horror of the *Medusa*), and Delacroix's *Scio* picture, a protest against the wrong to Greece committed by the Turks, in the apathetic presence of France and England. Painting such as these disciples of Gros were doing (not to mention sculpture like that of Barye, concerned principally with animals, as it was) alarmed the politicians and reactionaries of the art world a thousand times more than the "originalities" of Ingres. Hence the immensely able man appeared to the dismayed academicians as their best chance for salvation. Hence also their prompt election of him, in the first weeks after his great success at the Salon.

His friends, as the biographies tell us, also urged him to open a school, in order that the true faith be passed on to the rising generation. We have seen one of his adherents turn Amaury-Duval away from Gros and persuade him to study with Ingres; the advice may perfectly well have been disinterested, and its results were happy ones. Nevertheless, in getting an understanding of our master's change of position, from his "revolutionary" status of the past to his welcome in the highest official circles, we need to penetrate to the springs of thought in the time, as well as to those which motivated his own acts.

What concerns us above all, however, is not the working of the machinery of art in government (or the government in art) though the subject is important enough to America at the time when these lines are written — and probably for much time to come. The effect of Ingres on institutions is a question of temporary interest: what we want to know is whether the institutions had any effect on him — in the one thing of importance — his work. I can see none, any more than I can see any effect on Delacroix of his service in the Municipal Council of Paris, where he spent a portion of his precious time over problems like the heating apparatus for public buildings. (Let us hope that such tasks, which he seems to have believed in as part of his duty as a citizen, were at least partly responsible for the award to him of the commissions for his great decorations).

61

The Life and Work of Ingres

The contact of artists with the outer world is their personal affair (a serious one for David, for example, when he barely escaped the guillotine); the matter of their immediate effect, through professional teaching, is one that history can scarcely follow (had Barye, let us say, not studied with Gros, he would have been a great man, even so, and left us masterpieces); so that the remaining question, the one that does concern the world, is the production of the sculptor and the painter. Through this—and only through this, in reality—do they speak to the men of their time and those of all the after time. Ingres, in the remarks cited before, those after his discussion with Thiers, referred to himself and other artists with the phrase, "we who cannot write," and when the reader enters upon those pages of the present book which cover the spoken words and the letters of the master, he must do so with a constant readiness to check up the statements there with the paintings and drawings in which the essential genius of the man appears. Without implying a contradiction between his words and his works, it may not be too soon for me to take the precaution, even here, of saying that the theory of Ingres may be interpreted only in the light of his practice.

For example, his statement that the effort of the young artist must be to raise himself to the feet of Raphael so as to embrace them, might be interpreted as a demand to abnegate all personal genius. But the work of Ingres replies superbly to any such idea of renunciation. He incarnates the classical values for the nineteenth century, but he is of that century; and the fact that it has an active need of his role in it is the best commentary on his dictum that all questions of art have been settled by the Greeks. Magnificent as his principles are, they have been misapplied by later men—as have those of all the masters. Fortunately, as we shall see, Ingres has had some successors to carry on his great lesson. It resides in his painting, and so we may return from this excursion into history and philosophy, to look again at a glorious picture.

The *Mme Marcotte de Sainte-Marie,* now in the Louvre, dates

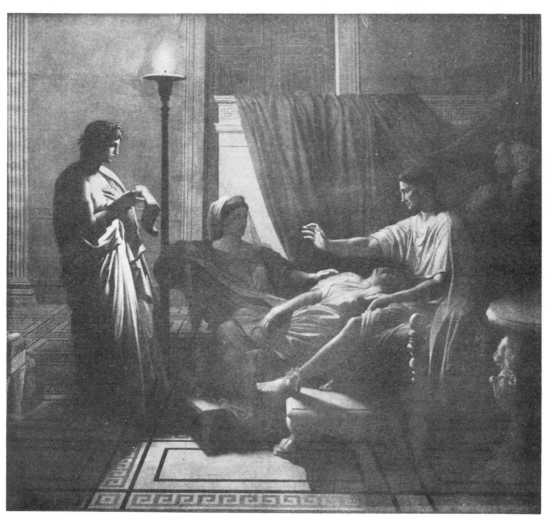

Virgil Reading the Aeneid Before Augustus, or *Tu Marcellus Eris,* 1812,
Museum of Toulouse

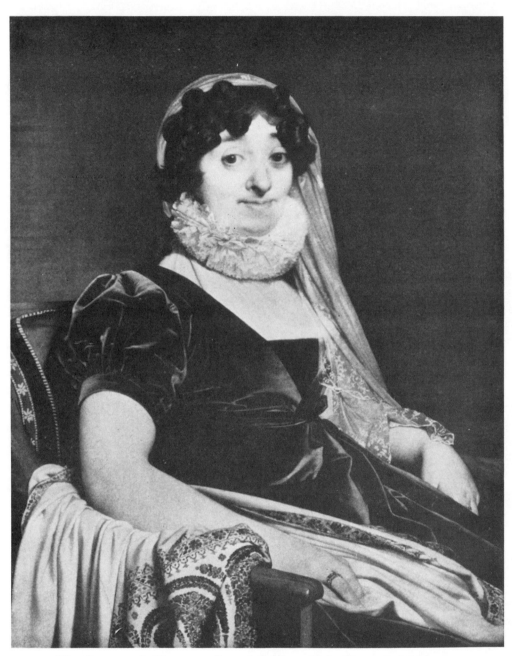

The Comtesse de Tournon, 1812, Collection of Mr. Henry P. McIlhenny,
Philadelphia

from 1826 (not 1827, as stated under the reproduction in Lapauze), and so carries us on from the *Louis XIII* to the *Apotheosis of Homer,* the great composition of 1827. The portrait of the sister-in-law of Henri Marcotte, Ingres's old friend, was prepared for by a drawing of greater beauty than is usual even among the marvels of this kind. The sitter was in bad health and could not pose with the assiduity required by Ingres, who generally made heavy demands on his models. The closeness with which the painter follows his drawing suggests the idea that the work was done largely without the presence of the lady. But whatever the circumstances surrounding the evolution of this picture, its quality assures it a special place in the affections of Ingristes.

That rather sectarian term, denoting people who have given special study and admiration to the master, will include larger numbers as time goes on, and more and more persons finding their esteem for Ingres turning to love. The renewed understanding of the French seventeenth century, with its grave penetration into character, its emphatic design, and its passing beyond the charm of surfaces will situate this poignant work — and many another by Ingres — apart from the Raphaelesque ideal that sums up, in too exclusive a way — the descent usually assigned to our painter.

Such questions are easy to play with, but they always leave one before the enigma that an artist's origin must still remain. Let us rather look on the picture itself, for it is one to exemplify certain considerations as to the quality forever to be associated with the name of Ingres: his drawing. Both admiring and hostile writers on the master bear witness to lapses on his part from strict accuracy of representation. Mostly these are of a minor nature, and quite involuntary. There are, however, instances where they were pointed out by his friends — and yet allowed by him to remain in the work. The fact is that, despite the phenomenally true eye and facile hand which were his from childhood, his work defines the quality of drawing for us in terms distinctly broader than those of mere reproductive exactitude.

The *Mme Marcotte de Sainte-Marie,* for example, sings the praise

of line in its double function of rendering form by contour (aided by a minimum of color and shading), and as a chief element of composition. The impression one gets from photographs of Ingres's pictures, that the camera has done an almost perfect job in representing them, is contradicted when we come before the originals. Even the present work, reticent as it is in color, and clearly defined as to outlines, is infinitely finer than the reproduction tells. The subtlety of edges, the way in which the planes flow into one another or contrast with one another are matters of Ingresque drawing that only a sight of the painting itself can reveal. More accessible from our plate, but still insufficiently felt (since the lens and the ink and paper are inferior in sensitiveness to the human eye), the other phase of drawing is still to be appreciated in full only from contact with the original. The dress designer gave to the collar of the lady's costume a repetition of curved lines that the painter followed, modifying them subtly as he went along, so that their pattern really becomes his own. Similarly every line is given its place in the scheme of the whole.

It is a process so natural, so inevitable, that we are unaware of it, and think the sight before him could not have been a shade different from what he has given us. But, to start with one of his changes, that we can trace: the position of the hands is other than what it was in the drawing — where they are quite as perfectly represented as in the painting. And as his instinct told him here that he must make an adjustment in order to get the ravishing ensemble that he sought, so there is a stressing of the curves of eyes, eyelids, mouth and facial outline that contributes to the same effect. Wherefore we can say that, for all his perfection as a portraitist, the drawing of Ingres is immeasurably less a matter of nature than of art.

With the *Apotheosis of Homer,* we come to a work that may be looked on as a full enunciation of his philosophy. Beginning it in 1826 and completing it the following year, he was vexed at not having more time for so important a theme. He resumed it afterward in a large and extraordinarily detailed drawing, produced with the thought of having

it engraved by Calamatta, his favorite among the men who, by their faithful reproduction of his work, made it accessible to thousands of people who could not see the originals. Under the title, *Homer Deified,* this drawing offers important modifications of the original design — very successful ones they are — and increases the number of the *Homerides,* the great men who, throughout the ages, have carried on the tradition of art established by the supreme poet of Greece.

By the choice Ingres makes among the writers, painters, and sculptors included in the scene, he defines the tendencies which, for him, spell art and truth. Thus, in the version of 1827, Shakespeare appears;[1] but in 1865, when he finally completed the drawing, the English poet was banished because of his Romantic tendencies. Lehmann, a painter of German origin, who was one of the very faithful defenders of Ingres's doctrine, besought his teacher to include Goethe — who certainly had no lack of devotion to the Greek ideal; but the master was adamant against the thought, and said, "People will exclaim against me, but what do I care?" It is true that, after many hesitations he felt that he could not put in his beloved Mozart (for reasons that I have not discovered; he gives them in the case of Shakespeare, Goethe and others). At the very end of his life he changed his decision about Mozart and gave him a place in the picture.

The affirmation of his ideas that he gives in tracing the line of authority from the antique world is doubly stressed by the subject of the picture as a whole, and by its ordering. Here is no scene of the Mid-

[1] *This statement may seem open to objection on the ground that Shakespeare does not fully appear, only a part of his face being visible, at the left edge of the picture, and many a person has had an uneasy feeling that a lack of respect was implied. But if the "Shakespeare corner" here was never a very conspicuous one, the case for Ingres is better than it seems from our reproduction of the picture as it is today. Old engravings prove that the whole of the English poet's face was shown by the painter, and that a certain amount of canvas has been cut away. This doubtless occurred when the picture was detached from the ceiling which it originally decorated. "Restorers" are not always squeamish about small matters — or even large ones.*

65

dle Ages such as would have fitted in with his early love of the
"Gothic" or Primitive artists; this is not even the world of the Renais-
sance, still less that of modern times, with the realism of approach
which would naturally have gone with subjects like those of Gros, his
elder among David's pupils. In a period when "literary" values were
deeply considered by artists and public alike, this choice of a subject was
of consummate importance, especially as the picture was to have a con-
spicuous place in the permanent decoration of the Louvre. (After being
removed from its unfavorable showing there, as a ceiling, and placed in
the gallery of nineteenth century masterpieces, a recent re-hanging has
again increased its effect).

Important as are the personages in the work and grandiose as is their
setting, it is above all through the design and execution of the picture
that Ingres imparts to it that philosophic value which I mentioned be-
fore. The Greek temple forming the center and pinnacle of the com-
position prepares the symmetrical disposing of the groups of figures
that are so severely balanced around the commanding presence of
Homer as he sits enthroned. The graceful movement of the Victory
who crowns him is conceived, obviously, as a counterpoise to static
passages which might become rigid; and so one proceeds through-
out the lines and masses and, amidst the possibilities of complexity or
even confusion, to which a lesser man would have succumbed, the eye
follows out an order that is of limpid simplicity. Even in the later ver-
sion, where the number of personages is greatly augmented (and
where — in my opinion — a far grander order is achieved), the new
difficulties do not diminish the clarity which reigns everywhere.

Behind the whole work one feels the lesson of Raphael in his two
great compositions of *The Church Triumphant (La Disputa del Sac-
ramento)* and *The School of Athens*. Ingres was bringing to France the
most cherished of his memories of Rome. But now our questioning
begins. Is it not the spirit of the city of Raphael rather than the spirit of
Athens that presides over the Homer picture? Or, more truly yet, is not
Ingres a modern and a Frenchman when he conceives this work, even as

66

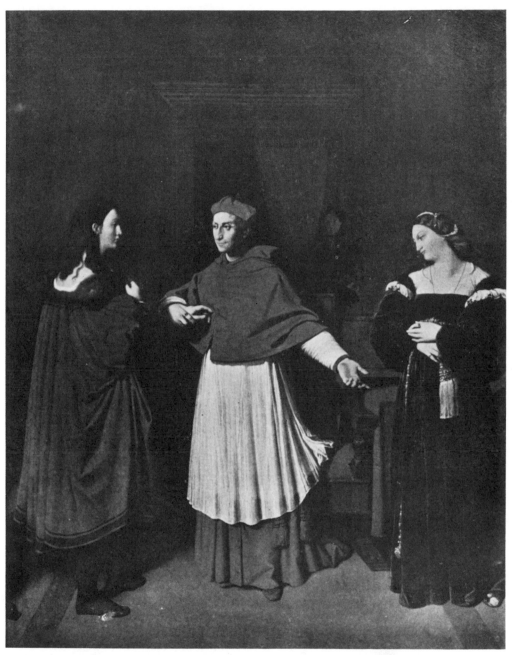

Cardinal Bibbiena Betrothing His Niece to Raphael, about 1812,
Walters Gallery, Baltimore

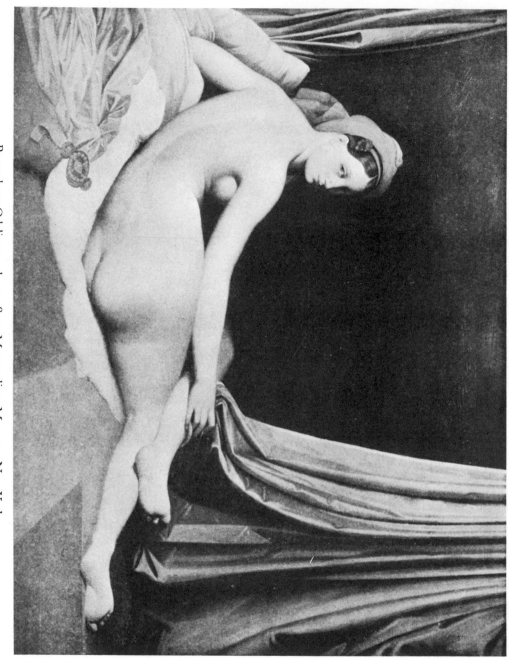

Recumbent Odalisque, about 1814, Metropolitan Museum, New York

his idol remained a man of the Renaissance and an Italian when he produced the *School of Athens?* Artists can not escape being of their own time, whatever the period they depict.

The painter of the *Apotheosis* would not have claimed that Homer himself was passing judgment on posterity, and deciding who were the true issue of his genius. Delacroix, it is true, saluting Rubens as the Homer of painting, adds (in the privacy of his *Journal*), "There is nothing Homeric about Ingres save his pretensions." Concerning the late version of the *Apotheosis,* the painter has left us notes of explanation, including a statement that the young servant who keeps alive the fire on the altar of the god is himself.

And so one can scarcely restrain the thought that Ingres is invoking the masters from whom he claims descent in order to establish his authority through their presence. For his admirers, there is no question but that the painter of the *Virgil,* the *Mme de Senonnes,* and any number of other works, is indeed supported by the great men of the past. But these artists are, personally, no longer of this world; they were not consulted as to being made the spokesmen of Ingres. Marshaling them as his supporters, he may therefore be pretty fairly accused of indulging in "pretension," as his rival so acutely remarks.

The work remains, to a great extent, a manifesto, a claim, rather than a performance. I know how pious sectarians, as well as certain more credible students, endorse it, and take the master's words at face value. Among those who do so is our good friend Amaury-Duval — and he is more than a biographer, or a merely faithful admirer of Ingres. He is a painter of distinguished merit, in his own right; the single work of his in the Louvre is far from representing him at his best. We must therefore give due weight to a statement he made in an article published in 1856 when he said that "the *Homer* ceiling is, without exception, the most astounding creation of modern painting." In *L'Atelier d'Ingres,* he cites — some twenty years later — the opinion on the picture held by his contemporaries, Ary Scheffer and Edouard Bertin, whose enthusiasm quite echoes his own. So that there is here a

challenge which one cannot ignore; and though I have tried to keep my opinions within reasonable bounds in this book, I want to state my belief that the *Apotheosis* does not rank with the most successful achievements of the great artist.

I have already pointed out what I regard as an impossibility in it: the attempt by a modern to re-create Greece through the aid of archeology. The restoration of temples, and indeed of cathedrals, in which Viollet-le-Duc and others of Ingres's time believed, has proved illusory. (Only Athenians of the classic era could build a Parthenon — which we think to see in the *Apotheosis;* only men with the peculiar fervor, science, and art of the Middle Ages could build Chartres.) The temple of Homer is neither of Periclean Athens nor even of the time that is supposed to see the rebirth of antiquity, but which is simply — and gloriously — the Italian quattrocento and cinquecento. Ingres remains a modern, a son of the Revolution who goes on into the time of the Restoration, of Louis Philippe, and of Napoleon III.

His art is of their period, and when he turns here to portraying the famous men of the past, he is none too far from the engravings that we heard Diaz allude to so scornfully, and that he of course did consult for his likenesses. Does he go beyond likeness, does he create? I think few would affirm as much about the portrait gallery in the lower part of the composition, where one's main impression is of the industry, the tenacity of the man, in executing one head after another, with all the realism he could muster.

But again there is contradiction as between this and the imagined figures of the Victory, the Iliad and the Odyssey. It is not so flagrant as it is in a later work where the artist takes the magnificent portrait from life that he did of Cherubini and — in the version of the Louvre — inserts a Muse who crowns the composer. The disparity between the two conceptions is intolerable. For his genius for abstraction to assert itself, as in the *Recumbent Odalisque,* a full acceptance of the delight of line, mass, etc., was necessary. The marvelous design that we get in several renderings of the *Virgin of the Host* more than reconciles us to

the extreme submission to Raphael in the type of the head, but where realistic and abstract elements conflict, as in the *Cherubini* (of the Louvre) and the *Homer* pictures, the effect of both conceptions of art is destroyed. Drawings of supernal quality prepare the way for those great symbolical figures I have mentioned, and something of their beauty survives in the painting.

Yet even with these, the most successful parts of the *Apotheosis,* one is pretty well forced to prefer an isolated study, like the one of the *Iliad* reproduced here, to the use made of it in the big composition. Delacroix told Amaury-Duval how perfect is the execution of the picture, but it is very doubtful that he could have gone on in the praise he uttered to his friend, the devout follower of Ingres, and taken the same tone about the general conception of the picture. It is perhaps most Greek in its aspect of symmetry. That quality appears in the vases and the buildings of classical times. But the workmen who made the vase had a relatively limited problem. The outlines, the placing of the handles, etc., are taken in at a glance, and we are free to enjoy the charm of the delicate strokes of the workman's brush or stylus as he decorated the surface with tiny figures.

A building calls for a broader coherence, a genius capable of maintaining vitality in an ensemble that no mere craftsman could imagine. We are amazed at the way that fragments of the marble, broken off and seen in isolation, continue to quiver with the life of the great work, of whose scope they are an index. In the *Apotheosis of Homer,* as in others among the big compositions of Ingres, the whole is not on the extraordinary level of the parts.

With a hundred years of growing admiration for the master behind us, it is still possible to utter such criticism (that of Roger Fry reaches much the same conclusion). How strongly, therefore, must the men of 1827 have felt such things — especially when, at the Salon of that year, they turned from the *Homer* to the *Death of Sardanapalus,* Delacroix's picture in the same exhibition! Like the work of the Classicist, that of the Romantic has its defects. Derain once spoke of it as having

69

"une mauvaise mesure," by which I think he meant that the proportions of the enormous canvas are ill suited to the disposition he made of them. Perhaps a wider, perhaps a narrower rectangle would have been more appropriate to the design, and doubtless a number of details in it explain themselves imperfectly and are difficult to relate to the ensemble.

But having said this much, how impatient we are to get to the positive side of the story, to the quality of fire and passion in which the tragic thing is so rich, and to painting—hardly inferior to that of Rubens—which carries the generous and unexpected vision to its immense power. The poem on which the picture is based was dedicated by its author, Lord Byron, to Goethe; so that we find ourselves in the full tide of the spirit of the time. To this, Ingres's contribution to the Salon opposed a review of the past, and an affirmation that the source of all authority is in the Olympian majesty of the genius of Greece.

Official opinion on the two great canvases was unanimous: the success of Ingres—if not equal to his triumph with the *Vow of Louis XIII*—was as outspoken as the hostility to the tremendous effort of Delacroix. For the latter, one important voice was raised in approval—that of Victor Hugo, whose *Preface to Cromwell,* of that year, has remained as one of the landmarks of the century. A turn toward the forward-looking art of the Romantics was strong in the younger generation, even if it was not yet felt by the people in power. And though, for many years and in many another test of opinion, Ingres was to come off the victor, a splendid exhibition of his work in 1911 caused André Suarès to write that, in contrast with the men descended from the great Classicist, all modern art had issued from Delacroix.

The thesis is persuasive and has its aspect of truth. Yet it is not the whole truth. We shall attempt a more exact analysis later, when we have followed the art of Ingres to its conclusion. For the present, in the face of the adverse judgment I have permitted myself on the *Apotheosis of Homer,* I want (before returning to a more impersonal vein) to

take my own stand against the idea that Classicism is, in any necessary respect, a retrogressive or even static form of art.

It is easy to see the moving quality of a great work like the *Sardana-palus,* few can escape the contagion of its kindling flame, even today. But the movement that Ingres brings into art from the ancestors he claims in the *Homer* (and who are his indeed), is a no less dynamic force. Delacroix, like himself, looks to the past, and the fact is a part of the Romanticist's pride and strength: without his memory of certain phases of our great heritage, it would have been forgotten for longer than it was. And as no one looks upon him as *passéiste,* so we must come to see that Ingres also looks essentially to the future. At times when the noble tumult of Romanticism has degenerated into senseless noise, the calm and purity of Classical art come over our spirit with their healing strength, and in Ingres, above all, we see its creativeness; his thousands of drawings and his wonderful painting carry us along the lofty plateau where health and certitude have their dwelling place. I do not know a higher claim that could be made for his art, yet any praise will seem weak when we come before certain pictures that await us in the forty years of life that Ingres still had ahead of him on finishing the *Apotheosis.* But the period of that work, including the years just after it, is one in which his mind is apparently directed above all toward a realization of his doctrine by works of a severely intellectual character, and it is the drawings, almost exclusively, that show him yielding to the sense of beauty that had expressed itself so ravishingly in the *Bather of Valpinçon* in 1808 and that was to reappear, in quieter times, with a succession of glorious things like the *Odalisque with the Slave* of 1839, the *Birth of Venus* of 1848, the *Mme Moitessier* of 1856, and the small replicas of his masterpieces which occupied him at the end of his life.

The Revolution of 1830 affected his mind as little as did the other historical events through which he lived. When excesses by the populace were to be feared at a moment of excitement, we find him hastening to the Louvre, as did any number of the artists, and standing guard

with a great saber in the room of Italian art. Paulin Guérin, armed with a musket, was in charge of the Rubens room and, in the night, the two artists got into a discussion about Raphael. It had carried them to a "paroxysm of fury," at which moment, happily, they were relieved from duty by Etex the sculptor who, with another member of the profession was to carry on the vigil.

Ingres's period of financial difficulty was well behind him, but he still needed to paint small, salable pictures, a number of which date from the years we are considering. His pride as a painter had made him take umbrage, even violently, when people applied to him for pencil portraits and, at about this time, he announced that he would do no more of them except as a compliment to friends. The sale of rights to engrave his work provided a more acceptable form of income, and it was supplemented by the students who came to him from 1825 onward in rapidly increasing numbers. He expended upon teaching the same passionate energy that marked every activity of his life, looking on his pupils as a good father does his children, and seeing in their career a continuation of his own.

The year 1832 is marked by the painting of a portrait which, ever since, has remained in the minds of French people, above all, as one of the real creations of the master. Indeed so characteristic is it of the men like its subject that the *M. Bertin* rises to the height of a symbol.

To understand the France of the time of Louis Philippe, one must realize what the Revolution did in giving the country over to the middle class. We may recall what Elie Faure says on the subject in one of the masterly analyses in which his *History of Art* abounds (especially when he treats of his own land). He explains part of Daumier's importance by that artist's commentary on the society of his time.

"The Pharisee and the hypocrite hide when he passes by, the bad rich man grinds his teeth, and the bad shepherd goes white. And since, in this time, it is the middle class that reigns, he lashes out at the middle class. This hatred against the bourgeois is a phenomenon of Romanticism, excessive, like all Romanticist phenomena, but very healthy.

Ingres will have none of it. Society must settle its problems and its politics without him. He appreciated the greatness of Daumier, however, or some of it, and lost no opportunity to see his work. His own was concerned with a different set of values and in his portraits he accepted the people around him at their own rating of themselves. He is, indeed, to quote Elie Faure again:

> . . . a bourgeois of his time, throwing himself into the conquest of form, like the notary or the banker into the conquest of money.
>
> But he is a great bourgeois. He has the precise intelligence, rigorous and limited, the brutal idea of authority, and the specialized probity, of those strong conquerors who, with an eye to lucre and practical domination, dug canals, laid out roads, covered Europe with railways, launched fleets, and exchanged paper for gold over their counters. And so he could make, of these men, portraits which seemed to be cast in bronze and hollowed out with steel. It is because he closely corresponds with those who are of his epoch and his class that he is the last in France to trace with a pencil as hard and sharp as steel those clear-cut psychological images which leave nothing of the inner character in the shadow, and suppress every detail which does not emphasize this character of the man and the woman who belong so intimately to this country. . . . And when he casts his eye on some illustrious sitter, however austere the costume is intended to be, the person is already disrobed. As man is defined for him by wealth, woman is defined by love. He weighs the bellies of the bourgeois and the bosoms of their wives. How many beautiful arms, emerging from their shawls, with fat hands, and the fingers spreading as if full of sap, which the rings press to the finger tips! How many dewy glances under heavy eyelids, how many moist mouths where voluptuousness trembles!

Elie Faure's penetration into the character of the time and its people has more authority than that of a person born outside of France and, if he does not touch on the genuine nobility of such a rendering as the *M. Bertin* (and other great portraits by Ingres) we may accept the fact as proving these canvases or drawings to be exceptional. The special popularity they have had from the time when they were first shown offers an additional reason to see them as superior things, expressive of the character of the time on a particularly high level.

Amaury-Duval, telling of the Salon where our artist showed the *M. Bertin* and the *Mme Devauçay* together, has written that, "The exhibition of 1833 was the one where M. Ingres gained his greatest success, and this time an almost uncontested success." Add to this fact the enormous esteem that both works have subsequently enjoyed, and it is clearly of the most intense interest to artists to learn that the painter, then at the height of his powers, went through a veritable martyrdom in his attempts to express his idea of the famous editor who was his subject. A first conception of the work, preserved for us in an admirable drawing, had to be abandoned.

"I couldn't do anything. I couldn't find anything. To be sure, my model was a fine one, and I was enthusiastic about him. But the thing I was doing was bad."

Mme Ingres interrupted him, addressing herself to me:

"He always has got to begin again; now I considered that picture very beautiful."

"Don't listen to her, my dear friend, it was bad, and I could not finish it like that. I had had the good fortune to fall in with the best and most intelligent of men. M. Bertin came from Bièvres just to pose; he had already given me a great number of sittings, and I found myself compelled to tell him that all his trouble was wasted. I was desolated. But I had the courage to speak out. Do you know what he answered me, how he brought back joy into my heart?"

But let us go on with the recital — so moving for every artist who has struggled with the difficulties of portraiture — in the words which M. Bertin himself spoke to Amaury-Duval at a later time. During the sittings the painter would fall into such despair that he would weep.

. . . and I would spend my time in consoling him: "my dear Ingres, don't bother about me; and above all don't torment yourself like that. You want to start my portrait over again? Take your own time for it. You will never tire me, and just as long as you want me to come, I am at your orders." One day when Ingres was dining here, we were taking our coffee in the open air, just as we are now; I was talking with a friend and was, it appears, in the pose of the portrait. Ingres gets up, comes over to me and, speaking almost into my ear, tells me,

"Come and pose tomorrow, your portrait is done." The next day, as a matter of fact, I began my sittings again, and they were very short ones; in less than a month, the portrait was finished.

We have records of other portraits over which the painter spent long and difficult days, but no account is as dramatic as this one of the creation of a work that might well seem to have been accomplished with ease. The fact probably means that, at this period, when the Romantics were making great headway, Ingres needed to make an answering effort which should defend his position anew.

That is doubtless the explanation also of the years he gave to *The Martyrdom of St. Symphorien,* which appeared at the Salon of 1834. He had been engaged on it since 1826 and, beside the general problem of the composition, the large number of figures and the unusual poses of many of them called for hundreds and hundreds of studies, not only in pencil but in paint. It may be the matter of a detail — the movement of an arm, for example — which will be experimented with again and again; it may the relation of several personages in a group, which will seem to the artist to demand special investigation in order that he may clearly know how they should appear in the big picture — an order from the government for the cathedral of Autun, where the masterpiece has hung, ever since.

And a masterpiece it is. The preoccupation with Raphaelesque principles of design which weighed on the artist's mind when he was composing the *Homer,* is spared him here, as is the tedious work from old portraits of all the famous men whom he had never seen. Instead, the *St. Symphorien* offers him the intense drama of the central theme, the excitement running through every accessory figure, the sweep of a design so magnificent and so original that even in the gray light of the chapel at Autun one feels its dominance. The reserved color is no bar to the expression of a powerful religious idea; we are moved by it even after seeing the great symbols which Romanesque sculptors, at one of the highest reaches of their art, carved on the exterior of the cathedral.

It is worth while to recall that another masterpiece, so dissimilar in every way, is to be found on the building. Doubtless the art of the Middle Ages was nearer in spirit to the fervor of the boy who sacrificed his life in Christian martyrdom. The figure by Ingres illustrates ecstatic resignation but does not create through an image, as do those which render vision in the ages of faith. The mother who, from the ramparts, shrieks to him an encouragement to go on firmly, does not equal in her terrifying gesture the impressiveness of the god of judgment who sits enthroned in the tympanum over the entrance portal. The art which the modern man represents so superbly is a naturalistic art — descended from those very pagans who, in the picture, are dragging the son of Autun to his doom. And so, in the cathedral of his native city, we have a double confrontation of the opposing principles.

The great canvas was to be the occasion, for Ingres, of one of his own bitterest experiences. The principles he had expressed with such particular intensity in the *St. Symphorien* had had a period of success, and now, for a time, a reaction set in. The critics tore the work to pieces. The *Journal des Débats* (M. Bertin's newspaper) was one of the rare exceptions, and support came also from the unexpected quarter of the Romantic artists — Decamps, for example, speaking out strongly in favor of the picture. Its attackers were the academic men, who carried the crowd with them, as they usually do. Once again the truth of George Moore's observation is driven home for us; he said, "When I was young, I used to think there were many schools of art. Now I know that there are only two: the school of the men who have talent, and the school of the men who have no talent."

Ingres never realized, or certainly never more than dimly realized the beauty of the work he considered opposed to his own (his statement, on exhibiting the *St. Symphorien* was that it should "beat the hydra to the ground," the many-headed monster being his symbol for Gros, Géricault and above all, Delacroix). But what does that signify? — that the critical, philosophical sense of the man never developed in a manner comparable with his creative faculty. Within his field, his

76

perception of nuances of idea was as rich as are the incredible subtleties of his lines and planes; in matters of general principle, his austere character, his uncompromising probity (to use a word to which his speech gave new lustre) carried him to the absoluteness that one feels in every inch of his work. What he lacked, evidently, was the capacity to see that other forms of art had their absolutes.

The Martyrdom of St. Symphorien is therefore re-enacted in his own case — with the difference that, this time, it is the Roman school he represents which is the victim. Two fierce decisions take shape in his mind as he suffers from his bad treatment. One is that he will never again exhibit at the Salon and, in fact, Delaborde tells that he held to his vengeance till the end of his life, his only appearance in a governmental exhibition being at the World's Fair of 1855 (where he had a section all to himself).

The other decision was more fraught with consequences. He determined to leave Paris and, refusing the offer to paint a mural at Versailles, he asked and obtained the directorship of the Ecole de Rome, whither he had gone as a student in 1806. Since a frivolous and ignorant world refused to see the greatness of the work which, at the end of his life, he referred to as "that master picture," he would withdraw from the world, and it may well be that this is the moment when he writes in his notebook, "Mozart said, 'I did my *Don Juan* for myself and for three of my friends.'"

77

CHAPTER V

Ingres the Teacher, Rome, 1834-1840

THE ARRIVAL OF INGRES IN ROME FOR HIS SECOND SOJOURN in that city is so vividly related by Amaury-Duval that no one else will ever tell the story with half the immediacy we get from the old artist who, in recalling his youth, gives us images of his master which we must, this time, take over bodily in a quotation of considerable length. His book has never been translated into English — much of it having to do with his own career and his own art which, like that of many another minor man of the time, has suffered neglect; a later period, returning to the fascinating days when he lived, may well cause him to be better known.

He had consulted Ingres about the advisability of entering the Ecole des Beaux-Arts so as to compete for the *Prix de Rome,* and at this point we may let Amaury speak for himself.

At my first word on the subject, M. Ingres stopped me.

"I am going to ask you a question that is slightly indiscreet," he said. "Do you think your father could spare you the money that a trip to Italy would cost, when you are prepared to profit by it?"

"I think so," I answered; "at all events, my father has often told me that, if I did not succeed in the competition for the Rome prize, which is really very difficult and very much a matter of luck, he would somehow find the means to let me have a stay which should be long enough for me to get the benefit of it."

"Then don't go to the Ecole," exclaimed M. Ingres, "for I am telling you what I know is true: that is a place where men are ruined. When one can do nothing else, one has to adopt such an expedient; but one should not go there save with one's ears well closed (and he made the gesture of stopping up his own), and without looking left or right."

Thereupon he unrolled before me all the ineptitudes of the teaching there,

entrusted, as it is to four or five painters who, each month, come and tell the students the exact opposite of what they had been told by the preceding instructor. And then the *chic* [the work having no basis in nature], the mannerism — everything except naturalness and beauty; skill — nothing but skill. He got more animated, the more he talked, and ended up with extreme violence.

He did not need to make such an effort to dissuade me: on the contrary, I was happy to hear him forbid me to go to the Ecole and, throughout my life, I have never set foot in any class-room there.

After taking part in the Salon of 1834, Amaury-Duval set out for Italy. His arrival in Rome preceded that of his teacher by a short time, and he soon called at the Villa Médicis, where Horace Vernet was still director of the *Académie de France,* awaiting the coming of Ingres, to whom he was to turn over his charge. The Academy had about it something of the character of the extraordinarily able but shallow painting of Horace Vernet (the son of Carle Vernet, Géricault's early teacher, who was himself the son of Joseph Vernet, the charming landscapist of the eighteenth century). It is of interest to hear, briefly, of the institution to which Ingres came, and especially of the change he wrought in it. So we put ourselves once more under the guidance of Amaury.

I was struck, as I entered the drawing-room, by the very Parisian elegance which reigned there. Amidst charming women, ambassadors, Italian princes — in a word, all that Rome had of the most brilliant society — I was happy to find myself again with former classmates of art-school days; Flandrin and Simart, now pupils at the Academy; they gave me the warmest welcome. I was presented to Horace Vernet, and was received with a slightly military cordiality which set me at ease immediately; then I met Mme Vernet.

. . . It may be imagined how interesting were these reunions, with their so varied elements. Whatever distinguished people were passing through Rome attended them, the nucleus being the group of young men already marked by their talent. And so we never missed a chance to go to the soirées of the Academy, which ceased when M. Ingres came and replaced Horace Vernet as director.

The news of M. Ingres's arrival spread rapidly through the clan of artists.

The pupils of the Academy, as also the painters outside it who professed a deep admiration for M. Ingres, arranged together to go forth to meet him and provide him a reception suited to the importance of his entry into Rome.

All the horses we could get were requisitioned and, forming quite a numerous cavalcade, we set out for the tomb of Nero, where we were to meet the master; but we waited in vain. Night fell quickly at that season of the year, and the lot of us were compelled to return, each one to his own lodging, a bit disappointed. I do not know the cause of the delay, but the fact remains that M. Ingres arrived only on the morrow of the day announced for his coming.

On the first Sunday that he received visitors, we went to call, Bertin and I [Edouard Bertin, the painter, not the editor whose portrait Ingres had painted].

Good Lord, what a change! Was it really the same palace, the same drawing-room, that I was seeing again? that drawing-room where, but a short time before, I had found such a brilliant and elegant company!

Everything was somber and dull: one lamp at each corner of that immense room, which was rendered even darker by the tapestries with which it is hung; one lamp on the table and, near the table, Mme Ingres holding her knitting in her hand; M. Ingres, in the midst of a group, conversing gravely. But not the ghost of a woman, nothing but black coats, nothing to brighten your eyes. Furthermore, there was about the attitude of the pupils that indefinable sort of constraint and uneasiness that we never got over with the master, and that a new director could scarcely fail to inspire in the other young men.

It was lugubrious.

Our entering caused a brief moment of agitation. Bertin was received with open arms by M. Ingres; as for myself, he showed genuine pleasure on seeing me again. But the ceremonious tone very soon regained its dominance. In vain did I put forth my best efforts to liven up all those people; I went and shook hands with my former comrades, I went up to Mme Ingres and complimented her on her knitting: nothing did any good, they all wore a look of consternation.

A word that I spoke by chance finally brought us down from those frozen heights.

I expressed to M. Ingres our regrets over having been deprived of the honor of accompanying him on his entry into Rome, and I mentioned the tomb of Nero as the point where we had halted to await him.

"Oh," said he, "you speak of a place for which I have a very lively and tender memory, and I wanted to stop there again this time. For it was there that I saw Mme Ingres for the first time. I am speaking literally, gentlemen, I

did not know her. She was sent to me from France," he added laughing, "and no more did she know me . . . that is to say . . . I had sent her a little sketch of myself which I had made . . . "

"You did indeed, and you flattered yourself nicely," said Mme Ingres without stopping her knitting.

That naturally gave us a good laugh, M. Ingres himself taking part in it, Madame's humor being contagious.

Then he related to us in a few words the history of his marriage. He was sad and isolated in Rome; he told one of his friends about his state of spleen, and it just happened that that friend had in his family a young person endowed with all the qualities which could assure his happiness. Everything was arranged by correspondence. One day it was announced to him that his fiancée was about to leave for Rome and that he should await her. The date was precise. M. Ingres set out to meet her at the tomb of Nero, and there, descending from the coach, he saw the woman who was to be his wife. "And," he added, looking at her, "she has kept all the promises of her friend, and gone beyond them."

This little story, told by M. Ingres with charming simplicity and with Mme Ingres listening to it as if it was the most natural thing, seemed to us most interesting, and we felt we must congratulate them very heartily.

The conversation took a different turn; we talked about the marvels of Rome, the masterpieces that surrounded us.

"You doubtless know all of them by this time, gentlemen," said M. Ingres; "as for me, I haven't been for a new look at anything. What with the confusion at getting installed . . . and yet I've been to say my prayer . . . I needn't tell you where I went . . . oh! gentlemen, it is more beautiful than ever. The more I see that man, the more beauties I discover in his work. Let them be your nourishment, gentlemen, take everything from them that you are able to take. It is the manna that fell from heaven, the thing that will nourish you, that will strengthen you . . ."

Whenever M. Ingres grew animated as he always did when in this way, speaking of the masters, his eyes gleamed with an extraordinary brilliance, his face became handsome, and I could not look at him without real admiration.

A week after that evening, we were invited to dine at the Academy.

The very strange dinner became interesting only toward the end.

Hardly had the roast been served, when I understood that something extraordinary had just happened, noticing M. Ingres's features, as I did, and his twisting on his chair, and his beating a tattoo with his fingers on the table. Then he stopped eating and, in the direction of Mme Ingres, sent forth furious

glances, which ended in smiles whenever he thought he had been noticed. Mme Ingres remained impassible, while all the rest of us were in consternation, especially I, as a submissive pupil, fearing I might have been the cause, through some ill-considered word, of such a strange state.

A chance remark by one of the guests put an end to the situation and changed the current of M. Ingres's ideas. The words were, "I can't understand how Watteau can be admired, how his name can be pronounced in this place."

"What?" exclaimed M. Ingres. "Don't you know, Monsieur, that Watteau is a very great painter? Do you know his work? It is immense. I have everything by Watteau at my place, yes, Monsieur, and I consult him . . . Watteau! Watteau. . . ."

The reader will imagine the situation we were all in, especially on account of the unfortunate fellow who had uttered that opinion. Luckily he was a friend of M. Ingres's, and he managed to extricate himself quite skilfully; but M. Ingres wasn't listening to him, and kept on saying through half clenched teeth, "Very great master, Monsieur, very great master! . . . whom I admire! . . ." [1]

Mme Ingres gave the signal, probably a bit earlier than she would otherwise have done, to put an end to this scene, and we went into the drawing-room where I approached her at once to find out the answer to the enigma that was so much on my mind.

She began to laugh and told me, "You would never believe what got him into that state . . . well I am going to tell you. . . . It is because I served roast veal . . . and he does not consider it proper to serve that when we have company. That was the whole thing. You see, I couldn't get anything else, and I said to myself, well, they'll just have to be satisfied with that."

[1] *The incident is of importance, in the first place because it shows the great difference between the attitudes toward Watteau of Ingres and of David. The earlier master's idea is known to us through a sentence recorded by Delécluze. Speaking of Prud'hon, David said, "He is the Boucher, the Watteau of our time; we can just let him go his way — that can't produce any ill effect today in the state to which we have brought the school." The admiration for Watteau which Ingres expressed so vehemently, above, is confirmed in the fullest way by his act, years later, when he was preparing the composition of his great mural,* The Golden Age. *From those engravings after Watteau which he had "at his place," he made many drawings, and they served him admirably in his search for the design of various parts of the masterpiece.*

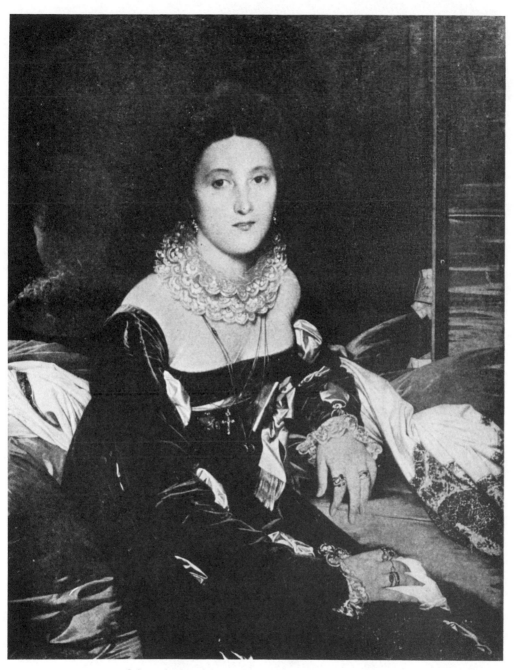

Mme de Senonnes, 1814, Museum of Nantes

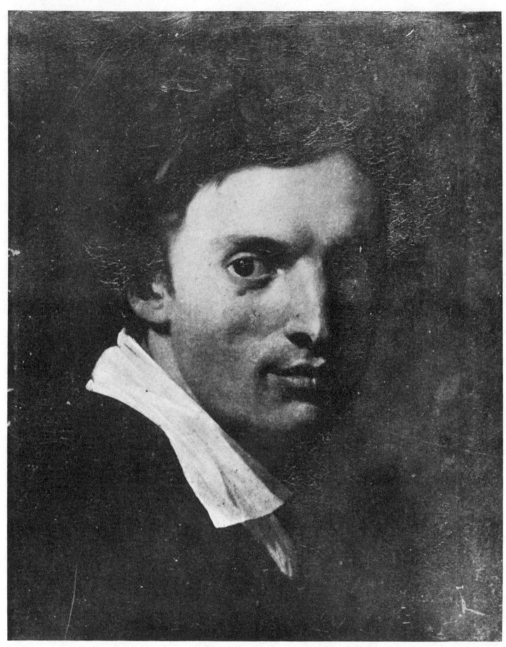

The Sculptor Cortot, 1815, Collection of Mlle de Comps, Paris

"Oh I'm so glad!" said I; "I was so afraid that someone had offended him by some luckless word!"

"Not at all," answered she, "I've told you what caused his bad humor."

I hastened, with a bit of a laugh, to go and reassure the guests, who were very curious about the whole thing.

Soon people began to arrive, and the drawing-room became quite full. The students, who are usually invited only by ones and twos for the Sunday dinner, came down and increased the numbers; but it was always more men, and therefore the things had the same sombre look.

Then began the famous soirée of the Academy, which would be repeated every Sunday, and that I never knew to vary during my stay in Rome.

Ambroise Thomas would go to the piano. Everyone would take his seat in silence, M. Ingres in the center of the room, holding his head high and preparing to listen. Then the silence became complete. Woe betide anyone whose chair creaked, and certain straw-covered chairs at the Academy had a tendency to creak! M. Ingres would turn around furiously in the direction from which the noise came; and soon the very anxiety you felt prevented you from sitting still enough, the noise would begin again, and with it also, the irritated glance of M. Ingres.

But the Mozart sonata was ended, and Thomas, escaping from the applause would go and hide in a corner next to Flandrin. He certainly might have accepted that applause, for it was very well deserved and very sincere.

Other artists followed him, always playing *virtuous* music, as M. Ingres used to call the compositions of Mozart, Beethoven, and Gluck.

At the end, everyone would depart, the majority doubtless regretting the brilliant soirées of Horace Vernet, and I very happy, always, at having seen my teacher, and having heard masterpieces so ably rendered.

I think that no reader will do otherwise than take pleasure in the length of my citation from the delightful book which an American Ingriste, Mr. Royal Cortissoz, calls the one for which he would exchange all the others on the master. The glimpse we have just had of him in his character of music lover, recalls an observation of Delaborde. He informs us that Ingres at the age of twelve, when playing compositions by Gluck, would weep over their beauty, and that, seventy-five years later, just a few days before his death, he experienced the same

emotions on going once more to the opera for the *Alceste* of the German composer.

Ingres had played Beethoven quartets in a group organized by Paganini at Rome, and he preserved his admiration for the celebrated violinist, of whom he has left a portrait in pencil. At a later time, when Paganini was giving a concert in Paris, the painter attended, and Amaury-Duval, who sat in the next box, records the following:

From the first notes, grave and profound, that the violinist drew from his instrument, one understood clearly in whose presence one was, and M. Ingres began to express, by his gestures of admiration, the pleasure that he felt; but when Paganini indulged in those exercises of prestidigitation, in those *tours de force* which have begotten such a ridiculous school, the brow of M. Ingres darkened and, his wrath increasing in inverse proportion to the enthusiasm of the public, he could no longer contain himself: "It isn't he," came from his lips. I heard his feet tap on the floor as his impatience grew, and the words *apostate,* and *traitor* gave vent to his indignation.

Need I add that his intolerance about music equalled that which he concealed so little as regards painting? He recognized no composers save the old ones, and would not hear the moderns discussed. I must say that he made an exception in favor of Henri Reber; I am pretty sure that that was the only one.

It is worth while to pause for a moment over a thing we have just heard from one of Ingres's most devoted — and most competent admirers. To be sure, *intolerance* is a pale word when compared to the full-blooded invectives of the master himself, but it deserves comment on the score of his principles. The "imprecations" which Ingres hurled down from his seat on Olympus were not directed at men, but at ideas. After the death of Géricault, he demanded in a sentence which we shall find on a later page (one which has not ceased to trouble his apologists) that the *Raft of the Medusa* and other canvases by the great early Romanticist be banished from the Louvre. He does not stop there, however, but gives his reason: what he sees as the ugliness of the works. And it is not likely that he forgot that he owed to Géricault his ac-

quaintance with Coutan, one of the collectors whose support was so helpful in those early days when money was cruelly scarce.

The younger artist had visited him in Rome, moved by one of the generous impulses which characterize his whole career. Another such case, later on, is seen in Géricault's journey to Brussels where, after the fall of Napoleon, David was in exile. "He came to embrace me," wrote the old man in a letter which tells of his joy in seeing the painter whose work at the Salon had startled him by its unexpected power.

As regards Delacroix, there is a letter from Ingres himself refusing to vote for the other master, who was presenting himself for election to the Academy. Here again the reason is given explicitly; he says, "I recognize the talent, the honorable character, and the distinguished mind of the artist, but I look on his doctrines and tendencies as dangerous, and I am regretfully obliged to reject them."

When, at the age of fifty-four, he returned to Rome as director of the famous Academy that dates back to Louis XIV, the principles that we have heard him enunciate had been clear before his mind a long time. If he could give up his school in Paris (and Delaborde condemns him for leaving his flock without a guide), he doubtless felt a justification for his course in the influence he would have on his new charges, the winners of the *Prix de Rome.*

His recent and bitter experience of Paris, in the criticism of his *St. Symphorien,* made him eager for the quiet of Rome and for the work with the young men he would find there. As with his rancor over the injustices he suffered at the Salon in the year when he first went to Rome, so the new hurt to his sensitive mind died away — in its immediate effect, at least — when he was once more in communion with the masterpieces that had meant so much to his youth.

And, once more, they meant to him something quite different from what was taught in the Davidian school which Gros still tried to continue. That teacher was, in Delaborde's words, "preoccupied solely with the desire to expiate, by what he called 'pure Classical teaching,' the independence of his early acts — the former boldness of his genius."

85

We recall that Delacroix's immense admiration was for Gros the painter, not Gros the teacher. Even after the latter's great personal kindness to him, he declined the famous man's offer of instruction; to the young painter, it doubtless meant self-immolation, of the kind that Gros himself had accepted at the hands of the terrible old artist who, from Brussels, never ceased to send for his decrees.

Thus Ingres, standing between the school of the past and the school of the future, again sought salvation for himself and his pupils in the classics and in nature. His painting explains — for those who can read its true meaning — the connection between the two sources of art. But it took time for the students arriving from Paris to grasp the idea — which is far from being generally understood even today.

An example of the young men's difficulty is contained in the memories set down by one of them, the gifted painter, Hébert, in an article published in 1901. He had gone to Italy, on winning the *Prix de Rome,* determined to follow the advice of his cousin, Stendhal who, with the words, "Beware of chocolate color," had warned him against Ingres. But his fine judgment soon made him aware of the qualities through which this new mentor transcended any minor limitations, and he became a submissive student. Henry Lapauze summarizes the recollections of the young man at the time when the latter invited Ingres to come and see a design he had been preparing for a picture.

The project had been drawn with the idea of pleasing the master. The other students were proud of having accomplished the conversion of the newcomer, who had previously imagined that he would express his vision of life and beauty in quite a different way. Hébert had adopted so completely what he thought were the ideas of Ingres that, in view of the expected visit, he had hidden a certain number of his studies after the peasants of the Roman Campagna. Ingres came and viewed the design of the *pensionnaire;* he spoke with the kindness he habitually used, and showed, by a few rapid indications as to matters of detail, that he had examined everything. Hébert was "at the pinnacle of happiness," as he was bowing Ingres to the door. But the director, having put his hand on the wrong knob, opened a closet where he found himself before a study of a

piper "with a peaked hat which threw a shadow on his black eyes, his red mouth, and his pale cheeks, the whole man trembling with fever under his mushroom colored cloak." Ingres stood still, knitting his brows and not saying a word. Suddenly he turned around:

"Who did that?"

"I did, Monsieur le directeur."

"You, monsieur, you did that?"

"Yes, monsieur, it was I."

"Well, it is very good," said he in a loud voice; then turning to the drawing on the wall, "and this one here is bad."

This one here was the design in the Ingriste style. A word from the teacher, seeing a water color which vigorously defined the real temperament of the artist, sufficed to reveal the latter to himself. And the word certainly proved, as Hébert writes, "that M. Ingres himself was of a broader mind than any of the pupils he had at the time, or before that, or afterward!"

The statement of the old artist, as he looks back to his youth, gives an idea of the admiration with which the teacher was regarded by the young men whose course he directed. He could be severe, he could contradict himself (often quite consciously, when he found different types of error among the students), but always they felt that it was for their own good that he was speaking. When the time came to act, to defend their interests in the exhibitions or before the representatives of the government, no one could be more vehement than Ingres. When cholera raged in Rome and deaths occurred at the rate of three hundred a day, he was firm in his courage, kept up his work and, well seconded by Mme Ingres, prevented a panic in his school. Above all, there was the sense of his unswerving devotion to the classics, of his being their truest interpreter to the new generation. It was more than respect that he called forth: "The good master! How I love him!" wrote Hippolyte Flandrin to his father.

From the days when the first students applied to him, his method was to inculcate the art of the masters — especially Raphael — perhaps with a memory of his childhood adventure of finding prints after the Urbinate in the studio of Roques, his teacher at Toulouse. One of his

watchwords was that the teacher must be the first pupil of his studio, and he lived up to the principle throughout his life. When past eighty years of age he used to go to the house of one of the Rothschilds to copy a work of Holbein, whom he placed — at moments — on a level with Raphael. It is related that someone, finding the illustrious man engaged on this task, and supposing it to be for students alone, asked him why he did such a thing. Ingres raised his eyes from his work for just a moment, and fairly snapped, "So as to learn!"

He always objected to any statement that his admirations among the masters were confined to a narrow range. The story of the Holbein may confirm his idea for those who think of him as devoted to Raphael exclusively, and the unshadowed surfaces beloved by the German master prepare us to understand the interest of Ingres, more than fifty years earlier, for the art of the Orient: the painting of the Chinese and the Hindoos. Long before Manet and his group had popularized Japanese prints, they had an admirer in Ingres. Amaury-Duval sees something of their quality in the head of Mme Rivière.

Since the attitude toward nature is so different in these various schools, it will be seen that the incident we have cited in the career of Hébert has nothing exceptional about it as regards the teachings of Ingres. Strong as was his love for the things of the museum, he demanded an equal fidelity to the things of the surrounding world as registered in the personal vision of each pupil. Even when it was merely naïve, he would encourage the young man to go on his own way — just as he did with Hébert, whose tendency appeared to the other students to be opposed to their school.

In words of characteristic terseness Ingres himself has given the best statement of his attitude toward pupils of an independent turn of mind. In *La Légende des Ateliers,* a book that furnishes much information on the period we are considering, Jules Laurens tells of the visit of Ingres to the church of Saint-Méry where Lehmann and Chassériau had recently painted decorations. "Some people who were accompanying him, less indulgent than he and desirous of gaining his favor, treated a

number of defects in the work as a sign that his two pupils were not entirely faithful. Ingres replied vigorously. 'In my house, I have never obliged anyone to wear my livery.' "

If the best of his pupils are so far from reaching his level (beside Chassériau, Mottez, Amaury-Duval and Flandrin, others have left fine works), the fault is not with his teaching but with their endowment from nature. As Elie Faure points out in his invaluable notes, to the *Atelier d'Ingres,* the true succession of the master is not to be sought among the men who worked directly in his studios, but among those who have followed him through the teaching of his works. It is by no means impossible that certain early drawings by Delacroix himself were done in emulation of Ingres, so strongly do they suggest the *Recumbent Odalisque.* Puvis de Chavannes owes much to him, both for his sense of form and his love for the artists of early Italy. Courbet and Manet undoubtedly accept influence from him; Degas (who knew him personally in his latter years) bases his art on that of Ingres very directly; Renoir's debt to him was pointed out in the opening pages of this book; so also his conception of form continues to our day in the strong traces of it to be noted in the work of Matisse, Derain, and Picasso.

The case of Seurat is a special one. I had for a long time been impressed by the Ingresque quality of his drawing and thought it simply a part of the heritage that the master draftsman had left to the school of his country. But then, reading that Seurat had studied under Henri Lehmann, I was led to inquire into the work of that forgotten artist All I needed to discover was that he was a pupil of Ingres's; and when I met a man who had worked beside Seurat in student days, he told me that Lehmann had transmitted to them—very directly—the principles of art he had, in his youth, derived from his famous master. It was from Lehmann that Seurat got the idea, which he carried out, of copying Ingres's *Roger and Angelica.*

The utility of copying the masters, nowadays so little understood, was a cardinal point in the philosophy of artists, down to a hundred

89

years ago, and even later. In the earlier centuries, it was, of course, one of the chief means of education for the painter. Many a museum director has spent a bad day (or a bad year) over the question of original versus copy attaching to some picture in his charge, or submitted to him for purchase. After generations of experts have hammered away at such problems, the gravest doubt remains as to whether many works may be given to the celebrated masters whose names they bear, or to an early copyist. He may have had no intent to deceive, he may have been producing an honest reproduction, destined to enrich a foreign gallery (which, at a later time, because of the destruction of the original, became the representative of the master), or he may have been doing his schoolwork, with no purpose save that of deepening his knowledge of the methods and principles of some great man.

A delightful exhibition held in Paris in 1930, was entitled *Les Uns par les Autres:* "the ones" were the earlier masters, of whom "the others" had left the copies composing the show. How perfectly one saw the line of descent from Rubens, the Fleming of the seventeenth century, to Watteau, the Fleming of the eighteenth! An adorable drawing in the Louvre underlines his relationship with the same Olympian — to whom Barye, Bonington, and Géricault, at the exhibition, were seen rendering homage. Goya, quite naturally, was represented by one of his copies after Velasquez, but the bond between the two masters of the same country was no more strongly felt than the likeness between Delacroix and Veronese. The latter's *Marriage at Cana* is known, historically, as one of the chief influences on the modern colorist, who acknowledged the debt by a magisterial water color after the central group in the masterpiece. Less expected — by those who know Delacroix badly — was one of his copies after Raphael, which turned up. The exhibition, having thus revealed the school to which the Romantic had gone, also showed the descent from him: there was a copy after Delacroix made by Odilon Redon in his youth—and retained by him on his wall throughout his long life. And with what pleasure one found that both Renoir and Braque had made their prayer at the

altar of Corot! Different as were the lessons that the Impressionist and the Cubist drew from the serene master of Ville d'Avray, one realized that both the later painters were right in what they told of him — and that his art was even richer than one had previously seen it to be.

Ingres, as one need not be told, was no exception to the rule about copying, whose effects we have just observed. And that exhibition afforded the merest glance at the perspective: the list of copies begun by *"Les Uns par les Autres"* could be extended indefinitely. One thinks of Poussin in his excitement over the discovery of the *Aldobrandini Wedding*, copying the ancient fresco three times over. One thinks of his copying a master like Titian, apparently so far removed in temperament from himself (Rubens, whose glorious canvases after the Venetian — hanging near the originals in the Prado — might seem the logical man to be studying the sumptuous colorist). But — of a sudden, certain beauties in the apparently cool painting of the Norman master tell us that in Poussin also there was a warmth, a passion that responded to the art of Titian, and no less splendidly than did the rich temperament of Rubens.

If the latter master was permanently to remain suspect — or worse than that — for Ingres, many and many another Frenchman has resented the Fleming's influence on the art of their Latin country; it is to Poussin that they look as the true source of their painting. Even a colorist like Redon — a fervent follower of Delacroix, the greatest admirer of Rubens — could write antagonistic things about the Fleming, whose work he visited in the museums and churches of Belgium. In these opinions he rejoins Ingres, to whose own work he was not inclined, as we have seen. And again Ingres, in copying the *Venus* of Titian, rejoins Rubens, to that extent at least. The masters are never very far apart, in reality. That part of their company at which we have been glancing is seen to be bound together anew when Ingres copies the central group of figures in Poussin's *Eleazar and Rebecca*.

The fact that the nineteenth-century master, like his glorious predecessor of the seventeenth century, should have worked from a fresco

coming down from Greco-Roman times, was the cause of a real thrill of pleasure for me when I came on the bit of history through a chance reading of Charles Ricketts's article on Puvis de Chavannes. I had been trying to trace the influence of the Greeks of Pompeii and Rome on modern painting, and had not met with much success. To be sure Raphael, with his borrowings from the decoration of Nero's Golden House was a link, and there was the case of Poussin and the *Aldobrandini Wedding*. But, among the moderns, the one important man from whom I got words of enthusiasm was Renoir — who compared the priestesses of Pompeii to the nymphs of Corot. The influence on the most Grecian of all modern painters, Delacroix, can not be substantiated by any document that I have found (it was only in Paris or London that the great man could have seen classical painting, for he never visited Greece or Italy).

My good old *Atelier d'Ingres* turned out to be of no assistance this time, for though I recalled that Amaury-Duval had a chapter on Pompeii, it yielded no more than his own experiences — not a word about his master's relation to the painting of antiquity. Then, in an old *Burlington Magazine,* I found the account Mr. Ricketts gave of his early visit to Puvis de Chavannes, and I got the fact I was sure must be hidden somewhere. The passage reads, " . . . the *Medea* from Herculaneum and the superb *Hercules and Telephus,* and *Hercules and Omphale,* also at Naples, one of which was copied by Ingres." Puvis de Chavannes was of course the very type of artist to show the descent himself, uniting erudition and inspiration in equal measure, as he did.

The two qualities I have just ascribed to him appear in the same proportion in the master we are studying — which fact explains the words I shall quote to round out these pages on Ingres as a teacher:

Do you think I send you to the Louvre so that you may find there what is conventionally called "ideal beauty," something apart from what exists in nature? It is silliness like that which has brought about the decadence of art during bad periods. I send you to the Louvre because you will learn from the Ancients how to see nature, because they are nature themselves. And so

one must live on them, they must be one's food. It is the same with the painters of the great centuries: do you think that when I order you to copy them I want to make copyists of you? No, I want you to get the juice of the plant. Address yourselves to the masters, therefore; speak to them, they will answer you, for they are still alive. It is they who will instruct you; I am only their quizz-master.

It was not enough for Ingres to study the great men at the Louvre and in the museums of Italy: he needed to have their production in his home. When the question was of the famous masterpieces, engravings and casts had to suffice; but there were many lesser works that were within his means for purchase — or that he thought were within his means — even if prudent Mme Ingres sometimes had a different opinion. In a delightful painting that shows the couple in the studio at Rome, one sees on the wall a picture from the brush of a master whom one does not often associate with Ingres, for it is a Velasquez. Jules Laurens tells the story of its acquisition.

One day a dealer in the minor loot of art brings to the author of *Stratonice* a marvelous bit of Velasquez's painting which he had cut from a much larger canvas. Suffocating with indignation as much as with admiration, Ingres breaks out in fury: "What's this! Miserable, infamous brute, you have committed an unmentionable crime, in your mutilating of a beautiful thing!" The man was so aghast with fright that he rushed away. "That is one picture that was not expensive for me," added M. Ingres, later on. "I never saw the dealer again."

The painting is today at the museum of Montauban, a part of the collection which Ingres bequeathed to his native city.

Still on the score of the artist's admiration for other schools than those he most favored, we may cite one more incident from the book by Laurens:

The Italian engraver Calamatta had come back several times to the bad things he said about Rembrandt, whom he called *Moussu Rénbran* to *Moussu Ingres*. One day when he got to insisting too much on his refrain, while Ingres was bending over the work on which he was absorbed, the great artist suddenly

93

straightened up and, turning on the engraver, proclaimed "Monsieur Rembrandt! Moussu Rénbran! Listen: I'll have you to know that you and I, alongside of him, are nothing but little bits of — dashblank!" [The French evasion of the word is "Saint-Jean."]

With a temperament that gave rise to generous explosions like those related in the two stories above, it is small wonder that Ingres endeared himself to the students at the Villa Médicis. Not only the painters and sculptors were devoted to him. We have seen Ambroise Thomas playing at the director's soirées when a pensionnaire, and it is related that the future composer of *Mignon* was so charmed by Ingres that he stayed for six months after the time when the regulations as to his scholarship at the Academy called for his departure for Germany. Another future composer of a famous opera, Charles Gounod, was at the Villa Médicis in the time of Ingres. He has registered his devotion to the man in some fervent lines, which tell particularly of the way that the director insisted on the importance of his pupils whenever the Academy received visitors, of no matter how high a rank.

Conscientious to an extreme, and continually harassed by orders from the Administration in Paris, Ingres had to give a vast amount of time to details of management during the six years of his directorship. The regulations governing so ancient and revered an institution were minute and strict. The old gentlemen at home were for keeping a firm hand on the students and, at one time, Ingres had to make an indignant answer to charges of "soft indulgence"; they were doubtless quite unfounded; very possibly they were a result of the continuing hostility toward him of the weaklings of art. More troublesome still were the Italian officials with whom he had to deal, often through the French ambassador, when some little tyrant in the church or state made too many difficulties about copying, or other matters connected with the students' work.

A thousand petty details, and a big volume of correspondence, reports, etc., consumed time that the artist would rather have given to

painting. Yet he had the satisfaction of knowing that the young men never wanted to leave and, in his personal work, especially during the latter part of his sojourn, he accomplished a great deal. Certain small canvases, like *Raphael and La Fornarina* (the second version), date from this time. There was, apparently, work on the *Cherubini and the Muse,* which had been begun in 1833 (the splendid canvas in Cincinnati was done after his return to Paris); and the first rendering of the *Vierge à l'Hostie* shows what his renewed frequenting of Raphael did for him in these years at Rome. But the two great landmarks of the period are his *Stratonice* and the *Odalisque with the Slave.* (Of the latter work, a repetition with variants dates from 1843. It is now in the Walters Collection in Baltimore.)

The former picture, which he repeated with success in the last year of his life, has a variant to its title: *The Sickness of Antiochus.* Stratonice was the wife of King Seleucus; his son by a previous marriage, Antiochus, fell violently in love with the young woman and, realizing the wickedness of his passion, became deathly sick. The scene depicted is the one where the physician attending the youth becomes aware of the nature of his malady through feeling the heart of Antiochus beat faster, as Stratonice passes near his bed.

The subject was one of tragedy such as the great Greek dramatists had treated, and the period and type of the scene gave it especial interest for Ingres, in his devotion to the classical city where he produced the work. He had had it in mind since the beginning of his first stay in Rome so many years before, when a drawing of flower-like sensitiveness already presents the essentials of the idea. It lost nothing of its beauty in the years intervening; and when he treated the subject once more, at eighty-six years of age, it was to produce a work superior, in certain qualities, to what he had done in middle life. No other painting so well justifies, therefore, his argument that the repetitions of his pictures were done with the thought of obtaining virtues that he had not previously been able to reach. One thinks again of Duchamp-Villon's definition — "An artist's life is a process of perfecting."

95

That last word applies particularly to the *Stratonice,* whether in the two paintings on the theme or the exquisite drawings that prepared for the finished work. The interior of the palace is taken from ancient pictures which were studied by the master's pupils. One of them, Raymond Balze, wrote to Henry Lapauze about the days in Rome when they were all engaged on the work:

> The emotion of Ingres was extreme: it frequently moved him to tears. He told us the story of the picture several times while we were working on it, my brother and I. It was I who did the furniture and the lyre, which was put into a different place in the composition a number of times. My brother Paul had the most extraordinary patience with this painting and with the *patron.* At the beginning, before the present columns were introduced, the background was composed of the *Battle of Arbela* — from the Pompeiian mosaic; later, the labors of Hercules were substituted, then at last, the columns and all the rest of the architecture.

With such changes, even considering the aid traditionally given by assistants, it is small wonder that Ingres worked for years over his pictures. And we have not yet touched on another, and important, phase of the "process of perfecting": the almost miniature-like execution of the painting. One is puzzled as to which is the more wonderful — the sense of beauty seen in the figures, or the tenacity which follows out every detail of the scene (the design in the pavement, the drawing of the columns, etc.). Fortunately, in this picture, all the elements work together harmoniously, and the minutiae only enhance the effect of the whole, with its grand story and its deeply appealing characters.

The mention by Raymond Balze of a great painting of antiquity sends us off on another train of thought. Of the famous Alexander mosaic that was at one time introduced by Ingres into his picture, Goethe could write, "After considering and investigating in a way that throws new light on our study of this work, one is always brought back again to admiration, pure and simple." If the same words apply to the Stratonice, it is for a very different reason. The ancient painting

is monumental in effect, its bold masses carry from a distance; the Ingres is a thing to be seen near by, for enjoyment of its delicate finish as much as for its breathless refinement of feeling.

Here then is the reason why the artist has done so little to emulate Raphael in mural work, the field of his idol's greatest achievement. The *Apotheosis of Homer* was painted as a decoration, and the copy which replaces it on the ceiling of the Louvre (one executed by Paul and Raymond Balze, of whom we have just heard) must convince anyone that the authorities of the museum did right to remove the work from its architectural setting and treat it as an easel picture; the artist himself concurred in their decision. Then, at the period we have last been discussing, Ingres was offered the great opportunity of decorating the Madeleine—and refused the commission. Resentment against his treatment in Paris may well have been part of the reason why he let pass such an opportunity as the one presented by the great church in its unequaled setting; but the government was making amends for the offenses he had received after the *St. Symphorien*, and his declining the order was probably due in part at least to his feeling that the monumental scheme of the building was not for him.

Furthermore, when he did undertake a mural for the Duc de Luynes, we shall see him abandon it unfinished, after seven years of work. Here again, circumstances outside the matter of his art intervene — very terrible ones, for they include the Revolution of 1848 and the death of Mme Ingres, the following year — but when we note what marvels of drawing and painting the work contains, we can scarcely avoid looking on his renunciation of it as the result of an attitude toward the art of the wall which would be unthinkable with the men who did the frescoes of the Vatican. Finally, the *Apotheosis of Napoleon* at the Hôtel de Ville (destroyed when that building was burned down) seems to have lacked the sense of scale demanded by an architectural work, and to have relied for its effect on finesse of drawing, and other qualities which could not fail of achievement by a man with the gifts of Ingres.

97

His whole period is marked by attempts to revive the great tradition of mural painting. Beside the work of Gros at the Louvre, there is that which he did at the Pantheon, neither of them succeeding artistically. But the man whom he influenced so powerfully, Delacroix, took up the problem anew, and produced a whole series of decorations, running along to the very end of his life, when he reached what is perhaps the climax of all his painting in the great frescoes of St. Sulpice. Noble as is their effect, they are not the *fresco buono* of the old Italians; yet even the technical question was being worked out at the time—and under the very eyes of Ingres.

His pupil, Mottez, had been trying out the recipés handed down from the time of Giotto by the follower of that master, Cennino Cennini. Mottez had translated the book in which the old practitioner reveals the secrets of the craft and, to make proof of his understanding of the methods he had been studying, the pupil of Ingres had laid new plaster on the wall of his studio in Rome, and had painted a profile of his wife on the wet surface. Her beauty, as portrayed by the admirable man with whom she spent her life, now looks out on us from a wall of the Louvre. We turn once more to Amaury-Duval for his account of how the picture could be there.

Mottez had requested M. Ingres to come to his studio and see certain works that he had executed during his stay in Italy. I have told that M. Ingres had a great affection for Mottez; he also had a veritable inclination toward his talent. He therefore accepted the invitation, and examined with much interest anything he was shown, even the numerous and fine copies of the works of one colorist after another. Anyone but Mottez [a man of very simple and straightforward character] would have hesitated to show them to him. But M. Ingres was admiring everything wholeheartedly, when his attention was caught by a study done in fresco on the wall.

"What have you got there?" he suddenly said to Mottez.

"A study that I did of my wife."

"I see that, to be sure. But are you leaving it on the wall when you go back to Paris?"

"Why, Monsieur, what else can I do? It would be very expensive to have it taken off and to carry it away with me."

"And so it's to be lost? Well, then, listen, I'll have it taken off myself, if you don't do so; it's a masterpiece! It's like Andrea del Sarto!"

And M. Ingres walked up and down, gesticulating and exclaiming disconnectedly. "Leave that on the wall! it's impossible, I won't stand it!"

Mottez could not calm him down except by telling him that if the master really considered the study to be worth preserving, his desire would be obeyed, as it was the most flattering of commands. One of those able Italian workmen was entrusted with the very delicate operation, and Mottez brought to France the beautiful portrait. I have often admired it in his studio, where he told me the adventure, laughing as he always does, and without the least bit of vanity.

It was characteristic of Ingres to be generously enthusiastic before a work of art, but his admiration for the fresco by Mottez, did not cause him to use the medium himself. Much as we have to be thankful for in the quantity and quality of his painting, we may well regret that he did not address himself to fresco, for its requiring of prompt and uncorrected execution would have increased the number of works in which Ingres gives us the delight that his drawings, for example, afford through their spontaneity; moreover the incitement to think of the work in terms of broad surfaces, to which fresco generally leads, might have favored a development of his art like that which gives such grand unity to the murals of Raphael.

Yet when we reach a picture like the *Odalisque with the Slave,* our one feeling is gladness that Ingres went on as he did. In the quarter-century since he produced the *Recumbent Odalisque,* his painting had progressed to a point where one specially competent judge, Mr. Richard Goetz, looking at the drapery in the foreground, could exclaim, "It's like a Vermeer!" Perhaps the name will come as a shock to people who think of the marvels of color which the Dutch master has given us; but not much reflection is needed to bring before the mind the black-and-white basis of the color which Vermeer and the rest of his school employed. What we enjoy with the old masters of the Netherlands is quality, fineness of relationship in a perhaps limited range of

99

hues, and not the full gamut that the Orientals, the Byzantines, and
certain modern artists have taught us to think of as the mark of the
colorist. For beauty of surface, for delicacy of color adjustment (already
in a work like the *Mme Le Blanc,* with the exquisiteness of painting in
the transparent black gauze of the sleeves, and the modulation from pale
pink to clear red in the lips), it is by no means difficult to find passages
in the work of Ingres quite comparable to the perfections of Vermeer.

But there is a phase of the *Odalisque with the Slave* that strikes
one even more strongly than does its remarkable color quality. The
picture brings us to thoughts about the artist's admiration for women,
in a way for which the *Mme Devauçay,* the *Mme de Senonnes,* and
the earlier *Odalisque* had hardly prepared us. The passion for their
beauty that Ingres the man seems to have kept so well in hand (I refer
once more to the facts I gave previously about the sobriety of his per-
sonal relations) comes out through his art in steadily increasing fashion
as time goes on. The painter mentioned just previously, Mr. Goetz,
called my attention to the way that sensuality grows in the master's
work, the more he advances in years. When we reach the *Turkish Bath*
of his old age, we come to a voluptuous enjoyment of the nude that
has not been expressed, qualitatively any more than quantitatively, in
any preceding work of his; and the studies for it go even further in this
respect than does the finished picture.

Some may be tempted to see in the sensuality of Ingres a reason for
the fact brought out as regards the *St. Symphorien,* that it does not
equal the works of the Middle Ages as an expression of the religious
spirit. But we must quickly recognize the error of such an idea if we
refer back to the work of the great centuries of the past. Set aside Leo-
nardo and Dürer, if you will, as well as Michelangelo and Rubens, all
of them being of a time when pagan ideas had returned to the world;
decide that even their grand scenes of the Christian story cannot stand
with the work of the age of pure faith; yet the very schools (and pos-
sibly the very men) that gave us the most awe-inspiring works in the
cathedrals also indulged a love for the things of this world, from which

the joys of the flesh are by no means excluded. It is not in this respect, therefore, that Ingres differs from the man who carved the tympanum at Autun, but in the monumental scope of the old sculptor who saw his work in relation to great architecture.

There is no futility more profitless than wishing that a given master had shared in the privileges, the inspiration, of an age to which he does not belong. The period of Ingres had no architecture of importance, and so we do not find his murals in a grand relation to the wall. For Raphael, for Piero della Francesca and for Giotto the sense of support from architecture is a chief basis for their art. That does not mean that the contact which Ingres had with the great works of the Renaissance was without effect. As a single individual epitomizes the genius of his whole race, so a single quality of art, concentrating the powers, which, in other times went out to a wide range of elements, may achieve such results as to make us feel a quite sufficient compensation for the loss observed when we make comparisons among the arts (a misleading process, as a rule, and fruitless — if not odious, as the proverb calls it).

That superiority of Ingres over Raphael in the easel pictures, which Renoir spoke of with the brave innocence of great artists, may well derive from the cutting away of the branches of the tree of art which would have absorbed part of the sap. The enormous intensity of the man, going into things like the *Stratonice* and the *Odalisque with the Slave* was due not merely to the isolation he found again in Rome, but to his ever-deepening sense of the beauty stored up in the art treasure of the great capital.

And so when the time came, in 1840, for Ingres to return to Paris, and his students escorted him and Mme Ingres for a distance on their homeward journey (even as the young men of 1834 had set out to escort them to the Villa Médicis, on their arrival), when the pupils, in tears, had embraced their master as he looked for the last time in his life on the city that had meant so much to him, he could say with deepest conviction, "How beautiful is Rome, how small is all the rest."

CHAPTER VI

The Second Return to Paris, 1840-1849

HISTORY REPEATED ITSELF WHEN INGRES REACHED FRANCE
again after his second period in Rome. Only, this time, instead of a
success at the Salon, it was a private showing of his *Stratonice,* some
time before his arrival, which started his acclaim. The Duc d'Orléans,
for whom he had painted the picture, opened to visitors the room at
the Palais Royal where the work hung, and opinion was almost unani-
mous that Ingres had surpassed himself. M. Marcotte, his old friend,
who had ordered the *Odalisque with the Slave* and had awaited it ea-
gerly, was no less warm in praise of his new possession. People felt that
the bad reception of the *St. Symphorien* must be atoned for, and many
had heard of the stupid treatment that the Director of the Academy
at Rome had been forced to endure; that demanded amends also, and
Paris was on its best behavior toward the painter when he came back.

The royal family set the tone for the rest of society. The Duc
d'Orléans, beside writing a warm personal letter, of the kind which
moved Ingres — quite naturally, asked the artist to paint his portrait,
averring that he had refused all proposals to have it done by anyone
else. The son of Louis Philippe was popular because of his kindness
and intelligence, qualities that one feels in no uncertain way upon
one's first glance at the effigy of the handsome officer. His shocking
death in an accident followed but a short time after Ingres finished his
portrait — of which the king ordered several copies from the artist.
Then followed requests to design stained glass windows for the chapel
built as a memorial to the prince. Their success caused the Duc d'Au-
male to ask for work of the same kind for his château at Chantilly;

102

The Guillon-Lethière Family, 1815, Boston Museum

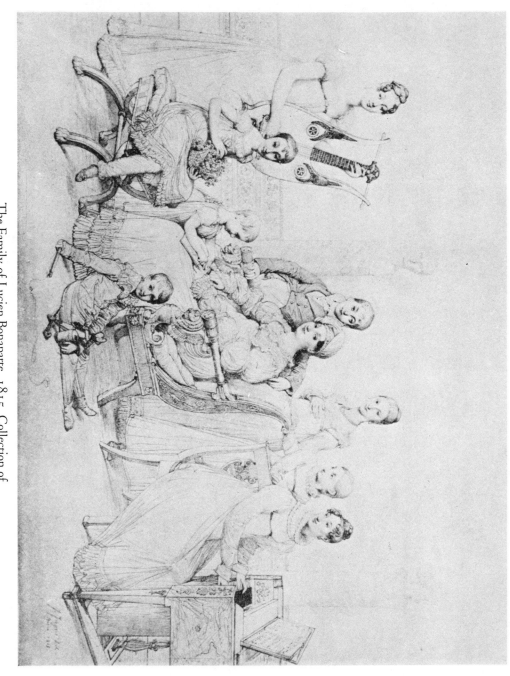

The Family of Lucien Bonaparte, 1815, Collection of
Mr. Grenville L. Winthrop, New York

THE SECOND RETURN TO PARIS, 1840-1849

Ingres agreed to do it, but political events rendered impossible the execution of the plans — that had already been made.

While still at Rome the artist had accepted a commission from the Duc de Luynes for two murals, to be painted on the walls of his château of Dampierre, so that with the prestige of such patronage, a reputation of forty years' standing, and the heightened awareness which people now had of his genius, Ingres could make any demands he pleased on prospective portrait sitters. He did not fail to exercise this power, and those who managed to overcome his reluctance about undertaking their likenesses soon had reason to know the measure of whim there was in his difficult temperament, and his capacity for prolonging the work. His insatiable demand for perfection had to wear away all the minutiae that stood between him and the absolute which was his goal.

From the time in David's studio when he had felt that the Greco-Roman formula of his teacher must give place to a more naturalistic ideal, work done directly from the living model was at once his deepest enjoyment (when before the full glory of the nude, above all) and his severest trial, when the idea of contenting a portrait sitter obsessed him. But whatever personal vanity, whatever ignorance of art he may have encountered among his patrons, his own demands were more exacting than any others.

One lady, Mme Reiset, has left us the fact that when he was doing her portrait in 1844, he would be seized with such despair over his failure to get the qualities he wanted in the work, that he would rush from the studio and several times, she heard him sobbing in a near-by room. Yet the picture gives an impression of serenity comparable to that of a Fra Angelico; indeed in its pure surface and its ethereal color, it has a not too distant suggestion of the art that the beatified brother of San Marco practiced in the calm of his monastery.

The Vicomtesse d'Haussonville was posing from 1842 to 1845 and a letter of hers says, "for the last nine days Ingres has been painting on one of the hands." With the detail of the flowers and their reflection in the mirror, the noble sense of space in the room and above

all, of course, the beautiful young sitter, one can guess how the artist labored. Fixing attention on that circumstance, the effort and time he spent on the portrait, one may by a stretch of the imagination, see cause for the word "disastrous" we heard him utter about the work. Yet when the lady showed the picture to Thiers, the statesman exclaimed, "Ingres must be in love with you to paint you like that."

And I shall not forget the gesture of Jacques Villon, seeing the picture for the first time when he visited America, and doing a bit of comedy in his pretense of being on the point of fainting. He had seen many another portrait by Ingres, but the ineffable perfection of this canvas did seize him anew, as always happens when one comes suddenly on a fine work by the master. Yet I think that, for my friend, as for almost every painter, there was also a sense both of the hopelessness of equaling such a thing — and a question whether finish like this is human or even desirable, whether he did not finally prefer the broad planes, the animated surfaces, and the general sense of freedom enjoyed by more recent times. The picture is strategically placed for study at the Frick Collection. Nearly related to the magnificent David, it connects also with the wonderful paintings by Terburg, Vermeer, Tintoretto and other masters of the past, and so gives one the feeling that their great art continues into our period.

And it is already our period, what we of today call the modern time, that we feel in the picture, nearly a hundred years old though it is. Mention of those classics of the earlier time makes us feel in the modern classic a reaction to character, an outlook on matter, that date from the time since the French Revolution, when David and his movement swung the world into its present orbit. The presence of the Cézanne in the gallery yields new light on the nineteenth century. We are almost surprised to recall that the last-named master — opening up the tremendous perspectives which have appeared since Impressionism — is of the same period as Ingres.

In 1867, when the great draftsman died, Cézanne was twenty-eight years of age. Naturally, his art was, at that date, far from re-

vealing the geometrical basis it was to build on more and more; it was equally far from the answering logic we see today in the man's color; but these things were implicit in the early works of Cézanne, among which are the decorations for his father's house that he signed Ingres "out of derision," as Elie Faure has said.

But the laugh he had over that little gibe is, if not turned against himself, at least, but little attuned to the mood of the present generation. We probably see the *Mont Ste. Victoire* at the Frick Collection more accurately than did the men of Cézanne's own day, whether they be the ones who thought him a bungler or those who took literally the word he used when he called himself a primitive. Doubtless there was a good measure of humility in his employment of the latter term, but the twentieth-century appreciator will say, "a primitive — only in the sense that this man is one," and will point to the Piero della Francesca in the same gallery.

Cézanne has had his period of dominance among the interests of artists. I doubt that he will ever recede in men's idea of what is great — more probably he will gain, as time goes on; but other men are advancing, and more than he, in the time since his great rise began, thirty or forty years ago. It is from actual observation of serious visitors to that Frick room which spans the art of four centuries, and from studying the trend of present-day painters, that I say that the man now receiving the closest attention is Ingres.

For the naïve visitor to the gallery, the beauty of Mme d'Haussonville the woman, may be what counts (I do not go so far as to consider the mentality of the Currier and Ives collector who delights in her old-fashioned dress or the hint of early Victorian gentility in her room). What the artist sees is that Ingres's feeling for his lovely model is sublimated into values accessible to all who can follow him in the language of form and color. He learned that language from the earlier classics, he passes it on to the present day, and (if prophecy is ever to be indulged in) he will transmit it to later times.

The day is gone when the dead hand of the academies can come

between the master and the eager world that needs him. Even more surely, his misunderstanding by Renoir's early contemporaries is a thing of the past, as far as concerns men of any similar importance. It is only twenty years, or thereabout, since the Metropolitan Museum in New York got its first Ingres, about half that time since the Frick Collection got its picture, and not five years since London has had that almost final masterpiece, the portrait of Mme Moitessier. The Louvre, which will forever be the place (as it should be) to study Ingres, still represents him by his early work, save in the case of a few things. There will be progress in appreciation when such pictures as the magical *Baronne de Rothschild* and the *Princesse de Broglie* come before the public.

What is doubtless most needed is general knowledge of *The Golden Age,* at the Château of Dampierre. Roger Fry calls it "the supreme effort" of Ingres, and, without agreeing on all of the great English critic's conclusions about the master, one may well decide that here — as in most of his fine essay — he is near to absolute rightness of judgment. It is therefore most regrettable that so few people can know the work in the original. If ever the enormous job of removing the mural to Paris is undertaken, the results will be sensational.

After Ingres declined to continue with it, the Duc de Luynes veiled the decoration under a curtain, and its companion piece — which had barely been started — was also hidden. Since then *The Golden Age* has been uncovered and can be seen by such people as get to the château, but for most of the world it is accessible only through photographs and through the small repetition which the artist made at the very end of his life. In this painting the work has been completed and various important changes have been made. Further, there are the drawings from which Ingres painted on the wall of Dampierre. There were originally over five hundred of them, but their number was reduced by about a hundred, which were lost in a fire. The remaining ones are at the Musée Ingres at Montauban. Henry Lapauze has published many of them in his work on the drawings at that museum;

only a hundred copies of it were issued most unhappily, for there is scarcely a more fascinating and instructive collection to be seen anywhere.

Unfinished as is the big mural at Dampierre, it is to that (or to photographs of it) that we must return oftenest. In his sixties, as was Ingres when he painted it, his powers were at their height; and though one must be cautious about preferring an earlier to a later work by a master of first rank, it seems certain that the version of 1843-1848 has great advantages over the version of 1862. The first of these is the size, the work having been conceived for execution on a large scale, and some of the figures apparently getting an importance when seen close by, in the small picture, that they do not have when merged by distance with the surrounding passages. This, however, may be an effect of the unfinished condition of the original work; its suggestiveness might have diminished if the artist had gone on with it.

As it is, qualities of grandeur and mystery are present that no other work by Ingres offers to a like extent. I said that the *Apotheosis of Homer* was an expression of his philosophy and, from the standpoint of the intellect, it is so. But the man, for all the clarity and logic of his art, is far more an intuitive, emotional being than one to deal with the analytical ideas to which tangible shape is given by the *Homer* picture. Its conception is, to a great extent, "literary," which is to say that the value of its personages is determined by factors independent of their role in the design. Raphael and Phidias are prominent because they did certain work, Shakespeare is inconspicuous (and, later on, absent) because he stands for something that Ingres cared for much less. The wonder is that the artist's sense of the picture succeeded in reaching the impressiveness he actually has obtained; in less gifted hands such material would have led to mere polemics, the kind of thing which gives us the political cartoon.

In *The Golden Age,* no such extraneous difficulties complicate the handling of the figures. They are far from meaningless—a libretto could be composed from notes left by Ingres as to the role and action

of the divine or human personages in the scene; but they bear within themselves all of their significance — youth, health, love, gaiety or thankfulness. And so the hymn to nature and life flows on harmoniously — without such organization and power as Poussin gave, if Mr. Fry is right — but with a suave play of nuances that does not exclude control of volume.

One might think of trees suddenly stirred by the wind: masses of sun and shadow alternate and change place with the swaying of supple trunks and branches; little islands of bright leaves suddenly emerge from transparent depths of darkness; a rightness as of things in nature gives us pleasure when a clear silhouette appears in one place — and when it ripples back or forth to another place.

The fidelity with which Ingres had studied the frescoes of Raphael, his devotion to the art of combining such figures as he had loved in the *Mass of Bolsena,* the *Saint Peter in Prison,* the four Sibyls at Sta. Maria della Pace, and especially the glories of the *Psyche* pictures in the Farnesina, all his best memories of Rome are fresh before his mind during the months of enchanted quiet he has at Dampierre during the years when he worked there.

But great as is his preoccupation with his art, the passion of the man for the beauty of the nude appears even more clearly at this time. We think of his exclamation to his students "The Greeks, the Greeks! Raphael himself grows pale beside them!" — and we feel sure he had in mind the impression given by Greek sculpture that the man or the woman portrayed is actually before us; and so the figures he draws at this time live with an immediacy that they have never had before.

In the period when he was working at *The Golden Age* he painted the *Mme d'Haussonville,* the *Mme de Rothschild* and, as if he were making explicit the question as to which deity presides over such pictures and the great mural he returns to on escaping from Paris, he takes up some studies of forty years earlier and paints the *Venus Anadyomene.* The well-known, well-loved figure at Chantilly tells us of the height his art had reached in 1848 — unless, as I think, figures in

The Golden Age — and not a few of them — surpass even the innocent young goddess as she stands out, clear and luminous, against the blue water and the blue sky.

The idyll of these years is cruelly destroyed. The Revolution of 1848 disturbed even the mind of Ingres, and the next year brought him the greatest grief of his long life, for Mme Ingres, the faithful Madeleine of the hard years in Rome, the admirable companion of his time of success, died after a brief period of suffering — an injury to her foot having resulted in gangrene.

Ingres was sixty-nine years of age and the blow fell upon him with such force that all thought of continuing with the work at Dampierre was intolerable. He had lived at the château with his good wife: now he wanted never to see the place again. His old friend Gatteaux, the medallist, arranged a dissolution of the contract he had made with the duke, and the work remained unfinished.

Delaborde, writing of Ingres's picture of the *Virgil Before Augustus* which is in Brussels (a later repetition of a group from the great work at Toulouse), says that it is like a thing from Pompeii. It seems more like a Roman relief: *The Golden Age* is the work that most suggests the beauty of painting that was known to antiquity. And as a mere fragment of Greek marble tells us of the wonder of the whole work, so the mural at Dampierre, which is in no sense a fragment, tells us of the classical genius of Ingres — what had led to it in his earlier effort, and what he was still to do.

CHAPTER VII

The Later Years, 1849-1867

THE LETTERS WHICH INGRES WROTE AFTER THE DEATH OF Madeleine are like the cry of a wounded animal. Thirty-six years of faithful and loving comradeship were ended, and the old man — never too sure of his health and always in need of the practical aid he could rely on from his good wife — felt himself terribly alone. The friends of his early days, especially the Marcotte and Gatteaux families, who were unwaveringly loyal at all times, were a resource to him, and he poured out his heart to them in the broken words that we shall read when we reach his correspondence.

But if he ever wished for his own death — which is doubtful — it was not to come for many years. And it is fortunate for us that this was so, for his work in the time he still had before him, reaches heights he had never attained before. There were to be great accessions to the marvels he had produced in the almost three score years and ten he had already lived, and they were needed to complete the cycle of his career.

At first it seemed completely broken. But the refusal to go on with the vast painting at Dampierre need not be viewed by us, from this distance, as betokening a sense, on the part of Ingres, that his work was ended. That one painting was so, indeed, but it is so wonderful in its present state that we may well imagine him as feeling a return to it inadvisable because of the quality he had achieved, quite as much as because the mental and physical effort dismayed him.

After a time of uncertainty, of attempts to find solace in new impressions, of journeys undertaken and abandoned, the best of consolations — his work came to his aid again. In his studio there was never a lack of canvases on which some additional finish might be expended;

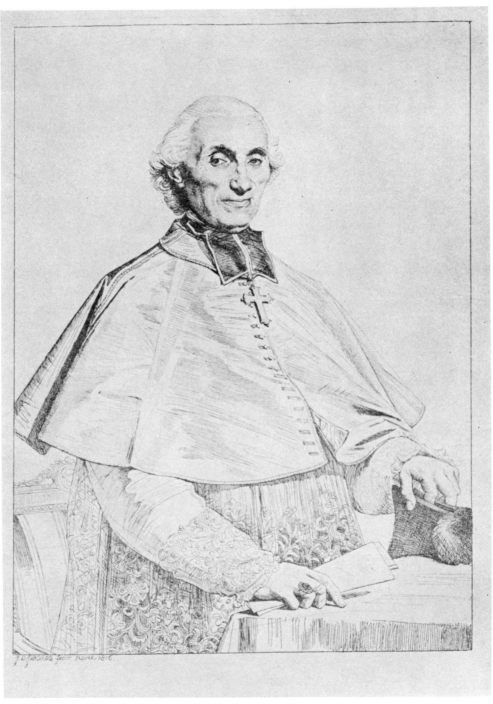

Monseigneur Cortois de Pressigny, 1816, etching

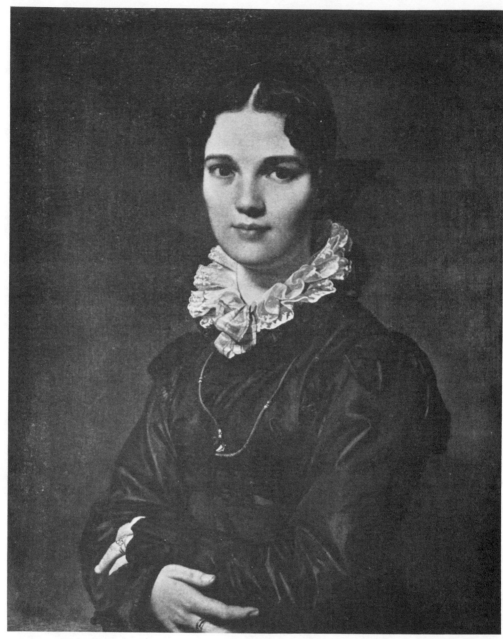

Mlle Gonin, 1821, Mary M. Emery Collection, Cincinnati Art Museum

and there was one portrait, begun five years before the death of Madeleine Ingres, that he could resume and, for another two years, work at with unremitting interest. Of all the people, of all the women, especially, who furnished inspiration for his painting, none has so great a place in the story of his art as Mme Moitessier. Beside this picture of her, which he signed in 1851, there is the one which he began soon after finishing the first, and which may well be the greatest single portrait of his life.

The goddess that Mme Moitessier was in person did not claim special consideration, such as might have seemed the due of her rank and beauty. On the contrary, she was all tolerance and generosity toward the old artist's changes of program and preference. Details of clothing or jewelry were added to the pictures or taken away, sittings were postponed, other work intervened, yet throughout the twelve years spent on her two portraits, Mme Moitessier seems to have remained at all times the same adorable being.

As with the *Mme de Senonnes* of so long ago, the beautiful lady reflected in her mirror seems to need no painter, save for the fixing of our vision in permanent shape. But the contrast between the picture of 1814 and the one of 1856 is the best possible proof that such an idea is illusion. To begin with, it is not *our* vision that is given us, but that of Ingres. And then the changes which have come about, as between the two portraits, are not simply the result of a sense of life that has matured in these forty-two years, a development from the gently sad mood of the period of hardship to the exultant note of the late time, when success — before the world and before his work, even more — has crowned the long labor of the artist.

He would scarcely merit that title if his labor had not been directed, as it was, to achieving a finer conception of painting. The long periods he devoted to one picture after another, his tenacious refusal to let them go from his studio until they fully satisfied him, the very excess of elaboration which took away the freshness of certain works and gave them an aspect of dullness, all this goes into his art, and it is his art

III

which has been enriched with the passing of the years—far more than his sense of life or, more specifically, his love for the beauty of his models.

From youth to old age he "copies" them as humbly as he said in that conversation we heard him hold with Granger, when he was so exasperated by the charge of idealizing the model for his *Oedipus*. But a living man or woman can never be copied. To talk of doing so in marble or on canvas is simply to use a figure of speech. Ingres employed it to express the humility which he felt before nature, as he told his old schoolmate. And that humility, that closing of the doors of his mind on preconceived notions of the *beau idéal* which he held in such contempt, opened other doors—those which set free deeper sensations than those derived from Raphael and the Greeks. The beautiful Italian lady of 1814 and the beautiful French lady of 1856 are copied as to their physical appearance, and we may feel sure that their likenesses are as exact as the representation of the lace ruff of Mme de Senonnes or the jewels of Mme Moitessier.

But already old Dürer wrote under his picture of *Melanchthon* that he could give the image of Philip's face but not of his soul. And if we believe that his modesty made him understate the value of that deep piece of psychological insight, we may affirm also that the life of the two lovely sitters appears in their face and gesture. What then is it that Ingres's continuing study of art has added in the time between the two works?

I think it is the sense of a life outside that of the persons depicted: a new vitality in the means of the artist. Nothing could be more enchanting than the oval of Mme de Senonnes's face, but in 1814 the painter's art ends when he has attained a marvelous contour and some fine modeling. In the later portrait (as we see particularly from the large detail of the head) the single beauty of the oval is re-enforced by the echo of line and plane that Ingres obtains by relating the several contours of forehead, eyes, cheeks, lips, and chin. The difference is that which we get as between the pure and gracious theme that the

orchestra announces with simplicity at the beginning of a symphony, and the rich elaboration of the same melody as the piece develops, while still remaining within the frame set by the composer's mood and genius. He is himself from first to last; his *motif* has remained unchanged—save for the added sonorities and the intensified design that have come about through a deepening comprehension of what he can do with his material.

To those who have felt the beauty of Mme de Senonnes, with the mystery of her pensive face, the warm, stirring curve of her breast as it is thrown into relief by her red dress, the long grace of her body, and the flower-like perfection of her hands, it may seem as if nothing could go beyond this picture. And I cannot disagree with those who prefer the early masterpiece from the standpoint of the model's loveliness. But not to see that Ingres has added new qualities of his own by the time he reaches the glorious work in the National Gallery, is to fail in appreciation of the study, the love and the intelligence that have, for forty-two years, been pouring into the art of one of the most persistent contemplators of nature and of the masters.

In our gratitude for what his single-minded zeal has given us, we are rejoiced to learn that, while he was engaged on the two portraits of Mme Moitessier, a new happiness came into the life of the artist. We read in a letter of 1852, written to a lady he was painting, that at the house of Mme Marcotte, his old friend, he had spoken to a charming Delphine who had stirred "old fires" in him, and who makes him see that what he had loved in early days can still reappear without change—"adorned with freshness and youth." He adds, "I saw clearly in her calm indifference that, happily, she is as yet without any intimation of my thought."

Delphine Ramel was a relative of M. Marcotte's and, through her mother (whose maiden name was Bochet), a relative also of that M. Bochet whose admirable portrait, now in the Louvre, Ingres had painted in 1811. She was forty-three years of age, and the artist at first protested to his friends that, at seventy-two, he could not pre-

tend to her hand; he cited his lack of any great fortune as an added obstacle to a union with a lady of her connections, but all difficulties were soon disposed of. His friends knew his need of companionship, and he was to find it with the wife they obtained for him. Her musical gifts and the steady, kindly nature we see in the magnificent portrait he painted of her were the light of his old age, and doubtless meant for posterity an added measure of work, as a result of the care she gave him.

The year before their marriage (which took place in that same 1852 when he wrote of her) he began his portrait of the Princesse de Broglie, which he signed two years later. In its calm perfection, it shows how little of the exceptional there was in the other superb portraits of this period. And once more we are surprised when we hear of the exhausting effort they cost him.

Other pictures of these years might seem, far more, the cause of that dissatisfaction with his work which he always expressed with regard to portrait painting. I have already touched on the reasons why he found it so troublesome, and shall come, on a later page, to the explanation of its great role in his art.

Mr. Fry sees him as a man capable of glorious things when facing a restricted problem, but failing when he had to organize on an extensive scale. The writer makes reserves as to this analysis, *The Vow of Louis XIII* having succeeded in considerable measure, as he sees it; and *The Golden Age,* with its multiplication of superb single figures or small groups being for him almost beyond the reproach he makes. But just before the end of his essay he says, "Within the rather narrow limits of his own territory, Ingres must be placed among the very greatest masters. Within these limits he is passionate, self-abandoned, alert and sensitive — outside, he becomes pedantic, self-conscious, theoretical and often ridiculous, the little, strutting, hectoring schoolmaster that he often was in real life." The painter-critic's final sentence affirms that we "still turn to Ingres with a passionate admiration of what he did more supremely than anyone else," the statement be-

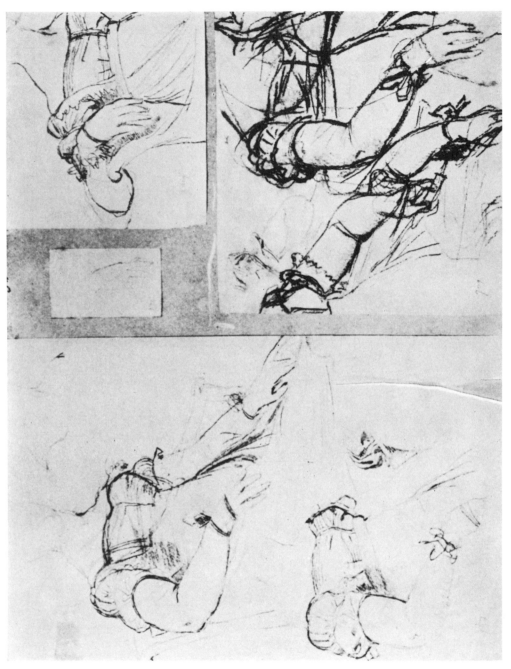

Mme Le Blanc, Studies of Hands and Arms, 1823, Musée Ingres, Montauban

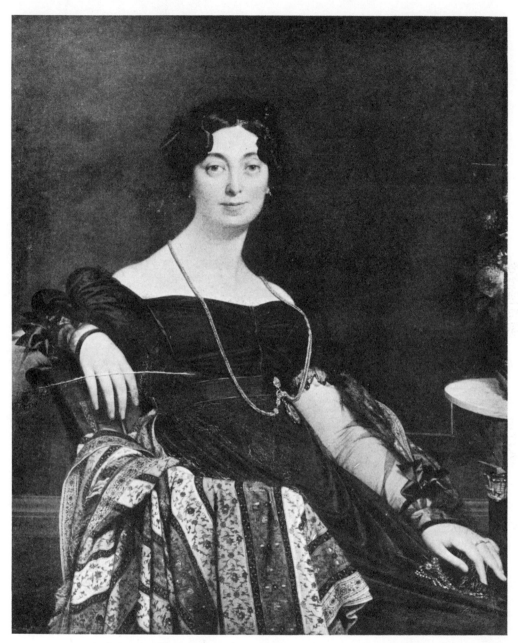

Mme Le Blanc, 1823, Metropolitan Museum, New York

ing made as a rebuke to Delacroix for a criticism he wrote down as to the Classicist. It is a criticism that Mr. Fry himself is almost willing to forgive, however, since it was provoked by so poor a work as the *Apotheosis of Napoleon* at the Hôtel de Ville.

Commissioned in 1853 and carried through within the year, the ceiling decoration — like the *Apotheosis of Homer* for a ceiling in the Louvre — might seem to have had a special chance of success, because it demanded prompt execution and so excluded the repaintings which have wearied some of Ingres's pictures. But such reasoning applies in the case of small works, or the endless marvel of the drawings, with their response to the sensations of the moment. It does not help in the matter of the two big compositions. Here, as in other works that we shall see, the artist plays safe — as he evidently imagines — build-ing up a "machine" (the French word for such fabrications) out of the approved material that he has drawn from his documents of ancient art. M. André Joubin calls the *Apotheosis of Napoleon* the enlarge-ment of an antique cameo, and roundly defends his hero, Delacroix, for the judgment which Roger Fry objects to; it is one which the great painter notes in his *Journal,* in the entry of May 10, 1854.

Having to attend a meeting of the municipal council, he has taken a look at the decorations by Ingres, and writes:

The proportions of the ceiling gave one a real shock: he did not calculate the loss that the perspective of the ceiling brings about in the figures. The emptiness of the whole lower part of the picture is unbearable, that big solid blue in which the horses — quite nude also — are swimming, with that nude emperor and the chariot going through the air, produce the most discordant effect, for the mind as well as for the eye. The figures in the panel are the weak-est that he has done: awkwardness predominates over all the merits of the man. Pretension and awkwardness, with a certain suavity in details that have charm, in spite of or because of their affectation — that, I think, is what will remain of this for our descendants.

Mr. Fry used a translation of the *Journal* in which the words are mistakenly rendered as — "what will remain of Ingres"— ? far more

sweeping statement than is implied by the criticism of the unsuccess-
ful work that the painter was considering. This—and Mr. Fry's gen-
eral lack of enthusiasm for the Romanticist—may explain his com-
ment: "Delacroix was wrong." Two other points deserve to be noted
—that at the outset of the passage the entry says, "Insipid morning
and bad state of mind," and then that, immediately after the words
on Ingres, Delacroix says, "I went to look at my Salon [his own decor-
ation at the Hôtel de Ville]. I did not get back a single one of my im-
pressions, everything in it seemed to me garish."

Also, in forming an opinion on the *Napoleon* ceiling, we must re-
member that our only document is the painted study for it in the
Louvre, and the drawings, one of which is here reproduced. The big
work (like Delacroix's decorations at the city hall) perished in the fire
of 1871, and Ingres's mastery of a smaller surface may well give to
the existing version of the picture certain advantages over the enlarge-
ment of it which Delacroix saw. The present drawing again, is finer
than the painted study which has survived. Even so, its graceful de-
sign and felicity of detail hardly compensate for the stilted rhetoric
with which the painter hoped to meet the problem of giving the con-
queror his place in the heavens. We are not surprised to learn that
the *Apotheosis* was thoroughly approved by the new Napoleon, then
just affirming his succession to the title of his great relative.

We saw, during the early years of Ingres, what type of opposition
he drew upon himself through the "revolutionary" works that so dis-
turbed the old school. It is a totally different hostility that is aroused
by the pictures of which the *Apotheosis of Napoleon* is a characteristic
example. They are not the work of the creator that we have seen in
our artist, again and again—and that he still remains, as certain later
pictures will testify in eloquent fashion. But this book would deserve
the contempt which properly goes out to empty panegyrics if it did
not face the issue raised by the inferior works which appear, especially,
in Ingres's period of complete official acceptance.

I have passed over in silence a quantity of things he did in his early

years, pictures in which the illustration of some historic incident was carried out in laborious detail, and where the lack of any deep aesthetic conviction was no bar to ready sales, which the artist needed in the time of his poverty. But the *Napoleon* ceiling offers a different problem, as does the *Joan of Arc* of the following year. Apologists for the master may remind us that the latter picture is, in part, the work of pupils. But it is Ingres who has the credit for the fine space relationships, for the subtle way that the background figures stay in their tone, and for the large masses that make the design. He must therefore take the blame for the characterless head of the Maid, for the uniformly cold and hard quality of the textures, and for the way that the beholder is made to feel the whole picture as an agglomeration of still life objects in which the heads have no more importance than the armor. Each detail of the altar is worked out with a miniaturist's patience, that ignores all subordination of the part to the whole, and so destroys that sense of reality which comes with the genuine observation of nature. The illustrator, the image-maker that Ingres is here, has forgotten every trace of the delight he feels before the sights of the world, a feeling which he has shared with us a thousand times, in his drawings, in his nudes, his portraits, and certain of his compositions.

One feels the difference in going over a collection of the drawings themselves, or of reproductions from them. Here is one where the line is fresh and spontaneous, like the movement of the nude girl as she came into the room. (It is recorded that the painter would call his wife into the studio so that she might share his pleasure in some young figure that had made him see again the marbles of Greece). Here is a portrait with the eyes and mouth seized at the same moment, as some thought — grave or humorous — caused an instant of light to play over the features and illumine the whole mind behind them. Another drawing shows the process of applying drapery to the lovely body that the artist regrets to conceal — and that is still clearly felt under the folds of the tunic. Still another departs from that voluptuous surrender to

117

life pure and simple, and tells us more of the qualities of the drafts-man's art in itself, its way of making line respond to line, light emerge from darkness, and color, even, have its share in the magic of this black-and-white — for all we have before us is a series of pencil marks on a sheet of paper!

But then comes a drawing that has none of the characteristics we have been noting. It is an outline wriggling along without pauses and breaks and emphases such as those by which a great actor gives the effect of the words he speaks. This drawing is like the monotonous singsong of the tyro who does not understand his role. The reason, as we quickly come to recognize, is that the work before us is merely a tracing from another work, a thing that artists make in order not to lose the felicities of a previous drawing when they are preparing to go on; afterward they can impart life to the dead copy, as they bring an enriched inspiration to their task and make ready for the final beauty of the painting. (Only when it is at its best does it equal the vitality of the studies, though its completeness offers compensation for the loss which usually occurs).

When we come to the picture of *Christ Among the Doctors* we find Ingres at his poorest level. Replying to criticism of it by such a devoted student of the master as Léopold Mabilleau, even Henry La-pauze, in his text on the collection of the Musée Ingres, falters as to the eulogy that he is almost always ready to pour forth. He says he cannot see why M. Mabilleau reproaches the composition with its sym-metry, when Raphael, in the *School of Athens* and in the *Disputa,* applied symmetrical balance to the two sides of each work. But such inability to see the difference between the inventive, living design of Raphael and the poverty, the mechanical lifelessness of the painting at Montauban, is to abjure all critical judgment and become the parti-san for whom every act of his hero's lifetime must be made to appear inspired and noble.

The dullness of mind that so wearies us as we read the pious ecstasies of Lapauze is illuminated for at least a moment with a realiza-

tion that the *Christ Among the Doctors* is a dead work, for, in speaking of the abandonment of *The Golden Age,* he contrasts its fate with the *Christ* picture and says that "commissioned in 1842, it was not finished until twenty years later, but, at least, it was finished." His words "at least" are eloquent as to the result: the picture was not given up as a failure — but lovers of Ingres may well wish it had been. Even the studies for it, the things in which Ingres is usually so wonderful, tell that what distinguishes this work from the nauseating "religious" art of modern times is a matter of the painter's tradition, intelligence and will-power — not the rounded and healthy art that the name of Ingres should evoke.

As we see most of the studies of nude women who, with draperies and patriarchal beards added, are to represent the doctors in the temple, we feel that even this recourse of the old beauty lover's cannot save the situation. In a book whose illustrations cover so small a part of Ingres's immense production as does the present work, I do not think that space should be given to a reproduction of the *Joan of Arc* or the *Christ Among the Doctors*. The defects of Ingres appear, in attenuated form, in many other pictures by him; the reader need only isolate their weak or bad phases and imagine things in which such qualities are the predominant — not to say whole aspect of the work. Rare indeed is the man who can be judged from every performance of his career. An artist has the right to live in our thought through the work in which he has said his say with fullness and success. And with our loss of the unity which still characterized even the eighteenth century, the modern period, with the cross-purposes, the doubt and struggle which are so much a mark of the time, particularly demands such an approach as I have been making to the work of Ingres. He must be thought of on the level he attains in his great pictures.

The year 1855 provided the master an opportunity to show his art to the public in its most favorable aspect. Still faithful to his vow never again to exhibit at the Salon, he undertook the most vigorous measures to insure a complete representation of his art at its best for

the *Exposition Universelle* of 1855, the first world's fair of France. From a portrait of his father, painted in 1804, to his latest work at the time of the Exposition, the career of half a century was covered, and his exhibit included masterpieces like the *Bather of Valpinçon,* the *Recumbent Odalisque,* the *Vow of Louis XIII* from the cathedral of Montauban, and the *Martyrdom of St. Symphorien* from the cathedral of Autun.

The reaction of the critics was, in general, so enthusiastic that the few dissenting voices were not noticed. But the susceptibilities of Ingres were injured from another quarter. It had been understood that a Grand Medal of Honor should be awarded to only one artist, himself. A change of plan caused the awarding of ten such recompenses, and Ingres found himself on the list with Delacroix — Horace Vernet standing at the head of the roll, since he had received the largest number of votes from the jury. Ingres nearly refused to attend the distribution of prizes, but the emperor's cousin, Prince Napoleon, smoothed the matter over by obtaining for the painter a new rank in the Legion of Honor. A series of newspaper articles envenomed the situation, and the old man continued to feel rancorous about his treatment.

What made his thoughts particularly bitter was the growing disposition of the Academy to accept Delacroix. Calm in the face of successive defeats for election to the body, the Romantic painter considered it more worthy to continue his fight for recognition than "to sulk in his tent," as he put it. Early in 1857, what Ingres called the "fatal election" actually occurred, and he voiced his forebodings with the words, "Now the wolf is loose in the sheepfold." The sentence tells quite as clearly what he thought of his fellow academicians as it characterizes the "apostle of ugliness"— his description of Delacroix. A few months earlier, he had referred to the situation when he wrote to his pupil, Albert Magimel: "Today I want to break with my century — to such an extent do I find it ignorant, stupid and brutal, for it now burns its incense only before the idols of Baal, and with complete effrontery, at that."

Possibly some people will find absurdity in the use of the Biblical allusion to express a judgment on art (Ingres, as we have noted, had nothing but respect for Delacroix as a man); and such incidents as that of the medals at the World's Fair of 1855 may have been Roger Fry's reason for applying to Ingres words like "strutting, hectoring and ridiculous." But when a man well along in the seventies sees the world turning to the painter who, to his mind, will corrupt and perhaps ruin the art to which he has devoted all his strength, all his life, he has a right to take the thing seriously, even tragically, and to say that he wants to break with the time in which he lives.

For our purposes, however, the interesting point is that the work of the artist is far removed from the world which horrifies him. Indeed, I see it as a general rule that outer circumstances, even such as strongly affect his profession, have but little influence on the essential thing about a painter or a sculptor — which is to say, his production. Testimony on this score comes from the fact that the year when Ingres wrote so vehemently to Magimel is the very one that sees him sign the second portrait of Mme Moitessier, which stands a chance of being his masterpiece; it is the year which sees him finish *La Source,* an extraordinary work — the one that has probably had more admirers than any other he ever did; from this same year, 1856, date the truly marvelous portrait of Mme Delphine Ingres,[1] and *The Birth of the Muses,* a work that is pure joy; and finally, it is exactly at this time that he resumes the *Homer Deified* which he had not touched since 1840, and through which he was to continue, till

[1] *I am here accepting the date as given in the book by Lapauze, since it is so much more recent than the one by Delaborde, whom the later historian is always happy to show up as erroneous, when he can. I assume that he noted the date given by Delaborde, 1859, and that there is some record of the picture's having been done in 1856. It may have been retouched by Ingres, three years later and then dated, which would explain the fact that Lapauze sticks to the earlier dating when he republishes the picture ten years after the appearance of the catalogue of the Ingres exhibition of 1911 which states that after the master's signature, he gives his age as "LXXIX," which would place the picture in 1859. I have not seen it since 1911.*

less than two years before his death, with the statement of his decisions on art.

It may be held that the outburst of triumphantly successful activity which takes place in 1856 is a result of that "break with his century" of which he writes in the same year. I do not think so. What carried him on to the splendid things of this time was the effort begun in 1796 (when he entered David's studio), and the sixty years of passionate work that followed so steadily. Ingres the man could feel bitterness on seeing his rival placed at the level he considered as his alone, but Ingres the artist went on with his painting as he had in the days of his poverty, or as he had when the greatest of Revolutions was shaking the world, when the greatest of conquerors was sweeping over Europe, when that emperor — his patron — was overthrown and exiled, and when one government after another succeeded him. After all, who were the people with whom Ingres was breaking? They were the crowd — whose misunderstanding he had been made to feel from his earliest years as an artist. Had not his beloved Mozart taught him that one works for oneself and three friends? That audience was constant — and it approved him; "the century — ignorant, stupid and brutal," might hurt his feelings, but it could not touch his art.

That is what he meant by his angry outburst, and he was right. But there is a sense in which no man ever escapes from his time, for it contains not only the crowd that Ingres had in mind, but also the "three friends" — and himself. His painting is not that of the period he prefers — the century of Raphael; it is of the nineteenth century. And we feel that particularly when we stand before *La Source*. The grace of the famous figure and the ineffable perfection of its modeling are things of an intensity which tells us that a few men are concentrating in their art the talent which, in a time of more evenly distributed sensibility, had gone out to an immensely larger number. In this way it is modern art that we have here, and a certain literalness in the painting of the urn, the water and the plants is of the period which so strongly renewed the study of natural appearances.

Boyer d'Agen says that the picture dates back to a sketch of the year 1807 but, with the very close similarity of the figure here and that of the *Venus Anadyomene,* it is often difficult to tell toward which of the two canvases a given study is pointing. *La Source* was, according to the statement of Amaury-Duval, begun in Florence during Ingres's early stay there (1820-1824). The pupil saw it in its original state on his first visit to his master's studio, and retained until his old age all the enthusiasm he felt for the spontaneity, the naturalness, which were its characteristics at the time. It appears to have remained untouched until 1856. Here is how it impressed Amaury-Duval in 1825:

> In its execution there was such simplicity that one might have supposed it to have been done all at once, in a single sitting.
> And that is what turned into *La Source,* where he changed the pose of the arms in giving her the urn to hold, in making the extremities heavier, perhaps as a result of his desire to get rid of an excessive quality of realism. The torso alone has remained intact. But how the picture has lost! and how happy one would be if one could find again, under the retouching done in his old age, the marvel that I admired in the early days!

Significantly enough, the detail that Renoir spoke principally of admiring in his youth (when *La Source* was already in its final state) was, precisely, the torso, where the original inspiration of the master appears even to this day, and has given many an observer his greatest pleasure in the whole work. Amaury-Duval says that in 1825, the bare, yellowish canvas on which the picture is painted still formed the background, and it is doubtful whether the accessories which Ingres later introduced are an advantage. Roger Fry, who admired *La Source* very specially, said that one may not be too difficult about relating the figure to its surroundings.

Beautiful as the work unquestionably is, the reserves or even regrets we have just heard from two genuine Ingristes permit us to keep our unalloyed enthusiasm for other pictures. If I may voice my own preference, it would be for the nearly related masterpiece at Chantilly, and

my feeling is by no means lessened by the fact that it was rejected by
the collector who persuaded the artist to resume the work begun forty
years earlier, and who was to have acquired it. The reason he gave for
declining the *Venus Anadyomene* was that he had discovered a mis-
take in drawing in one of the knees.

Henry Lapauze observes that if the fact were not recorded by Dela-
borde, we should think we were hearing one of those silly legends that
gather around famous pictures. But others among Ingres's most glor-
ious figures have been criticized for their drawing, like the *Recumbent
Odalisque,* with her "three vertebrae too many." I doubt whether
anyone but the original (the very original) discoverers of these lapses
has even seen them; which is a way of saying that they do not exist. I
have never heard *La Source* reproached with such faults, and the fact
that it is looked on as such very pure gospel by the professional votaries
of the master arouses suspicion, which is far from being allayed by
the terms in which they express their ideas.

Like other admirers of Ingres, I am grateful to Delaborde for his
conscientious labor in setting down the facts of the master's career and,
above all, for assembling the quotations which give us our most
precious insight into the mind of Ingres — save that which is fur-
nished by his painting. But the ideas of Delaborde's day are no longer
our own and, even if the writer does not fall into the weak renuncia-
tion of judgment which distinguishes the votaries I just mentioned, a
present-day student is under no obligation to follow him when he
writes of *La Source* in the following terms:

"She is neither a woman, nor a mythological heroine like those
nymphs who have a name and a history: she is, so to speak, a formula,
a general personification of youth, of naïve grace, of virginity in the
soul and the senses." He quotes with approval a word from Paul de
Saint-Victor, who calls *La Source* "a plant-like soul," and then re-
sumes, on his own account, with the words: "under that white epi-
dermis, it is not blood that circulates."

And at that point, I feel my own blood begin to rise. Such

doubts as I felt over the preceding phrases are resolved in a way that cancels out their charm, and they do have that quality, as they render something of the gentle fascination that every one must feel before *La Source*. But with it, for a great many, goes a pallid feeling which Delaborde confirms with words like — "neither a woman nor a mythological heroine . . . but a formula . . . " under whose skin no blood circulates. Does the Venus of Milo, on the one hand, or a Gothic virgin, on the other, lead us to ask whether they have blood in their veins? Doubtless not, but one would as promptly deny that they are in any sense abstractions, mere "general personifications" of ideas, as Delaborde says, following the term by naming the qualities of youth and grace — which are indeed so attractive.

La Source does bring them to mind, and delightfully; but the woodland divinity hesitates between the naturalness of the Italian girl that Amaury-Duval saw in the early study and the "formula" that Delaborde calls her, *"en quelque sorte,"* to quote the words which express his own hesitation about a term which he thought might belittle the work. Comparing its effect with any of the great portraits by Ingres, one feels again that he is of his time — one in which the generalizing conception that gave us the gods of Greece, or the heavenly personages of the Byzantine, Romanesque and Gothic times, has given way before the particularizing genius of the nineteenth century. It is not necessarily placing Delacroix on a higher plane than his rival to say that the Romanticist's work at the Senate, the Chamber of Deputies and Saint Sulpice carries more conviction as to the life of the mythological and religious figures there than the parallel creations by Ingres. Delacroix was even less inclined toward portrait painting than was the Classicist; he has no comparable list of successes in the art to show — though on occasion he did do beautiful things in it. In his *Journal,* he speaks of the sketches he made in Morocco as resulting from a preoccupation with mere truthfulness, and he says that it was afterward that he brought into the pictures he painted from them the superior qualities of his art.

In *La Source* Ingres took a study from nature in which, as Amaury-Duval states, the nude girl was so painted that "the most intimate details were not omitted," and then, desiring "to get rid of an excessive quality of realism," he produced the picture in which the allusion to ancient mythology disarms criticism by the evil-minded, a matter that various writers on the work hasten to push out of consideration.

Even the artist whom I last quoted, as I have so often — his *Atelier d'Ingres* being unique in its revelation of the master — even Amaury-Duval feels constrained to relate an incident designed to prove how moral his teacher was in his thought about the nude. Having told repeatedly of the fascinating nature of that old book, I feel that I am far from demolishing the impression I have hoped to give of it if I translate the following:

A charming young girl who used to pose for M. Ingres said to me one day, "If you knew what cries of admiration he utters when I work for him ... they make me quite ashamed ... And when I am leaving, he goes to the door with me and says 'Good-bye, my lovely child,' and he kisses my hand ... "

Is not this the purified cult of the beautiful?

Elie Faure inserts an asterisk, just at this point in his edition of the book, and when one's eye goes to the foot of the page, one finds: "*?(Note by the Editor)."

I agree, and in proof of my idea and that of "the Editor," I call attention to a study like that for the *Venus Anadyomene* here reproduced (which may also have served for *La Source*). It is typical of thousands of others in showing Ingres as a man expressing his natural love for the beauty of women — a thing that needs no "purification." I am sure that the word would have seemed prurient and repulsive to him — who was furious when the authorities of the cathedral of Montauban put fig leaves on the infant Christ and the little angels of the *Vow of Louis XIII*. He spared no effort till he got the insulting things removed from the work, which was for a sacred place, and not for the city hall to which the shocked Montalbanais had relegated the mas-

terpiece. Ingres himself wanted it brought back there after the indignity it had received at the cathedral; but then the church authorities refused to give it up.

Here is another example of the artist's contempt for the prudery of the time (which has not yet disappeared from the world, though I think that some of it has).

The sculptor Duret, [as Jules Laurens tells] just having finished his charming *Neapolitan Dancer,* the figure of a young man completely nude — save for a very short pair of drawers, begged Ingres to come and see the work. The painter first spoke in praise, and did so repeatedly, making reserves only as to certain accessory details. It was clear that he wanted to consider only the question of the highest art, whereas most people would be particularly interested in ideas connected with *the dance* and the *Neapolitan.* Duret, ill at ease, was already excusing himself on the ground of having to interest the public, of satisfying the requirements of the salesroom, etc.

"Under what conditions do you work?" broke forth Ingres, all of a sudden. "Do you live by your profession alone, or haven't you some other resources?"

Duret replied that he had always had a good family fortune, and that he was giving himself to the thing he wanted to do, independent of material worries, for he had an income of about twelve thousand francs a year.

"Monsieur," exclaimed the master severely, as he was leaving the studio, "when one works at sculpture and has twelve thousand francs of income, one does not put drawers on one's statues!"

Ingres's most famous dictum, that "Drawing is the probity of art," has met with the criticism that it is sententious in tone, and that it leads off to moral considerations none too secure in their relation to art. But even the severest critic of the painter must admit that the purity of drawing in the work of Ingres is no greater than the frankness of the man in the conducting of his life. He loves, he hates — and he makes no secret of one sentiment or the other. He trounces Duret for making concessions to ignoble people, and he adores the heroes of art for holding to their ideals.

In the *Homer Deified* that he resumes in 1856 he goes on with the

judgments he began to pass and the homage he began to offer, thirty years before, in the grand work in the Louvre (it *is* a grand work, whatever reserves one may feel about placing it with the masterpieces of the painter). When, at the age of eighty-five he is finally content to let stand the large drawing, his second version of the *Homer,* he has not merely added to the number of its personages and to the fullness of his credo: the intervening years have given an amplitude to the design that is not in the work of 1827, and the figures — of a purer classicism than those of the early time, when he affirmed the direction of his whole art — are clearer and more harmonious in their relationship than those of forty years before. Even so, there are superb pieces of local composing in the first version. What is important with an artist who had the extraordinary faculty of Ingres for resuming his pictures after many years, is to see that real development had gone on meantime. We shall be specially interested in this point when we come to consider the *Turkish Women at the Bath.*

The wonderful year of 1856 gives us one more work to see, and it is a most precious work. Prince Napoleon asked him to do it — a water color to serve as the decoration for the model of a Greek temple, commissioned by that cousin of the emperor's from the architect Hittorff. The subject of the painting was *The Birth of the Muses.* Nothing is more impressive, after we have seen Ingres go on for years with a picture, than to find him carrying out this exquisite, complicated and finished work, in a few weeks. The fact that he did so tells how the theme interested him, and what energy remained to the artist at the age of seventy-six. It is recorded that, two years later, indeed, he still worked six hours a day at his painting. His health, though it had frequently caused interruptions in his work, held out till the very end, and — best of all — his eyes, which sometimes gave him concern, took on new strength in his later years. Though Delacroix, dying at the age of sixty-five, had no such span of life as Ingres, we are here made to think that he also, for our happiness in the work of his final period, enjoyed a splendid accession of new vitality at the time.

THE LATER YEARS, 1849-1867

The Birth of the Muses was prepared for by a succession of drawings whose quality we may go so far as to call unexampled. They are far from the marvels of finish that we have seen in earlier years, particularly in portrait work. But at all times, as in the sketches made in 1834 for a picture never to be executed, the *Triumph of Mediocrity*, Ingres had been accustomed to plan his work through studies marked by extreme breadth; with the foundation they gave him in the logical relationship among the parts of his design, he could retain its clarity even when proceeding to embellish it with minute detail.

We see that well in *The Birth of the Muses*. One can imagine the figures as already of the full size they would have had if the model for the temple had been carried out. Yet when we consider the water color which the Louvre acquired in 1929, at the sale of the works by Ingres collected by Henry Lapauze, we are astonished at the small dimensions in which the work is actually executed. The mat surface and the clear, delicate color give one sensations like those one gets from the Greek paintings on marble or on those exquisite white vases which were a specialty of Athens in its greatest period. There is the largeness of those supreme productions, and the nice contrast of that largeness with tiny forms. The latter afford relief from the monumental passages, which receive grace and even an added support from the seemingly slight details.

Never had Ingres been so close to the best of his beloved classics, and never does his work explain more eloquently why the most "modern" of the later artists draw on him for inspiration. The lovely masterpiece confirms the position assigned to the painter by Alexander von Humboldt when he said in a letter to Ingres, four years previous to *The Birth of the Muses*, "It is your happy mission to bring modern art back to the sublime and eternal types of antiquity."

Since the honors which Germany tendered the old painter were in part a result of the admiration in which he was held by Cornelius and Overbeck, the leaders of a German school whose ideals lay in the past, it may be that in the lines we have just heard from the famous philoso-

pher, the word "modern" is used merely to designate a period, and not with the sense of new creation which is usually implies today. No one would for a moment contest the relationship with antiquity referred to by Humboldt, but the progress of our understanding, as regards the work of Ingres, causes us to see that he did not "bring modern art *back*," but forward, to principles as valid in our day as in that of the ancients.

The King of Prussia had testified to his esteem for Ingres as far back as 1842, and recognition came also from Russia, Italy and Belgium. In 1858 the painter signed the self-portrait which was to represent him in the gallery of such works in Florence, and it must have been with a special feeling that he saw his picture go to the Uffizi where, more than half a century before, he had deepened his knowledge of Raphael and of Titian. In 1865, he painted another portrait of himself for the gallery of Antwerp. A replica of this work is now in the possession of Mr. Grenville L. Winthrop, of New York. Like two other pictures in the same city, the self-portrait of 1804 forming the frontispiece of this book, and the version of the *Recumbent Odalisque* now in the Metropolitan Museum, Mr. Winthrop's canvas was designated in the artist's will as going to Mme Ingres after his death.

It is far less because of this fact than because of the quality of the painting that one must question the exactitude of the statement made about it by Lapauze. That writer, who was sometimes not above considerations of a special and personal nature, speaks of the present work and another of the same subject as repetitions by pupils working under the direction of Ingres. We shall presently find him saying the same about the later *Stratonice,* as to which I think I can show that it would have been impossible for the students to do the work. They may well have begun it and spared him a certain amount of physical effort in advancing it, but the finishing — as he tells us about other pictures — is his own. And with new beauty coming into the work at this late day, one is made to think of Titian, Hals, and other masters

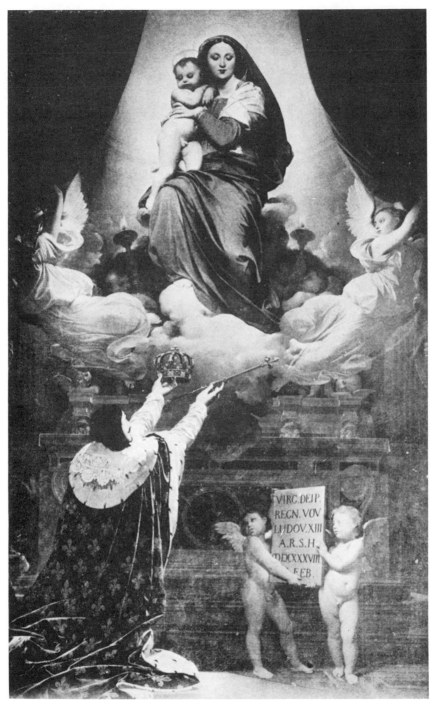

The Vow of Louis XIII, 1824, Cathedral of Montauban

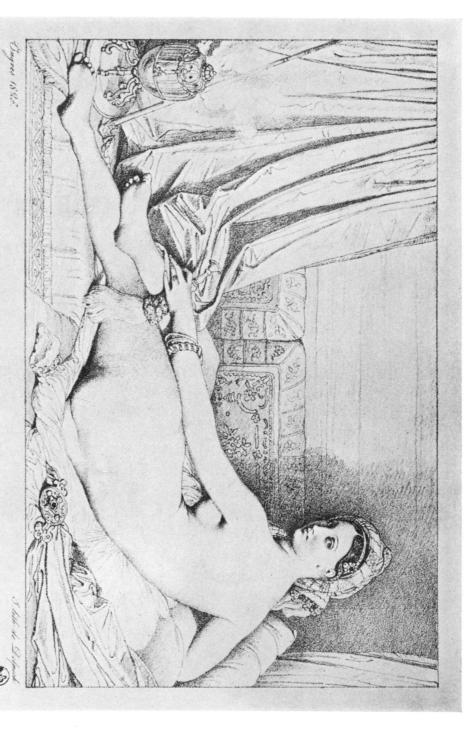

Recumbent Odalisque, 1825, Lithograph

who lived to a great age, and only then reached the highest level in their painting.

The last years of the veteran were to include honors from his own countrymen that doubtless meant more to him than the acclaim of foreign lands for, if he took no part in public affairs, aware of his lack of any understanding of such things, he was intensely patriotic, and never slow to claim for France any credit he considered her due. And so when Napoleon III, in 1862, caused Ingres to be made a member of the Senate, the extraordinary recognition must have touched the old man, as it did his friends — the well-tried ones like Gatteaux and Marcotte — and the later ones, especially those of his profession, which shared in the distinction conferred on its most famous living member. The students at the *Ecole des Beaux-Arts* asked to be allowed to sign the document containing the felicitations offered to Ingres, and we of today have almost the sense of participating ourselves, when we see among the signatures that of a man still so close to us as Renoir, then twenty-one years old.

Soon afterward, Montauban reaffirmed its pride in the master's origin by sending him a golden wreath of laurels, for which a subscription had been opened and paid by two thousand of the citizens.

But the rewards of the great career, in their supreme form, came neither from abroad nor even from the compatriots of the artist — the people whose appreciation Ingres had most desired. What rejoices one in reading of his extreme old age is to find him, still with books and works of art about him, still delighting in the music of Haydn, Gluck and Mozart as played by the faithful Delphine — and with his pencil and brushes still obedient to his unwearied hand.

In 1859 he thought he had finished that astonishing composition, the *Turkish Women at the Bath,* but since it was not to be taken from him at once, he went on with it for another three years, when he finally wrote the date on the canvas. We can not be certain as to how long he was engaged on it: Delaborde says it was in his mind for forty years, upon which statement Lapauze observes that the notebooks of

the painter have no entry to serve as foundation for this estimate. It is likely to be the true one, notwithstanding, for the *Turkish Women* is a kind of résumé of all Ingres's work on similar themes.

It is, however, a résumé that goes immensely beyond any preceding picture—unless we stand firm in our devotion to that masterpiece of more than fifty years earlier, the *Bather of Valpinçon*. It is quite easy to do so when one is in the presence of the adorable figure in the Louvre, or even of a reproduction of it. The cool quality in its perfection is no bar to the most ardent admiration, and yet I think that Ingres is still within the rule that the masters do their greatest work at the end of their lives. As between the *Bather of Valpinçon* and the *Mme Delphine Ingres* of 1856 (or 1859), I think no competent museum director would hesitate, could he select the one or the other work for his institution. Ingres himself gave a reason for choosing a picture of the later style when he told a young painter to work for mastery of the full round in rendering form: he said that in his youth he had liked an aspect of flatness in his work, but as time went on, he saw that the painter's problem is not solved until he has attained a strong sense of the third dimension.

The *Turkish Women at the Bath* gives us that technical triumph of European painting, the rendering of existence by solids and spaces without loss of the picture plane. The feat here is not merely one of science: it is one of art, for the composition is as wonderful when we look at its placing of the figures in depth as when we are beguiled by the happy way that one contour picks up that of a neighboring form and weaves a pattern on the flat surface.

In 1859, the picture was still a rectangle; in the three years after the master resumed work on it, the circular form was given to the composition, and changes within it (registered by old photographs of the work in its first state) accentuate the movement in depth, to reinforce the spherical character of the design. The figure at the extreme left of the first plane is a later addition which carries the eye more strongly into the depths of the composition; the niche with the vase, as also

the door at the back of the room, are afterthoughts too, evidently designed to break the flatness of the wall which stopped the movement too suddenly and prevented its taking a returning direction, the one indicated by the continuing line of the circle that bounds the picture in its definitive state.

When the artist had achieved that result, he must have looked at it as a milestone in his life for, beside the date, he set down his own age, eighty-two, using the Latin form *aetatis* as proper to so serious an occasion. (It occurs with other signatures of his later life, like those of the *Golden Age* and the *Self-Portrait* here reproduced, both of which he completed in the same year of 1862; but it is infrequent for him to state his age.)

The finishing of the *Turkish Women at the Bath*, after whatever period of gestation, has an importance aside from the technical and aesthetic matters that we have seen the artist working out so tenaciously, for it is his most emphatic statement of his feeling for women —unless that be in certain portraits. Visitors to the Louvre, especially when seeing the picture for the first time, are often moved by the sight of such a mass of nude females to emotions quite unconnected with art. "All that perfectly good woman-flesh—and not a man in sight!" laughed an English girl, whose usual thought about pictures was on the questions of painting, which art she practiced herself and with distinction.

That being the reaction of a person to whom the presence of nude models was a part of daily life, we are not descending into the sewers of pruriency if we give one more glance at the attitude toward the human body expressed by Ingres—and by other masters.

For example, we in America have the case of Thomas Eakins, who aroused bitter dissension in his own day. His picture of *The Swimming Hole* has a grand and frank literalness which makes us feel that his personages are naked, as boys and men often are, when going for a swim, and not just nude, like models in a studio. When the painter wanted to explain comparative anatomy to his students, he had a man

133

and a woman pose on the same platform without any of the draperies which, with his clean mind, he regarded as a concession to low ideas. That made trouble in the Philadelphia of his day, but he was so oblivious to convention that once when a model failed to arrive for her work, he told one of the girls in his class to take off her clothes and get up on the model stand. Such incidents are of less interest for the history of changing times in America than for a comprehension of the unchanging attitude of artists toward the nude.

To be sure, Ingres had to locate his scene in the Orient in order to give it probability, and he was documented on his facts by a book of travels in Turkey, in which the authoress, Lady Montague, gives a detailed description of such a sight as Ingres has painted. But the authenticity of the scene has no importance as regards this picture; neither need we see it, in the way some people have done, as a token of the interest of the French in Mohammedan lands (into which they had penetrated repeatedly in the earlier nineteenth century). *The Golden Age,* a thing of pure myth, leads us quite as well to our ideas — and the contemporaries of Ingres, just as much as later people, exclaimed over the nudities in that mural. Visitors to Dampierre aroused the indignation of the painter by trivial remarks about his figures there, and the *Turkish Women* had to be removed from the Palais Royal because of the "virtuous" scruples of Princess Clothilde — her husband, Prince Napoleon, having acquired the picture.

So many years having passed, and Ingres being securely ranked as an immortal, we smile comfortably about the prejudices of the Victorian era; but that is not a proof that we have made a genuine advance in understanding. As Lewis Mumford has pointed out, history often shows waves of tolerance, at times when the need for renewing the population — as after a war — causes a special interest in sex matters; and so there is a turn toward clothing of a scantiness or cut that shall give provocative glimpses of the body. But the old hatred of nudity again has its day, branding our natural love for the human figure as licentious.

Mme Marcotte de Sainte-Marie, 1826, Louvre

Study for Figure Representing *Smyrna* in the Setting of the *Apotheosis of Homer,* about 1826, Musée Ingres, Montauban

Ingres, like other artists, was devoid of any idea that would let him meet the puritanical or the lascivious on the ground of a common understanding. To delight in the beauty of women, to want them in his studio (and we are told that he accepted certain portrait commissions for that reason), or even to desire them in the flesh was one thing; to use them as models was quite a different thing. For those who understand painting, the emotion it arouses is quite a different one from our sensations before men and women.

The nude girls who posed for the figures of the old men in the *Christ Among the Doctors* were unquestionably a pleasure for the artist to see, and they gave him inspiration to put forth the best effort in his work. But when the picture is done, the classical draperies take on folds that tell nothing of the sex of his models: a metamorphosis has taken place, and the experience of the man before nature has been transformed into sensations quite different from the ones given him by those girls.

If it be objected that I am illustrating through a picture I do not consider successful, let me turn to a thing as superb as the portrait of the Duc d'Orléans. A little child, the story goes, pleased Ingres by exclaiming before the picture, "And is that only a painting, that handsome soldier?" The artist could accept the naïve remark as a compliment, but he would scarcely have enjoyed hearing an older person say that his work was "only a painting." That is just what makes it important. Handsome soldiers, even if they are also princes, come and go, but the life of that canvas — a thing deriving from the magnificent silhouette, the overwhelming but delicate balance, and the dramatic light (all things that were never in the world until Ingres put them there) are for all time.

One would need to apologize for offering all this ponderous theory in answer to the pretty simplicity of the childish critic, if there were not other childish critics — of mature years — who make an identical confusion between the subject of a picture and its art.

As regards the *Turkish Women,* there can be no question as to the

painter's masculine enjoyment in seeing his models (to doubt it, indeed, would be to doubt his sex). But one is failing completely in comprehension of the picture if one tries to explain it in terms of its voluptuous theme — if one does not see that the artist's feeling is sublimated into new values by delight in his work. It is this which, a thousand times, has made us say "Ingres" as we looked at a religious picture like the *St. Symphorien,* a portrait of some old lady like the Comtesse de Tournon, or one of those marvels of still-life rendering — the flowers in the mirror behind Mme d'Haussonville, for example.

The almost incredible fact that the man of eighty-two years advances in the quality of his painting in the *Turkish Women,* even as he attains a new fullness in his expression of feminine beauty, prepares us for the perfection of a number of small water colors that he did in his last years, when failing strength caused him to avoid the physical effort demanded by large canvases. What is probably the ultimate repetition of the *Bather of Valpinçon,* a water color in the possession of Mr. Grenville L. Winthrop, of New York, is one of those things that for sheer, breath-taking beauty, have occurred but rarely in the whole history of art.

The same collection contains the precious new rendering of *The Golden Age* which, like the *Turkish Women,* dates from 1862. (One needs a bit of latitude in dating Ingres's pictures: the year he inscribes on one may be — as we saw with the *Venus Anadyomene* — forty years after the picture was begun; again, another work may have been painted on for a long time after the date he gave it).

Whatever reserves we find in the writings of the master's contemporaries, who sometimes prefer the earlier to the later state of his pictures, the second *Golden Age* can only make us rejoice that he left us this wonderful document about the vast decoration at Dampierre, even though (as I said previously) the unfinished work is grander, in scale and mystery, than the small replica. The latter has its advantages in other respects, besides showing us beauties, in new combinations of figures, that Ingres had not yet imagined, fifteen years before.

The same applies, and even more forcibly, to the second design of the *Apotheosis,* called *Homer Deified,* which the painter completed in 1865. As with all the great artists, merely dwelling with his work (in one's mind, if not in the actual presence of originals or reproductions) causes the man's qualities to take on such power over the imagination that often the things which, at an earlier time, seemed to be of secondary merit, assume a quality that carries one to unconscious exaggeration, to what Ingres himself, in speaking of Raphael, styles his "exclusiveness." The lesser works contain something, at least, of the qualities of the greater ones — which transfer their impressiveness to the things where the man's qualities appear less clearly and strongly.

This takes place as between the later and the earlier versions of the *Homer,* and the picture of 1827 seems to assume more of largeness, of majesty even, as we grow with the years. Ingres himself was really the one who grew — and we rejoice to find him, when so near "the great departure," as he called it, incomparably ahead of the man he was when he first wrote his tribute to the followers of the Greek ideal, his own ideal since the age of nine, when his childish hand drew that antique head with the astounding firmness which makes one think of the precocity of Mozart.

It was therefore fitting that, seventy-seven years after making that drawing, the picture which occupied the very last of his life should still be one on a classical theme. The version of *Stratonice* of 1866 is of a less severe geometry than the rendering of 1840, the one at Chantilly. But the work of his extreme old age, now at the museum of Montpellier, has a mellowness for which the man of sixty was not yet ready. M. Lapauze states that the late painting is largely due to Raymond Balze, that faithful pupil whom we have seen, with his brother Paul, working beside the master on the earlier *Stratonice.*

Raymond Balze died only in 1909, at the age of ninety-one; and toward the end of his life, he wrote down for M. Lapauze certain memories of his association with Ingres. It may well be that the impression he gave induced the historian to overstate the pupil's share of

the work on the final picture. The composition is exactly the reverse of what it was in the painting of 1840, a thing that Balze would never have ventured to do by himself, still less would he have suppressed an important figure, which disappears entirely in the later canvas.

Such changes and others — all for the better, according to my idea — bespeak the continuing labor of Ingres himself; the quality of the painting agrees with that of other very late works, and the adorable figure of the young wife has a Greek felicity that goes back to the earliest studies which the master made for it. And so it was just sixty years that his thoughts went back, to the great days of 1806 which saw his first transports over coming into contact with ancient art on its own soil, when he arrived in Rome from David's studio. The teacher himself had planned to paint a *Stratonice* in 1774, and Méhul, one of Ingres's preferred composers, had written an opera on the theme — for which Hoffmann (of the *Tales*) furnished the words. The memories of more than one lifetime, therefore, were occupying the master during those last months he had to live — and work.

Only a few days before his death, on January 14, 1867, he made his final drawing — significantly enough a thing which must have brought back his delight in that pivotal journey he had made to Italy in his youth, for it is the tracing of a print after one of Giotto's frescoes, those "Gothic" works to which his love went out at the end, even as when at the early time, he had called Masaccio's chapel the antechamber of Paradise. A last evening of music at home, with Delphine and the friends who gathered to be with the illustrious man once more, then a cold that overcame the feeble reserves of strength which had endured so long, and Ingres was of the great company of the past.

PART II

THE IDEAS OF INGRES

His Recorded Words, his Notes, his Letters

PART II

THE IDEAS OF INGRES

His Recorded Words, his Notes, his Letters

ON READING A BOOK ABOUT AN ARTIST, WE ARE OFTEN LED
to the conclusion that the few words of his own quoted in it are the
best ones in the whole work; and what we know of the words of Ingres
is new evidence in favor of such an idea. The intensity with which art-
ists give their lives to their work makes them express themselves with
a positiveness and indeed an accuracy usually denied to writers who
treat art from outside observation. It is true that there are often contra-
dictions in an artist's speech, due to the changes in his mood; also
there may be need for interpretation of what he says, for words are
tricky things at times, and even men skilled in the use of them fre-
quently find that they have said something different from what was
intended.

But, whatever could be added to the foregoing reservations, it is a
fact that the pithiest, most authoritative and deepest things on art are
found in the speech of artists. What would we not give to know the
words of the great men of the past? We have some of them, but only
enough to realize our loss in having missed all but a tiny fraction of
what they said or even wrote.

With Ingres, as compared to most other artists, we are lucky in
this respect. A large number of his letters survive, as do notebooks in
which he set down ideas for pictures, alongside of records of the dispo-
sition of his previous work, and other matters he wanted to remember.
Frequently there are thoughts on the theory and practice of his art
and, after gleaning these wherever he could, the Vicomte Henri Dela-

borde supplemented them with the words which he and other students of Ingres's heard from the master's own lips, and wrote down. Such material forms an invaluable part of that writer's source book: *Ingres, sa vie, ses travaux, sa doctrine,* published in 1870.

I have followed the arrangement made by Delaborde as to the extracts he offers, though they are not always in chronological order. It would have been a somewhat more desirable one, since it might show evolution in the philosophy of Ingres. He is, however, the same man from the beginning to the end of his life — and to the most astonishing degree; so that the chronology of the notations (which is sometimes given) matters less than it would in the case of other men. Doubtless there are many instances, also, where Delaborde could not be sure in what year a given statement was to be situated, and today it would be mere guesswork to assign such dates.

Undated also, but almost surely from a very late time in the life of Ingres, are some papers found by Delaborde among those of the master, recommendations for public policy which he may have started to draw up at the request of some Minister of Education and Fine Arts. The editor reduces them in his text to such as he thought were making an approach to definitive shape, and I, in turn, shall limit myself to one of the fragments, that which deals with architecture.

Many of the quotations given by Delaborde under his general heading, *Notes and Thoughts of Ingres,* are to be found in their context, and in more complete form, in Boyer d'Agen's *Ingres d'après une Correspondance inédite,* published in 1909. It contains a biography of Ingres, explanatory notes on the letters (the largest collection of them now published), and much other material of great value, especially the account of the author's interview with Chenavard. Almost completely forgotten in a quiet corner of the *Vieux Paris,* lived the painter-philosopher, then nearly ninety years old, who had known Ingres and been a close friend of Delacroix's. With what emotion must the visitor have listened to the memories that the ancient man retained in such clarity! And they were no trifling souvenirs of the

Study for Figure Probably Representing *Argos,* in the Setting of the *Apotheosis of Homer,* about 1826, Musée Ingres, Montauban

Study for Phidias in the *Apotheosis of Homer*, 1827, Collection of Wildenstein & Co.

great artists with whom he had associated on equal terms — due to the important painting he himself had done. (It is best studied at the museum of Lyons.) Some of our most important glimpses of Delacroix come from the stories told to Boyer d'Agen by Chenavard, whose acquaintance with the Romanticist dated from a very early time in the life of that master. Among the memories is the glorious one which I shall relate again in Part III of this book, when we come to a historic meeting of the two great rivals.

The letters of Ingres which I give here are taken, save for one to M. Marcotte, from Boyer d'Agen's book. While they frequently contain most important ideas, it is rather a chore to go through all the letters in the volume, for a great majority of the material there is of a purely ephemeral character, the civilities exchanged by Ingres with his friends, the minor happenings of the time, his grievances against an unjust world, and then repetitions of his always-present admiration for the masters — about whom we learn no more from the twentieth (or fiftieth) statement than from the first.

Finally I give extracts from a document throwing light on the vital question of Ingres's attitude toward exhibitions. No reader will fail to be struck by the way that the conditions of the earlier nineteenth century continue right through till today, when they appear, indeed, in an intensified form. What also stands out from this passage is the frankness, originality, and power with which the mind of Ingres attacked the problem.

Our quotations from the master's words begin with those from Delaborde, whose titles for the divisions of the text I have retained.

I

Ingres Portrayed by Himself

WHEN ONE KNOWS ONE'S CRAFT WELL, WHEN ONE HAS learned well how to imitate nature, the chief consideration for a good painter is to *think out* the whole of his picture, to have it in his head as a whole, so to speak, so that he may then execute it with warmth and as if the entire thing were done at the same time. Then, I believe, everything seems to be felt together. Therein lies the characteristic quality of the great master, and there is the thing that one must acquire by dint of reflecting day and night on one's art, when once one has reached the point of producing. The enormous number of ancient works produced by a single man proves that there comes a moment when an artist of genius has a feeling as if he were being swept along by his own means, when, every day, he does things which he thought he could not do.

It seems to me that I am that man. I am making advances every day; never was work so easy for me, and yet my pictures are by no means scanted: the exact opposite is the truth. I am finishing more than I used to do, but much more rapidly. My nature is such that it is impossible for me ever to do my work in any other than the most conscientious fashion. To do it quickly in order to earn money, that is *quite impossible for me.* (1813)

As regards the arts, I am what I have always been. Age and reflection have, I hope, rendered my taste more certain without lessening its warmth. My adorations are still Raphael, his century, the ancients, and above all the divine Greeks; in music, Gluck, Mozart, Haydn.

144

My library is composed of some twenty volumes, immortal master-pieces — you can well guess which ones; and, with those things, life has many charms. (1818)

Painting as I do, with the determination to do good painting, I work a long time and, consequently, I earn little. . . . Poor devil that I am, with the most assiduous and — I venture to say distinguished work, I find myself, at the age of thirty-eight with scarcely a thousand *écus* saved up [about 5250 gold francs, or $1050]; and, at that, one has to live day by day. But my philosophy, my clean conscience and the love of art sustain me and give me the courage to consider myself passably happy, especially when I think of the virtues of my excellent wife. (1818)

To brave everything with courage, never to work save with the idea of pleasing first one's conscience, then a small number of other persons: there is the duty of an artist; for art is not merely a profession, it is also an apostleship. All such courageous effort has its recompense, sooner or later. I shall have mine. After so many days of shadow, the light will come. (1820)

To live with moderation, to limit one's desires and think oneself happy is to be so in reality. To be neither rich nor poor is a blessed state. It is the best of conditions in which to live. Luxury corrupts the virtues of the heart, for the unhappy truth is that the more one has the more one wants to have, and the less one thinks to have. Without the stupid dissipations of what is called society, one lives with a small number of friends whom one has gained through inclination and experience; one practices the arts with delight; literature and the study of mankind may occupy you at any hour and render you different from the crowd. The sources of such enjoyment are inexhaustible. Here then, in my opinion, you see the happy man, the true sage, true philosophy. (1821)

Down to the present time (April 20th, 1821), I have produced a good many works at least as good as those of others, and perhaps, indeed, directed toward a better goal: but never has the desire for gain caused me to be hasty in the way I have produced my pictures, which are conceived and executed in a spirit that is foreign to the modern spirit; for after all, in the eyes of my enemies, the greatest defect of my works is that they do not sufficiently resemble their own work. I do not know whether they or I will turn out to be right in the end; the matter is not yet judged: it is necessary to await the slow but equitable decision of posterity. In any case, I am willing to have it known that for a long time my work has recognized no other discipline than that of the ancients, of the great masters of that century of glorious memory when Raphael laid out the eternal and incontestable boundaries of the sublime in art. I think I have proved in my pictures that my sole ambition is to resemble them, and to continue art by taking it up at the point where they left it.

I am therefore a conserver of the good doctrines, and not an innovator. Neither am I, as my detractors claim, a servile imitator of the schools of the fourteenth and fifteenth centuries, though I know how to make use of them with more of results than they can see. Virgil could find pearls in the manure of Ennius. Yes, even should I be accused of fanaticism for Raphael and his century, I shall never have any modesty except as concerns nature and as concerns their masterpieces. (1821)

I count very much on my old age: it will avenge me. (1821)

It must not be thought that the exclusive love which I have for this painter (Raphael) causes me to ape him: that would be a difficult thing, or rather, an impossible thing. I think I shall know how to be original even when imitating. Look: who is there, among the great men, who has not imitated? Nothing is made with nothing, and the way good inventions are made is to familiarize yourself with those of

others. The men who cultivate letters and the arts are all sons of Homer. (1821)

If nature has endowed me with any intelligence, my effort is to penetrate more deeply to the truth, through study of every kind; and if I feel that I sometimes make a few steps ahead, it is precisely because I see *that I know nothing.* Yes, since the moment when I first came to feel what grandeur and perfection are, I find myself admitted to an advantage which may well bring one to despair: that of measuring the extent of these qualities. I destroy more than I produce and I am too slow in arriving at a combination of the results of beauty, for I am above all a lover of the true, and see the beautiful only in the true, the quality which has produced the beauty of Homer and of Raphael.

Add to that the ignorance and the stupidity of the public and you see that I have enough occupation to fill up every moment of my time and to give me sleepless nights. In reality, all this trouble and labor resemble the delightful suffering of lovers, or rather the courageous and tender suffering of motherhood. A success, a bit of acclaim, above all a conscience that has been more or less satisfied — and one resumes one's beloved pain. (1821)

How happy I should be if the legitimate means of making a name for oneself and for annihilating the ignorance of this century came as easy to me as producing art in the way that I produce it. (1822)

At my age, as I well see, one does not treat one's attachments lightly without causing oneself a great deal of regret. My sudden transplanting to Rome is a heavy trial for me. I knew perfectly well that I loved my friends, but not to the point, perhaps, of realizing that I should miss them so much. . . .

It is true that I am as well off in every respect here at Rome as I very well can be, about a month after my arrival: I am quite in harmony with my predecessor, but I am never fooled (if there were any ques-

147

tion of that), and I go straight along the line of my own will. Excellent ambassador, a good secretary of the embassy; consideration and entire confidence on the part of my pensionnaires, who get along together among themselves very well indeed; a very comfortable house that carries on in perfect order, and one in which my wife, with that genuine capability of hers, has already taken control of all the machinery, even the financial part, which is no small matter for me. In sum, except for outside cares and duties which tire me more than my directorship, I ought to be satisfied; I ought to be happy over my honorable and flattering position, most assuredly, if I could forget all those whom I left behind, and if I were better able to stand the idea of separation from them. (1835)

The fine services that Pope Leo XII has done us! The divine *Capitoline Venus* has been shut up in a cabinet, like the women of evil life at San Michele: one has to get a permit to see her. Anyhow, one has to get permits for everything. Enormous fig leaves cover the statues, those of men and those of women; public places are barricaded and under lock and key; they keep right on whitewashing, they are doing St. Paul's over in the Valadier style. In a word, from this point of view, Rome is no longer Rome. The monuments are getting old, the frescoes have so many white hairs that one is distressed on looking at them, the processions and the ceremonies are somewhat less beautiful: there is no longer any picturesqueness in the common people, neither in the city nor outside it; leg of mutton sleeves everywhere. Everything is getting bastardized; but in spite of that, one still sees the most beautiful faces, and works of antique art that are still sublime; the sky, the soil, and the buildings are admirable and, beyond all else, there is Raphael, resplendent in his beauty, a being really divine who came down among men: and that, after all, explains why Rome is still superior to all else. Paris takes only the second place. (1835)

The Minister has turned to me for the decorations of the Made-

leine and, by a letter in his handwriting, he proposes that I do them. My answer is a *no*. In giving it, I am, for many reasons, following my natural sentiment; in the first place I must think of staying out my six years in Rome, where I am now well installed, and then because it would have been a new occasion for arousing envy and for bringing back upon myself torments which I have fled; because I have had difficulty in surmounting the resentment, against a lot of people and a lot of things, which still assails me. I have wanted to remain consistent in refusing everything, as it is my intention to do every time, because they should not have let me depart, because I am the one who should have been the very first to have received the offer of those great decorations. . . .

Fine as it would be to do that work, I am offered it only later on, when it merely happens that the other man is not going to do it. To be sure, the opportunity was a fine one, for everything has served my passion: oh! how sweet and sensual that *no* was to my lips when I uttered it! (1836)

These small pictures [the *Stratonice* and the small *Odalisque*] I shall finish because I am conscientious and want to keep my promises. Yet they are dwarfs, out of which giants should be made. I wear out all my patience with them, and I have plenty of patience; but my position in this matter is one of such frightful difficulty that, should I spend my whole life on this work, should I die while engaged on it, my first need is to satisfy myself . . . Never shall I take the risk of showing — still less of turning over to the engraver — a thing that was produced in haste; I would no more do that than I would consent to do an evil act. (1836)

It is no use for them to tell me "go on and get done with it, hurry up, don't start the thing over." If my pictures have possessed and still possess value, it is because . . . I have gone back to my work on them twenty times over, I have had to chasten them with the most extreme

researches and the most extreme sincerity. And so what I have been, I shall apparently be, all my life. Does that give me cause for repentance? Let others be the judge of that. As for me, I can do no differently. (1836)

Now that I am feeling well, Rome has a complete hold on me, and to leave it before the end of my time would cause me nothing less than despair. And yet the cholera will perhaps soon drive us away. Already there have been cases of it in the Transtevere, though it is said that they are not genuine cases. . . . I shall be told that that gives me a reason for returning: no, I cannot do so. We may flee from Rome, but not flee to Paris. And then, in the present circumstances, my position is that of the father of a family; it is clear that I must stay at my post till everything is settled, and that is what I mean to do. (1837)

When we think of our friends, which we often do, my good wife and I, we hate our exile. It really is one, fine as it is. Not to see one's friends, not to enjoy their presence is halfway to being dead. (1837)

I have received a proposal to paint a picture for Versailles. So as not to delay my reply any longer, I am saying *no,* because I am absolutely decided never again to paint anything for any public. (1838)

I am of the opinion of the good La Fontaine: "No peace with wicked men!"

In Paris they are making accusations about my influence, they are making public accusations about "the tendency which has been manifesting itself for some time in the work of the pensionnaires at the Academy in Rome." . . . All right then, there *is* influence, and at that, I defy any director, whoever he is, unless a Lethière or a Thévenin, not to have an influence, necessarily, on his pensionnaires, in the matter of the spirit with which they work at their art. Is my influence a good one? Yes, excellent; yes, no other has been good to the same

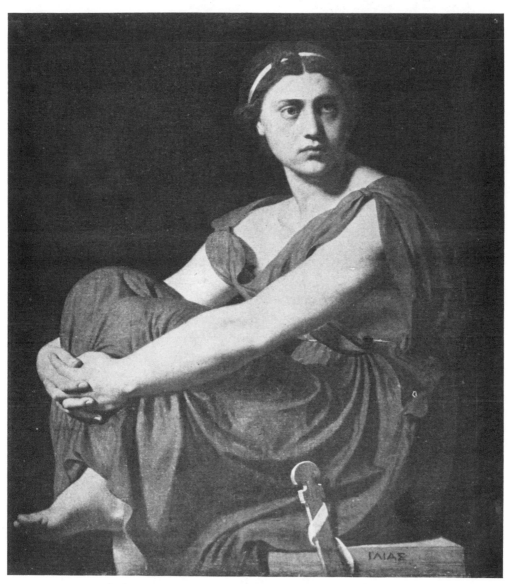

Study for *The Iliad,* 1827, Collection of M. David-Weill, Paris

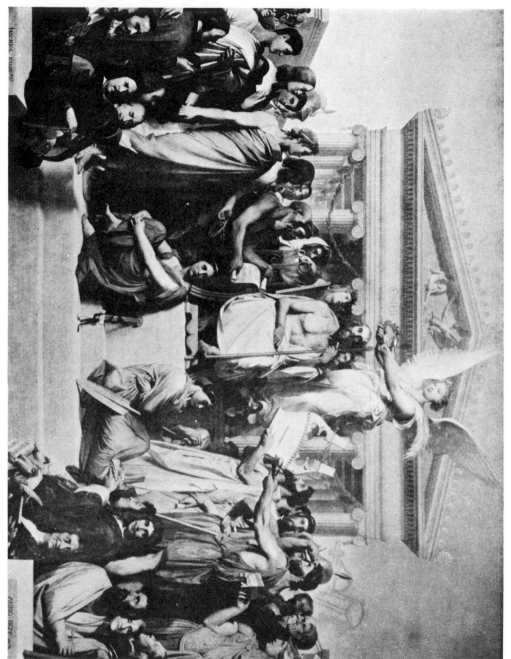

The Apotheosis of Homer, 1827, Louvre

degree. My wretched enemies, hypocrites and deceivers that they are . . . therefore mean that it is their bad doctrines which shall govern! They cannot cure the deep wounds given them by the beauty and truth of my doctrines. Very well: though I have certainly not been spoiled by the public, even the public that has intelligence (though not enough of it to share my ideas completely), I will let it be the judge between them and myself. It is impossible, despite everything it is impossible for the public to do otherwise, in the end, than prefer me to them.

. . . I foresee all the rest of my troubled life. Realizing that the dogs will always seek to devour me, I should have plunged headlong into a wild decision if a friendly hand had not restrained my pen. . . . I have given in for the moment, until I shall have avenged myself on my stupid detractors, until I shall have thrown them into shameful confusion. I am furious, I know, and I have patent proofs that the few friends remaining to me are surrounded by a lot of donkeys; but at all events, I still have those friends. Without that, I don't know what would become of me here where, moreover, we are so isolated. Our good men leave us to go home, and we still have two long years to spend here before we can get back to our friends! Nay, more, who knows whether I shall not be forced to say a last farewell to France, my beautiful country, yet one which should give me a softer bed to lie in! I am getting used to this unhappy thought, for it would really take but little to make me put it into effect. Bah, mediocrity will always get the upper hand! (1838)

It is in no state of happiness that I am living here. . . . And yet, despite everything, I am going to stay on till the last day. I count the minutes till I shall be able to resume contact with a life among friends, a very retired one, however, that I mean to lead in Paris. I am disenchanted with everything except music, inner peace, and a few old friends, a few, yes very few. (1839)

151

There is no use talking, everything has to be done under my eye, and I am not even thinking of the difficulties about the permits that have to be obtained, etc. This country is all changed. The Rome of other days that used to be so generous, so liberal to art, simply exists no longer.

All doors are closed, and one is humiliated at having to ask for everything, to make supplications on the smallest pretexts. Just imagine how that fits in with a character like mine! And at that — many a time I meet with refusals. The thing has gone to the point where I am obliged to address complaints and long tales of woe to our ambassador, to get red in the face with anger, and yet to keep my dignity. And then there are grievances against our Academy which I cannot let pass without setting them to rights. That is the way I am living, without ever being allowed to think of myself, thrown out of my course the whole time, and kept busy at every moment: and the whole thing is that I want to be a good director, that I want to do my duty properly, and in the end I shall be blamed for it — and by whom! But I have certain compensations. My pensionnaires are, if possible, more devoted to me than ever. I don't care what happens, I shall keep right on doing better and better, and that will be my revenge on my wretched, stupid and wicked enemies. (1839)

My good wife consoles me and encourages me to face the present; but as for myself, the past is killing me, and I am like Orestes, deploring the fatality which has caused me to undergo so many cruel disappointments during these six years, very nearly, that I have, alas, been here. But I don't want to begin speaking again of the unhappy matters which, one after the other, have piled up as obstacles to my plans. And then there are things that I have not been able to overcome, in spite of my patience, and what I venture to call the will-power of which I have often given proof: I am not made of wood — on the contrary, the devil gave me the worst of nerves. (1839)

Once my picture [*Stratonice*] was finished I went down with a fever. The devil take such miseries, and Rome with them. For one can't live here with the climate it has: it is no longer the Rome that I used to know. Everything in the city is unbearable. I am just starting the first of the five months still remaining of my stay. Fortunately I shall have but little time to feel the burden of it, because of the things that I have still to do: three pictures to finish up, and a lot of other things beside. (1840)

Despite this kind of living apotheosis, which really makes me happy, my whole life as an artist is summed up in that admirable axiom: "Know thyself." And I am able to do that, since, of the great praise which I receive, I take only what may truly belong to me; I look on the rest as a motive for noble striving. I make use of this remainder as I would use wings to fly higher; but I thank Providence for bringing me so much success. (1840)

At last I am away from beautiful Rome whose enormous value one feels only when one has left it. And how one does feel its worth at such a time! I was like an unhappy child shedding hot tears when I said good-by to Raphael: who knows whether I shall ever see the Vatican again? And what shall I say of the pain or the pleasure that was given me by the adieu, so touching and so honorable, that was bade me by my friends and my pupils, whom I could not leave without profound emotion? And yet I have the consoling idea that I am going back to other friends, who are just as dear to my heart, and even more so. (1841)

I have accepted big jobs; I have accepted a great deal; but everything was offered me so heartily that I could not help saying *yes*. Perhaps I have given in too much and have broken with the thing that I constantly guarded for six years—my liberty—by entering on the position of a public man, with all the claims upon him. To tell the

truth, I do not know whether I shall have the heart to struggle as I used to do, and to fight in the turbulent arena, when I think that for six years I have tasted the happiness of being nobody, except (and that was something) the Director of the School of Rome. There has been plenty of denying or of envying the good that I have done! But even while fearing my new position, the very encouragements, praise, and homage which I have received have overcome my old resentments, and I am going straight ahead, come what may! What is sure is that my nervous sensibility having, if possible, increased with age, it is necessary that they leave me in peace; for if they torment me too much, I shall soon make up my mind and do like the dog of Jean de Nivelle;[1] meanwhile, I ask nothing better than to serve my country, which I love above all things. (1841)

Sometimes, rewarded by my own approbation, I am happy: especially when I see, in the world into which I have launched them, my works, those children of my soul who have caused me so much care, so much tender and courageous solicitude! (1841)

Living in Paris, I am as if bound to an anvil upon which all the vexations of an artist's life beat down, each trying to outdo the other. Yes, here I rage at everything that I see, at everything that I hear, at everything that cuts me off from freedom of any kind. And now they have given me the whole of Paris to paint! . . . Despite which, despite things that might kill another man, I am in good health, barring a few infirmities. (1846)

Men here are vying one with another as to which shall blaspheme

[1] *Allusion to an old French song:*
> ". . . *le chien de Jean de Nivelle*
> *Qui se sauve quand on l'appelle.*"
> (*The dog that ran away whenever he was called.*)

most, by word and by act, against the god-man that we adore, Raphael. Oh, the cruel country! If it were not for my little household gods, the works of art which surround me and with which I have bound up my life, I should quickly decamp. . . . But where can one go? To Italy? It is plague-stricken also. Oh, how I hate the imperious necessity which ties me down here where I suffer, but where, in truth, I have friends whom I could not leave without despair! (1851)

I have been prevented from going to the meetings of the Commission, a greatly confused body, where the only thing anyone knows is how to undo what was already well done. And now there is not to be any Grand Medal of Honor! The Commission has given birth to a list of nine, where I, the painter of what is greatest in history, I am placed on the same level as the apostle of ugliness. . . . At this very day, at this very moment, the assembly of all the commissions is engaged in sanctioning these iniquities. In truth, I do not know what I ought to do. All I know is that I am not content with what they will do for me; I am deserting the world, my position, and every kind of participation in art work; I am shutting myself up in my own house in order . . . to give my last moments to the love of art, through practice and the sole frequentation of the masterpieces, living the life of a laborious lazy man. (1855)

I am absorbed by my work, which I have never loved as much as I do now. The older I get the more the need of it becomes irresistible for me.

My health is wonderful, and yet, on account of my great age, I am very near the point of packing up; but I want my bag to be the biggest and finest possible, for I want to live in the memory of men. (1856)

What can one do in Paris, in this ungrateful country which is given over to the most violent, the most absurd and the most hopeless things that the anarchy of the arts can produce? I am resting here, in the

bosom of my good and excellent family; but the vexations of art pursue me nonetheless, and my life is deeply troubled by them. I shall end by leading a different form of existence. Already, except for honor —which is not lost, thank God, and my intense love of art, except for a few friends who are precious to my heart, all the rest has become indifferent to me. I shall end by living in isolation from that which is odious and unbearable to me.[1] (1857)

I am now so old in spirit, I see and appreciate to such a degree (more than ever before) what things are, and what they are worth, that my desire is merely to live out my life amidst the kind affection of my intimates and amidst pleasures of a purely personal kind. They are pleasures that cannot be taken from me save with my last breath. And so I am freeing myself from many vexations by breaking with society, which is ignorant, false, envious, and bad in its taste; the main thing is that I avoid becoming forever a center of discussion. (1858)

I am caused to observe, and perhaps accurately, that I used to reproduce my compositions too often, instead of creating new works. Here is my reason: the majority of my pictures, which I like because of their subject, have seemed to me worth the trouble of rendering them better by repeating them or retouching them, which I have often done in the case of my earliest things, the *Sistine Chapel,* among others. When, through his love of art and through his effort, an artist can hope that he will leave his name to posterity, he cannot do enough to render his works more beautiful, or less imperfect. I have my example in great Poussin, who often repeated the same subject. Yet to follow a principle blindly is to abuse it: there are also works which are not to be repeated, and to speak without pride, I should be absurd if I wanted to do over the *St. Symphorien.* (1859)

I am reproached with being exclusive; I am accused of injustice

[1] *This is the year of Delacroix's election to the Institute.*

toward everything that is not the antique or Raphael. And yet I know how to love the little Dutch and Flemish masters because, in their way, they have expressed the truth and because they have succeeded, even admirably succeeded in rendering nature as it was before their eyes. No, I am not exclusive or rather I am so only against what is false. (1859)

If I did not feel how harsh it is to be separated from my best friends, I should be very happy in my solitary and studious life, being self-sufficient, when I have books, a brush that I still hold pretty well, thank God, and good classical music. (1860)

The actual truth is that since last month I am eighty years old: that's a serious business! You are a few years older, but let us have confidence. Despite our age, we are not fools, like so many other people. The age we have reached preserves our spirit, our minds; that's all one lives for. (1860)

This golden crown, had it been made for the Emperor, could not have been rendered more beautiful; but what touches me much more is the sight of those two thousand signatures coming, as they do, from all classes of society.

Thus one sees that in this life there are good days and bad days; but the latter are by far the more numerous. What I have suffered, now that the time is so near when I must pass out of existence, discourages and revolts me, for there are two men within me. One is still very much alive, endowed with a youthful and intelligent sensibility which increases rather than declines; and this man becomes irascible and unbearable, telling the poor, dilapidated, infirm and suffering body, "What do you want, you fool? Why should you be old?" And so, if my religion and the tender care of my excellent Delphine did not soften my ills, I should be very unhappy despite all my halos and despite a position that is so enviable and so glorious.

157

I have brought here [to Meung, his country place] the real treasure of life — which is work, a good sized canvas of a Madonna that I can finish without fatiguing myself too much, and that will give me the enjoyment of a gentle pastime; I shall profit by the fact that I still have all the fire of a man thirty years old, and I shall use it, if God wills and grants me that grace, by increasing the weak number of my works, until the moment comes for the great departure. God grant that posterity may find in them some little merit! (1863)

I am of my country, I am a Gaul, but not one of those who sacked Rome and wanted to burn Delphi to the ground. There are still such among us. They no longer destroy by means of weapons, it is true; but in their petty pride, and in the disordered state of their mean ideas, these little Gauls of today turn their effort against their own country by working to dispossess it of the art which is the true one. This art is undermined by them at its roots; they are like the termites, they gnaw at its marrow until it finally crumbles and nothing is left of it but dust. To certain minds I may seem hard and bitter: but strong ills call for strong remedies. Moreover I believe I am only just in my unshakable opinions and in the love of art, as to which, at least, no one will venture to question my sincerity. . . . Suppose that I am considered singular, intolerant, bizarre: since my tastes are elevated to the point where they form part of a religion, since I can give reason for the greatness of the things that I love, that I adore, it will be understood (not even to mention my nervousness) whence comes my so-called bizarreness and why I am intolerant. (1864)

The bad connoisseurs, the bad artists! Like devils issuing from beneath the earth, they overthrow and destroy everything, and they are in power; but we with our faith, are stronger in our spirit. Since they are blind and we alone see clearly, they are in an even worse case than we. (1866)

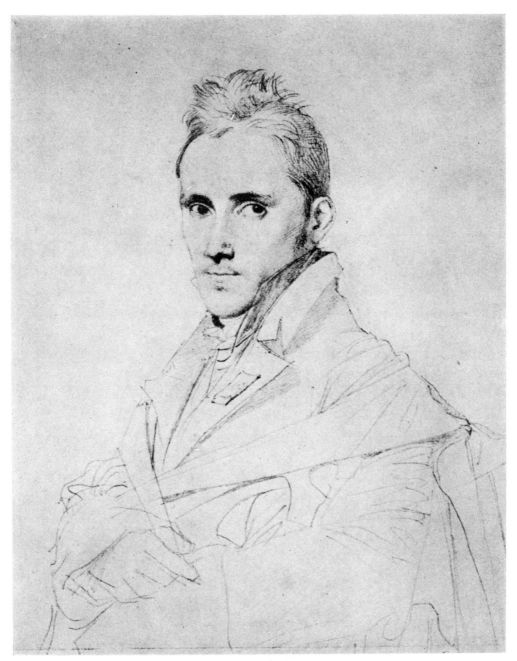

Portrait of Lemasle, Drawing, Collection of Mr. R. Burden Miller,
Cambridge, Mass.

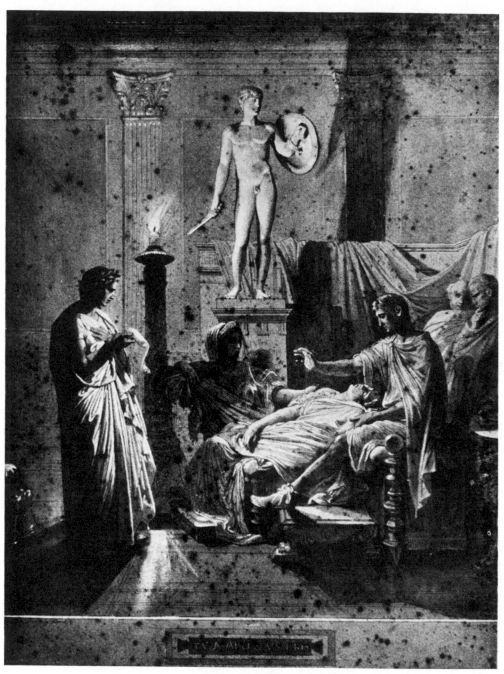

Later Design for the *Virgil* Picture, 1830, Louvre

Right down to today, fear as to what people will think has never caused me to make a step backward; for with me, it is a point of honor to remain faithful to old convictions, to convictions that I shall never abandon, even at the last hour. (1866)

II

On Art and the Beautiful

THERE ARE NOT TWO ARTS, THERE IS ONLY ONE: IT IS THE one which has as its foundation the beautiful, which is eternal and natural. Those who seek elsewhere deceive themselves, and in the most fatal manner. What do those so-called artists mean, when they preach the discovery of the "new"? Is there anything new? Everything has been done, everything has been discovered. Our task is not to invent but to continue, and we have enough to do if, following the examples of the masters, we utilize those innumerable types which nature constantly offers to us, if we interpret them with wholehearted sincerity, and ennoble them through that pure and firm style without which no work has beauty. What an absurdity it is to believe that the natural dispositions and faculties can be compromised by the study — by the imitation, even, of the classic works! The original type, man, still remains: we have only to consult it in order to know whether the classics have been right or wrong and whether, when we use the same means as they, we lie or tell the truth.

There is no longer any question of discovering the conditions, the principles of the beautiful. The thing is to apply them without letting the desire to invent cause us to lose sight of them. Beauty, pure and natural, has no need to surprise through novelty: it is enough that it be beauty. But man is in love with change, and change, in art, is very often the cause of decadence.

The study or contemplation of the masterpieces of art should render the study of nature only more fruitful and easier: it should not tend

to cause any rejection of it, nature being that from which all perfections emanate and draw their origin.

It is in nature that one may find that beauty which constitutes the great object of painting; it is there that one must seek it, and nowhere else. It is as impossible to form the idea of a beauty apart, of a beauty superior to that which nature offers, as it is to conceive a sixth sense. We are obliged to establish all our ideas, even that of Olympus and its divine inhabitants, upon purely terrestrial objects. The whole great study of art therefore, is to learn to imitate these objects.

The principal and most important part of painting is to know the production of nature which is most beautiful and best suited to art, in order to choose it according to the taste, the way of feeling of the ancients.

One should remember that the parts which compose the most perfect statue can never, each by itself, surpass nature, and that it is impossible for us to lift up our ideas beyond the beauties of nature's works. All that we can do is to succeed in assembling them. To speak strictly, the Greek statues surpass nature only because the sculptors assembled in them all the beautiful parts which nature joins together so rarely in a single subject. The artist who proceeds in this way is admitted into the sanctuary of nature. He then enjoys the sight of the gods and the sound of their speech; like Phidias, he observes their majesty and learns their language so that he may communicate it to mortals.

Phidias arrives at the sublime by correcting nature through herself. For his *Olympian Jupiter* he made use of all natural beauties together, so that he might reach what is clumsily called ideal beauty. That term should be conceived only as expressing the association of the most beautiful elements of nature, which is rarely found to be perfect in this matter; nature being, moreover, so constituted that there is nothing

above it, when it is beautiful, all human effort cannot surpass it, nor even equal it.

It is on our knees that we should study the beautiful.

In art one arrives at an honorable result only through one's tears. He who does not suffer does not believe.

You should look upon your art with religious feeling. Do not think to produce anything good, even approximately good, without elevation of soul. In order to form yourself for the beautiful, look on nothing save the sublime. Look neither to the right nor to the left, and even less to what is beneath. Go forward with your head raised toward the skies, instead of inclining it toward the earth, like the pigs who keep their eyes on the mud.

Art lives on elevated thoughts and noble passions. Let us have character, let us have warmth! One does not die of warmth: one dies of cold.

What one knows, one must know sword in hand. It is only through fighting that one gains anything and, in art, fighting is the work which one imposes upon oneself.

Draw, paint, imitate above all, and were it no more than a still life. All that is imitated from nature is a work, and that imitation leads to art.

The nature of the masterpieces is not to dazzle. Their nature is to persuade, to convince, to enter into us through our pores.

Bad practices kill everything: they do not exist in nature.

Poussin had the habit of saying that it is through observing things

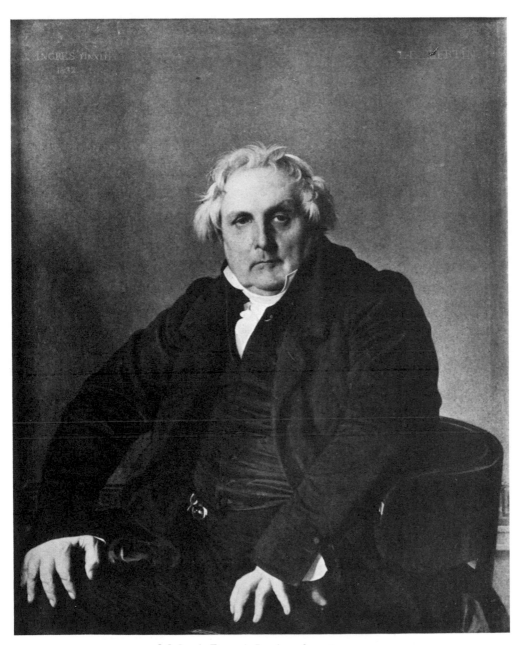

M. Louis-François Bertin, 1832, Louvre

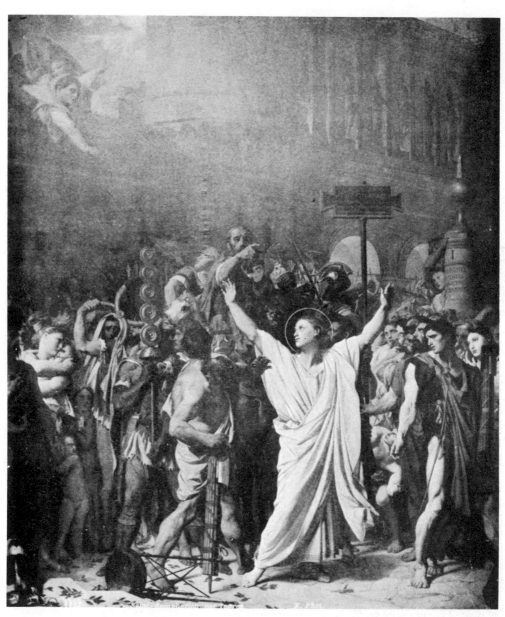

The Martyrdom of St. Symphorien, 1834, Cathedral of Autun

that the painter becomes skillful rather than through wearying himself by copying them. Yes: but it is necessary that the painter have eyes.

The great point is to be guided by reason in order to distinguish the true from the false, and that result is reached only by learning to become exclusive which, in turn, is learned by the sole and continual frequentation of the beautiful. Oh, the comic and monstrous love that men have when, with the same passion, they love Murillo and Raphael!

In the matter of the true, I prefer to see men overshoot the mark a little, whatever risk there may be in doing so for, as I know, the true may be lacking in probability. Very often the question is no more than that of a hair's breadth.

In art's images of man, calm is the first beauty of the body, even as in life, wisdom is the highest expression of the soul.

Let us seek to please so that we may the better impose the true. It is not with vinegar that one catches flies, it is with honey and sugar.

Look at that [the living model]: it is like the ancients and the ancients are like that. It is an antique bronze. When you study the ancients you see that they did not correct their models, by which I mean that they did not denature them. If you sincerely translate what is there, you will be proceeding as they did and you will arrive at the beautiful as they did. If you follow any other course, if you think to correct what you are seeing, you will arrive only at the false, at the equivocal and the ridiculous.

When you are lacking in the respect which you owe to nature, when you dare to offend her in your work, you are kicking your mother in the belly.

163

THE IDEAS OF INGRES

Art is never at so high a degree of perfection as when it resembles nature so strongly that one might take it for nature herself. Art never succeeds better than when it is concealed.

Love the true because it is also the beautiful, if you are able to discern it and to feel it. Let us strive to have eyes that see well, that see with sagacity: that is all I ask. If you want to see that leg as ugly, I know that there will be cause for you to do so, but I will tell you, "Take my eyes and you will see it as beautiful."

The ugly: men go in for it because they do not see enough of what is beautiful.

You tremble before nature: tremble, but do not doubt!

One always reaches beauty when one reaches truth. All the faults that you commit come, not from any lack of taste and imagination on your part, but from your not having put in enough of nature. Raphael and that [the living model] are synonymous with each other. And what was the road that Raphael took? Even he was modest, even he — Raphael that he was — was submissive. Let us therefore be humble before nature.

Sculpture is an art that is severe, rigid: therefor it was consecrated by the ancients to religion.

Woe to him who deals lightly with his art! Woe to the artist who does not retain seriousness of mind!

Do not concern yourself with other people, concern yourself with your work alone; think only of doing it the best way you can. See how the ant carries its egg: it goes its way without stopping, then, when it has arrived, it looks back to see where the others are. When you shall

have reached old age, then you will be able to do the same and compare what you will have produced with the productions of your rivals. Then, but only then will you look at all things without danger, and then will you estimate all things at their true value.

III

On Taste and Criticism

WHEN HE IS SURE OF WALKING IN THE RIGHT ROAD, WHEN he is following the traces of those among his predecessors who rightfully enjoy their title to great celebrity, the artist may arm himself with the boldness and the assurance which are proper to true talent. He should not let himself be turned from the straight road by the blame of an ignorant crowd. It is he who is right, it is from him that come the lessons and examples of taste.

The more convinced and strong one is, the more kind one must be toward the hesitating and the weak. Kindness is one of the great qualities of genius.

The misfortune of great artists, the one that is known only to themselves and that they complain about only among themselves, is that they are not sufficiently appreciated. There is a general feeling as to their success; but those details by which they reach perfection, that infinitude of precious strokes — either because they cost so much or because they cost nothing at all — those are the things that only a few connoisseurs enjoy in private, those are the things that public applause does not tell about, that envy always conceals, that ignorance can never hear and that, were they well known, would be the first recompense of true talents.

"Rarely has anything great been done in the world save through the genius and the firmness of a single man struggling against the prejudices of the multitude or giving prejudices to the multitude."

On Taste and Criticism

(Voltaire) Yes, if it is a good genius, all is well; but if it is an evil genius, as his was, whither does that lead? To barbarism, to the absurd denial of that which is forever the beautiful and the true, to the drying up of the soul and the heart, to nothingness, to emptiness, to the frightful calm of an uninhabited earth.

Time metes out justice to all things. Absurd works may have been able to surprise, to deceive a century by qualities that are dazzling but false, because, in general, men rarely judge for themselves, because they follow the torrent, and because pure taste is almost as rare as talent. Taste! It consists less in appreciating the good wherever that appears, than in recognizing it under the thick layer of defects which hide it. The formless beginnings of certain arts sometimes possess, in reality, more of perfection than art when it has been perfected.

There is more of analogy than people think between good taste and the good way of life. Good taste is an exquisite feeling for that which is fitting: it derives from a fortunate disposition, and is developed by a liberal education.

It is rarely other than the lower type of the arts, whether in painting or in poetry or in music, which naturally pleases the multitude. The more sublime efforts of art have no effect at all upon uncultivated minds. Fine and delicate taste is the fruit of education and experience. All that we receive at birth is the faculty for creating such taste in ourselves and for cultivating it, just as we are born with a disposition for receiving the laws of society and for conforming to their usages. It is up to this point, and no further, that one may say that taste is natural to us.

The ignorant populace shows as little taste in its judgments on the effect of the picture as it does when faced with animate objects. In life, it will go into ecstacies over violence or emphasis; in art, it will always

prefer forced or stilted attitudes and brilliant colors to a noble simplicity, to a tranquil grandeur, as we see them in the pictures of the ancients.

Can one ever sufficiently love, sufficiently admire supreme beauty? What flower, among the flowers that are most beautiful, can equal the rose, and among the birds of the air, which one could one compare to the eagle of Jupiter? In the same way, is there anything comparable to the works of Homer, to a statue by Phidias, to a lyric tragedy by Gluck, to a quartet or a sonata by Haydn? Is there anything more beautiful, more divine, and consequently more worthy of love?

Pallid praise of a beautiful thing is an offense.

One must at all times form one's taste on the masterpieces of art: to concern oneself with other study is to waste one's time. One may cast one's eyes on inferior beauties, but not study them, still less imitate them.

When the ancients went on a journey, when they went to the country, they always took works of art with them, pictures, or small bronzes. The Emperor Tiberius invariably traveled with a picture by Zeuxis or Apelles representing a priest of Cybele. When we of today are away from the places where we ordinarily live, let us always have under our eyes our engravings, or our sketches after the masters, in order to keep up our taste, to help us understand new things or to preserve us from temptations.

It is natural to see one's friends in the best light, except when they fall into what is false. In that case it is the part of true friendship, of charity (for that virtue does not consist solely in giving alms), to assist, to fortify, to lift up the soul and the heart through enlightened and sincere councils as to all that is good, beautiful and profitable. The praise of a simpleton or of an ignorant man, far from encouraging us,

should on the contrary give us warning that we are committing some fault.

To derive fruit from the criticism of our friends, it is very necessary for us to know, through an acquaintance with their character, their taste, and their habits of mind, how to distinguish the point at which their observations are well founded.

The same sagacity which causes a man to excel in his art should lead him properly to utilize the judgment both of learned and of inept persons.

In order to be a good critic of great art and of great style, it is necessary for a person to be endowed with the same pure taste which guided the artist and presided over the carrying out of his work.

There are few persons, whether well taught or even ignorant who, if they freely spoke their thought on the work of artists, could not be useful to the latter. The only opinions from which one can draw no fruit whatever are those of semi-connoisseurs, Denon, for instance.

IV

On Drawing

DRAWING IS THE PROBITY OF ART

To draw does not mean simply to reproduce contours; drawing does not consist merely of line: drawing is also expression, the inner form, the plane, modeling. See what remains after that. Drawing includes three and a half quarters of the content of painting. If I were asked to put up a sign over my door, I should inscribe it: *School for Drawing,* and I am sure that I should bring forth painters.

Drawing contains everything, except the hue.

One must keep right on drawing; draw with your eyes when you cannot draw with a pencil. As long as you do not hold a balance between your seeing of things and your execution, you will do nothing that is really good.

The painter who trusts to his compass is leaning on a ghost.

Never spend a single day without tracing a line, said Apelles. By that he meant what I repeat to you: line is drawing, it is everything.

If I could make musicians of you all, you would thereby profit as painters. Everything in nature is harmony: a little too much, or else too little, disturbs the scale and makes a false note. One must reach the point of singing true with the pencil or with brush quite as much as with the voice; rightness of forms is like rightness of sounds.

On Drawing

When studying nature, have eyes only for the ensemble at first. Interrogate it and interrogate nothing but it. The details are self-important little things which have to be put in their place. Breadth of form and breadth again! Form: it is the foundation and the condition of all things; smoke itself should be rendered by a line.

Consider the relationships of size in the model; therein resides the whole of character. Let yourselves be vigorously impressed by that, and it is vigorously, also, that you should render these relative sizes. If instead of following this method, you merely feel about, if you make your research on the paper, you will do nothing of value. Have in your eyes, and in your mind, the entirety of the figure that you want to represent, and let the execution be only the bodying forth of that image which has already been made your own by being preconceived.

When tracing a figure, set yourself above all to determine and characterize the movement. I cannot too often repeat to you that movement is the life of the drawing.

Let us not complain as to the time or the labor we give in order to arrive at purity of expression and at perfection of style. Let us even, in order to correct ourselves without cease, use whatever facility we may have. Malherbe, it is said, worked with prodigious slowness: yes, because he was working for immortality.

One must render invisible all the traces of facility; it is the results and not the means employed which should appear. Facility is a thing to be used and at the same time despised; but despite that, if one has a hundred thousand francs' worth of it, one must still get another two cents' worth.

The simpler the lines and forms are, the more there is of beauty and of strength. Every time that you divide up the forms, you weaken

them. The case is the same as that of the breaking up of anything else.

Why do men not get largeness of character? Because in place of one large form, they make three little ones.

When character is not based above all upon the great lines, the resemblance arrived at is no more than a doubtful one.

In constructing a figure, do not proceed piecemeal. Carry the whole thing along together and, as our good expression has it, draw the "ensemble."

One must not attempt to learn to produce fine character: one must discover it in one's model.

The beautiful forms are those with flat planes and with rounds. The beautiful forms are those which have firmness and fullness, those in which the details do not compromise the aspect of the great masses.

What is necessary is to give health to the form.

The completion of the form is achieved by finish. There are people who, in drawing, are satisfied by feeling; with feeling once expressed, the thing suffices them. Raphael and Leonardo da Vinci are there to prove that feeling and precision can be allied.

The great painters, like Raphael and Michelangelo, have insisted on line in finishing. They have reiterated it with a fine brush, and thus they have reanimated the contour; they have imprinted vitality and rage upon their drawing.

From the material standpoint, we do not proceed like the sculptors, but we should produce sculptural painting.

On Drawing

A painter is perfectly right to be preoccupied with finesse, but to that he should add force, which does not exclude finesse — far from it. The whole of painting resides in drawing that is at once strong and delicate. Let anyone say what he will, painting is a matter of drawing that is firm, proud, and well characterized, even if the picture in question is supposed to impress by its grace. Grace alone does not suffice, neither does a chastened drawing. More is needed: drawing must amplify, it must envelope.

There is good always, whatever defects may also appear, in a work where the head has commanded the hand. One should feel that, even in the attempts of a beginner. Skill of hand is acquired by experience; but rectitude of feeling, of intelligence, there is a thing which may be shown from the very start, and there also, to a certain extent, is a thing that can make up for everything else.

Draw with purity, but with breadth. Pure and broad: there you see drawing, there you see art.

Draw for a long time before thinking of painting. When one builds on a solid foundation, one sleeps in peace.

Expression in painting demands a very great science of drawing; for expression cannot be good if it has not been formulated with absolute exactitude. To seize it only approximately is to miss it, and to represent only those false people whose study it is to counterfeit sentiments which they do not experience. The extreme precision we need is to be arrived at only through the surest talent for drawing. Thus the painters of expression, among the moderns, turn out to be the greatest draftsmen. Look at Raphael!

Expression, an essential element of art, is therefore intimately bound up with form. Perfection of coloring is so little required that excellent

painters of expression have not had, as colorists, the same superiority. To blame them for that is to lack adequate knowledge of the arts. One may not ask the same man for contradictory qualities. Moreover the promptness of execution which color needs in order to preserve all its prestige does not harmonize with the deep study demanded by the great unity of the forms.

All nuns appear beautiful, and experience makes me certain that there is no such thing as an artificial adornment or studied dress which can cause half the impression that is produced by the simple and modest habit of a nun or of a monk. Oftentimes, in churches, I have remarked and also admired the sentiments of affection and of love which animate the faces of pious persons. The devotion which they feel before the Madonnas or before their preferred saints must be extremely satisfying to the heart. I confess that I envy their state. From the depth of my soul I curse that philosophy which, by its coldness and its insipid triumphs, leaves us in a kind of stoical apathy, and blots out the gentlest emotions within us.

In any case, what resources there are for art in the study and imitation of those externals of the peace and serenity that are within! One gets at once a consolation for the soul, a fortifying example to offer to it and, from the point of view of the beautiful, an admirable spectacle for the eye.

The light in a picture should fall powerfully upon some special point, and the attention of the spectator should be drawn to that point. The same applies to a figure: the luminous effect should radiate from a central point; that is how fine gradations are produced. As to the form also, it is necessary to have one large section that dominates all the rest, and thus seizes the eye from the very beginning; therein lies one of the principal elements of character in drawing.

To attain beautiful form, one must not proceed by square or angu-

lar modeling; one needs round modeling, and without any too apparent interior details.

When one has a single figure in one's picture, the modeling of it should give the effect of the full round, and the picturesque effect be obtained in that way.

Always have a sketchbook in your pocket, and note down with the fewest strokes of the pencil the objects which strike you, if you do not have time to indicate them entirely. But if you have leisure to make a more exact sketch, seize upon your subject lovingly, envisage and reproduce it in all its forms, so that it may be lodged in your head, incrusted there, as your own property.

I believe strongly in having a thorough knowledge of the skeleton, because the bones form the very framework of the body and determine its lengths, thus giving a constant basis for judgment to the draftsman. I believe less in an anatomical acquaintance with the muscles. Too much science in such a matter works against sincerity in drawing and may lead away from characteristic expression, bringing about, instead, a banal image of the form. It is, however, necessary to take careful note of the order and the relative disposition of the muscles, so that, from that aspect also, mistakes of construction may be avoided.

They are, all of them, my friends, those muscles: but I don't know one of them by his name.

Never do the exterior contours bend inward. On the contrary, they bulge, they curve outward like the wicker of a basket.

The term "types of beauty" is applied to the results of observations frequently made from fine models. A broad neck, for example, is found, fifteen times out of twenty, among well-built men; we may

therefore regard it as one of the conditions of beauty. However, if your model has a slim neck, don't give him a heavy one; but take care not to exaggerate the smallness of it. To express character, a certain exaggeration is permitted, at times it is even necessary, but principally when the question is one of separating and emphasizing an element of beauty.

Human beings usually carry their head backwards from the body, with the chest thrown out; it is a noble attitude, it is the true attitude. Save in cases of movement, thrusting the head forward dishonors the human figure; it expresses exhaustion, lassitude or intoxication.

For a young man model, a young athlete not yet formed: the pectorals short, as also the torso, the arms strong at the top, but slender at the attachments, the same applying to the legs: a sign of strength and agility.

You will never see a Hercules with the lower part heavy and strong.

The length of the torso among human beings, large or small, varies but little. And so a torso that is large as compared with the legs indicates a small man and, reciprocally, a small torso denotes the general tallness of the individual.

The head and neck never link together: they always form two non-continuous lines.

In a head, the first thing for an artist to do is to make the eyes speak, except that they should be indicated only by the mass. First one sets down the hollow of the eyes, then one goes on to the projection of the nose.

Descending nostrils are a fine means of expression; they indicate tranquillity.

On Drawing

The wing of the nostril very lightly traced gives beauty; the nostril well adjusted to the cheek is also an element of beauty.

The moustache should leave the cheek fully uncovered. Consider the *Jupiter*.

The arm always commands the forearm: it is the stronger part. It is only in the aged and the decrepit that exceptions to this are found.

Raphael drew his draperies from the students who worked under him, because they naturally knew better than other people how to make the cloth take on beautiful folds.

We must follow that example to the letter, and banish lay figures except in the case of portraits, and then only use them in the case of trinkets such as women wear and which call for detailed finish.

Therefore, no lay figures. Once a fine bit of drapery has been found, one must adapt it to the nature, dress the model in this preconceived drapery and get from life the movement of folds and the indication of details.

V

On Color, Tone, and Effect

COLOR ADDS ADORNMENT TO PAINTING; BUT IT IS ONLY THE tiring-woman [court lady charged with dressing a queen], for she does not go beyond rendering more amiable the veritable perfections of art.

It is unexampled that a great draftsman has not had the color quality exactly suited to the character of his drawing. In the eyes of many persons, Raphael did not use color; he did not use color like Rubens and Van Dyck: *parbleu,* I should say not! He would take good care not to do such a thing.

Rubens and Van Dyck may please the eye, but they deceive it; they are of a bad school of color, the school of the lie. Titian: there is true color, there is nature without exaggeration, without forced brilliance! He is exact.

Never use a too ardent color; it is anti-historical. Fall into gray rather than into ardent tones, if you cannot attain a perfectly true tone.

The *historical* tone leaves the mind tranquil. Have no more ambition about that than about other things.

The essential matters about color do not reside in the ensemble of light or dark masses in the picture; they are rather in the particular distinguishing of the tone of each object. For example, place a fine and brilliant white cloth upon a dark or olive-hued body, above all let your spectator see the difference between a blond color and a cold color, be-

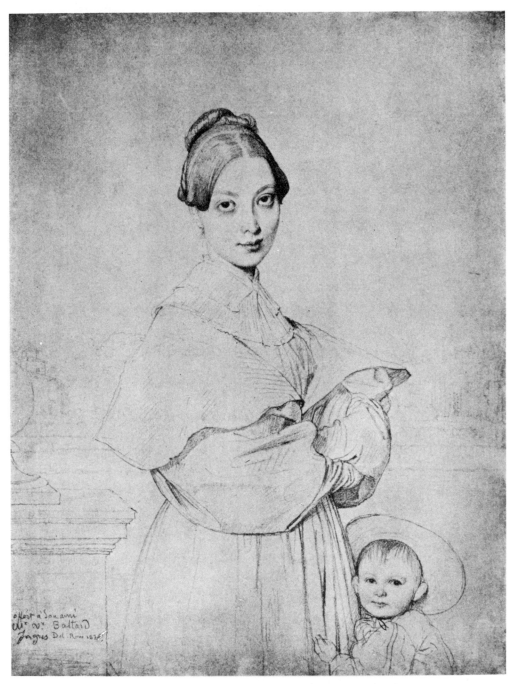

Mme Baltard and Her Daughter, 1836, Collection of
Mme Arnould-Baltard, Paris

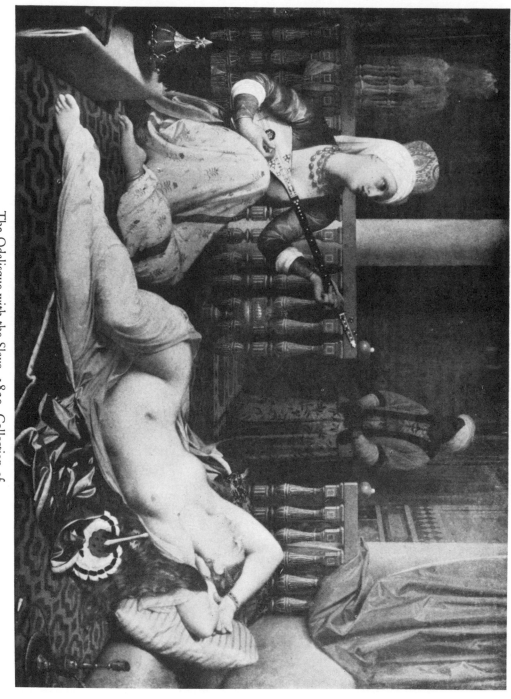

The Odalisque with the Slave, 1839, Collection of
Mr. Grenville L. Winthrop, New York

tween accidental colors and those which result from the local tints. This thought was inspired in me by the chance which caused me to see on the thigh of my *Oedipus,* reflected in a mirror, a white drapery, so brilliant and beautiful in its contrast with that warm and golden flesh color!

Painters make a big mistake when, giving too little thought to their pictures, they use an excess of white; later on they have to lower and dull it in tone. White should be reserved for those passages of light, for those points of special brilliance which determine the effect of the painting. Titian used to say that the desirable thing would be to have white as costly as ultramarine, and Zeuxis, who was the Titian of the painters of antiquity, rebuked those who were ignorant of the harmful effect of using white to excess. Nothing is white in animated bodies, nothing is positively white; everything is relative. See the contrast between women who gleam in their whiteness and the color of a sheet of paper!

It is indubitable that one can obtain great breadth and warmth in the tints, in a word, do heavy and golden painting like the Venetians, without using canvases of a coarse texture, as they did. The proof resides in the contrary effect produced by the portraits and other pictures of certain painters, among them Allori, who have painted in a very solid and finished manner on smooth preparations.

The means of painting in the Venetian fashion was revealed to me through a sketch by Mr. Lewis, an English painter. This sketch was one that he did from the fine Titian in our museum, *The Entombment.* In order to imitate the master, the artist painted on a canvas having no more texture than was given by a light coat of glue, as it seems that all the painters have used, most often spreading out that coat on ticking or drill. He recognized the fact that, in order to obtain transparence and a fine warmth of tone, it was necessary to glaze everything, and conse-

quently do all the underpainting in a more or less colored gray, in a kind of monochrome:

No. 1. Blond flesh in a very light violet-gray, dark flesh in a stronger gray, the same thing for hair.

No. 2. Green draperies with yellow, the blues with white, as also the reds and the skies.

In general, painting should be hard, sharp and frank in its oppositions. One may lay things in very lightly, still maintaining this same practice; but when one comes back to the work one must strengthen the contrasts and thoroughly thicken the paint.

The picture thus prepared should, despite its monotony, give a feeling of color. One should let it dry for at least one good month before taking it up again to finish it, and then paint everything with glazes, except in the case of white cloths.

There is nothing better than the use of glazes to imitate the beautiful color procedure of the old Italian painters. Many a piece of drapery painted with white has been glazed with color. That is, I think, the means almost always employed by Titian, Andrea del Sarto, and Fra Bartolommeo.

La Fornarina, in the *Tribuna* at Florence: an admirable example of the use of glazes.

It is a fine thing to blacken the eyelids of old men: look at the *Julius II* by Raphael! It is a fine thing to discolor the eyelids in painting the eyes of women. Observation from nature.

The white of the eye has a specially clear part which it is essential to indicate in a lively manner: it is the part next to the pupil.

Flowers should be consulted in order to get beautiful tones for draperies.

On Color, Tone, and Effect

Warm violet and the gray of linen turning toward a watery green have a fine effect when large white meanders are then embroidered upon them.

Draperies lined with a different color produce a fine effect. The proof resides in works of the Renaissance. A thing to put into habitual practice.

Tones of draperies suited to a fine figure effect: in the fresco of *St. Joseph* by Baroccio, for the Virgin, a red brown jerkin with a little crimson, but of a very dull character; ultramarine blue mantle. A figure in the *Flagellation* by the Chevalier d'Arpin [Giuseppe Cesari]: a very dark man with black; light breeches with yellow that gets the whole of the light. Make plenty of notes like this one, especially after Titian.

In judging the effect, one should see one's picture in the darkest place in the studio. The old-time sculptors placed their figures in cellars in order to get a better judgment of the masses.

Make yourself a little peep-show cabinet, like that which Poussin used: indispensable in judging effects.

Light is like water; whether we would or not, it reaches its true place, and instantly assumes its own level.

In a picture, the light should fall on one part with more power than on others and concentrate there, so that the eye is immediately drawn to that place and travels to it. The same applies to a figure: hence the gradations.

In the shadow on a contour, one must never put the tint alongside the line; one must put it on the line.

181

Narrow reflections in the shadow, the reflections that run along the contours, are unworthy of the majesty of art.

The quality of making objects in painting "detach" (which many people regard as such an important thing), was not one of the matters on which Titian, who is moreover the greatest colorist of all, principally fixed his attention. It was painters of inferior talent who treated that as the essential merit of painting, as it is still considered by herds of art enthusiasts, inevitably satisfied and charmed when they see in a picture a figure so painted that, as they say, "it seems as if one could walk around it."

Sometimes the little pictures of the Flemings and Dutch themselves are, with their limited dimensions, excellent models for the color and effect of a historical picture. In that respect, one may ask them for guidance and note them as examples.

M. de Lauréal and His Mother, 1840, Musée Ingres, Montauban

Mlle Bénard, 1840, Collection of Wildenstein & Co.

VI

On the Study of the Antique and of the Masters

DOUBT ITSELF IS BLAMEWORTHY WHEN WE ARE CONSIDERING
the marvels of the ancients.

To claim that we can get along without study of the antique and
the classics is either madness or laziness. Yes, anti-classic art, if one may
even call it an art, is nothing but an art of the lazy. It is the doctrine of
those who want to produce without having worked, who want to know
without having learned; it is an art as lacking in faith as in discipline,
wandering blindly because of its having no light in the darkness, and
demanding that mere chance lead it through places where one can ad-
vance only by means of courage, experience, and reflection.

The one reason why the ancients were so superior to us was because
their manner of seeing depended on good sense as much as on power; it
was as sincere as it was beautiful. This principle among men was never
lost; they applied it to everything, they made it habitual in every cir-
cumstance. And so we admire the ruins of their art or of their industry
down to the least details, down to the common pottery which they
doubtless held in light esteem, but whose beautiful contours still
enchant us.

It is that way of seeing which we must regain. The thread is
broken; it was joined anew for a moment during the renaissance of the
arts in Italy; new centuries of barbarism broke it again: we must strive
to bind it together once more.

183

It was through the debris of the works of the ancients that the arts came to a new birth among the moderns; it is through the means that they themselves employed that we must seek to make the ancients live again among ourselves, that we must seek to continue their work.

We must copy nature always and learn to see it well. It is for that purpose that we need to study the antique and the masters, not to imitate them; what we need, as I repeat, is to learn to see.

Do you think that I send you to the Louvre to find what is conventionally called "ideal beauty," something different from what is in nature? It is foolish ideas like that which, in bad periods, have brought on the decadence of art. I send you to the Louvre because you will learn from the antique to see nature, because it is itself nature: and so you must live upon it, feed upon it. The same is true of the paintings of the great centuries. Do you think that in ordering you to copy them I want to turn you into copyists? No, I want you to get the juice of the plant.

Address yourselves to the masters, therefore, speak to them, they will answer you, for they are still living. It is they who will instruct you; I myself am no more than their quizz-master.

All I have is the small merit of knowing the road that one must follow in order to arrive, and I indicate it to you. Here is our purpose: to approach that [the antique]; and what is that? It is nature, it is intimate acquaintance with beauty and form and the finished, philosophic expression of those things.

To such a degree did the Greeks excel in sculpture, in architecture, in poetry, in everything they touched, that the word Greek has become the synonym for the word beautiful. It is only they who are absolutely true, absolutely beautiful, because they saw, recognized and rendered. You have seen them, those masters: they do not tantalize us with doubtful words; they say: it is thus, it is so! The Romans imitated them, and they are still admirable; but as for us, we are Gauls, we are

Barbarians, and it is only by striving to approach the Greeks, it is only by proceeding as they did, that we can merit and obtain the name of artists.

One need feel no scruple about copying the ancients. Their productions form a common treasury from which each man may take what pleases him. These productions become our own when we know how to use them: Raphael, even while ceaselessly imitating, was always himself.

If we consult experience, we shall find that it is by making oneself familiar with the inventions of others that, in art, one learns oneself how to invent, as one accustoms oneself to think through reading the ideas of others. Therefore it is only by observing, by constantly studying the masterpieces, that we can vivify our means and give them their development.

Monsieur, you know everything that one can learn by oneself; but as long as you have not consulted the ancients, you will not succeed in rendering this model as he is. They alone will teach you that. As well organized as your mind is, you would stand in front of nature throughout your whole life without arriving at the ability to translate it in spirit and in truth.

He who is not willing to ask the contribution of any mind other than his own will soon find himself reduced to the most miserable of all imitations, which is to say the imitation of his own works.

An able painter, one who is in no danger of being corrupted, can make advantageous use of many things, even those which may be vicious. He will derive benefit from complete mediocrities, and in passing through his hands, their work will turn into perfections. In the coarse attempts to produce art which derive from the time before its

renewal he will find original ideas, happy combinations or even more than those, for at times he will discover nothing less than sublime inventions.

Every time that I have refreshed myself through looking at the compositions painted on ancient vases, I have come forth from the experience more persuaded than ever that it is from such models that the painter must work, that they are the thing for him to imitate when he paints Greek subjects. He can do Greeks only when he imitates them, following them step by step. Far more than that: he can, without being a cold plagiarist, take entire compositions from the paintings on the vases and translate them on a canvas. There is still genius, in knowing how to re-create the nature which was so well indicated already, though it had previously been only half expressed by mere outline; this re-creation is achieved by the perfection of the colors, and by a finish like that of nature herself; and it will be attained through study.

The example of others, far from weakening our imagination and our judgment, as many people think it does, serves, on the contrary, to strengthen and consolidate our ideas of perfection, for at their beginnings, these ideas are weak, formless and confused. They become solid, perfect and clear, through the authority and the influence of the men whose work has been consecrated by the approbation of the centuries, as we may very safely say. Compared to the things that make the glory of the ancients, what are those which cause the pride of the moderns? Pompous designs, flatteries achieved through color, through the balancing of masses, the linking together of groups, and any number of other *coquetteries* of the craft, things which have no word to say to the soul. It was to the soul that the ancients would speak, and it alone was considered by Raphael, Michelangelo and the others as worthy to receive the homage of art. By the same token, it is the soul which has generally been neglected by the painters who stand as the great colorists, the great *machinists,* all those, in a word, who have particularly

excelled in those picturesque means which so many moderns have been pleased to celebrate as signs of progress; and it is because of this that they have had the audacity to award to themselves the prize which they have refused to antiquity.

One may say, without in any way detracting from the glory of the ancients, that they did not generally know, as do the moderns, about the multiplying of planes in their pictures, about observing the gradations which these successive planes demand, about linking figures to figures or groups to groups, and about captivating the eye by the prestige of color which is not that of nature and which causes itself to be accepted as nature. Yes, they did neglect these things, or they knew them but little, because they regarded them as distractions from the beautiful, which was their goal; they considered that these secondary elements of art would do nothing but turn the mind of the spectators, and their own as well, from those elements which merit all attention.

Homer is the principle and the model of all beauty, in the arts as in letters.

For two centuries, our theater has had no rival, and whatever may be said by the Romantics from across the sea or across the Rhine, people will have to agree, finally, that the stage on which the masterpieces of Corneille, of Molière, and of Racine are played is preferable to the stage which offers the monstrosities of Shakespeare and of Otway, the novels in dialogue by Schiller and the rhapsodies of Kotzebue. The theater is a great part of our national glory, and perhaps the surest of our titles to literature. Why? Because there, more than anywhere else, Homer and the great models of antiquity have been remembered; because there, more than anywhere else, the principle of faithful and reasoned imitation given us by the ancients has been put into practice.

In speaking of Racine and the others it has been said: these great

men knew Greek thoroughly, and it was by feeding upon the master-pieces of antiquity that they finally surpassed the ancients. What a stupidity, what an audacity! those great men, needless to say, were far more just and far more modest. Look at Racine's prefaces, at the humility of our great Poussin, and at the opinion of La Fontaine when he wrote to some abbé or other: "Which among us can think himself the equal of the Greeks and the Romans?"

Mme Dacier [the translator of Homer] knew Greek better than she did the spirit of her century. Her appearing renewed the stupid and shameful quarrel directed against the ancients, and this time started by a man like Lamotte: the struggle of good taste against ignorance and bad faith ended with the triumph of the ancients. But this victory was paralyzed; the blow had been struck, it was to be fatal to the beautiful in all its forms. An adversary more redoubtable than any other because of his popularity, a man as sceptical about science as about the higher forms of religion, Voltaire, through his sarcasms, made the final attacks on the beautiful. Soon the Greek language and literature were reduced to taking refuge in the quarto volumes of the Academy of Inscriptions. It is from that time that dates the passing out of French hands of the scepter of philology — never perhaps to return.

And yet the French language is, in the opinion of learned men, the one which most nearly approaches the Greek, which is to say the most perfect language that men have ever spoken. The French language, as the savants tell us, is incomparably the most beautiful of modern languages; it would take but little indeed, to make them give it preference over Latin which, in their opinion, does not possess enough of euphony and of clarity. They have no lack of reasons for throwing out the objections as to the number of auxiliaries and of short words which, through the difficulties of sentence structure, embarrass our language and strangle thought. Here is their proposition: the best language is the one which brings together in the highest degree, clarity, variety, and elegance. Now, the French language is the clearest one; there is but

one opinion on that matter. It is the most varied, for it lends itself equally well to all the forms of style, to all species of composition in prose and in verse: for every type of such production it offers finished models. And finally, it is the most elegant for, throughout Europe it is the language of cultivated society.

Does it not result from the above that since our language is the one which most approaches the Greek, people will speak it and write it all the better for having studied Greek literature intimately and zealously? That was the opinion of Boileau, who knew what he was talking about. Therefore, in letters as in the arts, there is no salvation save for those who, steadily fixing their eyes upon antiquity, ask it in pious fashion to guide and instruct them.

Let me hear no more of that absurd maxim: "We need the new, we need to follow our century, everything changes, everything is changed." Sophistry — all of that! Does nature change, do the light and air change, have the passions of the human heart changed since the time of Homer? "We must follow our century": but suppose my century is wrong? Because my neighbor does evil, am I therefore obliged to do it also? Because virtue, as also beauty, can be misunderstood by you, have I in turn got to misunderstand it? Shall I be compelled to imitate *you!*

Upon this globe there was a little corner of earth which was called Greece, where, under the fairest sky, among inhabitants endowed with an intellectual organization that was unique, letters and the arts shed what was practically a second light upon the things of nature, for all the peoples and all the generations to come. Homer was the first to reveal through poetry the beauties of nature, as God organized life by bringing it forth from chaos. He has forever instructed the human race, he has established the beautiful through precepts and through immortal examples. All the great men of Greece, poets, tragedians, historians, artists of every kind, painters, sculptors, and architects, are all born of him: and, as long as Greek civilization lasted, as long after that as Rome

reigned over the world, men have continued to put into practice the same principles that once were found. Later on, in the great modern periods, men of genius did over what had been done before them. Homer and Phidias, Raphael and Poussin, Gluck and Mozart have, in reality, said the same things.

It is error then; error to believe that health for art resides in absolute independence; to believe that our natural disposition runs the risk of being stifled by the discipline of the ancients; that the classic doctrines impede or arrest the flight of the intelligence. Quite the contrary: they favor its development, they render its strength more certain and fructify its aspirations; they are a help and not a hindrance. Moreover, there are not two arts, there is but one: it is that which is founded upon the imitation of nature, of beauty — immutable, infallible, and eternal. What do you mean, what is it you come to preach to me with your pleadings in favor of the "new"? Outside of nature there is no such thing as the new, there is nothing but what is called the baroque; outside of art, as it was understood and practiced by the ancients, there is nothing, there can be nothing but caprice and aimless wandering. Let us believe what they believed, which is to say the truth, the truth which is of all times. Let us translate it differently from them, if we can, as far as expression is concerned, but let us be like them in knowing how to recognize it, to honor it, to adore it in spirit and in principle, and let us leave to their howling those who try to insult us with a word like "old-fashioned."

They want novelty! They want, as they say, progress in variety, and to refute us who recommend the strict imitation of the antique and of the masters, they cast up to us the movement of the sciences in our century! But the nature of the latter is quite different from the nature of art. The domain of the sciences enlarges through the effect of time; the discoveries in them are due to the most patient observation of certain phenomena, to the perfecting of certain instruments, sometimes even to chance. What can chance reveal to us in the domain created by the

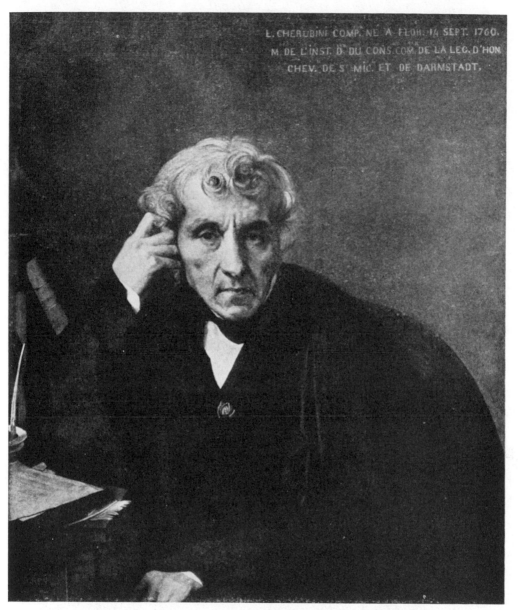

The Composer Cherubini, 1841, Taft Museum, Cincinnati

The Duc d'Orléans, 1842, Versailles

imitation of forms? Does any part of drawing remain to be discovered? Shall we, by means of patience or of better eyeglasses, perceive in nature any new outlines, any new color, a new kind of modeling? There is nothing essential to discover in art after Phidias and after Raphael, but there is always enough to do, even after them, to maintain the cult of the true and to perpetuate the tradition of the beautiful.

VII

On Practice and its Conditions

THERE IS NO NEED OF EXCESSIVE RESEARCH FOR SUBJECTS: a painter can make gold with four pennies. I won my reputation with an *ex voto,* and all subjects will serve the man who can produce poems. Neither should one concern oneself too much with accessories; they should be sacrificed to that which is essential, and the essential thing is the turning of the form, the contour, the modeling of the figures. The accessories should play the same role in a picture as the confidants in tragedies. Authors put them in as a frame for the heroes, so that the latter may stand out strongly: we painters should render surrounding objects, but we should do so in a way that makes them fix attention upon our figures, so that we enrich the principal things through whatever brilliance we take away from surrounding things.

A useless half-figure suffices to spoil the composition of a picture.

It is through engravings that pictures and their merit are frequently judged. As people can have engraving under their eyes more easily and more habitually than the picture itself, they can better grasp the weak points of the composition or of the style; they can appreciate each intention more rigorously and more at their ease. The painter must therefore consider his work closely when he thinks of letting it be engraved; he must take careful note of his armor before submitting himself to that test. If he comes forth from it victorious, the reason doubtless is that he deserved the victory.

What is called "the touch" [in English, 'brushwork' is perhaps the

192

nearest modern equivalent for this term] is an abuse of execution. It is the quality of false talents alone, of false artists alone, those who depart from the imitation of nature in order to exhibit their mere skill. The touch, able as it may be, ought not to be apparent: otherwise it becomes an obstacle to illusion, and arrests all movement. Instead of the object represented, it causes you to see the mode of procedure; in place of the thought, it makes you observe the hand.

There is a great difference between the art of reproducing in a picture the characteristic traits of nature that one has determined on in advance, and the talent which consists of a merely exact copying on the canvas of the man whom one has called in to pose. It is related that Annibale Carracci, having begun to paint the altarpiece of the *Dead Christ on the Knees of the Virgin*, which is in the church of San Francesco, at Ripa, produced a figure which was admirable and really divine, but then afterward, having engaged a nude model when retouching the body of the Christ, he changed that whole first production of his, which had been a thing of the mind. Because he too much distrusted his means, he spoiled his picture. Here, then, is an example for us, and one that we ought to remember when we are faced with the question of executing a picture. Besides, even without that example, there are a thousand proofs that the old painters and all the great masters, beginning with Raphael, executed their frescoes from cartoons, and their small, easel pictures from more or less finished drawings. . . . Your model is never the thing that you really want to paint, whether quality of drawing be your goal, or whether it be color; however, it is indispensable to have recourse to the model. To paint Achilles, the handsomest of men, you may have only a poor lout before you; but he has got to serve, and he will serve you for the structure of the human body, for the movement, and for the sense of being planted on his feet. The proof of this is seen in what Raphael did when he used his pupils to get a start on the studies of movement for the figures in his divine pictures.

As much genius as you may have, if you paint directly from the model and not from the nature already copied by you, you will always

be a slave, and your picture will give the feeling of servitude. Raphael, on the contrary, had mastered nature so thoroughly, he had it so well in memory, that instead of its commanding him, one would say that she herself obeyed him, that she came spontaneously to place herself in his works. One would say that, like a passionate mistress, her beautiful eyes and all her other compelling charms existed only that she might offer them to the happy and privileged Raphael, a sort of divinity on earth. And so the epitaph composed by Bembo is perfectly exact.

The ancients had a liking for clear separation among the objects in their pictures. We may see therein a principle which all of them followed to a greater or lesser degree, and which has been one of the special reasons for criticism of them by the moderns, because the latter have imposed upon themselves the absolutely contrary principle of binding everything together. If one thinks oneself authorized to condemn this principle of the ancients, then one must equally condemn their dramatic works. Go on then with your condemnation, senseless men! Condemn all among the works in which they have demanded simplicity, for today a vain brilliance and a mean pomp are sought for, in all types of art; we are climbing onto stilts in order to look big. That rule of spacing objects in painting and in bas-reliefs came from the desire fully to express beauty and to express it in the developments of lines. They would not have consented, as we do, to sacrifice considerable portions of a figure by concealing them behind a neighboring figure. In those days it was not permitted to an artist to resolve upon the smallest sacrifice or to abandon himself to the slightest negligence. Everything was to be beautiful in his picture, because everything had to be clearly distinguishable.

Fresco has always been cherished and employed by the greatest painters as the process which most inspires and which, through its more simple and easy execution, is best adapted to bringing great things to birth: that is the whole story, it is *monumental* . . . but over-rich decoration, the juxtaposition with marbles, for example, may hurt

the effect of this austere water painting. The greatest use of this tech-
nique is to be found at the Sistine Chapel, in the *Stanze,* the *Loggie,* at
the Farnesina and in other places, all decorated with fresco alone, with
arabesque ornaments and small architectural pictures, the whole thing
being set off with gold alone and with the most beautiful colors.

The painter of history renders the race in general, whereas the
painter of portraits represents only the individual in particular — a
model, consequently, and frequently one who is ordinary or full of
defects.

To succeed well with a portrait, one must first penetrate oneself
with the face that one wants to paint, considering it for a long time,
attentively, and from all sides; one should indeed devote the first sit-
ting to this part of the work.

Oftentimes a portrait is lacking in resemblance because in the be-
ginning the model was badly posed, because he was placed under such
bad conditions of light and shade that he would fail to recognize him-
self in the place where he was painted.

There are faces that will be more advantageous to paint from in
front, others in three-quarter view or as seen from the side, and certain
ones in profile. Some demand a great deal of light, others have more
effect when there are shadows. It is above all for thin faces that one
must get shadow in the cavity of the eyes, because in this way a head
has a great deal of effect and of character. To this end, let the light fall
from above and in small quantity.

In portraits, plenty of background above the heads; for this back-
ground, one side light and the other dark.

VIII

Judgments on Certain Works of Art and on Certain Artists

THE MATERIALS OF ART ARE IN FLORENCE AND THE RESULTS are in Rome.

The true cradle of fine painting was the chapel of the Brancacci in the Church of the Carmine, in Florence.

The two superimposed churches of Assisi. The lower one is dark, mysterious; it is the place of expiation. The upper one is clear, serene: it is heaven, it is hope with its accompaniment of happiness.

The sixteenth century produced the greatest men in all the arts. At that time, everyone was guided by this constant and infallible rule: that drawing is the sole principle capable of giving to works of art their true beauty and their true form. Hence the great number of eloquent works and of immortal masterpieces.

Raphael was not only the greatest of painters; he was beautiful, he was good, he was all things!

Heaven seemed jealous of earth when it so early ravished from us Raphael and Mozart.

Every man, however little he may possess of healthy understanding, of feeling for the arts and for the touch of the beautiful, will have an

always rekindled need to nourish himself from Homer, to whom he will owe his purest enjoyment. The more one speaks of Homer, the more things one will have to say about him; new ideas will be born from those that one imagines to be worn out. It will be the same way with the divine Raphael, whose praises are as yet only sketched.

I went with Paulin to see the *Stanze* (1814). Never had Raphael seemed so beautiful to me, and, more than ever before, I was conscious of the way that divine man stands out above other men. I am convinced that he worked according to the dictates of his genius and that he carried the whole of nature in his head, or rather in his heart. When a man reaches that point, he is like a second Creator.

The *Disputa* and above all the *Mass of Bolsena* appeared before my eyes as marvelous masterpieces. In the latter work, what portraits! And in the other, what beautiful and noble symmetry! one that he has almost always employed, and that gives to his compositions that air which is so grand, so majestic!

In the *Heliodoros,* he placed, according to custom (and it is a beautiful one), the principal groups at the edges, leaving an empty space in the middle.

The folds look as if they wanted to make place for others, so well do they imitate nature and movement.

I should need a book, volumes, to dwell upon the qualities of Raphael and upon his incomparable inventions: but I will say that the frescoes of the Vatican are, by themselves, of far more value than all the picture galleries put together. That beautiful museum is so varied, the man who made it touched so well all the strings, so well imitated the suppleness of nature in the very diversity of his effects! And all of that was painted by Raphael from drawings!

And so let us go on, and strive to imitate him, to understand him; I am, myself, in the unhappy position of having to regret, throughout my life, that I was not born in his century. When I think that, three hundred years earlier, I might actually have become his disciple!

Raphael has painted good men: all of his personages have the look of honest people.

Homer, rejected and miserable, begs. Apelles accused by calumny, is saved by the truth: his work serves as his justification. Phidias, unjustly accused, dies miserably, if not violently. Socrates, Euripides, Theocritus, Aesop, Dante, and Jean Goujon die a violent death or are tormented as the wicked should be: Le Sueur, finally! Poussin, our great Poussin, persecuted by a Fouquières, disgustedly leaves that France which he was to have adorned. And Domenichino, and numberless others, and Camoëns!

It is true that, even in the time of the heroes, Midas preferred Pan to Apollo.

The great men are persecuted as if they had deserved the punishment meted out to the guilty by the Furies, and precisely because they are the great men. And Molière! There is not one of his pieces which did not cost him bitter tears. Molière! And Mozart! . . . But I should never reach the end.

And yet — I shall be told — Raphael was happy. Yes, but that is because he was of a divine, inviolable nature.

When considering the gigantic and sublime works of Michelangelo, when admiring them with all one's heart, one still perceives in them the symptoms or the marks of the fatigues of humanity. It is the contrary with Raphael. His works are wholly divine, for their creation seems easy and, as in the works of God, everything in them seems a pure effect of the will.

Incontestably, Raphael and Titian hold the first rank among painters, and yet Raphael and Titian considered nature under very different aspects. Both of them possessed the privilege of extending their seeing over all things: but the former sought the sublime where it really is, in form, and the second in color.

The Vicomtesse d'Haussonville, 1845, Frick Collection, New York

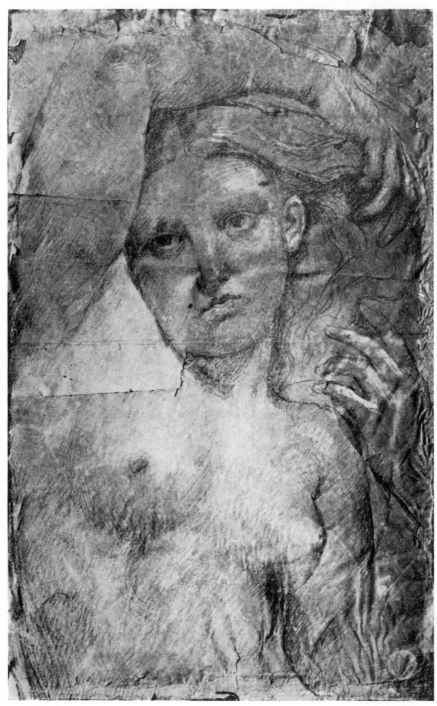

Study for the *Venus Anadyomene,* 1848, Musée Ingres, Montauban

Today (August 1854), I understand — if the divine intelligence of Raphael can be understood — how Raphael could produce so many works in painting, and I have reached my idea through what I have produced myself here of late, with the help of my two pupils, who paint — so to speak — as I do, executing the material beauty of my works under my continuing direction while I, for my part, do the finishing.

The frescoes of Andrea del Sarto in Florence are, in my opinion, very decidedly the most complete thing one can see in historical painting after the works of Raphael.

The portraits painted by Holbein stand, in the matter of physiognomy and of drawing, above all others. Only those of Raphael surpass them.

There is perhaps nothing which has better given me an idea of the painting of the ancients than certain parts of the frescoes by Giulio Romano in the Palazzo del Tè, at Mantua.

What a master it was who, at Mantua, did the figure of Polyphemus, and the nude woman, in the first plane, in the *Wedding of Psyche!* There is the thing that every painter of history ought to copy, in order to acquire treasures which will make him live throughout his life and to avenge that great man for the injustice or the impertinence with which the ignorant speak of him. He is generally regarded as "a docile aide," as a simple imitator of Raphael, almost as an able workman. It would, however, suffice to see, if one has eyes, his cartoons and his drawings in the Louvre; but it is agreed, Giulio Romano could only imitate his master, and that's all there is to that: whereas his genius was — if not as strong — as creative as that of Michelangelo, and at least as original and as ample as that of Fra Bartolommeo. Is there, in any school, a single master who has interpreted the

antique as this one has? The cymbal player in the *Wedding* and all
the compositions in the *Story of Psyche,* does that resemble Raphael?
With all his divine genius, he did not have the feeling of the antique,
like Giulio Romano. Raphael is grace, is beauty, is harmony, in a word
he is Raphael: Giulio Romano is the antique. And the execution of
those paintings at Mantua! I know none more perfect or more surpris-
ing, when one stops to consider that they are frescoes. Oh! What a
master, what a master! how could he have had so little reputation dur-
ing his lifetime? and after that, this iniquity has got to go on existing!
No, that must not be. All honest men who understand art must
league together and see to it that the honors he deserves are rendered
to him, and that he at last be put in his true place!

Poussin could tolerate nothing in the work of Michelangelo da
Caravaggio: he said that he had come into the world "to destroy paint-
ing," One might well say the same of Rubens and of several others.

Yet Caravaggio did fine portraits, notably the one of the *Grand
Master of Malta,* which is on a level with the best portraits, those in
the front rank.

Yes, to be sure, Rubens is a great painter: but he is that great paint-
er who has ruined everything.

There is something of the butcher about Rubens; it is above all
fresh meat that is in his mind, and there is something of the butcher
shop in the setting of his pictures.

You are my pupils, and therefore my friends, and as such, you
would not salute one of my enemies if he happened to pass beside you
in the street. Turn away from Rubens then, wherever you encounter
him in the museums; for if you approach him, it is sure that he will
speak ill to you of my teachings and of myself.

CERTAIN WORKS OF ART AND CERTAIN ARTISTS

The Flemish and Dutch schools have their own type of merit, as I well recognize. I can flatter myself that I appreciate that merit as much as anybody else; but, for goodness' sake, let us have no confusion. Let us not admire Rembrandt and the others through thick and thin; let us not compare them, either the men or their art, to the divine Raphael and the Italian school: that would be blaspheming.

The natural look, without affectation of any kind, in Titian's portraits commands our respect whether we will or no. In them, nobility appears as something innate and inherent. When by chance a portrait by Titian hangs next to a Van Dyck, the latter becomes cold and gray by comparison.

What is generally lacking in our school of painting, Poussin and two or three others excepted, is natural and healthy strength. Our school is more nervous than robust. And it is strength alone which makes the great renovators and the great schools.

All Poussin's pictures show the special study that he gave to that antique painting, the *Aldobrandini Wedding*. He carried his veneration for the ancients so far that he desired to give to his works the look of really ancient paintings, even in the proportion of the figures. He taught us that when one wants to represent subjects from antiquity, there must not be anything in the picture which turns people's thought to modern times. The mind then wanders through past centuries; nothing should be presented to it which might draw it away from that illusion.

The genius of Poussin would not have led him so far, to such heights in the philosophy of painting, if he had not added to it his assiduous study of the good authors of antiquity, and of the conversation of learned men.

Poussin does not present himself to posterity with the advantage of having executed great public works in our country. Whose is the fault? It is that of a little king, of ministers insufficiently educated who consequently became the instruments of evil, of Vouet and his clique, and of such an intriguer as Fouquières. The great artist's happy taste for philosophy consoled him. He cherished independence, and raised himself above the pride of overcoming his rivals, who were nothing but envious men. . . . Throughout his life, the extreme love that he had for his retreat, and also his misfortunes obliged him to give to his works only rather limited proportions: but what does that matter? Free from all vain ambition in the course which he laid out and from which he never departed, he knew how to get the best out of himself until the very end, and to bring into the world delights unknown to the soul of men before him; and, doing this, he could content his native genius and his heart.

Without leaving the countryside of Rome, almost without leaving Rome itself, the immortal Poussin discovered the picturesque soil of Italy. He discovered a new world, like the great navigators, Amerigo Vespucci and others; but his conquest was a more peaceful one. Poussin — and his name is glorious among all names — was able to see in the country which he so nobly exploited that which the others had not seen, not even men like Titian, the Carracci, and Domenichino, great painters of history and, because of that, great landscapists, for it is only the painters of history who are capable of producing beautiful landscapes. He was the first and the only one to imprint *style* on nature as it is seen in the Italian country. Through the character and the taste of his compositions, he proved that nature belonged to him; this is true to such an extent that, on looking at a beautiful view, one says, and one is exact in saying that it is *Poussinesque*.

In the seventeenth century, Italy, as if exhausted by her glories, seems to take a rest and to yield her power and her triumphs to our

country. Men like the Carracci and Domenichino close the gates to the temple. It is a Frenchman, it is Nicolas Poussin who inherits the authority and the privileges of the Italian masters, but it is with an admirable loftiness in his personal views, and with profundity in his thought and his art. Poussin! A model for mankind in his character, and one of the greatest painters of the world.

Eustache Le Sueur: a tender child of the works of Raphael, who, without leaving Paris, divined the beautiful and brought forth marvels of grace and of sublime simplicity. His almost unknown life, like that of Jean Goujon, was not, apparently, any more happy than that of the latter, whereas that of a rival far inferior to him in sentiment and in style was attended by the most lavish success: Charles Lebrun was laden with encouragements and with honors. However, in his own way, Lebrun is a great artist. Consider his fine compositions illustrating the *History of Alexander* and his immense labors at Versailles. Today his reputation has declined, but in reality he stands far above the position which remains to him.

If it is permitted to place Philippe de Champaigne among the painters belonging to our country, one may say that the most truly religious works which have appeared since the end of the Italian Renaissance are French works. The religious pictures of Le Sueur are far superior to everything that was painted in their class outside of France, and *The Nuns of Port Royal,* by Philippe de Champaigne, are a miracle of unction, of simplicity, and of profound expression under the calm of appearances, for which one would certainly find no equivalent anywhere else. And what admirable truth in those two portraits! And how ingenuous the painter is in the presence of nature, what sincerity he has, what good faith!

"The French," says Félibien, "have, by nature, the bad habit of not sufficiently esteeming the learned men who are born among them,

and of too highly esteeming that which comes from foreign countries." Félibien surely said that on the occasion of the preference that had been given to Bernini over the French architects, when he was called to Paris to execute the façade of the Louvre. Everybody knows that, though he was a man of genius, he found men here who could give him his reply, and it is known also that he had the modesty to retire. The man who today has inherited his reputation, he who is called Canova, who passes for the best artist in Italy but who gets nothing from Bernini save bad taste of another kind, does not behave with much modesty and good faith. Now those are the two qualities which round out the great man.

During his lifetime, Canova was looked on as a demi-god, even in Paris, where there were, however, sculptors who were quite as good as he. But since time is the real executor of justice, what has the great man become? Except for the figure of the pope on the *Tomb* at Saint Peter's, and a few graceful works of brilliant execution, what is there of him that remains? Nothing, or very little; nobody takes note of him any more. (1835)

The death of that poor Léopold Robert is frightful. I was doubly touched by it, because of my own grief and because of what M. Marcotte will have felt. It is a genuine loss for art; but, without speaking ill of the dead, I have very little liking for the picture of the *Fishermen*.

It is to be remarked that, even in the periods when it was least fine, the French school has maintained supremacy over the other schools. Consider what happens at the time of the too celebrated Boucher. Despite the evident decadence of taste, despite the impudent reign of mannerism and convention in France, our art of the eighteenth century has more of wit, of grace, and indeed of knowledge, than the art practiced at the time by the other nations. Those countries, in striving to imi-

tate us, manage only to repeat in a clumsy way that which we had said with ease and with skill, at all events.

I saw yesterday (October 22nd, 1852), but without the author whom I did not meet, M. Périn's chapel at Notre-Dame de Lorette. Cold painting, but full of talent; of an agreeable tone, with a good, religious character, and delightful qualities in the little pictures; the whole of it done in a conscientious way and with a care which, in themselves, constitute a merit that is rare, especially at this day. And so the whole thing should be looked on as entitled to important approbation.

Bah! what do I care for these talents, and were they indeed great talents, if they are directed toward a vicious purpose — if they culminate only in an immoral result? What do I care for the false brilliance of mind of men like Byron and Goethe and all the rest of them who, in letters as in the arts, pervert, corrupt, or discourage the heart of man? For me, they do not exist; for they are hostile or useless to the cause of true beauty. Let others vaunt them, if they like: as for me, I curse them.

Talent! in our time, it's found on every street corner; but that is enough to disgust one with talent.

I should like to see removed from the Louvre that picture of the *Medusa* and those two big *Dragoons,* its acolytes; let them place the one in some corner of the Navy Department, and the two others in the War Department, so that they may no longer corrupt the taste of the public; it should be accustomed solely to that which is beautiful. And we should be delivered, once for all, from subjects like those of executions, *auto-da-fe,* and the like. Is that what painting, the healthy and moral art of painting, has the mission to represent? Is that what one should admire? Is it in such horrors that one should find pleasure? I do not hereby proscribe the effects of pity or of terror, but I want them to

be rendered as they were by the art of Aeschylus, of Sophocles, or of Euripides. I don't want anything to do with that *Medusa* and with those other pictures of the dissecting room, which show us no more of man than his cadaver, which reproduce only the ugly and the hideous: no, I want nothing to do with them! Art should be nothing but the beautiful and should teach us nothing but the beautiful.

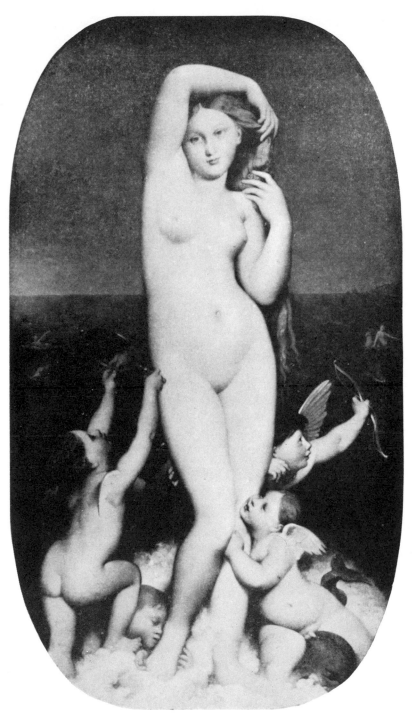

Venus Anadyomene, 1808-1848, Chantilly Museum

The Gatteaux Family, 1850, Collection of Mr. Douglas H. Gordon, Baltimore

IX

Music and Musicians

MUSIC! WHAT A DIVINE ART! AN HONEST ONE, FOR MUSIC
has also its morality. That of the Italian school is only a bad one: but
the German!

In music, as in all the other arts, there is no grace without strength.
Strength is a necessary quality, a great vehicle in works of art; but
few are those who possess it in a reasonable way, for there must not be
any excess.

To soften the manners of the Arcadians, who showed the effects of
their harsh climate, the laws forced every citizen to study music until
he had reached the age of thirty: by this means, the Arcadians became
the most polished and the most sincere of the Greeks. Only the inhabi-
tants of Cynetha refused to follow the example of the other Arcadians.
They despised music and remained in their natural savagery. And
what about ourselves? what do we mean to do? Are we becoming Ar-
cadians or Cynethians?

Lulli, more effeminate than Rameau, was sometimes great, and
Rameau, although generally majestic, sacrificed to the graces and to
voluptuousness. The former was regarded even by the Italians as a com-
poser for street fairs, whereas they admired and had translated into
their language some of the operas of the latter, who was a Frenchman.
In the same way, when I was in Rome, I saw a simple waltz by Mozart
charm every singer, male and female, for nearly four years. Would
that not be at once the best proof of the talent of Rameau, as also of the

207

genius of Mozart, and the clearest refutation of the system of that stoic (Rousseau) who denies that we have music?

Effect of the *Requiem* of Mozart at San Gaetano, which I heard in the company of the minister of Sweden. Aside from admiration for that divine masterpiece, it occurred to me that if I could produce the music of a mass for the dead, I should try to add to it certain powerful qualities in order to produce unaccustomed effects of pity and of terror, things for which we find example in the *Eumenides* of Aeschylus. I would cause to come forth from under the earth voices of the departed, roars, orchestral effects in the manner of Gluck. . . . The evil laughter of devils and the sound of the tortures of the damned. . . . There would be the greatest darkness and the greatest light, according to the position of the *ignis fatuus;* then would come the gentlest and purest contrasts: feelings of hope for the righteous, as opposed to the repentance and the cries of the guilty. The musicians would remain completely unseen, so that nothing should distract from the effects of the music itself, when its subject was so terrible and so solemn. The church, dark, studded with tombs, and lit only by shafts of light; no unmuted stringed instruments, all of them somber, gentle, melancholy: tenor and bass-violins, oboes, dull trumpets. (Florence, 1821)

Glory to Don Juan! Masterpiece of the human mind! Glory to Mozart, the god of music, as Raphael is the god of painting! Glory to Gluck, that divine declaimer, who alone among the moderns, has donned the buskin of the Greeks! And glory to that extraordinary man who, without being either of the others, has, by his single effort and by his terrible genius, transported his unconquered and sublime art to new horizons!

Let us forever adore with the same fervor and the same passion, Gluck, Haydn, Beethoven and Mozart, our Raphael in music. Say what you will, everything that is not of those truly divine men is lame

beside them. We return to them constantly: their beauties are so inexhaustible that we always think to hear them for the first time, and the last time is always the finest. . . . But let us never hear the slightest thing by the Italians! To the devil with their commonness, their triviality, where everything, including "I curse you," is made to sound like the cooing of doves!

For anyone who studies music, let the works of Haydn be his daily bread! Beethoven, to be sure, is admirable, he is incomparable, but he has not the same usefulness as Haydn: he has not the same necessity.

Haydn produced no masterpiece, he does not have his masterpiece. I should say not! Everything he did is a masterpiece.

The symphonies of Beethoven are grand, terrible, and also of an exquisite grace and sensibility, especially the one in C; but they are all beautiful, and the lesser ones appear always greater. And Haydn! The great musician, the first to create everything, to discover everything, and to teach everything to the other men! Am I growing old? At all events, he is the one to whom I always return with pleasure and calm, as one does to bread, of which one never tires.

I have heard it told that Beethoven often used to take walks alone in the environs of Vienna, so as to give himself up to his inspirations. He was almost deaf. One day he had knelt down in the road to write out what he had just composed. A funeral comes by, followed by a long procession: Beethoven remains motionless. The preoccupations of his genius, no less than his deafness, make him unconscious of all that is taking place around him; but he has been recognized. The funeral and the procession pause: "let us wait until he has finished," is the unanimous idea of all; and in fact they did wait until Beethoven got up.

What a fine homage that was to render to the great man! It was because genius when at work is in communication with God. That is

what is felt in Vienna, by an eminently religious people; that is why this people could, without impiety, make a dead man bow before a living man.

I no longer go to concerts, for they fatigue my nerves too much; but I love quartets of chamber music, and I love to listen to the piano. With that instrument, music comes in an effortless, legible way. That is when one tastes it, when one savors it. . . . My excellent Delphine lends beauty to my solitude, almost every evening, through the sonatas of the divine Haydn which she plays, not in the style of the virtuoso, which I detest, but with true musical feeling; and sometimes I accompany her.

Only musicians of genius know how to jest. Méhul jests in the *Irato,* but it is as a god that he jests : it is Jupiter in playful mood.

Mme Ingres (Delphine Ramel), 1852, Musée Bonnat, Bayonne

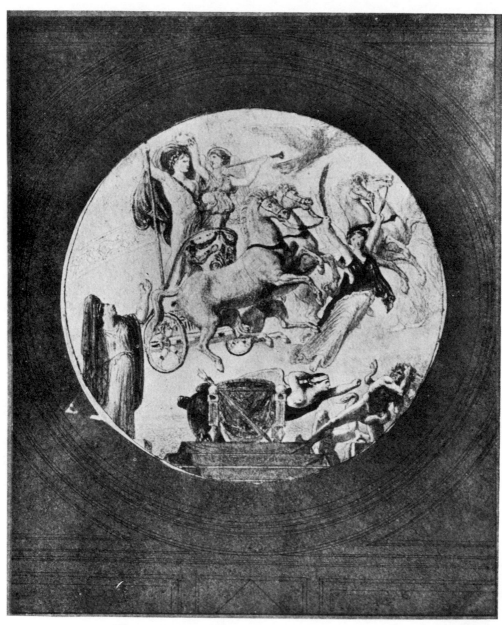

The Apotheosis of Napoleon, Study, 1853, Louvre

Notes, Letters, a Document

(Extract from notes for recommendations to the government;
not dated.)

IN THE MATTER OF NEW CHURCHES TO BE BUILT, I SHOULD like to see a complete stop put to any use of the so-called Gothic style. I approve and ardently desire the very greatest care of ancient buildings belonging to that type of architecture; but great and rich as it is, it cannot be permitted to serve as the type for new churches, because it produced temples for turbanned miscreants (and that will be well understood through the fact that it was imported from the Orient by the Crusades), heathen temples, therefore, rather than temples really fit for Christians. Let us adopt, in preference, the plan and character of the first churches built by Constantine! Let us inspire ourselves from the basilicas that one sees in Rome, St. John of the Lateran, San Clemente, Santa Maria in Trastevere and, to name the most beautiful of all, let us remember that ancient church of St. Peter's with the five naves, adorned with antique columns, with all the tombs of the popes, etc. Alas, we have the sorrow of remembering that that beautiful monument was destroyed to satisfy the ambition of Bramante, of Sangallo, and of Michelangelo himself when, successively, they were entrusted with building St. Peter's anew. Anathema upon those men, able as they were, for having committed a crime against art! Moreover, what has come out of all the efforts directed against the earlier St. Peter's? Except for the dome of Michelangelo, all we have got is a bad church, as bad as it is immense, uselessly enriched with the most precious

spoils, of marble and of bronze, from ancient monuments; in a word the biggest temple in the world, but a temple that is small in its bigness, and one of the most defective, also, in its taste.

And therefore, in our building of churches, let us preserve the original conceptions, the heroic traditions; for in a question like this, to preserve is to continue with creating.

Extracts from the Letters of Ingres

(Ingres carried on a correspondence with various friends and, as it went on throughout his long life, even the part of it which has been published assumes very considerable proportions. The volume of Boyer d'Agen entitled *Ingres d'après une Correspondance Inédite,* and composed chiefly of his letters to Gilibert, of Montauban, the friend of his boyhood, contains, alone, more than five hundred good-sized pages. Outside of the fact that most of the material therein is of interest only to the special student for whom every word of the master has value, it would obviously be inappropriate to give, in a work having the scope of the present one, any more than such examples as round out our idea of the character and history of Ingres. From the great store of material available, I have selected the following.)

Letters to Jean François Gilibert

Florence, April 20, 1821

. . . Here is the way we live at the house of friend Bartolini. Up at six o'clock, we have coffee for breakfast by seven o'clock, and then we separate to spend our whole day at work in our studios. We get together again for dinner at seven o'clock in the evening, a period of rest and of conversation until the hour for the theater, where Bartolini goes every evening of his life. We meet again on the morrow, at breakfast, and so

it goes on day after day. The truth is that this regular life is the one best suited for artists, men whose sole interest is their art.

Florence, August 29, 1822

. . . I hope to prove that there is no such thing as an indifferent subject in painting; the whole matter is to see well, and above all truly.

Thank the Lord! I can think out loud with you. I should consider myself only too happy if the legitimate means for making a name for oneself were not just the ones that rouse up against an honest artist the whole rabble of the envious and ignorant men of this century. I feel that I am in the full force of my talent, and I find in myself a facility for producing. One thing is the enemy of my repose: I, who am not at all a man for society, am continually required to see people. I am obliged to tear myself from my studio in order to receive the visits of merely curious persons. To put on full dress is one of the labors of Hercules for me. What I should like would be to remain here unknown, to concern myself exclusively with historical painting and never to sacrifice myself in doing little pictures that take up more time than the big ones. I should wish above all to have my life go on only in my studio. The life of study is the happiest one; it makes one forget everything that disgusts one with this world. I intend to begin isolating myself, and then I shall surprise and hit hard.

Florence, November 1st, 1822

. . . When one considers carefully, Raphael is himself simply for the reason that, better than the others, he has known nature. And *there is his whole secret,* a secret that everybody knows and of which so few can make use for the progress of art.

Florence, December 24, 1822

. . . The great object of our study is to become *exclusive,* and that is to be learned, I venture to say, by the continual frequentation of the beautiful alone. Oh, the comic and monstrous love that men have

when, with the same passion, they love Murillo, Velasquez and Raphael! [1] Those who have such ideas have never been admitted to the supreme understanding of beauty; and nature, when she created them, denied them one of the senses. How many things I have to tell you on this score! When shall we be able to make an exchange of the delights we get from painting and from music?

Speaking of that latter art, a few days ago I made the acquaintance of a German, a second Chik. (I don't know whether you remember the man or his name.) But anyhow he is passionately fond of music and the two of us work together at it. We have made up a quartet, with two local artists. He's a virtuoso at the piano and almost as much so on the violin, to which instrument he used to devote himself especially. And so he loves music and has a fine feeling for it, but especially a certain kind of music. But I must try to describe the man to you. He has great facility with the instrument, and climbs like a cat, by octaves, right up to the bridge; and he does that with art and with a certain grace, so that I get quite discouraged about my own lack of the art. I am absolutely lacking in it, unfortunately, never having been able to give much time to it for I have never had much. Anyhow, when he plays a quartet by Cramer, or Spohr or by Ramberg — our equivalent for Velasquez in music — he performs very well. But when he plays something by Haydn, by Mozart, or by Beethoven, I am sorry for him. And so you see that he is not sufficiently touched by the beautiful and too much so by the mediocre — he is not *exclusive*.

. . . .

As to men like Gérard, whose talent I always respect and whose *finesses* I always hate, I have no other weapon for forcing his esteem than good pictures painted conscientiously, but along lines that are

[1] *We have read this passage before, in Delaborde's transcription of it. Only, in that place, the name of Velasquez is omitted — doubtless to protect Ingres from any accusation of treating the famous Spaniard too severely.*

not his own. However, he has too much talent not to recognize, among my defects, my good qualities.

. . . .

Let us speak of the future. It depends absolutely upon my success in Paris. If I don't succeed there, I shall always have plenty of work to do here, for three or four years at least, with pictures that have been ordered from me and that I can perfectly well do here, where I am living very happily, in every sense of the word. And that happiness will be complete, if you come and join us here. As to finances and savings, it is with regret that I see that I can't even think of such matters, despite all the moderation with which we are living. The reason for that is perfectly simple: I am very slow in doing a picture or, to put it in another way, the others are doing three while I am doing one. That *one* brings me only half of what it is worth, and sometimes I don't even get a third. And during the time that I am doing it I have to live and support myself; nothing to excess, not the least bit of luxury of any kind whatever. I am even obliged to torment my wife if I am to get her to make a hat for herself, for she makes all her clothes with her own hands and, except for my dinner coat, she makes all of my clothes. That is not the least of her virtues. And as we have to keep up certain appearances, you can see where all our money goes and why it is that we can only just about make ends meet.

From a letter to M. Marcotte.

Rome, May 26, 1814

. . . As for David, let him alone; I have big reasons of my own for not having any kind of contact with him; and all I want is that he should see my works at the Salon.

. . . .

I am sorry that my little picture, *The Sword of Henri IV*, did not please you. But I will defend myself on every point. For that picture is true in drawing and in pantomime, pure in the details, with well-proportioned figures and carefully considered taste in the relationships. All those who saw it here have considered, and I was of their opinion, that it was true and strong in color, and that it had a good deal of the quality of the Venetian school, which I shall always think of when I paint. It is very delicately executed, and all the details are finely worked out, but not with the finish of a Gerard Dou, whose type of execution is wearisome and not esteemed the least bit by the painters of the Italian school, nor even by the excellent Flemings, as to whose works you give me a very proper reminder. The most able pictures by any of them are those of Teniers which are only brushed in but which are fine because the brushwork is exactly in place and used with feeling.

And now I will remind you of Metsu who is, par excellence, strong and delicate in his touch, and I could cite any number of other men. After that I beg you to tell me whether finish like that of Gerard Dou is not insipid and useless. I am very far, to be sure, from equaling those great painters, whom I shall always take as models; but I believe that in the matter of execution my picture has a certain aspect which recalls them; not to speak of what I may have added as a historical painter, a title that gives us the privilege of doing better work in every branch than what you get from the man who has merely a single specialty.

From letters to Gilibert.

Paris, February 19, 1827

. . . But my dear friend, what a life I am leading here! It is a delightful life, in truth, because it is the life of study. I live walled up in my studio day after day, from nine till six, when I go and get a meal and rest up a little, so as to resume my preparatory work for what I shall

do next day if, by good fortune, the tyrannous rules of society let me go ahead. New Year's day and the Carnival did manage to flatten me out with dinners, parties, visits, etc, etc. I am living with nature and the finest models, who reveal to me the classic beauties of Phidias and of Raphael; they reassure me even more, if that is possible, as to my beliefs, my doctrine, and the faith of which we have spoken so often.

You must know, my dear friend, that as soon as I arrived here I got to work on a finished sketch in color of our *Homer*. Not a person who has seen it but says the most wonderful things about it (I venture to report this to you, but let it remain between ourselves). M. de Forbin (the Minister of Fine Arts) has been talking about it; he is still doing so — in every drawing room, and they say that great hopes are entertained for it. As for myself, frankly, I have hopes also and I am quite excited. My studies, which I carried so far along, have caused everything to be confirmed and sanctioned, all the ideas that you are familiar with are expressed in them and given their full accent. Don't worry: *your Racine* is in the picture and I have given him a fine place, right in the same line with Corneille; but I am still doing it with reluctance. I am, you see, far less of your opinion — especially on account of the reasons you give me. You must understand that my mind is wholly set upon antiquity, that I am more of an arch-antique than ever, and that any comparison with the moderns seems to me a blasphemy. The more he is Racine the more guilty he is in my eyes. I cannot admit or understand your flower of poetry. What graces, what styles, what modes are there with which the ancients were not familiar? As for that other man of yours, that blasphemous and unworthy Voltaire, it is only in the matter of taste and high poetry that I admire him. Along other lines, I leave him to fight it out with Racine, and I don't care much which of them wins. I say all of this without rancor, my dear friend. Since we are fundamentally agreed on so many things, it is not astonishing that we should differ on one point — which does, however, astonish me, because that point is bound up with a fundamental taste for the ancients which I know you to have. I went to an evening of quartets given by

Baillot. There is nothing to compare with what he played and, as for the man himself, he is sublime.

<p style="text-align:right">Paris, March 15, 1831</p>

. . . It is really not worth while to defend the men of the present day, nor the things either, for can one call it living to live like this? What general blindness! Here and there a Cassandra may raise a prophetic voice, but people are deaf to it. Self-interest, the ego, and treachery reign. What a future! with so many elements of happiness and glory for men, they are—one must confess—as stupid as they are wicked. I cannot prevent myself from thinking that, every time when I enjoy a fine day, when I enjoy all the fruits of the earth, the sight of a *bel viso virginale,* or the sound of a symphony by Beethoven . . . I need music as much as Saul could have needed it to heal his mind. It does me good for a time, but when it ends I think that Mnemosyne sets my nerves on edge more than they were before, and renders them even more irritable.

There you see the state that I am in . . . and for the first time I am going to use singular language in writing you. I am almost disenchanted as to my future, founded as it was on what I used to call glory. I have to work hard because I know beauty, I have to undergo great torments with it, night and day. Suppose I succeed: I can be appreciated only by a very small number of men, and they are dying off every day; so that I tell you emphatically, my dear friend, I am ready to say: the devil take everything! Life is difficult enough in all its vicissitudes; and I am still supposed to go, all by myself, and confront the ignorant, interested and brutal masses. It is in vain that I raise my voice, *nowhere* am I listened to. If Raphael himself came he could not make himself heard. Gluck is driven out of the Opéra. Read the magazine entitled L'Artiste; go so far as to consult the doctrines of the leaders of the art of today, Messrs Gros, Gérard, Guérin and all the rest. The hand of death is on everything. Am I to be the only one to make an effort? I think I can hear you saying: "paint your pictures, work: you will force their

hand, you will be able to operate some miracle." I am willing to believe that I could do something, if there were any justice, but at what a price! Do have a little pity on me then, and don't bring me to the grave before my time.

And who is it who has made most sacrifices, in the sacred cause of the arts? I spent more than five years in painting my picture of the *Virgin*. I had to borrow in order to paint it, and I am hardly getting out of the debts that I contracted in order to do it. I should be rich, if people had been fair with me. "Paint your pictures!" That's all very well; but in order to do them in the way I do, I need a great deal of time; it is just in proportion to their merit. Art is much more difficult for me than for the others, as you well know. I work long and laboriously, although my things have the look of being done promptly and with ease. Where the ordinary painter would think the work perfect, I find a thousand imperfections, and I do not start over once, but ten times.

As to the present state of the picture I am doing, it is still only a lay-in, and for the reasons I give above. I do not blush on that account. Down to the present, my one feeling about it is hope, judging by the goal I have set myself. To feel or to paint otherwise is something I cannot do, and I should be wrong in trying to do otherwise, because that is the way things stand, and that is just why my works are remarkable. The longer I take to give them their form, the longer they will live.

Does all that make me happy? No. I have a bit of belief in the end of the world, the thing that is used to frighten us. I want honestly to rid myself of things that weigh too heavy upon me, and just live like a good bourgeois, as the saying is. I haven't any income from investments; my craft and my small position give me what money I have, and I refuse to worry my head about it. My picture will be finished when it is finished; if that isn't till ten years from now, I'm not going to bother. After that, we shall see. I refuse myself no pleasure that I can honestly have. *My own opinion is that I have worked hard enough.* I go on living one day at a time; in the morning I get ready to cover the distance until evening in the best way I can, following the example

of the amiable company of Boccaccio when they were taking refuge from the plague. I don't want any more worry for myself nor for other people either.

My excellent wife, who is rightness and wisdom personified, does not perhaps quite agree with my point of view, but she isn't so far from it and, above all, she wants to see me happy. As for me, I love her, and always more than before. She shares my lot without complaining. I hope to make her happy. We have peace and good health.

After the big page that I am engaged upon, I shall go back to small pictures, just to have a good time. They even bring in money, one purpose of which is to assure the future of my dear helpmate, who would answer that there would always be enough for her.

From a letter to the Minister of the Interior
(Not dated but certainly of 1835)

. . . I have obtained, and without difficulty, the respect and the entire confidence of the young men who are in my care and who are, for the most part, quite able artists. I am happy to be able to give assurance — and the following is not addressed to you, Monsieur le Ministre, who have given such intelligent support to the French Academy in Rome — that this School is not only a glory for France and for foreign countries, but that it is also the sole and true source which essentially maintains the supremacy of French art in Europe.

Letters to Edouard Gatteaux.

Rome, June 15, 1836
. . . I have so much confidence in you, considering you, as I do, as the most sincere man of all I know in this world (and I except no one) that, from my point of view, I believe it will be useful, I believe it my

duty to be of an absolute sincerity in informing you of the way I stand at present and of matters that lie next my heart.

I have refused to paint the Madeleine; I would refuse again, but not at all for the reasons that you advance. [Ingres had been criticized for slowness which, it was said, unfitted him for doing big mural works]. Once having given my word, I should have been able to keep it, despite everything; for I am quite as capable as the next man of doing work in a short time, as I did with the *Homer* ceiling, which is only too finished. In the advice to refuse that you gave me, you did not leave me the right to think that, in accepting, I should find an opportunity which would be unique, an opportunity like those which led our great painters to do so many splendid things; in a word, opportunity — the thing that produced Napoleon. . . . Well now, my dear friend (do not think that I am reproaching you in the least, though I consider that in this case you were lacking in patriotism, you who have so much of it, and give the greatest proofs of it every day), you ought, because of that very sentiment, to have been the first to advise me to accept that noble mission for the advantage and the glory of the country. . . .

According to you, I have made "a grave mistake" in going to Rome. The grave mistake is far more on the side of those who allowed me to depart, above all on the part of the men composing the Administration. But since causes exist, since they are always the same, I should do over again that which I have done, even had I to suffer once more all that I have suffered.

. . . The largest number of pupils that anyone since David has had, have brought me in very little, financially speaking. To make up for that I have gained a lot of ingrates, as many as possible. I cry out in the desert: "Love the true, and the beautiful which derives from it!" Deaf to my voice, they blaspheme at truth, seek out error, practice ill faith and use it for their purposes. In the fury of their passion, they do me the honor to associate me with the Ancients, the Saints, and the Gods, and with tooth and nail they try to destroy the granite pedestal on which such beings have their place. *Babilona! Babilona!* The arts?

People no longer want to have anything to do with them; people get on without them. The serious arts? Even less; they are in disgrace, forgotten! What, then, is there to do in such barbarous times (for we are in a state of complete barbarism), what remains for an artist who still believes in the Greeks and the Romans? He must retire. And that is what I am doing. Not one more brushstroke for this public which has so little feeling for the art that is noble.

Paris, July 20, 1843

(The following lines refer to his work on *The Golden Age*.)

I have a model of the whole thing in wax, to get the effect of the shadows, and I have about sixty figures in it. I wanted to send you a rapid tracing of the design. That will be for later on.

To M. Marcotte

Dampierre, August 8, 1847

. . . That cruel tyrant [his painting] even prevents me from sleeping, so absolute is her demand that she alone shall rule, and you can't imagine how she makes me toe the mark! In the first place, she won't even let me take a bit of a walk, even to go around the château, or perhaps only on the rarest occasions. As soon as I'm out of bed, my orders are: get to work, prepare your materials and be off with you until noon. Then I am allowed to give a little glance at the newspaper; after that, from two o'clock on, she drives me forth to the gallery, where I have got to keep on the go until eight o'clock without a stop. I come in for dinner, harassed by fatigue . . . and yet I love her, the hussy, and with passion, at that; for, looking at things squarely, she loves me too, and if I did not repay her in full, she would threaten me with weakness, with decadence in my work, she would threaten me with abandonment and even with death. And that's how it is that, after many an effort,

and keeping up one's courage, one does not too much feel the weight of one's sixty-seven years, well rounded out though they are.

Letter to Gilibert and His Daughter Pauline

Saturday, July 28, 1849 (A fatal day)

. . . She is dead, she has been taken from me forever, that admirable woman who was sublime in her cruel death. No, no, there is nothing I can liken to the frightfulness of the despair which seizes me — and to think that one does not die of such suffering! . . .

Oh, how I wanted to follow her! They prevented me from doing so; they tore me away from her. She is dead, dear friends of my heart, she is dead and I shall never see her again. My despair simply goes on, I cannot describe it. The innocent, admirable, heroic woman, I shall not see her again, never again. I think this grief will kill me. My dear child, my very dear friend, have pity on me!

And yet, dear girl, you whom she loved like a mother, spare her friend, that gentle father of yours. Do not let him learn this frightful news without sparing him in the tenderest way you can, for it might endanger his health and that heart of his, which is only too kind.

Letter to Armand Cambon

Meung, September 22, 1857

. . . I am feeling pretty well here, and my work goes on at its accustomed pace. And it is just on that account that I am begging you to do me a small service: it would be to look up, among the innumerable tracings or engravings from Greek vases, the apotheosis of Hercules, carried to heaven in a chariot, by Minerva. Hercules has his club on his shoulder, and I need that. Without making a tracing of the whole design, pick out for me the arms of Minerva and the part with the chariot

and the wheel. Please be so kind as to trace just those two details and to send them to me.

Letter to Henri Lehmann

<div style="text-align:right">February 8, 1865</div>

Dear friend, Since our interview, I have given much reflection to your request; but when one has conceived a work, it must have a sustained character. That of the present composition is completely Homeric. I must tell you therefore that, despite the high renown of the man and his incontestable talent, I cannot make up my mind to place in the number of my "Homerics" the author of *Faust* or *Werther,* and of *Mignon:* works that have been too much spread about to suit my taste. I cannot put in all the illustrious men, and it is with respect that I find myself compelled to evict my beloved Mozart,[2] Tasso, Camoens, Pope, Shakespeare and many another.

(M. Boyer d'Agen was invited in 1897, when he was editing an art magazine in Paris, to publish extracts from Ingres's manuscripts, which are preserved in the museum of Montauban. Delaborde had already drawn on them for the materials which I give on earlier pages. Supplementary extracts, as selected by Boyer d'Agen, follow below.)

Proclus says that he who takes as models the forms of nature and who limits himself to imitating exactly will never be able to attain perfect beauty, because the productions of nature are full *of imperfections, and consequently far from being able to serve as a model for beauty.*

(Boyer d'Agen makes a note to tell that this whole passage is crossed out with numerous slanting pen strokes, and that the words in italics are obliterated by a single stroke running through them. It is his idea that the realist in Ingres revolted against the above Platonic proposition, as the editor calls it.)

[2] *As stated earlier in this book, Ingres changed his mind once more about Mozart and put him into the* Homer Deified *which he completed in the same year.*

Notes, Letters, a Document

Traveling through Montfaucon, I became convinced that the history of old France, from the time of St. Louis and others, would offer a new mine which could be exploited, that the costumes of the period are very beautiful and that some of them approach the Greek; even those which seem bizarre may perhaps look so only because of the scanty art through which they have been transmitted to us; but beautiful heads, beautiful bodies, fine attitudes and gestures are of all times. A historical painter who made himself well acquainted with that century might draw great advantage from it, indeed the finest possible kind of advantage from the point of view of art; it would be of the greatest interest to our contemporaries; for Achilles and Agamemnon, splendid as they are, mean less to our time than do St. Louis, Philippe de Valois, Louis le Jeune and many another. It must also be admitted that the love of religion which animated those old warlike times gave to pictures a look that is mystical, simple and grand, particularly in the case of women; but even in the case of men, this is still true. I therefore conclude that I ought to consider this road to be the right one; I should content myself with exploring the Greeks, without whom there is no true salvation. What must be done is to amalgamate them, so to speak, with this new type. In this way I can become a skillful innovator in things of the mind, and give to my works that fine character unknown until now, and which does not exist save in the works of Raphael. I have the conviction that if Raphael had had to paint Greek pictures, he would interest us far less; I venture to say, indeed, that even with our lofty idea of the Greeks, one derived from their monuments, he might have made us very critical of his results. Therefore let us paint French pictures, those of Duguesclin, Bayard and the others.

Idleness resembles rust: it wears you away more than work does.

Remarkable analogy between the century of Pericles and the Renaissance.

Nicolas Poussin had taught Gaspard Dughet to see nature in a large way when painting landscape, and he continued to direct him in the matter of figure painting; that is why the works of this artist contain so much of elegance and of erudition. He painted with great facility and could do a picture in a day. He did several pictures with glue or tempera; they seem like preparations, because of their lightness and weakness of tone— like things to which he meant to return with rich oil glazes. I believe that with several of the old painters, especially with the colorists, I have distinguished the same method of preparing pictures: through colors with a glue binder; on such painting, the finishing work has been done with oil.

(A very important document for the understanding of Ingres is his report to the Permanent Commission on the Fine Arts, of which the Duc de Luynes, as the "representative of the people" was the president. The first part of the report on the organization of the following Salon is written as if by another person, but later on, as will be seen, Ingres speaks for himself.)

The recent Salon did not scandalize Ingres as much as has been claimed. He considers that there should be complete freedom of admission. His ideas may appear casual or eccentric; he does not consider that this is the place to go into them in detail. Freedom should be unlimited, because in many cases the refusal of a mediocre work brings to despair the man whose brushes are his only resource in earning a living for himself and his family.

To be sure, in the sickly state of art at the present time, the real remedy would be a heroic one: what should be done is to close the doors of the Salon in absolute fashion. People will say: Monsieur Ingres is a barbarian, Monsieur Ingres destroys! No, he is not a barbarian. If he destroys, it is in order to build anew.

To remedy the present overflow of mediocrities, which is the cause why we have no longer any school, to remedy that banality which is a public misfortune, which sickens taste, and overwhelms the Adminis-

The Princesse de Broglie, 1853, Collection of the Duchesse de Broglie, Paris

Mme Ingres (Delphine Ramel), 1856 (or 1859). Collection of Mme Albert
Ramel, Paris

tration by absorbing its resources without producing any result, the thing that should be done is to renounce exhibitions, there should be a courageous declaration that monumental painting alone will be encouraged. It should be decreed that we decorate our great public buildings and our churches, the walls of which are thirsty for painting. Those decorations would be entrusted to the higher type of artists, who would employ the mediocre artists as their aides, and the latter would, in this way, cease to oppress art and would become useful. The young artists would be proud to aid their masters. Everyone who now uses a brush could be utilized.

Why is it that the Italians have such sensitive ideas about painting? It is because they see it everywhere. What hindrance is there for France to become a second Italy? Does it not possess everything needed for it to become the first of the nations in art?

According to this plan, there would be glory, profit, and humanity in the manner in which the resources of art would be used. The superior men would be honored to receive worthy employment, and budding talents would be encouraged.

To come back to the exhibitions, either they should be suppressed or they should be open to all.

(A later passage in the report follows.)

Exhibitions have become part of our habit of life, it is quite true; therefore it is impossible to suppress them; but they must not be encouraged. They ruin art, for it becomes a trade which the artist no longer respects. The exhibition has now become no more than a bazaar where mediocrity spreads itself out with impudence. The exhibitions are useless and dangerous. Aside from the question of humanity, they ought to be abolished.

We must follow the same procedure as we had last year, and open the doors of the exhibition to all. Humanity and art itself are interested in that solution of the problem, for it is the most liberal of all. Society

has not the right to condemn the artist and his family to die of hunger because the productions of that artist are not to the taste of this or that person.

Exclusion could not be applied to any productions save those that are immoral, scandalous, or unquestionably ridiculous. A jury, whatever the manner adopted in constituting it, will always function badly. The needs of the time demand unlimited admission. . . .

I regard as unjust and immoral any restriction tending to prevent a man from living by the product of his work, as long as he does not attack morality.

What is your Salon at present? A bazaar. You should open it to all. We must learn to accommodate ourselves to freedom in its fullest extent, whatever may be its drawbacks.

(The above is taken from *L'Opinion d'Ingres sur le Salon,* minutes of the *Commission Permanente des Beaux-Arts,* 1848 to 1849, published by J. L. Fouché in the *Chronique des Arts* for March, 1908.)

PART III

THE ART OF INGRES:

Revolutionary, Classical, Realistic, European

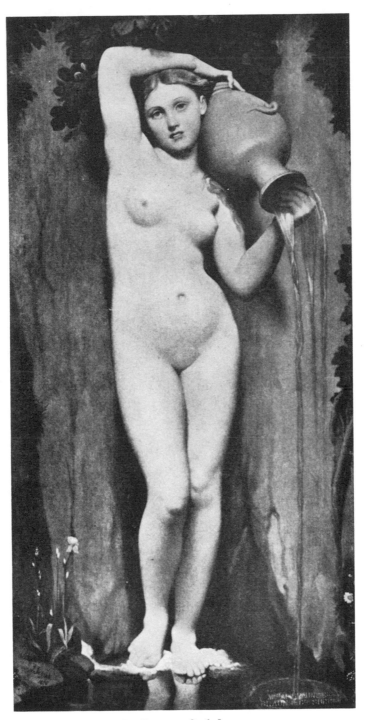

La Source, 1856, Louvre

Study for the Birth of the Muses, 1856, Musée Ingres, Montauban

CHAPTER I

The Revolutionary

SOME READERS, STRUCK BY THE MORE DEBATABLE PARTS of the foregoing pages, may have been coming to an opinion that the main thing proved by the words of the artist is that Roger Fry was quite accurate in calling Ingres a schoolmaster — which he did, using some other epithets also, that add pretty stiffly to the derogation in the term. Ingres has at times deserved them all (and there are moments when one would be willing to add some others for good measure); but there is a parallel word which has only an honorable, even lovable connotation, and that word is "teacher." Now what is above all necessary in order to teach, is that one first have learned, and if, as I hope to show, Ingres went deeply into the matter of learning, we may well pass by the "hectoring, blustering" tone that annoys Mr. Fry in the speech, and sometimes in the painting of the older artist. We shall then see to how great a degree the principles we are offered, in the words and in the work, are inspiring and sound.

That does not mean that I shall try to prove them all-inclusive or free from defects. As to the latter words, I return to that sentence of Charles Blanc's which I cited before: "Exaggeration was the distinctive trait of his character and his mind," and no man of whom that could be said by a competent critic may be accused of that most tiresome defect of being "faultily faultless." Ingres has his faults, but they are usually of the kind that render a man only the more appealing. As to any attempt to make him universal, I think no one is likely to blunder in that direction, though disservices enough have been done to the artist by men who have shut their eyes to his limitations, both those of his painting and those of his understanding.

THE ART OF INGRES

If the first thing a teacher needs is to learn, it is not the last one, and his learning is a poor affair if he does not go beyond his master. Leonardo said that, and I think some people have imagined he was ironical when saying so, as if he were mimicking the speech of a self-conceited pupil who merely thought himself superior. I am sure that was not the great man's idea: he meant that a student of any originality must see the mistakes of the instruction he has received, and correct them. That was what David was able to do, as regards the elegant painting of the later eighteenth century, and his activity in the political revolution of his time was probably a result, in part at least, of his bitter resentment against what he called the "academic" school in which he had been trained. The teaching he gave to Ingres and his other pupils (hundreds of them, including such mighty figures as Gros and Rude) was perhaps the best that has ever been seen in Europe.

Part of it was, of course, through his own example, and that was what Ingres was following—whether or not he realized he was—when he, in his turn, revolted. Did he thereby become a counter-revolutionary? To say so would be to affirm that he stood for reaction; and the first (and last) glance at his work must convince us of the absurdity of such an idea. He points forward, not backward, and I say this in the face of all the reminders we have just had from him that he sees perfection only in the Greeks and in Raphael. I will add to that point: not only does he fail to see the greatness in his contemporaries, above all Delacroix, a most glorious master, but we listen in vain throughout his life for a word of really powerful admiration for any modern artist. Though music reached its apogee only during his lifetime or shortly before it, he could still recognize its great masters and indeed give them passionate devotion. But where do we find a word comparable to those he spoke of Gluck and Beethoven when we listen to his opinions on the painters and sculptors of his time?

He inscribes his drawing of Hippolyte Flandrin "to the great artist," and the complete and characteristic sincerity of the words is borne out by his desolated feeling of loss on the death of that admirable pupil,

whom he had hoped to see carrying on his tradition. But can anyone dream of his looking on Flandrin as becoming a master of really high rank? I have said he was sincere when he paid his compliment to the faithful follower but, even if it means accusing him of inconsistency, I am obliged to recall the scene, so graphically recounted by Jules Laurens, in which Ingres, exasperated to the last degree by foolish praise of Flandrin, finally broke forth with the words, "Anything you like, only — it's the painting of a goose, do you understand? of a goose!"

And the painting of Flandrin was his own! — minus the brains, the spirit, the permanently revolutionary quality that must be in every man who is to deserve the words "great artist." When he wrote them on the drawing he presented to his pupil, he made the easy, paternal, confusion with such a phrase as "the able craftsman"; more critical men than he might have made the mistake. For there are few persons who can resist such homage as Flandrin gave to his master — and to the principles defended by that impassioned fighter. It was when carried beyond his partisanship by the words of a stupid adulator that his deeper thought appears and he denounces the slightness of his friend's equipment.

Flandrin had learned from him every lesson save the one which Ingres himself had drawn from his contact with his colossal teacher: that one must go one's own way, even if it opposes — and, in many cases, necessarily opposes the way laid out by one's preceptor. If our artist could not always apply that final lesson in the case of other men, he learned it thoroughly for himself.

The revolt of his youth continued throughout his life. The passionate denunciations of contemporary artists and their public that we have had from him again and again in the foregoing section, are all a result of his uncompromising hostility to what he considered a lessening or a misunderstanding of the classic values. David had misrepresented them, had "deceived" Ingres about the primitives, as he said: he rebels. Gros, Géricault, and Delacroix gave themselves up to false gods, to Rubens and others in whom draftsmanship was not the sole

or even the dominant quality, as Ingres sees it: he rebels. He will let no authority be mentioned in the same breath as the one he recognizes: "there are not two arts — there is only one!" as he so vehemently affirms, and so magnificently — even if he fails to recognize certain great men.

His lifelong revolt is against those who betray art, or distort it, or endanger it. "Yes, to be sure, Rubens is a great painter: but he is that great painter who has ruined everything." Does it never occur to him that he may be wrong, or if he is not wrong, that there may be aspects of the truth which he has missed? He never even asks himself the question, apparently; and when he is reproached with his "exclusiveness," he answers that it is only in his opposition to what is false. If one is asking for breadth of view, one must ask it elsewhere, not from a man whose life course follows that rigidly straight line from the drawing of his childhood to that of his old age. The man who could create the figure of the *Bather of Valpinçon* at the age of twenty-eight and use it almost without change at the age of eighty-two is not a person whom one can ask to widen his views. His goal is perfection, not eclecticism, even if it could bring with it such fine things as balance and breadth.

I raised the question of his consistency, and it is certain that in matters of detail he is the most inconsistent, the most whim-ridden of men, but in the essential conduct of his life, he holds to his purpose with a tenacity that no one has ever exceeded. The two phases of Ingres appear in a story told by Lefrançois, a favorite pupil of his, who accompanied him on a trip to Orvieto, during his second sojourn in Italy.

He had never before seen the great frescoes of Luca Signorelli in the cathedral, and he "fell in love with them with the violence that he brought to everything that he did." It was at once decided that the friends remain in Orvieto — "at least two weeks," for Ingres must study the powerful works, pencil in hand, and get to the depths of them. He started in promptly, but as Lefrançois watched the progress

234

of the master's drawing, he was astonished to notice a growing distraction on the part of Ingres, who wriggled about in his seat and appeared unable to concentrate on what he was doing. When the pupil inquired whether he did not like the figure he had begun to draw, Ingres replied, "Oh, yes I do. Of course I do. It's fine, it's very fine; only . . . it's ugly, and then, look here, I am a Greek, myself—let's get away!" A few minutes afterward, he left Orvieto—and never thought of Signorelli again.

When one recalls a later and not less absolute man, Cézanne, when one finds him seeing the Greek in that glorious Signorelli who gave us the *Pan,* at Berlin, and the other evocations of antique deities, when one thinks of how the compositions of the recent master could use again the Signorelli figures that so inspired Michelangelo, we see what Cézanne meant by exclaiming, "Ingres, despite all his style, remains a very small man." But to say that one understands the remark is not to say that one agrees with it. All that style could not have been achieved without the drive of a terrific force, such as would have wrecked a small man; and Ingres could control it, could make it fruitful.

The explanation of our difference with him (for I assume that we all take Signorelli's side today), the trouble that exists between Ingres and his opponents—or fancied opponents, especially Delacroix, was that the driving power which carried our artist so far was concentrated within a very narrow channel. In this respect he was a true follower of David, who might well have used Ingres's words: "for strong ills, strong remedies." That was what the Revolution had done, with its wholesale killing under the guillotine—and we recall Victor Hugo's comparing David's activity in the camp of Robespierre to his influence on art.

CHAPTER II

The Revolution Continues

THE PERIOD WAS ONE OF STRONG PASSIONS; IT NEEDED A riper time, more philosophic temperaments, to see things in a happier relationship. When Delacroix wrote in his *Journal* (which is to say in pages that he meant for no eye save his own) that a time may come when Rembrandt will be placed above Raphael, he almost recoils before what he calls a blasphemy (Ingres's word)—or what will appear to be one to so many people. But Delacroix *could* write the words: he was born after the Revolutionary fury was passed, and his classical education gave him, from the first, an assured acquaintance with Greece and Rome that Ingres gained only through later striving. Perhaps, however, the best reason (save the native breadth and power in the mind of Delacroix) was that he had, as a young man, made the great journey to Morocco that, for the rest of his days, gave him memories of a people completely different in life and philosophy and art from those of his own Latin stock. And it was among these strange people that he got, as he said, his deepest vision of antique beauty!

Look now at Ingres following Roman statues for the robes of his Christ in the *St. Peter* picture of his early time: remember that, in his old age, he writes to a friend for a tracing from a Greek vase so that he may go on with the figure he is doing, and you see the difference between the literalism in his following of classics and the quality of mind of Delacroix, who imagines them to himself without ever setting foot on the soil of Italy or of Greece. Not for nothing did Corot say, "Delacroix is an eagle." He is never more so than in this encompassing from the heights of the classical values, which mingle with his Romantic fervor.

2 3 6

The Revolution Continues

As I shall come before long to a presentation of Ingres's side of the famous controversy, I can go on, for the moment, with unfavorable aspects of it. The personal aspect is certainly one of them. Delacroix, as the younger man, always maintained a certain deference toward his rival, and the high-bred courtesy which shows in every act and word we know of, throughout his life, naturally kept him within the bounds of urbanity, at the very least, in the face of rebuffs and even insults from officialdom and the critics which make one feel that the things Ingres complained of so bitterly were, by comparison, very slight matters indeed. The direct, personal communication between the two men remained on a plane worthy of their great position; the difference in their procedure, as far as my reading informs me, consists in the things they said to the people around them, and in the activity they thus set up among their partisans.

We must remember, when thinking of the strictures which Delacroix uttered about Ingres that none of them was known to the world at large until 1893, when the *Journal* of the Romanticist appeared, many years after both men were in their graves. Even so, Delacroix wanted it destroyed before he died. This was scarcely because of references to his rival, which are infrequent in it; but it bristles with revelations about himself, which he set down in order to face them in the evenings when he re-read the notebooks; he would have hated to see such material fall into the hands of others. (Since that did not occur till thirty years after his death, and since the *Journal* is probably the finest book in the literature of art, those who published it needed to feel no compunction on the score of violating his privacy.)

In one respect the two great men are meeting on common ground in what they say of each other: both are talking of the principles of art, and the personal aspect of Ingres's remarks which I spoke of before comes from the fact that he let out his resentment to those immediately around him, and so must take his share of the responsibility for the attacks on the other man.

The most celebrated and picturesque instance of the kind is the

237

one relating to the visit made by Delacroix to the section devoted to the work of the Classicist at the exhibition of 1855. I give it in the words of Amaury-Duval, because he is both a contemporary of the two men, and one whose devotion to his master would have made him reject the story if it could be considered doubtful. He gives proof of this in the two paragraphs after the essential one, with which I begin the quotation.

That reminds me of a famous phrase attributed to M. Ingres, and it must be accurate, for Delacroix said—when recounting to me the story of his visit to the Ingres gallery—that he had been surprised by the master there, and had received a pretty cold salutation from him. Hardly had Delacroix left when M. Ingres called an attendant and cried out to him—"Open all the windows, it smells of sulphur here."

That phrase portrays M. Ingres and all the seriousness, all the passion he felt when art was at stake; but for those to whom it does not cause a smile, it may appear as more than severe. Yet it is merely the expression of a taste purified by study of the beautiful, and it is not the beautiful, one must certainly say, that dominates in the work of Delacroix,—I am speaking of form, be it understood; it was because of that quality that M. Ingres felt the hatred which he did not conceal.

Those persons, moreover, who seek in works of art something other than a *series of samples* of happy tones, those persons who are charmed but not deeply impressed by a Turkish carpet, really have some right to refuse so high a place as certain critics give to the incontestable talent of Delacroix.

Since we have read again the delightful scene where the devil visits the archangel, we may consider the other side of the matter, in the most significant of the judgments which Delacroix pronounced upon the work of Ingres: "The complete expression of an incomplete intelligence." Devastating as the epigram is and, as I wrote years ago, capable of misleading even while it illuminates, we are bound to see it as a reasoned verdict and not as the result of what Amaury-Duval, in speaking of his master, calls hatred. The object of that feeling, here, is a principle and not a man, true enough, but it is still a thing of the emotions rather than of the intelligence.

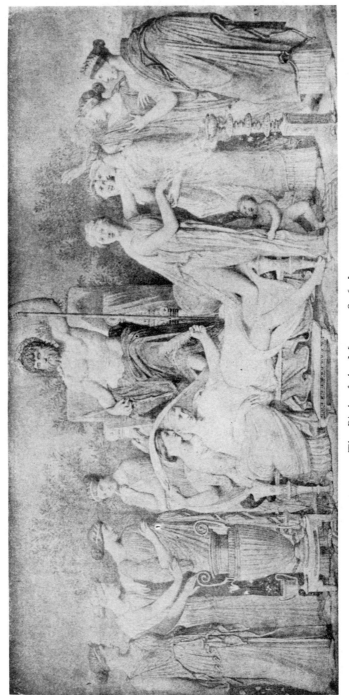

The Birth of the Muses, 1856, Louvre

Study for the Portrait of Mme Moitessier, 1856, Musée Ingres, Montauban

The latter faculty might well seem the one most to be demanded of an artist whom the world has agreed to call classical; emotion, of which Ingres is obviously so full, appears, on the other hand, to be the very stuff of which Romanticism is made. The solution of the seeming paradox is reached when we note that Ingres has a share in the Romantic tendency not alone through his period but through his nature. His rediscovery of medieval France, of which we have heard him tell, is parallel with Delacroix's excursions into little known scenes of the past, but the very center of Ingres's interest, the renewal of contact with the life and thought of Greece, was in itself a Romantic adventure. And introspection, his chief means of accomplishing his purpose, is a Romantic process of the most clearly defined type. Had his emotional nature not been involved to a very full extent in his pursuit of the ancient gods, had the *Venus Anadyomene* or *La Source* not drawn upon the man's feeling for the actual world, had not—in a word—Romantic values generously fused with his Classical harmony and balance, his work would have lacked an element which must exist in every painting (or sculpture), to some degree, if it is to rank as art.

In the most purely Classical works, there is a Romantic quality. In the calm of the *Apollo* at the center of the pediment of Olympia, in the ineffable grandeur of the *Theseus* from the Parthenon, the feeling of the particular sculptors who wrought those supreme works has its share in the effect, alongside the general or universal principles on which they repose. What is out of place in a group of Classical things is the academic. Throughout most of the nineteenth century, the time when the school led by David and later by Ingres dominated instruction, the academic had its spurious Greco-Roman look, but in later times this has changed, and we have academic Impressionists, Post-Impressionists and Cubists. So that the cry echoed by Théophile Gautier, "Who shall deliver us from the Greeks and the Romans?" was addressed to superficial matters only. The academic goes beyond externals such as the helmet of ancient warriors, a sort of stage "property" that appears so often in Salon pictures. Because of its resemblance to

the headgear of the modern French fire brigade, it gave rise, in the
studio slang of Paris, to the word *pompier,* to designate the art of an
outworn school.

What is more important, however, is to come to agreement on the
term "Classical" and, following the rejection of externals, such as we
made just now, our first step is to say that it has no necessary connec-
tion with a certain type of nose or brow, with certain folds of drapery,
certain poses of the figure, or with buildings characterized by columns,
pediments, and the other details of the Greek temple. The question of
the Classical is one of qualities. In these pages, we have repeatedly
noticed them: such things as proportion, harmony and equilibrium.
They were, of course, the supreme interest of Ingres, throughout his
career, but his "exclusiveness" took another turn than the one he in-
tended in speaking of the masters, when it caused him to see the Clas-
sical qualities only along the lines wherein he excelled.

The quotation from Amaury-Duval which I last gave, betrays,
through the words of the faithful pupil, the confusion in the mind of
the master. The two men definitely limit the judgment on Delacroix
to the question of form. When the writer of those paragraphs touches
on the expression of what he calls Delacroix's incontestable talent he
confines it to a matter of "happy tones" spread out in samples: an
échantillonnement, as he calls it, and he puts the words into italics
in order to emphasize the smallness of the aesthetic quality he recog-
nizes in the colorist, a quality one can see in a Turkish rug. What he
fails to see is that art is a bigger word than aesthetics, and that the
nature of a picture is as different from that of a Greek vase as it is
from an oriental carpet; he fails to see that form — quite like color —
is only an agent for the rendering of ideas, the sensation of life —
which often comes to us in terms wherein drawing plays only a limited
role. But part of the dogma he has accepted from his master is that
"color is only the tiring-woman" who dresses the queen. To reverse
the question: people who care exclusively for color are just as far
astray in seeing line as no more than the attendant factor, defining

the contours of the tones; such an idea is, of course, just as futile in explaining the nature of art, though no further than the other one from a truly classical approach to it. Both attempts at analysis mistake the means for the end, both fail to see that a picture is great when a deep conception of the world, of nature, of life has been rendered — no matter whether it be by line or color (most probably it is by both, in one or another dosage).

When I say, as I have just done, that Ingres fails on questions of judgment, I speak of his shortcomings as a critic, and not as an artist. Yet when, sixteen years ago, I warned against that brilliant — and perhaps just epigram of Delacroix's, I did so because it is all too easy to see Ingres's defective appreciation of other arts as if it were a defect in his own. I asked, in *The Masters of Modern Art,* whether anyone thinks that Ingres would have been more important as a painter if he had broadened his understanding of his rival. I strongly doubt any such idea. The question is not as to the number of qualities from which he derives his beautiful harmony, but as to the height he reaches through them.

We have seen that the driving force behind his search for perfection was the revolutionist's grand refusal to compromise, to make "peace with wicked men," in the words he quotes from the "good La Fontaine." It is a noble rage that possesses the old man when he curses the "termites" that gnaw the marrow in the roots of art until the great tree is ready to fall. If he is mistaken in his judgment, if the tree continues to flourish and he has seen evil where nearly all the world sees good, our regret must be for the unhappiness he went through as he witnessed the growing triumph of artists whom he looked on as his enemies. But the gods are just, and if Delacroix came into his true place despite the opposition of Ingres, the latter had compensation for his minor defeat, in the intimate conviction he could well feel, that his own work was carrying on in the direct line of his beloved classics.

CHAPTER III

The Classicist

FROM FAR-OFF AMERICA, THE UNKNOWN LAND, FROM A CONtemporary whose name Ingres probably never heard — our own Thoreau, we get a definition which, I venture to think, would have been acceptable to the painter as a statement of his ideal.

"For what are the classics but the noblest recorded thoughts of man? They are the only oracles which are not decayed, and there are such answers to the most modern inquiry in them as Delphi and Dodona never gave. We might as well omit to study Nature because she is old."

The classics and Nature, both for the American and for the Frenchman, sum up our problem; and in my remaining pages I shall try to show the relationship to each element of the artist we are studying. If I come last to the question of reality in his painting, it is because I think the final reason for his importance resides therein.

It is men of recent times rather than the contemporaries of Ingres who have seen him in this light. The earlier day accepted both the pigeonholing under "Classical School" and the definition of that category as one concerned almost exclusively with line. Even the idea of form was sensed in a confused way, for Delacroix, with his profound mastery of chiaroscuro, his rendering of volume, and his glorious composition in depth, cannot possibly be excluded from the group — even a rigorously limited group of artists who have handled the quality of form in magisterial fashion.

On other occasions I have spoken of the magnificent range of Classical elements in the work of Delacroix, and it would be out of place to do so again here. He is predominantly Romantic in his cast of mind,

and to show, as I have tried to do, that Ingres himself has a Romantic strain is not to bring up the futile question of relative value in the two types of thought. Without making one of them masculine and one feminine, we might as well enter upon a debate as to whether man or woman is more important to the world.

The one approach to the question of Ingres's Classicism is the absolute, not the relative approach. The man stands four square, throughout his immense career, for the idea that all has been done, all has been discovered, as he says. "In letters, as in the arts, there is no salvation save for those who, steadily fixing their eyes upon antiquity, ask it in pious fashion to guide and instruct them." Such words, and we have heard many more to the same effect, might seem to exclude any interpretation except that of a hopeless inferiority for the modern world. But if Ingres himself says nowhere that a new age, even while accepting the guidance of antiquity, may rise to heights that we have never seen before, neither does he give reason for rejecting such an idea; and his own indomitable will, as expressed in his painting and the advance he made with it, shows that his thought of antiquity was due to anything rather than a counsel of despair.

On the contrary, his mood is that of serene faith; he has limitless confidence in the guidance under which he moves, and his anger at those who see differently is a result of his belief that they are showing disrespect to what is, finally, a divine revelation. So that, even when they have success with an "ignorant and brutal world," he can leave them to their outcry, and go on with his art in laborious and happy retirement. His whole work is eloquent of its delight. From the unclouded drawings of his first sojourn in Rome, through the great effort of the *Vow of Louis XIII,* through the series of astounding portraits, past that symbolic peak in his art which is called *The Golden Age,* and right on to the *Turkish Women,* of his final period, there is the same even temper, the same trust in the "oracles that are not decayed," as Thoreau calls them.

I shall turn presently, to the words which follow in the superb lines

243

of the American philosopher, and try to show in what way the classics, more even than Dodona and Delphi, have answered "the most modern inquiry"; but we are here considering Ingres in his relation with the antique, and so I may cite a suggestive word of Delaborde's: he says that the religious paintings of our artist are more suited to museums than to churches. It was a similar thought that I touched on in discussing the masterpiece that the *St. Symphorien* is, for the Classical elements in the mind of the master predominate over those which would have been stressed by medieval art in its greater closeness to Christianity, itself a purely Romantic phenomenon, and the one which puts an end, temporarily, to the Greek era that Ingres adored.

How splendid must his mission have appeared to him! Through his birth in the most classical part of France, and through his training under David, who proclaimed the return to antiquity (even though, in the eyes of his pupil, the earlier revolutionary was not fully prepared for the step), Ingres was specially designated for the course he was to pursue, and every step he took in the Roman *campagna,* every drawing he made in the museums of the land where he lived so close to the ancients, brought him new evidence as to his role in art. No wonder he is perturbed over the rude force of Signorelli, and bursts forth to Lefrançois with the seemingly presumptuous words "I am a Greek!" At the end of his life, he is merely consistent with all that he has been before when, unable to attend a session of the Academy in Paris, he writes it a long letter in defense of a great assemblage of classical objects, the Campana Collection, which certain governmental authorities proposed to disperse.

It is interesting to find in Delacroix's *Journal* his sketch for the letter to the Minister in which he set down very similar protests against any loss of prestige to this important possession of the Louvre; and it is a pleasure to note that the rivals were successful as to the cause for which they pleaded in unison. Many times they had found themselves working for the same ends in matters of importance to their profession and to the public, so that the present juncture seems the right

one, to give once more, as I said I would, Chenavard's stirring words about the scene he witnessed when accompanying Delacroix to the Institute for one of its meetings.

Chance willed that Ingres should be only a few steps ahead of us. As we were approaching the door, and those two irreconcilable enemies were just meeting and measuring each other with a look, Ingres suddenly extended his hand to Delacroix, moved by an impulse of secret sympathy which, for a long time, had been drawing together the natures of the two great artists, both revolutionaries in their way, and both sterling men. . . .

I cannot tell you the joy that gripped my heart when I stood beside those two splendid athletes whom the French school had watched in their proud struggle, when I saw their two flags united by their embrace of friendship, when I evoked the memory of so many fallen comrades, who, could they have seen as I did Ingres and Delacroix — irreproachable draftsmanship and the life inseparable from it — meeting and clasping hands on the landing of the Institute of France, would have asked no more for the moment of their death as conquered men.

Boyer d'Agen recalls that the eyes of the ninety-year-old painter filled with tears as he lived over this memory of other days, and I see nothing unmanly in such emotion on the part of those who — still far from the great age of Chenavard — merely read of the moment in the life of the two masters.

And, having observed their common defense of part of the patrimony of France, we are prepared to reopen a chapter in the life of the man who, in his zeal for the Campana Collection, invoked the aid of the Academy. His promptness in accepting election to the body, which had opposed him in bitter fashion just before, was not due — or surely not alone due to an idea that it would contribute to his material success. We have noted the reason given by historians for the institution's change of front: the need to find a powerful champion in its new fight against Delacroix, who seemed the more dangerous revolutionary of the two (and we have just heard that term repeated by Chenavard, who thus recalls the ambition that the Classicist, in his

youth, proposed for his career). His reason for accepting membership was that he could thus advance his cause.

Amaury-Duval, in his article of 1856, treats Ingres as the cat's-paw of the defeated Academy which, having regained prestige through his joining its ranks, cheerfully allowed him to burn his fingers in the fire that was turned upon his *Homer* and, above all, his *St. Symphorien*. But our interest is not in the politics of academicians (a particularly odious brand of politics); what we need to grasp is the thought of Ingres himself. Completely unworldly, what he wanted was acceptance of ideas that seemed to him all-important on his return from the eighteen years he had just spent on the classic soil.

Again, in opening a school, his purpose was far less to add to his income (though it was small enough at the time) than to continue his work in favor of "the good doctrines." Even when he went into exile after the painful reception of his great *St. Symphorien,* his purpose was not alone to regain the quiet of Rome and to rebuke the government by his refusal of new orders for painting; it was, in large part, that he might go on, through the important influence of his position as the director of the Ecole de Rome, with his campaign for the art in which he believed. Finding some young French artists, with certain of his own pupils among them, in a position he regarded as dangerous with respect to the earlier masters, he said, "Those gentlemen are in Florence: I am in Rome . . . You understand that: I am in Rome. They are studying the Gothic . . . I know it too . . . I detest it . . . There is nothing outside of the Greeks!"

The fulmination was transmitted to Florence by Lefrançois, who had a mischievous satisfaction in it. One of the guilty parties, Amaury-Duval, who had no fondness for the self-appointed Hermes, bringer of this warning from Jove, considers it with a certain tone of doubt. Yet even his recalling of Ingres's early love for Giotto and, other "Gothic" men is not enough to shake one's belief (probably shared by Amaury himself) that the master's words were accurately repeated —both as to their import and their emphasis.

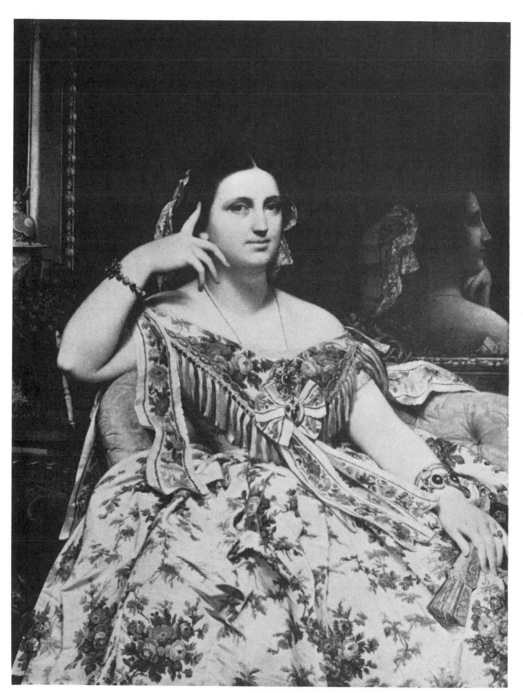

Mme Moitessier, 1856, National Gallery, London

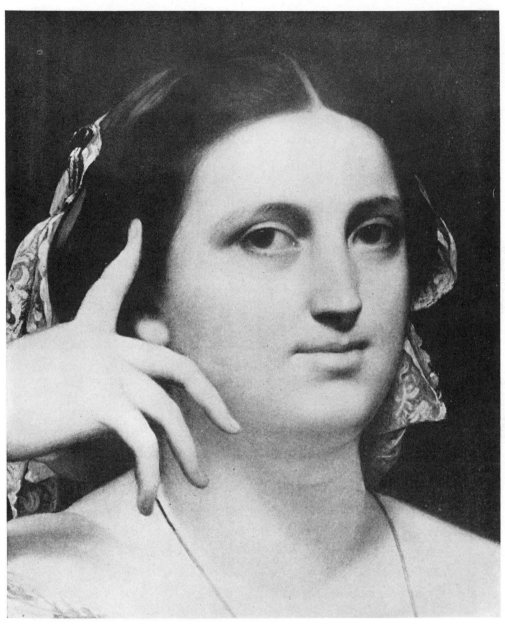

Mme Moitessier, Detail, 1856, National Gallery, London

CHAPTER IV

Classical Art Continues

"THERE IS NOTHING OUTSIDE OF THE GREEKS!" I AM MADE
to think of the moment when I heard Renoir say, "There is nothing
outside of the classics," and as he went on to include recent men
among their great company, I think he made a far better argument
for the eternal quality in the Classical than did Ingres when he situ-
ated it in antiquity. (On other occasions he, of course, spoke of its
rebirth, and of the new luster it received from Raphael. Nay, at the
end of his life when he has restored Mozart to his place among the
Homerides, as he calls them, he goes a step beyond the date of the
German artist by showing himself, as I would recall, in the *Homer
Deified*. Even if it is only as a very young servant before the altar of
the god, he is giving his affirmation that the ancient genius continues.)

But we need not trouble as to his attitude toward the moderns. To
renew contact, nowadays, with a man who has Ingres's supernal faith
in the Greeks is salutary to such a degree that all we want to ask is
whether his own study of them had good results. It did, as we feel at
once on turning to even his early work, after looking at what he left
behind him in the studio of David.

No lessening of admiration for that painter is implied in the re-
mark: artists do not leave their predecessors behind when they move
on in time and place, since the really great things always hold their
own, no matter what follows. But when Ingres went to Italy (and
doubtless even before that time) he realized that David's use of the
antique world was, to some extent, a matter of propaganda. Socrates,
the Horatii, and Brutus were stalking horses for the Revolution, and
Leonidas at Thermopylae — objected to by Napoleon as the image of

247

a defeated man — was, in the main, an unsuccessful picture, perhaps for some such reason as the young conqueror of Italy pointed out. Even the *Sabines,* which the master completed toward the end of Ingres's time in the famous studio, glorious as it was (and is) still showed the painter under the spell of the lesser gods of antiquity. The subject is Roman and the first inspiration of the art is Roman. Fortunately that is not its final quality, for it is French in its essence, and it is of its time.

But the time was one that had not yet seen the Venus of Milo, whose beauty was to have so deep an effect on Paris when it arrived soon afterward; above all, the world of northern Europe had not yet had its greatest experience of the Greek genius, which occurred through its contact with the Elgin marbles. When David, as an old man, journeyed to London in order to see them, he wrote to Gros, his successor in their school, that the whole idea of Classical art would have to be revised because of those supreme works.

The revision was already far advanced in the work of Ingres. Though he never visited Greece, though he knew her sculpture almost entirely through the Roman copies that had been accessible to his teacher before him, his more sensitive nature penetrated to a deeper source of the beautiful in the ancient revelation of it. I insist upon his precious glimpse of pure Greek painting (even if of a late period) that we know he had through the recalling by Puvis de Chavannes of the fact that Ingres copied a fresco at Pompeii. Roger Fry may be as scornful as he pleases about the "cheap commercial Greek pottery" which Ingres "took for consummate masterpieces": an instinct such as that of the artist we are observing could perfectly well reach out to the essentials of the Hellenic genius even through minor works like the vases; and lovers of those marvelous things, of the best among them, anyhow, will be slow to admit that they can be termed minor works.

Among the early drawings of our painter, such an extraordinary production as the *Family of Lucien Bonaparte* is clearly the result of one phase of the study given by Ingres to the ancient vase painters.

One feels it first in the incredible fineness of the line; that undoubtedly explains part of his breathless admiration for his classic models. Then, in the draperies also, there is a sense of beauty that had been nourished by passages in the Greek masters of line. Finally (if one may limit the matter to specific detail instead of seeing it as one of general influence), there are the faces of his sitters; here he performs a feat of his own in retaining his usual faculty for getting a likeness while at the same time giving to his personages something of the type of feature, something of the mystery and calm that he had loved among the heads on the vases. It is a peculiarly Greek quality, as widely separated from David's Roman strength as from the characterless look of the Neo-Classic art produced by the little men of the time. My own idea of Ingres's attaining of this quality is that we have here what Aristotle demanded when he said that the artist must see the universal in the particular.

The *Family of Lucien Bonaparte* is unquestionably a work put together from details: the actors in the scene — if Ingres ever saw them together at one time — never were in those poses and relationships simultaneously, or did not hold them long enough for even his prestidigitation to register them as they are seen in the picture I am so happy to have in these pages.

To understand a composition such as we get here, we need to consult a drawing like the early sketch for *The Triumph of Mediocrity*. Then we become aware how the perfection of a finished Ingres is based on deep study of the directions of line, the grand geometry of the masses, and the proportion held between solid form and empty space. It is one of the secrets of Picasso's impressiveness; and I am convinced that one reason why he is so much a master of these elements of painting is that he has studied them in Ingres. People who have no great admiration for the contemporary Spaniard cannot help seeing the Classical influence on part of his work, and they may even hear without resentment a mention of Ingres's drawings in relation to the lithographs of Greek subjects that Picasso made about 1923. But they are

missing a far more important phase of the modern man's connection with the past (and of the ancient men's prophecy of what our day has produced) if they fail to see that Cubism was a rendering of aesthetic structure through means that the older arts had always used: the difference is merely that in the complete works of the older schools these all-essential means are concealed under a realistic exterior. The recent school, taking pride in structure and expression as sufficient material for art, rejects those elements of painting which are merely a means of producing illusion.

That does not mean that it condemns naturalism or the men who accepted it as their guide. They did so at a time when imitation of nature was the approach to art that the painter consciously employed; but beneath the outer shell of appearances the more vital matters can be traced — and in few men more clearly than in Ingres. Roger Bissière, a strong artist of the non-realistic tendency, has written:

Ingres, one of the first, perhaps, among the moderns, and the only one in his generation, had the presentiment of the picture's being a finished world, possessing its own laws and its own life, independent of imitation, since it forms a construction in itself.

M. Bissière is certainly interpreting Ingres through twentieth-century conceptions, but the spontaneous and positive turn to the Classicist which occurred when the interest in abstract form replaced the preference for color and expression of the preceding generation was based on very clear affinities. The new men felt them strongly: they are part of those "answers to the most modern inquiry" which Thoreau said we find in the classics. The sketches for *The Triumph of Mediocrity* which were noticed before, caused Jacques Villon to make a quick association of names that I found very convincing. His words tell so much about the identity of purpose between the earlier and later masters that I venture to quote the account of his observation as I gave it in *Queer Thing, Painting*.

Noting the geometry behind the dashing lines which wove a design out of figures without faces, or indeed any semblance of anatomy, Villon remarked with mock-bewilderment: "But why is it that Ingres does not like Matisse?" "Because he died too soon," I answered. That was uncontrovertible, Ingres having died two years before Matisse was born.

My conviction is that, had he continued long enough in this world, he would have come to admire the modern draftsman who, like Picasso and indeed like practically all the great artists since Ingres, has given deep study to the art of the Classicist.

For those who see no progress in the master's work, who think that his phenomenal talent remains the same throughout his long life, I would recommend study of the *Portrait of the Gatteaux Family,* of 1850. Incidentally, it affords sure evidence as to the method which I said Ingres used in the *Bonaparte Family* of 1815; for in the case of the Gatteaux composition we have the drawings of which the work here reproduced is made up: that of the mother is dated 1825 by the hand of the artist, the portrait of the father was made in 1828, and that of the son, Ingres's great friend Edouard Gatteaux, the medallist, is of 1834.

When the painter had the kind thought of creating a family group for his comrade (perhaps it was because the latter had assumed the charge of his finances, at the death of Madeleine, in 1849) he gave proof that he had gone beyond what must seem the unsurpassable perfection of the earlier group. There we see an almost purely linear art, such as he had derived from the magical tracings on the Greek vases. Now, when he is seventy (just twice the age he was when he did the *Bonaparte* drawing) he is no less a master of line; but a comparison of the two masterpieces must convince us that the later work has added to his linear quality through form relationships, like those of a grand sculpture in low relief. And still his work is watched over by the antique genius. Its effect is less obvious, but no less certain, than in that family portrait of thirty-five years before: in these later likenesses, of people he knew so well, he is still the lover of the classics,

251

even when he renders every detail of dress, every lock of hair as it comes
out from under the lady's lace cap or as it falls in characteristic fashion
over the forehead of one of the men. We enjoy the charming glimpse
of a distant room and a figure in it, but that well-marked incident can-
not distract the artist from the great front plane, where the chief per-
sonages come up not merely into physical existence and nearness, but
into a psychological impressiveness hardly inferior to that in one of
those portrait groups where the Roman sculptor has rendered his
touching homage to the companionship of a husband and a wife.

But Ingres had still seventeen years to live and, for him, that meant
to go on with his advance. There is, for example, a drawing at Mont-
auban, a research for the head of Caesar, made for a decoration in
1862: it surpasses in plastic quality any that I know among the thou-
sands upon thousands of studies he had produced in the fourscore
years before he reached this point, and here he really seems to me to
equal the quality of the greatest masters of form that Rome gave to
the world.

But let us turn back a short time in his career and see once more
those sketches for the *Birth of the Muses*. Charles Blanc dismisses the
picture in rather summary fashion as being too near to its Greek in-
spiration. When I differ with those earlier writers on Ingres, it is with
no lack of respect for their splendid work in defending his art while he
was yet alive, or for their industry in giving us of today the firsthand
materials on which we base our notions of his character and history.
But as I have said before, the present time can see the master with cer-
tain advantages that were denied to the men who were nearer to him.
We see him through the commentary that Puvis de Chavannes, Degas
and Manet, Renoir, Seurat and the later men have made upon his
work in doing their own.

It is such artists, and especially the very recent or living ones, who
have opened our eyes to beauty that was missed by Charles Blanc,
with all his learning and all his admiration. I called the studies for the
Birth of the Muses unexampled when speaking of them previously,

and as we have followed Ingres in his continuing of the qualities of form that he saw in the ancients, I think the mere mention of the steps he made offers justification for the emphatic word I used. In these drawings there is the grandeur we see in the two studies here given for the figures which, at the Louvre, were to accompany the Homer ceiling. But how literal even those magnificent things appear when seen in relation to the stage of development he had reached thirty years later! How much of dependence (to be sure, a noble dependence) on the model is evident in the evocations of the two Greek cities! The comparison is not an odious one, this time, for the older works retain their beauty, even so, after we have made our confrontation; but how the drawings of 1856 rise above them as we see the artist on his plane of pure creativeness! Perhaps he had models for these works, perhaps they were born from his genius as spontaneously as the muses themselves issue from the lap of Memory in the lovely picture.

Presiding over the birth of his daughters, as Mnemosyne brings them forth, Zeus sits on his throne in a majestic attitude recalling that of Homer in the *Apotheosis*. But the little figure of the painter's old age is less material, more Olympian than even the impressive presence of the deified poet in the earlier work. If the nineteenth century preferred the *Homer* picture, perhaps it is just because that period did not see, in the *Birth of the Muses*, the full import of the Greek quality, the very one which rendered Charles Blanc cool to the work. Were he of the time of Maillol, could he see, as we may today, how much there is in common between the best of that sculptor's drawings and the study by Ingres here reproduced (superior to the work of our contemporary as the sketch for the *Muses* still is), he might well revise his judgment. And he would not be deterred from doing so if he had heard Renoir tell of a visit he made to Maillol.

We go to Marly, and we find Maillol working in his garden on a statue. He was getting his form without any preparatory model to enlarge from; it was the

first time that I ever saw a sculptor do that. The others imagine they are getting near to the antique by copying it; as for Maillol, without borrowing anything from the ancients, he is so truly of their race that when I saw the stone fall away under his chisel, I looked around me for olive trees . . . I thought myself transported to Greece.

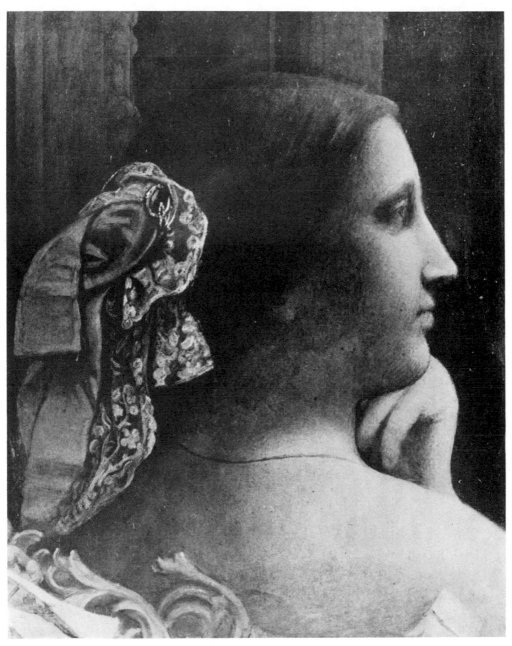

Mme Moitessier, Detail, 1856, National Gallery, London

Study for *The Triumph of Mediocrity,* about 1834, Musée Ingres, Montauban

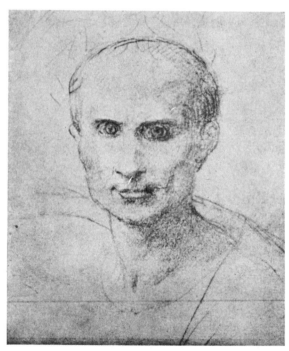

Study for head of Julius Caesar, 1862, Musée Ingres, Montauban

CHAPTER V

Classical Art Triumphs

CAN ONE IMAGINE AN ARTIST OF THE EIGHTEENTH CEN-
tury suggesting such an illusion as we just heard of from Renoir? Not
even Watteau could do so — and it is not beauty that is lacking in his
work. But we go on back, through Poussin whose constant study was
antiquity, to the great Italians, to Raphael, to Botticelli: and with all
the Renaissance enthusiasm for the rediscovered world of the ancients,
we do not yet come upon the essential, necessary revival of the classical
genius that is to be found again and again in the nineteenth and
twentieth centuries.

A cinquecento bronze worker might earn his nickname of Antico
by the closeness with which he imitated the ancient bronzes that his
period so eagerly sought for in the soil, but we know that he could not
have created such things from nature; we turn to realists like Pol-
laiuolo or Donatello for the great work of the time. In France, later on,
Coyzevox could make an utterly charming thing of his *Nymph with
a Shell,* which directly follows a Greco-Roman figure, but again so
very directly that, even before coming on the marble in the Louvre
which is, in reality, the original of his work, one feels that it is not en-
tirely his own — as are the splendid portraits he did of his contempo-
raries.

Later on again, the electricity which thrills Europe upon its new
contact with Pompeii and Herculaneum affords a more real sense of the
antique: it is, as men begin to realize, not a thing to copy but to assimi-
late. That could not be done all at once, though David's contribution
to knowledge of the classics, even if a partial one, was immense.

Prud'hon, whose painting was scorned by David, seems to have

meant but little more to Ingres. Yet in the wistful and noble art of Prud'hon there is an enormously increased understanding of antique beauty—as we see in his magical drawings. He seems to have found the Classical quality through his instinct more than through his study in Rome, where he went only after his genius was well formed. His association there with Canova may have disaffected Ingres toward him, for we have heard how severely the Italian sculptor was judged by our artist. It is a pity, however, if his silence about Prud'hon means that he failed to appreciate the beautiful quality of that painter.

The latter still has about him, however, something of the eighteenth century, and it is with Ingres himself that we first see in their purity the great results of the Greek revival. The term is sometimes too loosely applied: things that still copy, more than they recall to life the art of the Greeks are so referred to. But with Ingres, there is no mistaking the vitality that comes into the forms. In the *Oedipus* one still feels that the hand of tradition rests a bit heavily upon him (which explains, I think, why Renoir found the picture a bore) but, in the same year, the *Bather of Valpinçon* appears, to show how completely the artist could already unite his fresh, spontaneous delight in nature with the values he took over from the classics. For if there is no particular statue or drawing of antiquity behind the *Grande Baigneuse* (as there would have been with an orthodox work of the David school), those cool tones and breathlessly modulating planes of the early masterpiece tell that the young man's days of drawing from Greek marbles are directly influencing his painting.

The matter is more easily grasped when we consider the drawings, especially those where pure line predominates. Until the end of his life, the Greek quality continues: we see it very markedly in the study for the *Apotheosis of Napoleon,* of 1853. If the picture (more than the drawing shown here) deserves a hint of doubt on the score of excessive borrowing from the antique, no one can fail to see that the immense distinction of the design is more than could be derived from mere study of the art works furnished by the museums. This is an

Ingres, no matter what cameos or other models he may have consulted.

And so one feels restive on hearing the term Neo-Classic applied to the artist. It suggests that his relation to the past was at least to some extent passive. But a good picture by Ingres is dynamic: one feels an impetus, as of a coursing stream, in its lines. They pick one another up and pass along their energy, much after the fashion of successive waves which meet and unite their force in rolling toward the beach. Even in a thing of repose, in the undisturbed oval of a head, for example, there is vitality to the line—it might flicker as a flame does, although the firm, sharp-pointed pencil has cut the contour as sharp as a razor edge.

To distinguish the legion of imitators from the master is not always easy, but before a drawing of his, it rarely happens that his authority does not make itself felt. The followers try to recover his vibrancy by tricks of style — the little breaks, the sudden sweeps, an exaggeration of his firmness or his delicacy. But they are copying externals: they are those grandsons of Nature against whom Leonardo speaks. Ingres is her son, and the wonder of his line derives from its closeness to the ever-moving contours that he studied so passionately in the living model. In this respect one feels that Derain, after Degas and Renoir and Seurat, is his inheritor. Like Ingres, the contemporary artist has been accused of excessive devotion to the museums, and like Ingres again, he surprises us time after time, by the way his drawings leap to their effect by line that is alive in itself and yet so convincing in its fidelity to the character of the nude girl, the tree, or the still-life object that was before his eyes when he drew.

But line, like color, however delightful it may be, is still a means; the end it must serve is the animating of the work as a whole. The heart of Ingres's Classicism, it seems to me, resides in his getting a creative relationship among the parts of his picture — most often, perhaps, among the parts of a single figure or through the play of the features on a head. We noticed this with the *Mme Marcotte de Sainte-Marie;* now see one Greek head after another: the slight "irregularity" that appears (and precisely in those which have the most living quality),

257

will be felt to derive from the stimulating of one line by a neighboring line, the continuing of one plane into an adjoining plane, because the sculptor wanted it so and knew when he carried out the moving rhythm of the form that his work was truer than when, on an uninspired day, he had not dared to depart from cylindrical or conical regularity — which bores us so discouragingly in the work of decadent periods, and of imitators.

Since the latter types of artists have not the power to create, they defend their sterility by making rules. And the straight-jacket thus produced brings about impotence at first, and then deadness, — whether the work be copied from a master or from nature. I know that Ingres recommends the most humble following of the model. But if his own art tells us anything, it is that he did not practice what he preached — to students who might be trusted to depart from the letter of his demands if they had any of the spirit that makes the artist. And if they had it, the discipline of the severe teacher would only add to their strength. One after another of his pupils has testified to the bracing quality in that discipline, and we feel it so today — when merely looking at his work.

No greater mistake could be made (and indeed I apologize for mentioning it) than to think of Ingres as academic. It is his followers, the unworthy ones among them, who deserve that term. They have their own successors, down to those who look the most "modern." New phases of the academic mind appear, successively, as the creative men address themselves to one or another element of their problem: the schoolmen can reduce each technical matter to rote, and pass it on to the crowd of followers who need to have their thinking done by other people. Through their number and their accessibility to the public which, perforce, always needs time to get accustomed to original work, they naturally take the dominant role in art institutions and — whether by reason of their ignorance or their envy of the generating faculty which they lack — they exemplify and enforce the routine, the inertia, which are the earmarks of the academic. The history of Ingres's life

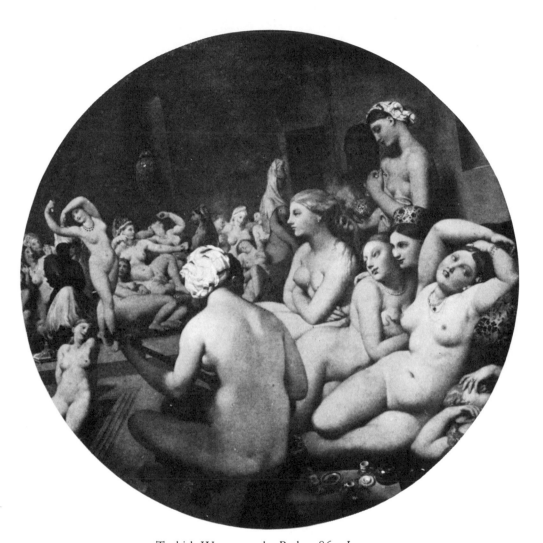

Turkish Women at the Bath, 1862, Louvre

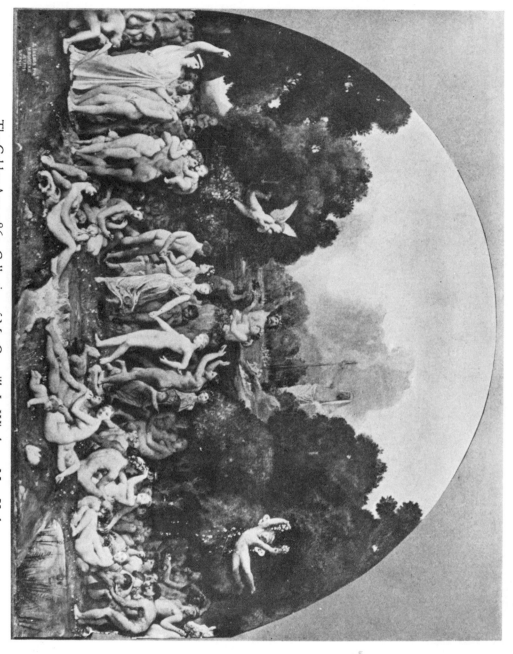

The Golden Age, 1862, Collection of Mr. Grenville L. Winthrop, New York

obviously keeps him out of such a category; but if we know nothing of his career, the most rudimentary appreciation of his art suffices to place him among original, forward-driving men.

The mistake about him which I denounce has been made, however, any number of times. Probably the future will hear less of it, as his imitators sink out of sight through the weight of their dullness. But in the days when the older academic school had its enormous vogue with the officialdom and the public of all countries, one impossible creature after another was palmed off on the world as belonging to "the good, sound tradition of Ingres," as representing the "noble continuation amid the anarchy surrounding us, of his impeccable draftsmanship."

We have heard of the crimes committed in the name of liberty; I doubt that they are any more numerous than those committed in the name of drawing. Could one ask for better proof of the beauty and vitality of draftsmanship than the fact that it survives in the healthiest fashion after a century of mistreatment by pedants and profiteers? The latter group are so quickly recognized as unworthy that we need not give a moment's thought to them. But the idea of drawing that has been kept in currency by the schoolmen of art deserves a glance in a book on Ingres, since it has always invoked his name, and has succeeded, with a large part of the world, in utilizing his genius to justify its production.

To review the evidence which ought to have discredited such an idea long ago would be a dull task, and the reader need have no fear that I am going to inflict it upon him. We have, fortunately, the most authoritative of statements on the subject, that of the Ingres pupil who for forty years stood so near the master and who, after the latter's death, could estimate the effects of his art very much as the great man himself would have done. When Amaury-Duval quotes the sentence of Michelangelo — "My style is destined to produce great fools," one might think it was Ingres one was hearing, because of the vehemence of tone and the proud self-confidence of the man who sees his influence carrying on to a long future. Had Ingres been the one to utter the phrase, he

259

would have been right on both counts — the second one (his belief in his art) nullifying the importance of its ill effect on weaklings, as we see also in the case of the great Italian. In that of the modern artist, we have not yet had time to reach a perspective which will show his superiority over the little men and their theory. We shall advance toward such understanding if we listen to Amaury-Duval's explanation of the quality which gave to his teacher the merit which is now recognized by every one. Here is the passage:

A well-drawn figure is generally regarded as one that is correct when it is measured by the right number of heads (the human body, according to the rules, is divided into eight parts, each having the length of the head); it is a figure in which all the muscles are in their place, and each limb is in mathematical relationship with all the others. All of that has nothing to do with what makes up a well-drawn figure. Photography gives that complete exactitude, and no one has any idea of claiming that a photograph is well drawn. What constitutes drawing, as it does color, is the interpretation that an artist makes of the objects which he represents, and he does so according to the impression produced on him by certain beauties, or certain aspects of his subject which seem beautiful to him; he insists on these and renders them visible to less practiced eyes, and finally imposes them through the power of his genius.

The impression which a great artist receives from nature and which he renders accessible to us by the means at his command, must necessarily be of infinite variety, according to the various men, their temperament, and their soul. If exactitude were the last word of drawing, diversity among artists would not exist. Imagine ten great painters doing the portrait of the same person. Those ten portraits will all resemble the model; there will not be two of them that resemble each other either as to drawing or as to color. If that were not true, art would be — for painters, and even more for sculptors — a matter of measurements by compass. We should no longer have that immense variety in the manner of drawing which is to be seen in Michelangelo, Raphael, and Leonardo da Vinci; neither should we have variety of color — which is so different with Paolo Veronese from what it is with Titian or with Rubens.

Happily these great artists have been but little concerned as to exactitude. They have treated nature with a high hand; mistakes in drawing, inexactitudes of the grossest kind, exaggerations and additions of muscles abound in

Michelangelo. . . . I should blush to treat as faults the sublime indifference to correctness of one of the greatest geniuses of art.

M. Ingres, like these admirable artists, laid aside the academic science learned at school; he created for himself a quality of drawing that is his own; it is of doubtful exactitude, it is bizarre, if you like, but it is very much his own in its rendering of his impression — which it forces us to share.

Just for that reason — because of the generous nature of Ingres (and, in art, few have been more generous than he) — Chenavard called his drawing "irreproachable" in speaking to Boyer d'Agen. The old artist, looking back over the century, would not have used that word about the man who had been his teacher if the latter's draftsmanship had been other than a means of giving himself — as color was for Delacroix, that other great figure in the memories of the veteran.

So also we can explain — and easily explain what must have seemed a Satanic paradox of Baudelaire's. Writing on Delacroix, he spoke of the accusation of bad draftsmanship often leveled at the painter, and asked what men could mean by such a thing, adding, "I know only two men today who can draw as well as M. Delacroix: they are M. Ingres and M. Daumier."

The great poet was one of the most penetrating art-appreciators of the nineteenth century, and nowhere does he prove it more than in his linking of the three names on the score of draftsmanship. Not only is he profoundly right in the particular statement he makes, but his originality in putting the two rivals on one plane and then adding the man who was looked down upon as a merely comic or political artist, forces us to recognize the common quality in the three arts. And, evidently, it is not to be found in that region of academic exactitude which Amaury-Duval, the intimate of Ingres, has told of as outside the purview of art. We are brought once more to expression and the aesthetic relations as the first criterion of drawing.

The further one goes in an acquaintance with art, the more impatient one becomes of attempts to split it up into separate qualities, like drawing and color. We have just seen how Baudelaire rose above such

things; and when Renoir, for example, discussed pictures, it was also in terms of their total effect. He adored certain works by Ingres and was cool to others. And his feelings are rarely expressed in matters of detail, although — as might be expected — he does prefer those paintings in which the color is fine. But if we concentrate on the drawings, where nothing is to be seen of that immense distinction of color which Ingres occasionally shows, we find the same differences between merely dutiful exercise and superlative art.

Having spent so much time over pencil and paper, and having affection for those peculiarly intimate expressions of the mind that drawings are, Ingres himself had a special fondness for his studies. Beside the story I told before, of the time when he said they would kill his paintings if hung with them, there is the scene remembered by one of his pupils, Sturler, whose wife the master had just drawn. It was at a time when his eyes were weakening and he had to use a magnifying glass. (I recall the fact that in his last years his eyes took on new strength; he even dispensed with spectacles.) On the occasion of his doing the portrait of Mme Sturler, he was troubled about his sight and, when compliments on the new work were offered him, he said:

"It isn't much . . . I don't see right any more . . . they've taken everything away from me, gentlemen — everything. . . ." But suddenly he straightened up and, pointing to the drawing, said, "But they haven't taken *that* from me!"

Marvelous as his gift was, pure emanations of his mind as the drawings are, they must, after all, take rank as his lesser works; the greater things are his paintings. And one does have moments when one wishes he had oftener given himself to them with the sensuous delight that is so frequent with his work in black and white. At times one almost thinks he hated painting; there are pictures in which his iron hand has crushed out the life to such an extent that the only preference one can have for the canvas, as compared to a Flandrin or some other student production, derives from the greater skill which the teacher still had. I think it is confusion between his work and that of his school which, to a

great extent, accounts for the terrible indictment of Ingres contained in Théophile Silvestre's article on him (republished in the great critic's book, *Les Artistes Français*). It gives the most brilliant portrait in words that we possess of Ingres, and tells the limitations, the weaknesses of his art in so masterly a fashion that even a thorough-going admirer can take but little exception to what Silvestre has said; where one differs is as to what is left unsaid — words which would do justice to the fine things which so far outbalance the unhappy ones discussed.

Even before the poorest level of Ingres's painting is reached, there is, in a large number of his pictures, an apparently willful disregard for the beauty of color, and there is, too often, a quality of surface like that of oilcloth or cast iron; such things explain the resistance to the man that the world has not yet outgrown. One reason why I said in my introductory pages that Ingres is the artist who points most clearly to the future is our growing distrust for work that seeks to beguile us by merely surface beauty; realizing how it points to empty preciosity, we must — and we shall — turn more and more to this painter, with whom such appeal (when it occurs at all) is completely subordinated to the deeper beauties that he saw in the classics and that he incorporated so splendidly in his own art.

CHAPTER VI

The Realist

THE CHIEF REASON FOR HIS PRESENT SIGNIFICANCE, AS I
see it, still remains to be discussed. And though my first interest is in
the artists and art appreciators of our own day, I am convinced that the
fundamental quality in Ingres, his realism, is not a thing merely for
the present, but for all time. That acute critic, H. D. Kahnweiler, con-
tending against the idea of the painter as definable in terms of his Clas-
sicism, once wrote that: "Ingres is not only a realist, but the greatest
realist of France."

And his country, including in its long roll of artists men like the
Le Nains and those around them, Chardin, Courbet, and the scientific
investigators of the phenomena of light, is a country of realists. The
main trend of the French genius is positive, in the sense that Auguste
Comte used the word — to denote people who act upon the evidence of
their five senses. It is the world of things seen, heard and touched that
counts; the sense of taste — whether in questions of wine, manners or
art, is proverbially strong among the French, the sixth sense — for
mystical or other-worldly things—is exceptional. Its expression is prob-
ably to be found, most often in a realm where the French genius has
made its smallest contribution, which is to say in music.

The art of Beethoven and that of Delacroix have more than once
been compared, and perhaps the reason why the painter had to wait for
wide appreciation so much longer than Ingres is that his art is so amaz-
ingly broad in its foundations: *"The Universality of Delacroix"* is the
suggestive title of an article by René Huyghe. And the name given to
his school, Romanticism, certainly carries with it the idea of a reaching
out to spaces of the mind that have not previously been explored. Dela-

croix himself was not without distrust of the term, but to Ingres Romanticism was the thing that "smelled of sulphur"; his doubt of Racine may have been due to the quality which made Delacroix say of the poet: "for his own time he was a Romantic"; and it is more than likely that Ingres's deliberate opposition to the use of a full range of hues by his pupils resulted from hatred of the lyrical, dramatic use of color by the rival school. Lyricism and drama are in no wise antagonistic to Classical art: it has exemplified the qualities a thousand times. The thing to which they often run counter is realism.

This might seem to represent our painter as one opposed to the very men he admires: Aeschylus with his passionate defiance in the *Prometheus,* Raphael with the pure lyricism of his *Parnassus,* Gluck with the deep sentiment of his *Orpheus.* But the contradiction is not a real one: it vanishes at once when we note that the several arts — in Greece, in Italy, and in Germany — are based on the firmest realism. The Titan of the tragedy by Aeschylus is a permanently recognizable type of humanity, one in which the modern age sees itself with all the clearness that fifth-century Athens felt in the great portrayal. And the scene of Apollo and the muses which the Renaissance painter carried over from the ancients responds in the same manner to deep realities in the nature of mankind, those which explain its undying need for the arts. Those wards of the muses bring us to a form of truth that is infinitely beyond the reach of their travesty by the academies: it is the loftiest of realities that we hear in the calm, abstract rightness of music such as that of Gluck. And that is doubtless why this hero of Ingres's retained his place among the *Homerides,* from the earliest to the latest time in the history of the painting.

Of that work, the artist said, "People seemed to be satisfied with the picture, I alone was not so." On the canvas he had painted the words of Quintilian, "Modesty and circumspection are required in pronouncing judgment on such great men [in Ingres's picture, the *Homerides*], since there is always the risk of falling into the common fault of condemning what one does not understand." Evidently he was not

265

thinking of the Romanticists when copying out those last words: the phrase "such great men" refers to the artists of distant times whom he was representing. And since the picture was, as I pointed out, a declaration of principles, his demand for perfection, for completeness is part of his realism when, in after years, he goes on to his second rendering of the scene — which he explains in the full notes published by Delaborde.

It is important to get well before one's mind the fact that Ingres's idea of reality is derived far less from the material aspects of nature than from convictions about art and life. We have just seen this to be the case, through our recalling of the *Homer* picture, the work which most fully summarizes the ideas that the artist looked on as the essentials. If one can see Ingres's demands for clarity of judgment as the token of his realism in dealing with the intellectual world, one is prepared to understand the elevated quality of the realism he used in depicting the physical world.

The black gauze of Mme Le Blanc's dress shows underneath it the whiteness of her beautiful arms; we marvel at the complete rendering of the pattern on that shawl of Mme Rivière's which has made people include it in the nickname of the picture; it is overwhelming exactitude that we find in those repeated studies of anatomy, relief, etc., which prepared the painter for the *St. Symphorien*. But — to refer as I did in my *Ananias* to a brilliant contrasting of words that Max Liebermann made in speaking of Degas — here is no *Kunststück* (a feat of skill), here is only *Kunstwerk* (the work of the artist). And it is in terms of the abyss which separates those two processes of mind that we can appreciate the unbridgeable distance between the handling of nature by Ingres — and that of the photographic realists of the nineteenth century. To those who care for the master, I make my excuses for mentioning the two things together, just as I did for offering my explanation of the anti-academic quality of his art; I feel that both matters had to be noticed because they are the occasion of widespread error.

It is not simply through such personal, undemonstrable things as our impressions before pictures that we may test the difference between

Ingres's realism and that of the bad artists. We come back, once again, to the great man's favorite quality, his drawing; it is in this field that we have our best proof of the misunderstanding of him by the pseudo-realists. Their following of a contour is purely descriptive, as is the geographer's wiggling outline when it tells of the indentations and projections of a seacoast. Within the boundary laid down by the typical academician, whether it looks like iron wire as in the older schools, or whether it is impressionistically vague as in the later ones, the drawing of the interior forms is equally devoid of any conception of unity, which is surely one of the outstanding aspects of the real.

Sometimes one asks oneself whether old, ready-to-hand ideas — which are often mere prejudices — are not taking the place of genuine thinking, in what one says of art. To try the matter out in this case, I looked again — and dispassionately — at the group of nineteenth-century paintings, (not the eighteenth-century ones) in the New York Public Library. No, my old impressions were not just *clichés:* from the humblest of forgotten Germans, Spaniards, and Americans, men like Knaus, Madrazo and Huntington, right up (if it *is* up) to Bouguereau, there was the same merely illustrative quality throughout these pictures. They are, literally, "counterfeit presentments" — or counterfeits of the literal — for had they indeed been true to the letter of the great draftsmen, whom they misrepresent in their bleary decadence, they would have shown some understanding of the live, functional nature of outline; there would have been some hint of the reciprocal activity of the inner forms, things no more to be looked on as independent of one another than are the nerves, the muscles and the tendons of a living body.

Ingres shuddered at the sight of skeletons, he hated the mere thought of the dissecting room and the kind of anatomical painting that was based upon studies made there. His knowledge of the body was of a deeper kind, its rightness came of such intense observation of life as makes the *Venus Anadyomene* rise from the waves with a single movement. Who would think of using the surgeon's scalpel on that

figure of *La Source,* which tells so charmingly of our delight in a woodland spring? It does not possess, to be sure, the ineffably grand simplicity we hear in the words of St. Francis — "Praised be thou, *mi signore,* for sister water, useful is she and precious and pure"[1] but the existence of the naïve little deity has gone so far into the mind of the world because she was first conceived as a whole, in the mind of the artist. Once more his physical realism is the expression of a realization within his mind.

And the means by which it is rendered? And, what I spoke of before, the differences from the drawing of the stupid men? To see these qualities in him we begin again with the contour. It is no "abstract" outline like the convention of the map-maker who washes in some blue color on one side of it and then some brown on the other, so as to say, "This is water, this is land." The passionate study of Ingres — inheritor of the long past of the race as he is — discerns those curves and those straight lines which will render the sensation of bulk, of existence. He thickens his line, spontaneously, to give the stronger accent which renders the sharp detaching from surrounding space of a brow, a chin, or some other illuminated surface; he lets his pencil run off into pale evanescences as the form is about to merge into its neighbor. But it *is* a form, regular or irregular, and it is part of his job as a draftsman, as a realist, to tell us that this head upon this neck is an ovoid upon a cylinder. Does not his beloved Gluck steadily remember to keep to the measure that he has laid down for himself in the plan of the composition? Yes, even in moments of the most terrible stress, as when the demons, with their thrice-repeated "no," scream their refusal to give up Eurydice.

"If I could make musicians of you all," we have heard Ingres tell his pupils, "you would thereby profit as painters. Everything in nature is harmony . . . " Perhaps the words are clearer now than on a first reading of them. He expressly says that he does not send his students

[1] *From the translation by Egisto Fabbri of* The Canticle of the Sun.

to the Louvre to make copyists of them, and in his unwearied insistence on the study of nature, what he is trying to make the young men see is the "harmony" which they might become aware of through the masters of that other art of music that he had loved throughout his career.

And always his means is the line. It was for Raoul Dufy that Guillaume Apollinaire wrote one of his splendid verses, but he may have had Ingres in mind when, at the threshhold of the *Bestiaire,* his own Orpheus proclaims the nature of art with the words:

> *"Admirez le pouvoir insigne*
> *Et la noblesse de la ligne:*
> *Elle est la voix que la lumière fit entendre*
> *Et dont parle Hermès Trismégiste en son Pimandre."*

Again I feel driven into defending: it is not line for the sake of line that we find in Ingres, as certain "decorative" artists would have us believe. They weave their flimsy patterns, fill in the cobweb stuff with milk-and-water tints, and chastely sigh over the departed days when people were taught to draw. But their pallid unrealities are as far from the full-blooded art of Ingres as are those colored photographs (also by "Classical" draftsmen) which libel, as nothing ever did before, the eternal art of portraiture.

In his own glorious portraits, Ingres tells of his people with the directness that a Hellenic poet uses when his subject — a person, an animal or an object — is evoked by words that do not need to go outside the beautiful things which nature so clearly shows to our eyes. A man of the South, Ingres continues faithful to the outlines cut sharply by the almost matchless brilliance of the light in his own country and its forerunners, Italy and Greece. The glare of the sun causes him to see almost in black and white what Cézanne, for example, could see in color. But that other meridional, so different in the general aspect of his work, is still akin to the older Classicist in his understanding of the power of line: a few washes of water color, a summary modeling with paint, and the form is created.

The Art of Ingres

Both men know that the inner masses and the contour are effects of weight and pressure. Consider again the words we heard earlier: "Never do the exterior contours bend inward. On the contrary, they bulge, they curve outward like the wicker of a basket." And — what is not in the Delaborde citations, what I got by word of mouth from Paul Sérusier — who doubtless got it in the same way, through the good tradition of the Paris studios: "M. Ingres used to tell his pupils — when you pour apples into a sack, they always make the line of it bend outward, and that is what the muscles do under the skin, and what the lines do in a good drawing."

Those homely words of Ingres the realist tell us of more than his own art. They tell us of the nature of drawing in general, and of the rightness of Baudelaire when his frank mind associated under the aegis of great draftsmanship the arts of Delacroix and of Ingres — whom people thought of as irreconcilable. And his adding of Daumier brings us to a technical quality held in common by the three artists — for with all their divergences of temperament, with all their varieties of emphasis — the three of them possess that understanding of line which permits it to create form, whether it is accompanied by little or much of chiaroscuro, by little or much of color.

Having seen that the two famous rivals are far nearer together than they were for so long thought to be, let us take another phase of their attitude toward art and see how right Elie Faure was in his condemnation of people who, in our day at all events, still try to see a fundamental difference between the two masters. In his essay on Derain, M. Faure writes of the painters who, as he says, "possess the greatest prestige since the art of Matisse appeared." They are two again, and "Derain and Picasso both of them go back to points of departure which seem antagonistic to the poor in spirit: for Derain the starting point is Delacroix, for Picasso it is Ingres."

CHAPTER VII

The Conserver (Scherzo)

THE PASSAGE JUST QUOTED IS PURE ELIE FAURE IN ITS COUR-
age, its penetration and in the love of art which leads him to the two
other qualities. He says, as we have just heard, that it is only the poor
in spirit who see antagonism between those masters of a hundred years
ago, and so I am glad to add one more example to those I have already
given as to the agreement of the two men. It is on the question of
restorations.

Readers of Delacroix's *Journal* will recall his angry impatience with
the rebuilding of Gothic churches, his insisting that the creative epochs
of the past were right, were finding new harmonies, when they added
to an edifice of an earlier time by a fine piece of architecture in a style
then alive, and that the nineteenth century was wrong when it tried to
"rejuvenate" a Gothic building by scrapings and reconstructions that
the modern men were incapable of performing with intelligence. There
are also the passages in the great book which tell of the master's dissen-
sions with his friend Villot, when that curator of paintings at the
Louvre was restoring the works under his care, often with disastrous
effect. Delacroix writes, "I prefer them with their respectable dirt."

The idea of Ingres on the subject comes to us in some pages from
Rioux de Maillou in his *Souvenirs des Autres,*[1] which are worth repeat-
ing in full, not only because they tell us of the matter in question, but
because they give us a final glimpse of the man as he was seen by his
contemporaries.

Haro, the picture dealer of the rue Bonaparte, had been standing in a door-
way of his shop for some minutes, letting his glance wander in the direction of

[1] *Paris, 1917; Les Editions G. Crès et Cie.*

271

the quai, when he noticed a thick-set man who seemed to be out of breath and a bit out of his mind, brandishing his hat with one hand and a cane with the other, as if he wanted to summon the passers-by to some revolt.

"A lunatic," he said to himself, "or some honest bourgeois who has just been present at an accident and, unable to control his emotion, yields to his need for passing it on to others."

But what was his stupefaction when, in that mass of flesh, in that breathless being approaching him, he recognized the illustrious M. Ingres!

There was no mistaking him, that was certainly his sugar-loaf skull with its hair, still of a southern blackness and parted in the middle like that of the angels in Italian Renaissance pictures. It was his retreating forehead, his big ears, his ardent, raging eyes, looking like hot coals under the thick eyebrows. It was his bilious complexion, his nose sticking so straight out, so disdainful even in this moment of fury, his solid jaw, his chin with all the will-power behind it, and also the solemn tyranny. It was his whole burly figure, in which the balloon-like curves only half concealed the man's vigor.

The master approached — now he was arriving, boiling — and boiling over to the bursting point, a water-spout on a pair of legs, with which he had been pounding along at a terrible pace.

Now Haro could hear the inarticulate cries of anger, the tatters of words which managed to escape from his convulsed mouth.

"Assassins . . . Yes, yes, I will go! . . . We shall see. Oh! Oh! oh; . . . We shall see . . . Yes, I'm going . . . I shall get the better of the assassins . . . Justice! Justice! . . ."

The dealer had quickly stepped aside to allow his famous client, entering like a hurricane, to hurl himself into the shop.

"Haro! . . . my friend! . . ." he was suffocating, strangling.

"Haro! . . ."

"Monsieur Ingres?"

"Haro! . . . they are cutting his throat, they are assassinating Raphael!"

The businessman's eyes went open and shut.

"Wha- What?"

"I tell you again, they are cutting the throat of Raphael!"

He had thrown his hat on a seat and his cane on a counter: "But they shall see; . . . yes, they shall see! . . ." and he prepared to rush forth, bareheaded, from the shop.

Haro wanted to stop him: "Your hat! Your cane! . . . Where are you going, Monsieur Ingres?"

The Conserver (Scherzo)

"I am going to the Emperor to demand justice!"

Haro imagined that the fiery old man had been seized by a burning fever: "Wait, Monsieur Ingres! I'll go along to your house with you."

Saying which, he first brings back the cane and hat, and then hastens to put on some clothes himself, picking them up whenever he was given a chance to do so, for the painter kept him walking up and down at a furious rate.

"I am going there!"

"I'm right with you, Monsieur Ingres."

"We shall see!"

"Where did I ever put that accursed overcoat of mine?"

"They are just wretches!"

"To be sure they are."

"Scoundrels!"

"Undoubtedly!"

"Bandits, iconoclasts!"

"Oh, my hat, where is it? I say also ——"

"Rogues and knaves!"

"I am ready now."

"Send for a cab!"

"For a two-minute ride? But just as you like."

There is a cab waiting at the curb. Ingres jumps into it, his head lowered like a ram's; then he shuts the door behind him — and right in Haro's face.

"But master. . . ."

"To Saint-Cloud, driver . . . take me to the Emperor!"

"Master! . . ."

"Good-bye, Haro! I shall get justice from the Emperor."

The coachman hesitates, and throws an inquiring look at the dealer to find out what the puzzle means. Haro lets his arms drop at his sides.

"Do as he says . . . Obey! It's M. Ingres!"

The coachman, reassured as to his fare for the trip, whips up the horse.

"Here we go!"

The water-spout from which Paris has just been saved, having raged and swelled and exasperated itself against the slowness of the old nag that is taking it so far away — to that far away which is Saint-Cloud — can at last descend before the imperial château.

"The Emperor?"

"But, Monsieur . . ."

"The Emperor, I tell you! . . . I am M. Ingres."

"I don't deny it."

"Then let me through."

"There is a council of the ministers."

"That's of no importance."

The usher, aghast, repeats, "A council of the ministers, Monsieur."

"All right, ask the Emperor to come out and speak to me for a moment. Tell him from me that it is a mattter of life and death! That they are cutting the throat of Raphael! . . . that I have come in the name of the whole Institute! . . . that, above all, I have come on my own behalf! do you understand? on my own behalf . . . M. Ingres! . . . He can't let them assassinate Raphael! What would posterity say?"

Napoleon III unquestionably had in him something of the good-natured man. Besides, he was fond of talent, and made a point of attracting the good will of those who possessed it: and that was at least a clever idea, whether or not his taste for the arts had anything to do with the question. From this point of view, the great artist had a right to favors. The Emperor left his ministers for a few minutes and came into the waiting room where the avenger of Raphael was walking about in a fever.

The water-spout had come to earth in front of the château; now it burst forth again like a bomb:

"Sire, your de Nieuwerkerke has gone in for a sweet business! The future will know how severe a judgment to pronounce on that assassin! . . . Yes, Sire, Assassin! Assassin! The word must be said aloud! . . . There is not a second to lose! Sire, you are going to sign an injunction for me . . . an absolute injunction! . . . against that public malefactor and his cutting the throat of Raphael . . . It is a question of Your Majesty's honor and of the glory of the crown."

It was only with much difficulty that the sovereign, taken by the collar in this fashion, managed to get a more or less intelligible explanation of the cause of the whole business.

M. de Nieuwerkerke, in dealing with the restoration of pictures at the Louvre, had had the *audacity* to permit the restoring of the *Saint Michael* of the Salon Carré, the work of Raphael. The delicate operation showed that certain details of costume had been modified in an important way. It was the removal of these later additions which Ingres was calling a crime of *lèse-art,* and against which he had just protested.

It is only fair to recognize that, in theory, the marvelous draftsman, the

Self-portrait, about 1865, Collection of Mr. Grenville L. Winthrop, New York

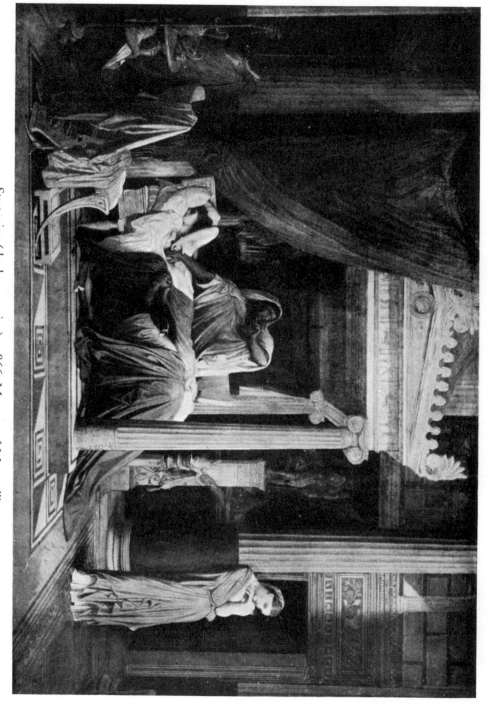

Stratonice (the later version), 1866, Museum of Montpellier

nobly obstinate defender of beauty as his genius conceived it, the man who made no concessions when there was any question of respect for art (a thing summed up in the incomparable person of M. Ingres) was right in being so sensitive. It is right for the masters to be sacred to us and for their works to profit by such veneration, the best of safeguards. "Raphael must not be touched" was a legitimate cry of alarm, and the man who uttered it was deserving of all praise.

Only, the problem was: had Raphael really been touched? It might perhaps have been useful for the artist to examine into that in a less fiery way, to elucidate it carefully before taking the bit between his teeth. That would have saved him from smashing in an open door.

The Emperor signed the injunction. Ingres was able to bring it back victoriously. But the hour of his triumph was also that of his confusion.

Not the slightest attack on the person of Raphael had been made. No outrage had been committed against the immortal master of form. Quite the reverse: his work had been relieved of later and French additions, of absurd smears that dated back no further than the end of the seventeenth century or the beginning of the eighteenth, arch-heresies perpetrated by the officious brush of Coypel.

The truth was that, in the seventeenth or eighteenth century, people had the presumption to improve on Raphael when restoring his pictures, and M. de Nieuwerkerke's only crime was to direct that the picture be *disrestored,* in order to bring it back to its original condition.

If M. Ingres's triumph had been permanent, he would have been avenging Coypel — and at whose expense? at Raphael's expense!

CHAPTER VIII

The Art of the European Race (Conclusion)

I HAVE SAID THAT THE FOREGOING ACCOUNT GIVES US A glimpse of Ingres as he looked to his contemporaries. Some of them had their own grievances against him because of the "solemn tyranny" that Rioux de Maillou saw expressed in the strong chin of the artist. The story, as it "circulated in the studios" to use the *raconteur's* phrase about it, lost none of its picturesqueness, nor its strong tinge of ridicule for the man who is its victim — but also its hero.

For if his whole conduct of the affair ended in an anti-climax, his motives, as the writer is careful to show, were not less than magnificent. He was defending the heritage of the human race in one of its most important parts, and all his excitement (he was well on in age — in the seventies if not the eighties), all his impetuosity in rushing out to the Emperor, the one man who could save his cause, must be accounted simply another token of that seriousness with which, throughout his life, he had regarded the things of his profession. His zeal in combatting the excesses of the restorers (even if they had made progress over the grotesque procedure of Coypel and his time) were a proof that he wanted to see the work of the masters in its true condition. And thereby — to return to my point — he was in agreement with Delacroix. It may be the place to cite one of those slightly sententious aphorisms of our "Monsieur" Ingres: "Men of genius are brothers, but they do not look alike."

One difference between the two great nineteenth-century artists should still be noticed, although they show likeness to each other even here; it is in the matter of their attitude toward the subject of the picture. Both are intensely absorbed by whatever subject they are painting,

both carry the beauty of the technical means to the point where later schools could build on them for arts where the means (form and color) displace the subject in its interest, and the whole conscious effort of the artist is to get a logical construction, "nature" becoming a very small factor in it.

The men who brought about that result turned to Ingres for inspiration. Picasso recalls him not only in a general way, but by very direct borrowings—and fruitful ones. Delacroix was somewhat neglected; yet it is he who explicitly says (in the *Journal*—entry of January 13, 1857): "Painting does not always need a subject." That sentence certainly opens the door to the arts which reject representation. Just preceding the words are these others, "The originality of the painter gives novelty to subjects." If it can do that, why can it not give novelty to the picture as a whole? We must agree that it is precisely what does give novelty to the picture.

And again, if originality can give that quality, why can it not also give beauty? Delacroix evidently considers that it does, for in explanation of his bold thought that Rembrandt may yet be held a "far greater painter than Raphael," he speaks of effects that render the pictures by the Dutch artist "the veritable expression of nature," and says, a moment later, "the further I go on in life, the more I find *truth* to be what is most beautiful and most rare." And he strongly questions whether Rembrandt could have attained such truth had he not departed (because of his originality, it is quite clear) from the studio practices to which Raphael "always conformed so conscientiously."

Ingres had, of course, never seen these lines in the *Journal* of the other artist, but he replies to them very directly with the words we have read before: "Let us not admire Rembrandt and the others through thick and thin; let us not compare them, either the men or their art, to the divine Raphael and the Italian school: that would be blasphemy." (The last word is used by Delacroix himself when he makes the comparison—but he cites it as the one with which the schoolmen will denounce his remark.)

The Art of Ingres

For Ingres there are — as always — no two ways of looking at the matter. In that long passage on "the touch" which we find among his "Thoughts," and especially in the latter part of it,[1] where he is evidently thinking of Delacroix in his condemnation of "modern" practices, he says that "the rule [of the ancients] of spacing objects in painting and in bas-reliefs came from the desire fully to express beauty and to express it in the development of lines." Just a little later he goes on, "Everything had to be beautiful in the picture, because everything had to be clearly distinguishable."

Again, in that passage where he specifically names the works of Géricault and says he would like to get them out of the Louvre, he again gives us an insight into his conception of the subject as related to art — and he is, naturally, in complete opposition to what we heard from Delacroix. I repeat the lines for convenient reference:

I don't want anything to do with that *Medusa* and with those other pictures of the dissecting room, which show us no more of man than the cadaver, which reproduce only the ugly and the hideous: no, I want nothing to do with them! Art should be nothing but the beautiful and should teach us nothing but the beautiful.

It is obvious that he has not even the beginning of a doubt but that the term "beautiful" is a perfectly clear and reliable one, as well defined as are those other ancient elements — earth, air, fire and water. Their properties vary according to their different combinations; we make new discoveries as to their uses, but we know, essentially, what they are. He is quite unshaken in his belief by the evident seriousness, the "incontestable talent" of Delacroix: he has no hesitation in referring to him repeatedly as "the apostle of ugliness." If any admirer of his rival had ventured to tell him that the ideal of Delacroix was the beautiful, Ingres would have looked on the words as mere perversity, like saying that black is white.

Consider his sentences about the *Raft of the Medusa* (and it is of

[1] See page 194.

great interest to recall that the words I quoted from Delacroix are also inspired by a thought about Géricault, to whom there is a fragmentary reference just afterward). Ingres says he will have nothing to do with a work that shows a hideous subject, like cadavers. His conclusion is all but stated: an ugly subject must necessarily yield an ugly picture, no matter how "incontestable" the talent of the painter. (He would scarcely have denied that Géricault had talent.) Conversely — supposing always that we are before an artist with good native gifts and proper training — a beautiful subject will yield a beautiful picture.

In support of this reading of his words I make a last — and always grateful — return to Amaury-Duval; the closeness of his statements to those of his master will at once show how he is to be relied on as an interpreter. He does not quite fall into the trap that Ingres's fierce, instinctive hatreds laid for him in his theory. The thoughtful mind of the younger man could see that the mere reproduction of things, as by photography — which he spoke of before — does not constitute drawing; and so he will not be misled into making a literal statement that the beauty or ugliness of a subject determines the same qualities in art. But basing himself on certain works, ancient and modern, he lays down a "precept" which, as far as I can see, forces one to that very conclusion — and it is an absurd one; or else the world of today is all wrong about Rembrandt and the men whom he typifies.

Here is the passage in question:

We might profit by the examples [of the ancients] that we have before our eyes, and at least not depart from the precept which antiquity followed, perhaps unconsciously, but which it certainly never discussed: to wit, that art should be nothing but the reproduction of the beautiful: either that or it should cease to exist.

In fact, I defy anyone to find in the works of the ancients an analogue for Rembrandt, for Murillo, for all those great artists who have never presented anything but ugly, hideous objects, from which one would turn away one's eyes if one saw them in nature. All antique statues bear the imprint of their author's talent, and show the individuality of their model; not one is like any other one: but all are beautiful, all set themselves the goal of reproducing a

beautiful being. Now if you will just imagine Murillo's *Boy Hunting Fleas* or a certain *Suzanna* by Rembrandt transported to the Athens of the time of Pericles and exhibited to the artists of that period, I venture to maintain that they would have turned their eyes away, or rather that they would not have understood what possible explanation there could be for such things.

I am rather shamefaced about arguing with the delightful writer, but I see no way to escape his challenge. So I will say that the ancients, the Greeks themselves, *have* left us representations of ugly things; deformity, drunken vomiting, conscious pornography, and cruelty. Their treatment of a subject differs from that of the modern world, but give those artists of Periclean Athens the time to understand what men have thought since their day and they will enjoy the work of their successors at least as soon as we came to enjoy the work of the Orient. (Were it worth doing, I could give passages in our earlier critics which excoriate the art of China and Japan as completely as any Classicist has done with the things he condemns — or any Romanticist either, I need scarcely add, though it is the other school that has just been making its attack.)

Finally — and this is the core of the matter — Amaury-Duval simply goes wild in saying (almost with the words of Ingres himself) that "art should be nothing but the reproduction of the beautiful." He would launch us on the boundless sea of discussion about what the beautiful is, as unconscious as his teacher that before the sights of the world everything depends on the point of view. It is different with the things of the mind; there, as Socrates affirms, education can bring men together. But common experience tells us that different countries, periods and individuals see the beautiful in their own ways — one of them often being the antithesis of another. The woman in whom one man sees adorable perfection is desolatingly commonplace to another. And then outside of this hopeless tangle in deciding on the beautiful, there still remains a worse difficulty, since the "precept" leaves no room for the type of art which has at all times been held supreme: that in which the thought of the artist is what we seek, and find.

The present book, however, is not one devoted to a theorist, and we

decided, long since, to pass by the mistakes of the man who could be as cool as Ingres was to Rembrandt, and as hostile to Rubens, who could misunderstand Shakespeare to the point of calling his plays "monstrosities," as we have heard him do, and link Goethe to Byron with the words, "I curse them." One may care greatly for the men he abominated, Géricault and Delacroix, and yet, before the long line of works from the *Madame Devauçay* to the *Golden Age*, one may forget the critic and join with Flandrin in his spontaneous outburst: "The good master! How I love him!"

If the words were spoken by a young zealot under the spell of the man's personal influence, their echo in more than words resounds from every museum wall where we see the painting of Courbet, Puvis de Chavannes, Degas, Renoir, and later men who could never have quite achieved the splendid things they did without the example of Ingres. At times they rebel against him — and thus prove only the more that they are of his breed. Year after year we make progress in seeing how necessarily they are related to him; we see also how far he is from the little men who, personally, were close around him. They did not grasp the essentials of his art, and so Rudolf Lehmann, a brother of the Ingres pupil mentioned before, and himself a painter, could write in his memories of the master, "Impressionism and 'plein air' seem nowadays to have succeeded in making an end of his powerful influence."

What a weak thought — worthy of the market place, where so many artists arrive at last — or rather, as soon as they can get there. Such men may, indeed, have forsaken Ingres for some painter more fashionable at a moment when the crowd went in for an art of bravura, what Delaborde calls "that false boldness, that courage of the poltroon." But we have seen that the artists who count have turned to the master with always increasing confidence.

And, as time goes on, that trend must strengthen. For there is one element in Ingres that seems destined to grow in importance as our race becomes more conscious of its heritage in art. That element in him I would call the European. The nineteenth century and the beginning

of the twentieth saw the development of interest in the exotic arts, those of Asia, of Africa, and of ancient America. In the production of these continents, there are immensely great things, but as we understand them better we are led back to our own things; we are refreshed and strengthened as we return to them—and it is with an increased conviction that the widest and deepest range of qualities is that of the European peoples.

Not only does Ingres confirm this by his words, by his continually returning in speech to the Greeks and Raphael, but his approach to his painting is typical of the best men of his race. The time was—and is no more—when we could be shaken by the doubts expressed by Oriental philosophers when they referred to our representation of the objective as a sort of magician's trick to produce illusion. The time is no more when we could fear the end of painting as a living art because of the invention of photography.

Ingres is one of our strongest answers to such doubts and fears. We look again at the portrait of Mme de Senonnes and know that the continent which could bring forth that wonderful mask has a genius no whit inferior to the one which produced the masks of the Africans or even of the Aztecs. But neither the continent nor Ingres stops at this point. The *Mme Delphine Ingres* of 1856 tells us that the painter has, in his old age, far outstripped the conception of that masterpiece of his youth. Not only from the aesthetic point of view does the later work tell of advance—through the use of the grand volumes which give a modeling in depth hardly more than indicated in that beautiful thing of 1814—but the whole philosophy of the work is more important.

Here is a final vindication of Ingres's attitude toward nature. In a lecture entitled Realism, the Art of the European Race, I once showed that the quality has been the steady goal of the peoples of that continent, (among whom Americans of course belong). Ingres held to realism with the unswerving fidelity we have seen, and in doing so he proved that the highest aesthetic qualities and the highest spiritual qualities are possible in an art that deals frankly and faithfully with the

THE ART OF THE EUROPEAN RACE (CONCLUSION)

world of facts. More than that: he proved again, as did Giotto and Piero della Francesca, Leonardo and Rembrandt, that only through such an acceptance of the world is the greatest art attained. And so, since Delacroix may well be placed beside him in his rank as a Classicist, I think the real distinction of Ingres is as a supreme European.

I know that the Japanese have invented — and independently — their own form of the Pygmalion story, but let us have the hardihood to say that with no other race than our own is the giving of life to the work of art on so high a plane as with us of the European stock. For with the increase of elements in our synthesis, there is an increase of difficulties and of the danger of falling into the merely imitative.

A parallel bit of reasoning may explain the phrase used by Charles Blanc when he wrote of Ingres as "perhaps the most original physiognomy of the whole French School." Just in proportion to the conviction with which he submitted himself to the discipline of the masters is the greatness with which his own genius rises to its extraordinary height: it is not hard to have an appearance of originality if one avoids comparison with the masters; the strong man can afford to let himself be measured by their standards.

Let us think once more of his eighty-seven years, for in forming our conception of him, the mere span of his life is of importance. Degas said that it is far easier to have talent at twenty-five than at fifty. Now think of Ingres like the oak that he was, keeping on to always higher levels, still green, still bearing — and with what richness! — even as his fiber grows more solid and stronger with the passing of decade after decade. The ancient man represents an ancient art. For sixty years he meditated on the *Stratonice* — and it is always more his own (to glance back at the claim that Amaury-Duval makes for his master's art). The study he made in his youth for the picture has already an amazing amount of beauty, but it is, after all, an early work, reserved and hesitant because of the awe in which the young painter holds his models of the classic time.

Thirty years later, when he is so moved in telling to his pupils of the

love for a woman (his own love) that the ancients wrote down in the story of Seleucus and Antiochus, he has grown to maturity and, still accepting the guidance of the past, he adds to our heritage with a thing such as we had not possessed before. Thirty years pass again — and see him only the richer and more powerful in his scope.

And so he is of those who have given to his city of Paris the right to its proud device — a ship on the waves, and the words *Fluctuat nec mergitur:* it rocks but does not go under. Once more, his significance is for our whole race: Europeans are equal to the task of continuing their tradition, since they can bring forth an Ingres so late in their history and, after his time — even today — show other men who grasp the fact that the means he used have still their old vigor and fecundity.

THE END

INDEX

INDEX

INDEX

Ingres, Mme Delphine (née Ramel), 113, 114, 121, 131, 132, 138, 157, 210, 282
Ingres, Mme Madeleine (née Chapelle), 16, 24, 56, 74, 80, 87, 97, 101, 109, 110, 148, 215, 220, 223, 251,
John of Bruges, 21, 46,

Kahnweiler, H. D., 264,
Knaus, 267,
Kotzebue, 187,

La Fontaine, 150, 188, 241,
Lamotte, 188,
Lapauze, Henry, 24, 35, 43, 52, 57, 86, 96, 106, 118, 121, 124, 129, 130, 137,
Laurens, Jules, 88, 93, 127,
Le Blanc, Mme, 51, 52, 100, 266,
Lebrun, Charles, 203,
Lefrançois, 234, 244,
Lehmann, 65, 88, 89, 281,
Le Nain brothers, 264,
Leonardo, 100, 172, 257, 260, 283,
Leoni, Ottavio, 41,
Le Sueur, 198, 203,
Liebermann, Max, 266,
Louis-Philippe, 68, 72, 102,
Lulli, 207,
Luynes, Duc de, 97, 103, 106, 226.

Mabilleau, Léopold, 118
Madrazo, 267
Magimel, Albert, 120, 121,
Maillol, 253,
Maillou, Rioux de, 271, 276,
Malherbe, 171,
Manet, Edouard, 4, 36, 50, 88, 89, 252,
Marcotte, Henri, 43, 53, 102, 110, 113, 131, 143, 204, 215,

Masaccio, 18, 19, 138,
Matisse, 89, 251, 270,
Méhul, 138, 210,
Memling, 21,
Metsu, 216,
Michelangelo, 60, 100, 172, 186, 198, 199, 211, 235, 259,
Moitessier, Mme, 31, 71, 106, 111,
Molière, 187, 198, [121,
Moore, George, 31, 76,
Mottez, 89, 98, 99,
Mozart, 19, 65, 77, 83, 122, 131, 137, 144, 190, 196, 207, 224, 247,
Mumford, Lewis, 134,
Murillo, 163, 214, 279,

Napoleon I, 11, 16, 20, 26, 50, 60, 116, 221, 247,
Napoleon III, 12, 68, 116, 131, 273,
Nieuwerkerke, Comte de, 274.

Orléans, Duc d', 102, 135,
Overbeck, 129.

Paganini, 84,
Phidias, 33, 107, 161, 168, 190, 217,
Picasso, 4, 50, 89, 249, 270, 277,
Piero della Francesca, 101, 105, 283,
Pollaiuolo, 255,
Pope, 224,
Poussin, 15, 18, 60, 91, 108, 162, 181, 188, 190, 200 et seq., 226, 255,
Prud'hon, 82, 255,
Puvis de Chavannes, 4, 89, 92, 248, 252, 281,
Quintilian, 265.

Racine, 33, 187, 188, 217, 265,
Rameau, 207,

289

INDEX

Raphael, 6, 16, 23, 35, 42, 46, 48,
53, 54, 55, 60, 62, 66, 87, 90,
92, 97, 99, 101, 107, 108, 112,
118, 122, 144, 146, 163, 172,
177, 186, 190, 193, 197 et seq.,
208, 213, 217, 225, 232, 236,
247, 255, 260, 265, 272, 277,
282,

Reber, Henri, 84,
Récamier, portrait of Mme, 7,
Redon, Odilon, 38, 90,
Reiset, Mme, 103,
Rembrandt, 31, 47, 60, 93, 236,
277, 279, 283,
Renoir, 3, 50, 55, 89, 90, 101, 123,
131, 247, 252, 253, 255, 257,
262, 281,
Ricketts, Charles, 92,
Rivière, (family portraits), 20, 23,
44, 266,
Robert, Léopold, 204,
Rodin, 36,
Romano, Giulio, 199, 200,
Roques, 6, 16, 87,
Rubens, 13, 36, 60, 67, 70, 90, 100,
178, 200, 233, 234, 260, 281,
Rude, 10, 232.

Saint-Victor, Paul de, 124,
Sangallo, 211,
Sarto, Andrea del, 99, 180, 199,
Scheffer, Ary, 67,
Schiller, 187,
Schubert, 59,
Schumann, 59,
Senonnes, Mme de, 47, 67, 100,
111, 282,
Sérusier, Paul, 270,
Seurat, 4, 89, 252, 257,
Shakespeare, 65, 107, 187, 224,
281,
Signorelli, Luca, 234, 235, 244,

Silvestre, Théophile, 46, 51, 263,
Source, La, 36, 121, et seq., 239,
Spohr, 214, [268,
Stamaty family, 25,
Stendhal, 86,
Sturler, 262,
Suarès, André, 70.

Tasso, 224,
Teniers, 216,
Terburg, 104,
Thiers, 16, 62, 104,
Thomas, Ambroise, 83, 94,
Thoreau, 242,
Tintoretto, 104,
Titian, 15, 91, 130, 178, 198, 201,
260,
Tournon, Mme de, 44, 136,
Turkish Women at the Bath, 39,
100, 128, 131 et seq., 243.

Valpinçon (Baigneuse de), 25, 38,
71, 120, 132, 136, 234, 256,
Varcollier, 9,
Velasquez, 90, 93, 214,
Venturi, Lionello, 55,
Vermeer, 99, 100, 104,
Vernet, Carle, 79,
Vernet, Horace, 79, 83, 120,
Vernet, Joseph, 79,
Veronese, 60, 90, 260,
Vespucci, Amerigo, 202,
Villon, Jacques, 104, 250, 251,
Villot, Frédéric, 271
Viollet-le-Duc, 68,
Virgil, 146,
Virgin of the Host, The, 47, 68, 95,
Voltaire, 167, 188, 217,
Vouet, 202.

Watteau, 7, 82, 90, 255,
Winckelmann, 28.

290

Printed in the United States of America, by
Noble Offset Printers, Inc. New York, N.Y. 10003